The Formation of Islamic Art

The Formation of Islamic Art

Oleg Grabar

REVISED AND ENLARGED EDITION

Yale University Press, New Haven and London

Designed by John O. C. McCrillis
and set in Palatino type.
Printed in the United States of America

Library of Congress Cataloging-in-Publication Data

Grabar, Oleg.
 The formation of Islamic art.

 Bibliography: p. 217
 Includes index.
 1. Art, Islamic—History. I. Title.
N6260.G69 1987 709′.17′671 87–8200

ISBN 13: 978-0-300-04046-3

The paper in this book meets the guidelines for
permanence and durability of the Committee on
Production Guidelines for Book Longevity of the
Council on Library Resources.

10 9 8 7

A Mes Parents

Contents

List of Illustrations

Introduction

Several impulses led to the writing of this book and, since these impulses dictated its scope and its format, there is a point in defining them briefly. A first one is that in the field of Near Eastern art there are almost no intermediates between the very specialized scholarly study and the very general book. The former rarely elicits much enthusiasm except in rarefied circles, while the latter is often general to the point of meaninglessness or erroneous in too many details because of the inability of even the most industrious scholar to keep up with the field's literature or to consider thousands of monuments in anything but a very superficial manner. A second impulse is the tremendous range in time and space of Islamic art. It is found in Spain in the eighth century and in India in the eighteenth, and almost all countries and centuries between these two extremes have contributed to its growth. While there may be perfectly valid reasons for considering such a vast area as a single entity over a thousand years, it is equally certain that considerable modifications, regional or temporal, were inevitably brought to it. Thus, it seemed appropriate to devote a study to one period only, thereby opening the way for further investigation based on distinctions of time and area.

A third impulse was that after years of writing, reading, lecturing, and teaching about early Islamic art, a number of ideas, hypotheses, and interpretations grew which never appeared in print but which seemed to deserve elaboration within a more general and more theoretical framework. For, as we will see, early Islamic art raises a number of abstract questions about the nature of artistic creativity and aesthetic sensibility which transcend the exact time and place of its growth. Or at least so it seemed to me. Many of the ideas and answers that follow are, of course, tentative and uncertain in value. Yet their very uncertainty and incompleteness may make them more useful than finished studies and solved problems since they may indicate far more accurately the hazy frontiers of contemporary knowledge and may inspire others to criticize, disprove, or improve their implications. Thus scholarship may become a dialectically creative process.

Finally, as I was asked to give the Baldwin Seminar for 1969 at Oberlin College, it occurred to me that a subject which led to a variety of ideas and hypotheses might be particularly suitable to an audience of art historians with little knowledge of Islamic art as such. These lectures, much redone, led for instance to the order in which the various topics will be discussed. And at times perhaps the selection of materials and the manner of presenting them reflect what began as a spoken exercise.

All these impulses have shaped the character of this book. It is not a manual of early Islamic art and it does not pretend to discuss all monuments and all problems. It consists of seven essays related to each other through a question defined in the first essay: if it exists at all, how was Islamic art formed? There are no notes, but in a bibliography arranged by chapter will be found such references as seemed necessary. This bibliography should be of help to those who may want to pursue some of the topics discussed in the essays proper. But my main purpose was not to provide another instrument for the gathering of information. Sir Archibald Creswell's great new volumes on early Islamic architecture, J. D. Pearson's *Index Islamicus* (Cambridge, 1958, with two supplements carrying his survey of periodical literature until 1965), or the more critical *Abstracta Islamica* of the *Revue des Études Islamiques* serve well the purpose of information. What I attempted was to suggest the varieties of historical, intellectual, functional, aesthetic, theoretical, and formal concerns which appeared to me to have created Islamic art. In places I have simply repeated what various scholars, including myself, have printed in well-known or obscure—but usually not read—journals. In other places I have introduced new ideas and observations. On occasions unproved—perhaps even unprovable—assertions have been made. Often I have tried to define the limits of our knowledge and the questions which require further investigation. Furthermore, it has seemed to me that a problem like that of the formation of an artistic tradition of more than a thousand years cannot be resolved simply through the continuous, monographic study of single documents. It must also be set in two additional contexts: the general cultural context of its time, the moment when all aspects of a new civilization are formed, and the context of a general theory of the arts and their development. It is my hope that both Islamicists and historians of other artistic traditions will find an interest in what follows, and

most of all, I hope that the hypotheses and conclusions which follow will be challenged and discussed.

It would be foolish indeed to claim that some great truth has been discovered in this book. It would be presumptuous to pose as an *agent Provocateur* challenging others to find solutions. What is presented here is an exercise in *Problemstellung*, in the setting up of categories of learning and investigation through which a series of fundamental questions may be answered. It is also an attempt to demonstrate the intellectual and at times even aesthetic fascination of a peculiarly rich moment of artistic creativity. If at times it appears to raise too many unanswered questions or to wither away into abstract considerations, the reasons are, on the one hand, that too little attention has been given recently to the theoretical principles by which we interpret existing documents and, on the other, that every piece of evidence—a great monument or a ceramic series—must have its epistemological limits properly defined before it can be used to suggest the growth and evolution of a culture's material and aesthetic creativity.

The pages that follow contain a number of very detailed discussions of single monuments as well as rather abstract considerations of general problems or of whole sets of monuments. This mixture of intellectual genres is largely dictated by the variety of the problems posed and by the great discrepancies in our understanding of and information about Islamic monuments. In order not to overburden the book with unnecessary geographical, historical, or technical details, I have assumed that the reader has an approximate idea of the major political and cultural events of the seventh through tenth centuries in and around the Mediterranean (fig. 1) and that he has some familiarity with the main traditions of Mediterranean and Near Eastern art before Islam. These basic facts are now available in a number of general books.

Like any essay in interpretation which implies that the history of art and even archaeology are largely aspects of a broader history of ideas, this book runs the risk of failing to satisfy either those who will seek in it precise explanations of otherwise known monuments and problems, or those who may expect some coherent theoretical system. It certainly is not supposed to replace much needed monographs and, while I can easily admit to some intellectual preferences over others, it does not seem possible as yet to work out a totally

valid abstract way of defining a priori all aesthetic and archaeological problems. And this is probably as it should be. Yet these essays are based on the belief that most knowledge and all explanations are only working hypotheses, whose constant refinement is the very stuff of intellectual endeavor and whose major criterion of value is not so much their possible truth as the degree to which they can serve to direct further studies, even if the latter end up by abandoning them.

I owe a great debt to many people. The most important one will be found in the bibliographical appendixes, for hundreds of studies by others have made these essays possible. Then various individuals read these pages, and their criticism did much to improve them at an early stage: Professor André Grabar, Professor Terry H. Grabar, and two former students, Dr. Lisa Volow Golombek, and Dr. Renata Holod. In the usual manner none of them bears any responsibility for the pages which follow. Nor can I throw any responsibility on the hundreds of students at the University of Michigan, at Harvard University, and at Oberlin College who over the past fifteen years have heard the slow and often unclear elaboration of the interpretations proposed here. Yet I owe more to their critical questions and comments than I dare to admit.

All works of Near Eastern scholarship face the thorny problem of transliteration. In order to avoid confusing as well as costly systems of diacritical marks, Arabic or Persian words and names have been simplified and a simple apostrophe indicates varieties of glottal stops, while no distinction is made between long and short syllables. Some may regret this decision but I justify it on two grounds. One is that a coherent transliteration tends to frighten nonspecialists away without adding anything significant to their understanding, while specialists can easily figure out what any one word or term was in the original language. And then it has always seemed to me that in comparatively general books the magic of arbitrary signs introduces a useless pedantry.

Finally it is a particular pleasure to thank those who have helped in putting the book through its last stages. I am very grateful to all those who have provided the photographs used in this book or who have allowed me to reproduce plans or pictures from their books and articles. A list of acknowledgments will be found with the list of illustrations. Mr. Howard Crane made the map in figure 1. Robin Bledsoe, of the Yale University Press, did more than anyone else to

make my text readable and saved me from a frightening number of inconsistencies and unclarities. Avril Lamb spent many hours writing letters, hunting for photographs, and retyping pages of text or lists of illustrations, all of it with cheerful good humor and critical concern. The book would have been much worse without their help. Finally, I owe a special debt to Mr. Dana J. Pratt, of the Yale University Press, who suggested that I write it all in the first place.

The Formation of Islamic Art

1. *The Problem*

In a book that is still one of the best short introductions to Islamic art, the late George Marçais proposed that a person with a modicum of artistic culture leaf through photographs of major works of art from the world over. He contended that almost automatically a group of works would be identifiable as Islamic, Muslim, Moorish, Muhammadan, or Saracenic, because they shared a number of commonly known features—what Marçais called the personality of Islamic art—which differentiated them from masterpieces of other artistic traditions. The ultimate validity of this judgment by a great historian need not concern us at this moment, nor is it important to know what commonly known features may have been in his mind or in the minds of the several writers on Islamic art who preceded or followed him. It is the suggestion itself that may serve as a convenient starting point for a definition of our objectives, for it contains a number of key theoretical and specific assumptions which are at the root of many difficulties and misunderstandings affecting the study of Islamic art, and yet without whose resolution—or at least discussion—neither the historical nor the aesthetic importance of a major artistic tradition can be properly explained.

The first assumption is that of the uniqueness of an Islamic art. But what does the word "Islamic" mean when used as an adjective modifying the noun "art"? What is the range of works of art that are presumably endowed with unique features? Is it comparable in kind to other artistic entities? "Islamic" does not refer to the art of a particular religion, for a vast proportion of the monuments have little if anything to do with the faith of Islam. Works of art demonstrably made by and for non-Muslims can appropriately be studied as works of Islamic art. There is, for instance, a Jewish Islamic art, since large Jewish communities lived within the predominantly Muslim world, and representative examples of this Jewish art have been included in a book on Arab painting. There is also a Christian Islamic art, most easily illustrated by metalwork from the Fertile Crescent in the thirteenth century but known elsewhere as well, for instance in the complex development of Coptic art in Egypt after the seventh century. Finally, even though its problems are far more complex and its pertinent examples much later than

the period with which we are concerned, there is an Islamic art of India which was certainly not entirely an art of Muslims. The important point is that "Islamic" in the expression "Islamic art" is not comparable to "Christian" or "Buddhist" in "Christian art" or "Buddhist art."

An alternate and far more common interpretation of the adjective "Islamic" is that it refers to a culture or civilization in which the majority of the population or at least the ruling element profess the faith of Islam. In this fashion Islamic art is different in kind from Chinese art, Spanish art, or the art of the Steppes, for there is no Islamic land or Islamic people.

If it exists at all, Islamic art would be one that overpowered and transformed ethnic or geographical traditions, or else one that created some peculiar kind of symbiosis between local and pan-Islamic modes of artistic behavior and expression. In either instance the term "Islamic" would be comparable to those like "Gothic" or "Baroque" and would suggest a more or less successful cultural moment in the long history of native traditions. It would be like a special overlay, a deforming or refracting prism which transformed, at times temporarily and imperfectly, at other times permanently, some local energies or traditions. As in the study of Gothic architecture or Baroque painting, one of the historian's problems becomes then to distinguish what in a given moment is native and what belongs to the Islamic overlay, and to keep some sort of balance between the two components.

In recent decades much research, especially that dealing with North Africa, Turkey, Iran, and Central Asia, has tended to emphasize the local, regional character of the arts, whereas an earlier scholarly tradition had stressed the unity of the arts created under the aegis of Islam. The reason for this modern preference lies perhaps more in the intellectual and practical isolation of scholars in many areas of modern Islam and in exacerbated nationalism than in a fully thought out rejection of the notion of an Islamic art definable in the ways in which Gothic or Baroque art is defined. Yet these new directions of research cannot and should not be easily dismissed; they are in fact quite important in forcing a realization of the danger that exists in interpreting the term "Islamic" as simply a cultural overlay affecting those lands which became Muslim by faith or civilization. It happens, for instance, that with the notable

exception of the southern half of Spain, almost no part of the world conquered by Islam between the seventh and the twelfth centuries ever gave up its particular cultural identification. Since it is logically unlikely and demonstrably untrue that a sixteenth-century Persian miniature and an eighth-century Syrian wall painting are related to each other in anything but the most remote fashion, "Islamic" either becomes meaningless as an adjective identifying a cultural and artistic moment or must be modified by a series of further adjectives such as "early," "late," "classical," "Iranian," "Arab," "Turkish," or whatever else scientific ingenuity can devise.

Other examples and comparisons could be brought together which would suggest that we are not very clear on what is really meant by "Islamic" except insofar as it pertains to many of the usual categories—ethnic, cultural, temporal, geographic, religious —by which artistic creations and material culture in general are classified, without corresponding precisely to any of them. There is thus something elusively peculiar and apparently unique about the adjective "Islamic" when it is applied to any aspect of culture other than the faith itself. One of our purposes in this work will be to try to propose a more precise definition than has hitherto been available for the term "Islamic" as it applies to the arts, and to consider whether there are non-Islamic artistic processes comparable to it or whether it is indeed of its own kind.

In the meantime let us assume, at least hypothetically, an apparent epistemological uniqueness of the term. This uniqueness can consist in a determinable number of differences between the Islamic artistic tradition and other artistic traditions; or, alternately, it can be the internally willed, positively identified decision of a given culture to shape the ways of its materials and aesthetic expressions. In the former case we would end up by defining an art from the point of view of the observer—contemporary foreigner or today's historian. Valid though such a point of view may be, it is incomplete because it is itself intimately bound up with the observer's own intellectual and aesthetic makeup. On the other hand, it is particularly difficult to see a work of art from the point of view of its creator or its first user, for, in most instances of pre-Renaissance art, we can only approximate the conditions which prevailed at the time of a monument's making. Yet, if one is to define the uniqueness of an aesthetic tradition, it is perhaps this internal cre-

ative purpose which must be explained—or at best hypothesized —rather than the external formal, iconographic, or functional characteristics.

Another implication of Marçais's opening statement derives from his definition of Islamic art as "the last one to have been born in our old world [with] its cradle in Western Asia" (p. 5). Since Islam as a religion or culture is an historical phenomenon that was formed in the third decade of the seventh century and that grew and developed in particularly spectacular fashion, the very possibility of an Islamic art presupposes a change in previous artistic traditions. This implicit change may be defined on two levels. One is vertical in the sense that artistic traditions described through some earlier cultural moment or geographical area from Visigothic Spain to Soghdian Central Asia became Islamic at a certain moment and can be identified as such through precise characteristics. The other, horizontal, level is that of a presumed uniformity in the character of the change which could make, for instance, the art of Cordoba in the ninth century closer to the art of Samarkand than to that of Compostello. If the latter definition proves to be correct, its implications are quite extraordinary. In A.D. 700 Cordoba and Samarkand had probably not even heard of each other; in 800 they belonged together; in 1200 they were no longer part of the same world. Granada in 1200 was still part of the world of Samarkand but no longer of Cordoba. As late as 1450 Constantinople was a Christian citadel of Byzantine art, but in 1500 its art is supposed to be comparable to the art of Delhi or to that of Marrakesh. These are obviously extreme instances, but they do demonstrate that an understanding of whether and how Islamic art may be an intellectually valid concept requires a precise elucidation of those common features which at varying times and in varying regions led to changes in the arts of different cultural entities.

Problems of change are of course neither new nor the unique privilege of the art historian. Social scientists have constructed elaborate models to explain the myriad of evolutionary or revolutionary ways in which changes have been brought about. Valuable though they may be in many details, these models are not easy to translate into more ancient terms and into the area of the visual arts because most of the time our information is too scanty or else

of a type which cannot readily be included within the patterns or paradigms developed by the social scientist. To attempt to use them may eventually be worthwhile, but for now the more fruitful approach may be to use the work of art historians dealing with other periods of significant and irreversible change. The history of late antique art in the Mediterranean, with its passage from pagan to Christian art, offers a superb and often discussed instance of change which has the advantage of comparative proximity in time and space to Islamic art. The most recent studies on the subject have, it seems to me, emphasized two points which are crucial to our purpose. One is that change in meaning and change in form are two separate phenomena that depend on each other but do not necessarily coincide. The other is that change consists not only in modifications to the visually perceptible features of form and subject matter but also to an interplay between these features and a feature that is less easy to comprehend, the mind of the beholder. In other words it is likely, or at least possible, that the fact that a Muslim looked at or used a form gave a different sense to that form, and that this difference of visual understanding or of practical use is largely what affected the making of further forms.

By searching for an identification of uses and attitudes, we may indeed be able to discover an essential inspiration of any given artistic tradition. It is certainly not by accident that most historians of late antique and of early medieval art have so often dealt with interpretations of texts, from those of Plotinus to the highly verbal Iconoclastic controversy. In this manner it has been possible to sketch a sort of profile of the verbalizing intellectual's relationship to the arts. Similarly, it is the study of ceremonies, religious or imperial, which has provided current explanations of buildings and often of images and decorative designs. In many ways related procedures have been utilized to define other changes, from the Romanesque to the Gothic or from the Renaissance to the Baroque.

It becomes evident then that an identification of the changes brought out by Islamic civilization in order to make an Islamic art possible requires an identification and explanation of three separate elements: the mind of the Muslim user and beholder, the meanings given to his artistic creations, and the forms utilized by him. It is clear as well that the knowledge we need of these elements is local-

ized in time, for it is as they appeared at the formative moments of
Islamic art that they effected the changes implicit in the presumed
existence of that art.

Thus even a rather simplified consideration of what seems to be
meant by the notion of an Islamic art has led us to the important
realization that, whatever developments the art of Muslim lands
may have had over the centuries, it is essential to understand as
fully as possible how it was formed, what *primi motori* were in-
volved in its creation. It is not merely a question of deciding what
features in a number of early monuments illustrate something new
that could be explained by Islam alone. It is also a matter of deter-
mining whether characteristics were developed which permanently
affected the arts of Islam or whether the phenomenon of Islamic
art is but a variant, regional or temporal, of other artistic entities.
It is finally a matter of defining a mind, an attitude toward the arts,
a psychological motivation, and an intellectual understanding.

Having outlined the general purpose of our investigations, we
must turn to more specific topics. Here two questions arise, one
pertaining to the times with which we will be concerned, the other
to the methods we are to follow.

The question of the period or periods with which one must deal
in order to explain the formation of Islamic art is not as simple as
may first be imagined. In considering artistic and cultural change
we have to account for what may be called absolute and relative
time. Absolute time consists in those centuries, decades, or even
years after which Islamic art was possible and probably existed. It
is a time that generally can be defined quite precisely through his-
torical events or through particularly important monuments. Rela-
tive time, on the other hand, is defined by the moment when a cul-
ture as a whole has accepted and is transformed by changes which
in themselves may be dated precisely. For instance, in absolute
time the new Gothic spirit is a phenomenon of the third quarter of
the twelfth century when Abbot Suger, for example, started re-
building St.-Denis; but the relative time of the Gothic is just as
clearly the thirteenth century, when practically the whole of West-
ern Europe became affected by the new aesthetic and intellectual
systems. Or, a Christian art may have been possible and even ex-
isted as early as in the second century A.D., but the artistic "land-
scape" of the time was still that of imperial Rome. It was only two

centuries later that the artistic landscape or climate of the Mediter-
ranean became Christian.

Absolute times may be fixed by precise monuments, as in the
cases of St.-Denis or in the painting of the Sistine Chapel, or by
political or cultural events which can be presumed to have had a
major impact of some sort, such as the French Revolution or Alex-
ander's conquest of western Asia. In the case of Islamic art an ab-
solute date may indeed be posited, and it is essentially a political
one. There could not have been any Islamic art before the existence
of Islam and for practical purposes one can adopt the canonical year
A.D. 622 as the basic *post quem* date for any possible formation of
an Islamic art. It was the year of the Hijrah when the Prophet Mu-
hammad established himself in Madinah as the head of the small
Muslim community, and it thus became the first year of the Muslim
calendar. But the events that took place in west-central Arabia
around 622 had only local significance at the time, hardly involv-
ing more than a minor area on the edge of vast deserts, themselves
at the periphery of the major centers of the day. The events could
have had any sort of importance for the arts only if some major
monument or idea about the arts were associated with them.
Though we will refine this point a bit later, it is generally agreed—
and on the whole justifiably so—that no such monument existed
and no obviously significant ideology about the arts had been devel-
oped. Thus, crucial though it may be as an absolute *post quem* date,
622 is not a very meaningful one for the arts. For a history and un-
derstanding of Islamic civilization this observation is not without
significance, for it differentiates the position of the arts from that of
religion or institutions in the formation of an Islamic entity. In reli-
gion, for instance, the Medinese spirit of the Koranic revelation
after 622 is distinguishable in form, content, and impact from the
earlier, Mekkan one.

Since almost all the preserved or known monuments of Islamic
art are found outside of the precise geographical region in which
Islam first appeared, a more appropriate absolute date may be that
of the conquest of a given region by Islam. This would be a curi-
ously curved date which would begin in 634 when the first Syrian
villages were taken over by Muslim Arabs and would end in the
early sixteenth century when the Mughal emperors consolidated
into one entity the many sultanates of India, or even much later in

the nineteenth century when certain parts of Africa became Muslim. In fact the process of islamization still continues, and scholars like the late Joseph Schacht who were concerned with the inner mechanisms of the growth of early Islamic thought and institutions have often shown the importance of contemporary phenomena for an understanding of early Islamic art and culture. After each point on this complex curve an Islamic art was formed in areas where it had not existed before, and it is indeed true that a proper consideration of the subject proposed by our title should include the ways in which and the degree to which the Muslim world, at any one moment of its long and successful expansion, forged the visually perceptible forms that identified its presence.

At the same time, the peculiarity of this curve is that it is one of long plateaus during which the *dar al-Islam*, the territory controlled by the faith, remained stable, and of sudden and rapid expansions, or, more rarely until modern times, contractions. The eleventh and twelfth centuries witnessed major transformations in the West, Anatolia, and India. The fourteenth and fifteenth centuries were times of tremendous conquests in the Balkans and India. In all these cases except Spain, an Islamic culture and an Islamic art appeared in areas from which they had until then been excluded. But what was either imported from elsewhere and translated into local forms, or created anew, had already had an Islamic existence or association before it became part of the new Ottoman art in Anatolia and the Balkans or of the new Mughal art in India. Our concern will be with the formation of that original system of forms which can properly be identified as Islamic and from which in evolutionary or revolutionary ways all other Muslim forms derived. Its absolute dates can be defined from the time of the first series of conquests between 634 and 751 when the present Tashkent in Central Asia was occupied and Arab armies encountered Chinese forces at the skirmish of Talas. Within this span of 120 years the core of the land which was to remain Muslim until today was taken over, and it is essential to note that with minor exceptions in the West (notably Sicily, conquered between 827 and 902) and in Central Asia or northwestern India, this geographical entity hardly changed until the eleventh century. The taking over of this area was not, however, the result of a single burst of conquest as in the case, for instance, of later Mongol invasions. It was rather like a

sort of ink blot with a periodic addition of new ink in the blot's several centers. This conquest was quite clearly and consciously recorded by historical tradition, and a precise date can usually be given to the establishment of Muslim rule in every province, if not, as in Syria, in every city. Each individual date is valid only for a particular city or province, but the span is valid for the whole culture because it identifies the period when a vast area irreversibly changed from something else to Islamic and thus became a unit to which little was to be added for several centuries. This definition of absolute dates is primarily a political one, almost always military in fact, and hardly ever corresponds to major changes in the composition of the population, for Muslim armies were small and for awhile did not constitute more than garrisons. Yet in the subsequent self-understanding and self-consciousness of every Muslim region or city, this date of conquest became the symbol of its new state.

If then we have an historically definable *post quem* date for our investigation, when should we end it? When can we say that an Islamic art has been formed? This is where the problem of relative time comes in. For, since the creation of an Islamic entity was the result of a cause external to the area in which it was created and since the precise dates we have mentioned identify political or administrative events only, there is no necessity—it is in fact almost erroneous to do so—to consider the time when Damascus, Cordoba, or Samarkand became administratively part of the Muslim empire as automatically the time when all expressions of their aesthetic or material culture can appropriately be considered as Islamic. The Dome of the Rock (fig. 5), the mosque of Damascus (fig. 25), or many an early Islamic building or silver object from Iran (figs. 98, 99) have been considered as monuments of Byzantine or Sassanian art, and every manual of non-Muslim art treats them as such.

Other examples exist that complicate matters even more. We know, for instance, that in 719–20 in the small town of Ma'in in Transjordan mosaic floors of rather mediocre quality were redone in a Christian church, and it has been suggested with considerable justification that these repairs were influenced by the changed political and cultural conditions, for representations of living beings—mostly animals—were replaced with vegetal motifs. A sizable group of thirteenth-century bronzes with Christian subjects can properly

be considered as works of Islamic art. Yet no one has ever called the Ma'in mosaics works of Islamic art, even though they postdate the conquest and are probably under the impact of the rule of Islam in Palestine and Syria. It is essential either to find a reason for this judgment about works done by Christians or to conclude that the prevalent opinion of them is erroneous. An even more complex problem occurs in Iran when one considers the so-called post-Sassanian silver objects (fig. 99) for, as several writers have observed, post-Sassanian means Islamic since Islam took over the Sassanian empire. Yet it has proved extremely difficult to decide by which criterion a given silver object is Islamic or Sassanian. Finally, much has been written about the vexing question of the relationship between Christian Coptic art and the Islamic art of Egypt, but not much has been solved. Inasmuch as the Muslim conquest was very rarely destructive, it can be taken for granted that earlier artistic traditions continued at almost every level of creation and patronage and that their production was used by Muslims and non-Muslims alike. Archaeologically, it has so far proved impossible to distinguish late Byzantine from early Islamic ceramics in Syria and Palestine, and Soviet archaeologists tend to consider the material culture of Central Asia from the sixth to the tenth century as an entity. Thus, at least at first glance, there does not seem to be any clear way of deciding how, why, and when a work produced under Muslim rule can properly be thought to be Islamic.

At the root of our problem lies the fundamental fact that the time of events and cultural time do not coincide, not even within the powerful totalitarianism of our own century. A John of Damascus was born and died within the political time of the Muslim empire and probably spoke Arabic in daily life, yet he can hardly be understood as a representative of Islamic culture. On the contrary, he was better informed about what was going on in Byzantium than in the Muslim world. John of Damascus's major contributions to Byzantine theological thought and his total involvement in Byzantine religious life are parallelled by the very remarkable fact that it was under Muslim rule, and possibly as late as the tenth century, that the codification of Zoroastrian religious writing took place in western Iran. In this latter instance, of course, we are not dealing with an involvement with politically foreign entities, but rather with a conscious attempt to preserve and develop a pre-Islamic tradition.

The parallelism with the case of a John of Damascus lies in the fact
that at a time when Muslim rule had been established for some time,
major groups or powerful individuals continued to exist as though
the Muslim rule were hardly present, or possibly in conscious re-
action to it. If a Muslim writer like Muqaddasi could still in the
tenth century complain that Jews and Christians had the upper
hand in Jerusalem, it is likely indeed that by that time many cities of
the Islamic Near East, not to speak of the countryside, had a strong,
if not always predominant, non-Muslim population whose degree
of cultural islamization is as difficult to assess as it is essential to
know. Yet at a certain moment Zoroastrianism became part of a
mythical pre-Islamic past rather than a component of contemporary
reality, and Christian or Jewish communities became secondary
and, with some exceptions, minor units within the Muslim world;
their culture and aesthetic merely mirrored with a few peculiarities
the views of the dominant Islamic way. It is probably only after
this domination was fully established that we can appropriately
talk about a *formed* Islamic art which would have become the art
of the various geographical areas ruled by Muslim princes and by
the Law of the new faith. It is only then that we can begin to an-
swer some of the questions raised above about the respective im-
portance of regional or pan-Islamic values and characteristics in the
arts.

There is another way of defining the relative time we are seeking
to establish. We may use a cultural term and say that we are look-
ing for a classical phase in the Muslim world. The term "classical"
is obviously a dangerous and difficult one, and we will have occa-
sion to return to it later. At this stage it may be easier to suggest
that this classical phase, if it existed for the arts, had to have some
of the following characteristics: wide cultural acceptance of certain
forms as identifying the culture's functional and aesthetic needs,
repetition of standardized forms and designs, quality of execution
at various levels of artistic production, clarity in the definition of
visible forms. Unfortunately the state of scholarship dealing with
Islamic art does not allow us as yet to say when such a classical
stage may have been reached, and one of our objectives is to make
some suggestions in this direction. The presumption of the exist-
ence of a classicism thus defined must, however, be accepted as a
premise for our investigations. For another way of expressing the

idea of classicism is that, be it in Islamic culture or in fifth-century Athens, there was developed a more or less idealized typology of forms that was automatically utilized by the culture whenever it made an object or erected a building. Without its existence, it is useless to suggest that an Islamic art can be defined.

Thus, whereas one can be quite precise about the absolute time after which an Islamic art is conceivable, one can reach no such precision about the relative time by which it had actually been formed. The only likely assumption is that this time varied from area to area, and one of our problems will be to determine the index of value any individual region or monument has for Islamic art as a whole. Only through the monuments themselves may we be able to discover the relative time it may have taken for Muslim culture to create an art that can be clearly defined as its own. At the same time, one must constantly recall that it was a political and religious impetus, not an artistic or even material one, which created Islam and so made Islamic art possible. If political history or intellectual history can provide us with "nodal" moments, that is, moments of crystallization of thought or of power, it is legitimate enough to assume a similar crystallization of the arts. At least the question must be raised, even though one must be mindful that the rhythms of the visual arts and of thought or of political and social events need not coincide.

The preceding remarks suggest that a method or methods must be devised which can resolve, from whatever evidence is available, the various problems we have raised. Some sixty years ago a superb article by Ernst Herzfeld was entitled "Die Genesis der islamischen Kunst." In it and in some of his other works the most versatile of the small group of scholars who, at the turn of the century, set the study of Islamic art on a more or less scientific basis, attempted to answer the question of the originality and uniqueness of Islamic art by raising the problem of its formation. He was the first to recognize that the problems of an art created in the unique historical circumstances of Islamic art cannot be explained in purely formal or purely art historical terms. It has to be seen in what since Herzfeld's time would have been called its ecological setting, that is in a certain relationship between man and his surroundings. Eventually Herzfeld—much under the influence of Riegl's idealistic answers to a recently grown materialistic theory of the arts—was drawn to a

sort of deterministic position that the conquered lands themselves had "foreseen the coming art of Islam" ("die werdende Kunst des Islam"). Even though one may easily argue against the likelihood of such an inevitability of artistic developments, it remains true that Herzfeld was the first to realize that a problem existed and that traditional or even novel methods were not entirely suited to it. Yet his solutions, tentative though he himself thought them to be and original though his premises may have been, still suffer from two defects. One is that his information was very limited compared to what is available now; the other is that, because he wrote at the time of the discovery of the Orient—and was much involved in the then virulent battle of *Orient oder Rome*, a fascinating debate on the sources of medieval art—he tended to resolve too many problems in terms of a contemporary dichotomy between a classical perfection and a recently discovered early medieval and Oriental decorative aesthetic.

It is rather curious that Herzfeld's last major contribution to the problems of early Islamic art dates from 1921. Other concerns, mainly Iranian ones, occupied him from then until his death in 1948, and he never had a chance or the interest to return to his earlier involvement in the light of new discoveries. We shall see later that in our judgment many of Herzfeld's ultimate insights were correct, even though most of his specific arguments no longer are. But he was much in advance of his time and of the knowledge available to it. Because of his involvement in the exciting arguments of the newly developed art historical schools in Vienna, he was conscious, especially in his earlier works, of the importance of theoretical and abstract considerations in dealing with the problems of early Islamic art. While one can easily grant the dangers attached to such concerns, the more pragmatic and positivist tendencies of the following generation have perhaps failed in making the monuments and problems of early Islamic art significant to the discipline at large.

It was from a totally different academic and intellectual tradition that new ideas and methods were to come. As after World War I mandatory power was established in the Levant, the aristocratic travels of old—like those of Sarre, Herzfeld, van Oppenheim, de Vogüé, Butler, Gertrude Bell—were replaced by the perhaps more prosaic but academically more fruitful establishment of permanent

schools and institutes which fostered a far more profound involvement in and understanding of the life of the lands in which early Islamic history took place. This new atmosphere fostered the brilliant thought of Jean Sauvaget, whose elaboration was left unfinished by his untimely death. Sauvaget was rather negatively and unfairly caustic about the intellectual value of art historical endeavors and his preference went to what he called "archaeology." In his sense the word should not be understood in its technical meaning of excavations (although it did not exclude them) but rather in its etymological meaning of learning about ancient remains. More precisely, Sauvaget felt that only by studying the total evidence available about a given site, monument, problem, or period can any part of it be understood. Shards have to the historian, even to the historian of art, the same documentary value as a masterpiece of painting or architecture, perhaps even a greater value for they lead to what Sauvaget called "the silent web of history" ("la trame silencieuse de l'histoire"). To him, only when seen against the unconscious and almost automatic material culture of the time could the conscious, if not even at times self-conscious, work of art be understood properly. While Sauvaget was propounding and developing his views in his teaching, quite independently of his work, the more tragically lonely figure of Ugo Monneret de Villard was putting down on paper an introduction to the archaeology of early Islam which has only recently been made available. Even though it too remained unfinished, it exemplified the same concerns for a sort of total history and the same realization that only through some organized correlation between a mass of very diverse kinds of documents could the art of early Islamic times and the formation of Islamic art be understood, in fact, even identified.

If I have spoken at some length about these scholars, it is in part out of deference to men I have not known, but whom I have read quite often over the past twenty years. As one attempts to synthesize, the sense of what one owes to the dead increases and replaces whatever irritation one may have felt at the unfinished character of their work. For it is unfortunate indeed that not Herzfeld, nor Sauvaget, nor Monneret de Villard was able, through a variety of accidents of history, to put together in any sort of final or systematic form the often brilliant insights he had. While it is presump-

tuous to suggest that this can be done in the pages that follow, it
is still true that, for better or for worse, correctly interpreted or
not, the thoughts and ideas of these masters have led to the posi-
tions and to the conclusions of this book. It is their pioneering work
which in large part suggested the methods which will be used
throughout. Even when I depart from their views or introduce doc-
uments that did not seem pertinent to them, the large debt schol-
arship owes to them will, I hope, be apparent.

We have shown that it is not through works of art or monuments
but through the unfolding of certain political or other events that
the very possibility of an Islamic art can be raised. We must, how-
ever, now ask ourselves whether there are monuments or related
documents that may make it possible to answer the questions posed
by history. Such monuments and documents not only exist but
are quite remarkably numerous and varied. Some of them are ac-
knowledged masterpieces of world art like the Dome of the Rock in
Jerusalem. Others are still unsolved curiosities like the series of
secular establishments which are found over a large area from the
celebrated unfinished Mshatta at the edge of the Jordanian desert
(fig. 66) to Qasr al-Hayr East way out in the Syrian steppe (fig.
103). They can also be works of the so-called minor arts such as new
ceramic types appearing in Iraq or northeastern Iran (figs. 107ff.).
They can be huge and imposing, as in the ninth-century Abbasid
towns and palaces artificially created over some thirty miles near
the Iraqi town of Samarra, or simple and prosaic ruins, as in the
many badly preserved estates of Transjordan. Finally, these docu-
ments can be texts describing buildings, as in the instance of most
early mosques or objects and ceremonies. It is clear that, whatever
the questions for which history requires answers, there is a practical
problem of dealing with a considerable and immensely varied doc-
umentation about the arts, of finding a common denominator for
them. The problem is compounded by a number of special diffi-
culties, of which two examples may suffice at this stage. It can be
demonstrated—and I will discuss the meaning of this later on—
that between 640 and 670 in the newly founded cities of Lower
Mesopotamia a type of building was created which has been called
a hypostyle mosque. A century later a similar kind of building is
found in Tunisia and Muslim Spain and can be reconstructed in

Balkh or Nishapur in northeastern Iran and Afghanistan. Should we assume a spread from Iraq to the confines of the Muslim world? Should we think that similar functions automatically created similar forms in different parts of the Muslim world? Or should we rather imagine that there was a *type*—in the technical sense of the word, a standard with variations—which was independent of any specific land but was tied to the needs of the faith alone and to the mind of the faithful? In other words, what is the kind of relationship which exists among forms spread all over the Muslim world? Should their history be written from monument to monument set in chronological sequence, as has been done in many basic manuals such as Creswell's monumental *Early Muslim Architecture?* Or should it accord to some underlying idea about forms and purposes which transcends individual monuments?

Or, to take another example, one can identify through the example of the reconstructed facade of Qasr al-Hayr West (fig. 65) a certain type of early Islamic princely residence with an elaborate architectural decoration in which most individual themes and techniques belong to a wide variety of non-Islamic sources. While it may suffice merely to identify these sources, the more important problem is to decide how these themes were understood when they were made, why they were made, and whether they were but accidental collections of motifs or significant and conscious accumulations of subjects in the process of creating a new aesthetic and material vision.

These examples illustrate that, in addition to the comparatively simple problem of ordering and organizing large masses of available archaeological documents, the issues we have raised and the incomplete nature of the evidence we possess about the huge world of early Islam require answers to larger and more theoretical questions. From a practical point of view one could indeed take the monuments one by one, analyze them, and then draw appropriate conclusions. But, outside of the fact that it would be a particularly long and cumbersome procedure in the confines of a short book, this task, which is made all the more difficult since information varies enormously from one monument to the next, is meaningless if it is not associated with the elaboration of hypotheses.

What can we consider an art historical hypothesis to be? And how does one develop it? Here one may again borrow from disci-

plines other than the history of art and suggest that there are three criteria attached to a hypothesis of the type I will propose. It has to explain a sufficiently high number of perceptible phenomena or documents without being compelled to explain them all; it has to be meaningful both in terms of individual monuments and in terms of the wider historical setting in which they were created; and, it has to be a perfectible statement in the sense that its acceptance is not a final conclusion but one that seeks and leads to further explanations and to further research. It has to be an instrument of work, a step in the asymptotic process of understanding that is characteristic of any science.

To reach such hypotheses we have to make two logical assumptions. One, already sketched in our earlier remarks, derives from the fact that the time and space which created Islamic culture automatically compelled the growth of certain physical and aesthetic needs of an art. But a priori the impulse for a uniquely Muslim art lay not in monuments but in certain identifiable habits and thoughts, which had to be translated into visually perceptible forms. Such a translation could be possible and meaningful only through the existence of underlying structures in all such creations, that is, of regular systems of relationships among individual elements of the monuments, without which no form could be made intelligible to its user. The other assumption is in fact that of the contemporary intelligibility of the forms created by man, that is to say that there was no arbitrarily nonsensical (as differentiated, for instance, from willfully or accidentally misunderstood) formal creation. If one grants these assumptions of intelligibility and of underlying structure, then the way in which the monuments and history can lead to hypotheses clearly lies in extracting from them the conscious or unconscious principles that made the material and aesthetic culture of early Islam possible and then in setting forth these principles as the hypotheses which explain a period.

In the following chapters I have begun with the general premise that there had to be a way in which the new Muslim culture expressed itself visually, and the first four chapters will be devoted to an exploration of this point. They will include considerations of the ecological changes brought into the conquered lands, the symbolic appropriation of the land, Muslim doctrines on the arts, and an art inspired by the faith. Then I will turn to themes derived

from such monuments for which no automatically "Islamic" function can be established. Centered on the palace and the city, these can in a general way be considered as works of secular art, although we shall have occasion to refine the meaning of the term. From these discussions one particular topic will emerge as uniquely Islamic: the fascination with a form of nonrepresentational decoration. In a last chapter I shall attempt to discuss it in some detail and then conclude by proposing various answers to the questions raised in this introduction.

2. *The Land of Early Islam*

Two subjects discussed above may serve as the starting point for what will be attempted in this chapter. One is the conclusion that in order to define the ways in which Islamic art was formed it is first necessary to identify the subjects, forms, and attitudes that developed over a vast area after 634, the year in which the conquest began to extend beyond Arabia itself. The other is the more complex question of absolute and relative times in the creation of a new artistic tradition, or when we are entitled to use the term Islamic for the monuments of the area taken over by the new faith. It has only been mentioned that in all probability the relative time varied from region to region.

This chapter will provide a sort of archaeological survey of the lands conquered by Islam between 634 and 751, for, in order to know when a work of art or a material object can properly be considered Islamic, it is necessary to be aware of the degree of islamization of the area in which it is found. This awareness forms at least one aspect of what the founder of scientific Islamic archaeology, Max van Berchem, called "the archaeological index" of a document, that is, the likely extent and value of the conclusions that can be deduced from it or, to use a term borrowed from linguistics, its semantic field.

An archaeological survey of the type needed cannot be limited to Muslim monuments alone or to the nature of Muslim implantation in any one area. It must also include some idea of what was there before Islam and of what was visible or used at the time of the conquest. There was, as mentioned above, a "landscape" or a "climate" of things and monuments against which, or according to which, Muslim creations were made and the degree of uniqueness or of originality of the Muslim element depended on the nature, strength, and vitality of local artistic traditions. To use a biological parallel, Islamic culture in general and Islamic art in particular can be imagined as a sort of graft on other living entities, and the degree to which and ways in which the graft took depended in some part on the body to which something was added.

The state of our knowledge does not make it possible to provide an archaeological profile of early Islamic times which would include in one full sweep all areas and all problems. Although we shall attempt something of the sort at the end of this chapter, the justification for our

19

conclusions lies, for several reasons, in a rapid sketch of what happened in each of the major regions involved. One is simply the tediousness of partly repetitive enumerations. Another is the difficulty of adequately controlling both the archaeological information scattered from Spain to modern Pakistan as well as the immense amount of written source material. Thus gaps and omissions will be found in the following pages; I hope they will spur others into completing the task begun here. Another problem is that of the preeminence taken by the Fertile Crescent in our sketch. In part it derives from my own greater familiarity with that area as well as from the fact that it has been much better studied. But it must also be admitted (and we shall return presently to some of the reasons) that this area played the most crucial part in the formation of a new Islamic art. Altogether it should be noted that the judgments and conclusions in this chapter are in part value judgments and personal conclusions and that the significance and importance of some of the provinces can be seen in a different light than the one seen here, for instance through social, economic, or literary history.

Let us begin with North Africa and Spain. Absolute dates are easily provided by the years 669, when the first governor of the new province of Ifriqiyah, the celebrated 'Uqbah ibn Nafi', took over what is now mostly Tunisia and began the slow Muslim conquest of Algeria and Morocco as well, and by 710–11, when the no less celebrated Tariq ibn Ziyad crossed the straits which now bear his name and became the first Muslim governor of Spain. But these dates are no more significant than that of 622. It is comparatively simple to show that in Spain, whatever the nature of the first Muslim occupation may have been, there is no trace in actual monuments or in any texts of original Muslim creation until the formation of the independent Umayyad caliphate in 756. It is only in 785–86 that the construction of the first part of Cordoba's mosque illustrates a building of any sort of significance in Muslim Spain (figs. 26–32). This building is still preserved, though much enlarged and partly modified; yet both archaeological and literary sources can be used to demonstrate the permanent impact of its first form. I know of no information elsewhere in literary sources about the construction of any other building or in fact about any work of other art before 785, nor is any known archaeologically. By then, of course, major developments had already occurred in Islamic architecture, and in many other arts as well, in other provinces of the Muslim world. Inasmuch as the growth of Muslim Spain after 750 coincided

with an influx of Muslims from Syria, we may consider the first steps
of an Islamic art in Spain as consciously affected by earlier develop-
ments elsewhere in the Muslim world. This point is significant when
one realizes the poverty of the living artistic tradition which did in fact
exist in Spain at the time of the Muslim conquest. Important though
Visigothic churches are for early Christian art and perhaps for the
eventual revival of a Spanish medieval art, they could not impress the
Muslim conquerors in the ways that Palestinian churches did indeed
impress them, and on the whole the more significant architectural
infrastructure which did exist was that of Roman Spain with its superb
civil monuments.

Matters are somewhat more complex with other arts, and in the
account of the conquest there are curious references to some extraordi-
nary table known as Solomon's Table, which was captured by the
invaders, as well as to considerable treasures of precious metal. Unfor-
tunately one can only speculate about what these were. Insofar as we
know them, the other arts of Spain before Islam were also rather
limited or, like the celebrated crowns of Guarrazar, accidentally Span-
ish examples of a much wider art of Germanic princes. Finally it must
be noted that, although ruled for several centuries by Muslim princes,
Spain in general and even Andalusia remained largely populated by
Christians and by an active Jewish minority in the cities. There are no
instances of major Muslim towns founded in Spain, and for the most
part a pre-Islamic toponymy has been transliterated into Arabic.

These points suggest that the value to be given to Islamic monu-
ments in Spain, within our general definition of an archaeological
index of Muslim provinces, was essentially a *reflective* value: the a
priori impetus for Spanish Islamic monuments and the models and
ideals which were followed belonged to an alien world. This is true
even of monuments of major historical or aesthetic significance, as in
the instances of Cordoba, Madinah al-Zahra, ivories, textiles, or much
later the Alhambra. For it was the cultural weakness of Christian Spain
and a number of accidents in early Islamic history that trans-
ferred this faraway province into a major Muslim center. Even when
uniquely Spanish forms were created—as they were indeed in archi-
tecture and in decoration—from the archaeological point of view of
defining the formation of an Islamic art, Spanish examples serve pri-
marily as illustrations for conclusions reached from other sources and
in other areas.

Matters are different in North Africa, where, at first glance, we meet

a curious paradox. North Africa and especially Tunisia had been a very wealthy and superbly exploited agricultural and urban area in Roman times. It became very early a major Christian center, and, although devastated in part by the Vandals, it was still a province to which Byzantium attached some importance since it was one of its main suppliers of olive oil and perhaps of wheat. Although most of its pre-Islamic monuments—cities, country villas, churches, mosaics—cannot be called typically North African since they reflect typologically the Mediterranean-wide art of the Roman empire and its successors, these monuments are of great importance because they are often from periods that are not well represented elsewhere, especially during the key centuries of the fall of Rome and the growth of a new artistic expression. Yet within a few centuries North Africa became a totally Muslim region and one of the very few formerly Christian lands from which Christianity disappeared altogether. Almost all North African cities are Muslim creations, especially in Algeria and Morocco. A priori then it would appear that North Africa, with a weakened local population and culture at the time of the Muslim conquest, is almost a perfect area to investigate how Islamic art was formed.

But in reality North Africa is not very useful for our purposes, mainly because, with the exception of the Tunisian coastal plains and plateaus, it was during the first century of Muslim rule the theater of long and complex battles between the newly arrived Arabs and the native Berbers. Furthermore, during early Islamic times the region was exploited as a source of raw material and of women. In a way that we will encounter in one other area of the new Muslim empire, this dramatic exploitation of a province went together with the development of a frontier spirit in which piety and missionary zeal acquired a militancy rarely found elsewhere. For these reasons North Africa became a haven where all sorts of heterodox movements and groups could find a refuge and a purpose. Thus North Africa in early Islamic times was an unusual region, officially exploited for the Near Eastern centers of the empire and a place of refuge for small groups of alienated Muslims. It is only in the ninth century that a group of small local dynasties—Aghlabids, Rostemids, Idrissids—established semi-independent rule and fostered local interests and arts. By then, of course, just as in the case of Spain, an Islamic tradition had already been established elsewhere, and for our purposes the monuments of North Africa have mostly a reflective value. This is particularly true of architecture, the only technique which is fairly well known, and it is even confirmed by the one apparent exception, the *ribat*. This

uniquely Islamic building, whose formal and institutional characteristics will be discussed in a later chapter, has only accidentally been preserved in a number of Tunisian examples (fig. 51). These monuments may be North African but their function is pan-Islamic. Thus, while for the history of architecture the North African ribat may be considered as a local form, for the formation of Islamic art it is an example, accidentally in North Africa, of a new typology of functions. Its importance for the general history of early Islamic architecture is great, the more so if it has a mostly reflective value.

There are other aspects of monuments from North Africa, most particularly from Tunisia, which are unique but which may be assumed for other Muslim regions. Such is the case, for instance, of monumental cisterns, of which spectacular examples remain near Kairouan. But these are all of the ninth century, and what is known of early Islamic art in both Algeria and Morocco is usually even later. The information from North Africa thus may confirm or modify conclusions reached elsewhere but is not in itself uniquely significant for our general problem. No doubt textual studies and excavations being carried out especially in Tunisia should, over the next generation, transform much of our understanding of North Africa.

One last comment needs to be made about the very particular phenomenon of Western Islam. Even if it is correct to understand the first Muslim monuments from Spain and Andalusia as reflections of an art created elsewhere, it is only correct from our point of view of understanding the formation of Islamic art as a whole. Within each region these early monuments acquired another value; they became the sources for regional traditions.

Geographically the next region to be considered is Libya. Our information on medieval Libya is almost nil, and it is difficult to understand why the rather prosperous late classical and Byzantine Christian Libyan coastline collapsed after the Muslim conquest. In line with the economic explanation to be proposed below about the Fertile Crescent, it may be suggested that the new balance of economic and administrative needs created by Islam no longer required the utilization of whatever resources Libya had, inasmuch as its agricultural potential demanded large financial investments. To argue, as has been done, that the Arab invasion led to an immediate nomadization of Libya is begging the question, for one would have to explain why such a nomadization did not take place elsewhere. It is only in the eleventh century that a fairly destructive nomadic invasion can be documented. Whatever explanation will turn out to be correct, communication

seems to have been Libya's only clear function in early Islamic times.

As one moves east the next identifiable Islamic region is Egypt. It was conquered rapidly and easily by the celebrated general Amr ibn al-'As. Except in Alexandria where the famous Hellenistic library was burned, probably accidentally, the conquest was accomplished without major destruction and without any major loss of population through emigration or other means. We can therefore assume that the Christian population of Egypt, heterodox and at odds with the main Christian centers of the time, continued to exist as it had for centuries as a primarily rural one. In all probability there was then as today a continuous population surplus since a number of documents indicate that laborers for major early Islamic programs of construction in the Fertile Crescent and in Arabia came from the valley of the Nile. In pre-Islamic times the countryside was dominated by the huge metropolis of Alexandria, the only truly significant urban entity in Egypt. It remained important in Islamic times, but its preeminence was soon challenged by the purely Islamic creation of Fustat, the first link in the development of modern Cairo. Situated just south of the delta in a superb commercial and strategic location, its population consisted primarily of newly arrived Muslims.

Much textual information exists about Fustat. It has been possible to establish a sort of profile of the city's main parts, to some of which we shall return later. Archaeological information is less precise. Except for the plan of the first mosque of Fustat which can be reconstructed with some certainty, the excavations carried out in the past and continued until now have tended to yield architectural documents belonging to the Tulunid and later periods, that is primarily from the second half of the ninth century onward (figs. 38, 42). This time corresponds to the moment when, after two centuries of pure exploitation as one of the provinces of the huge Muslim empire, Egypt acquired a certain degree of independence, first under a dynasty of Turkish governors sent from Baghdad and then after 969 under the heterodox dynasty of the Fatimids. From then onward the architectural development of Cairo transformed the city into one of the few major continuous showplaces of Islamic monuments. For the early period, however, architectural information is limited to the little we know about Fustat. It is almost nonexistent for Alexandria, although a major study in preparation by a team of Polish scholars may alter the picture somewhat; nor do any smaller centers contribute much.

Matters are more complicated with the other arts, for here information is plentiful, largely because Egypt, provided with a dry climate

and never conquered by destructive invaders, has well preserved the documents from its past. Large series of carved woodwork (figs. 126, 127) have remained, as well as hundreds of textiles which are usually attributed to the first centuries of Islamic rule. Recently a group of ivories and bone carvings, hitherto considered to be late antique, have been given an early Islamic date, while excavations at Fustat have brought to light the earliest datable (772–23) glass object decorated with luster painting (fig. 115). There is a major methodological difficulty in properly assessing the historical and artistic value of most of this material. On the assumption that a given number of technical or formal novelties are first known in Egypt, should we consider them as created in Egypt? Or should we instead consider that the peculiar physical and historical conditions of Egypt preserved documents better and that many of these novelties actually developed first elsewhere? The answer lies in an assessment of Egyptian history in early Islamic times and in the centuries preceding Islam. Our hypothesis in this volume is that, until the second half of the ninth century and perhaps even until the creation of the Fatimid empire in 969, Egypt was a secondary artistic and intellectual center, although the matter is highly controversial when one considers coptic art or, here and there, for instance in ornament, certain novelties that should in fact be attributed to Egypt. For our purposes Egyptian Christian art will be considered primarily as a derivative one, inspired on the one hand by the higher traditions of Syria, Rome, or Constantinople and, on the other, by a local folk art.

The first source of inspiration weakened after the Muslim conquest, if it did not disappear altogether. The second one continued to make itself felt in many ways, its only new component being the new Islamic tradition. It is uncertain, however, if the latter, in the forms it acquired in Egypt during the first centuries of Islam, is more than a reflection of centers in Syria or Iraq. Even if the earliest examples of lusterwork are found in Egypt, the logic of eighth- and ninth-century history tends to give an Iraqi origin to the technique, and a monument like the mosque of Ibn Tulun, regardless of its unique qualities, was inspired by Iraqi architecture (figs. 38, 42). Thus a proper understanding of the evidence provided by the many monuments of Egypt is greatly complicated by the fact that neither the pre-Islamic nor the early Islamic culture of Egypt appears to have been in the mainstream of contemporary developments. It is therefore evidence that must be used, or generalized from, with some caution.

No such doubt exists as one turns to the Fertile Crescent. For our

purposes it is more convenient to consider it as a single entity than to break it up into its three major geographical components—Syria—Palestine, Middle and Upper Mesopotamia (or Jazirah, to use the traditional Arab term for a region which includes the northern half of modern Iraq, all of Syria from the Euphrates eastward, and the Tigris and Euphrates basins in present-day Turkey), Iraq—or into the partly arbitrary administrative provinces of medieval Islamic times. Of all the areas conquered by Islam it is by far the best known historically and archaeologically not only for early Islamic times but also for the centuries immediately preceding the conquest. Since the vast majority of the monuments discussed in the following chapters come from the Fertile Crescent, and since particularly great importance will be given to it in our conclusions, it is essential to define as clearly as possible the nature of its archaeological characteristics. This can perhaps best be done by discussing three aspects of these characteristics and some of their consequences.

The first aspect, essentially an ecological one, is the relationship between man's culture or life and the land on which life is lived and culture enjoyed. At the time of the Muslim conquest the three geographical regions of the Fertile Crescent were quite different from each other. In Iraq recent research concentrated in a small area near Baghdad has shown that the pre-Islamic Parthian and Sassanian empires had created an extraordinary infrastructure of irrigation for the development of agriculture with a comparatively limited urban growth. But the huge palaces of Ctesiphon—parts of which still stand today and remained throughout the Middle Ages as symbols of the power and greatness of the Sassanian dynasty—were there, and many other remains existed of a high pre-Islamic imperial life. A word of caution is needed once again, however: spectacular though the royal reception hall of Ctesiphon may be and numerous though literary sources may be about the activities of Sassanian emperors in Iraq, published excavations of Sassanian remains in Iraq have not been until now as fruitful as one might expect and in many instances have consisted of information about pre-Islamic Arab kingdoms. Even though a slight decline in wealth occurred toward the end of the Persian dynasty, the Muslims inherited in Iraq a viable agricultural system and a complex set of ancient memories, whose actual testimonies in monuments are difficult to estimate, always with the exception of Ctesiphon around which a whole literature grew.

In Syria and Palestine something rather different had taken place.

After the full establishment of the Roman empire in the second century A.D., both provinces underwent an extraordinary economic growth which took the form of a large number of small towns surrounded by villages and agricultural establishments fanning out into the steppe or the mountains. Instead of creating a large-scale, complex, and centralized irrigation system, these settlements subsisted thanks to a sophisticated utilization of whatever water was available and especially through the extensive growth of those agricultural products—primarily olives and grapes—which were best suited to the land. This agricultural growth was closely tied to markets outside of Syria proper, primarily in Anatolia. The highly organized semi-urban and agricultural economic structure of Syria was controlled and ruled from a number of large cities: Damascus, Aleppo, the coastal ports, and especially Antioch. These were all very ancient urban centers and major showpieces of art and culture, in which Hellenistic and Roman emperors or their local representatives as well as native converts to high Mediterranean culture built temples, forums, theaters, marketplaces, in a particularly luxurious manner, in which a great art of sculpture developed (often with local stylistic peculiarities), and in which a highly speculative intellectual life flourished. Most of these cities had a long and continuous history, but some, like Palmyra, shifted over the centuries from spectacular moments of brilliance to almost total decadence. Much more than in Iraq there was a complex and varied regional history for almost every individual subprovince in Syria and Palestine, but nearly always the crucial moment of development corresponded to the apogee of the Roman empire.

The advent of Christianity did not modify the wealth of the region or its economy except in details that are not pertinent to our purposes but simply added to it a new dimension, that of the Christian faith, which resulted in the intensive developments of the holy cities of Palestine, in the erection of hundreds of churches, monasteries, and sanctuaries, and in the growth of a whole set of pilgrim roads with attendant institutions for the help and comfort of travelers. The steppe and the desert acquired monastic settlements of anchorites and cenobites in addition to military outposts and to commercial stopovers. Thus Syria and Palestine were exceedingly rich provinces, urbanized as well as agricultural, closely related with all the great centers of the Mediterranean and major foci in the intellectual and religious life of the time. Shortly before the Muslim conquest this complex world had been shattered by the Persian invasions and by the destruction of

Antioch. While there certainly was no time to build it all anew in its former splendor, it seems that on the whole the basic infrastructure of the two provinces remained intact and that the population did not change in character or in size, except in the agricultural regions of northern Syria.

Between Iraq and Syria there was, on the other hand, a steppe slowly becoming a desert. The boundaries between the desert and the "sown" were not static, fixed frontiers but variable ones, depending on the respective strength of the settled powers and of the nomads. The latter were to play an important part in the growth of Islam, since they were the main intermediaries between centers of high Mediterranean or Iranian culture and the oases from which the new faith sprung. Although much is still very unclear about the culture of the Arabs on the edges of the Persian, Roman, and Byzantine worlds, it is known that they were organized into elastic kingdoms, of which the most celebrated ones were the Ghassanids and the Lakhmids, and that they often sponsored agricultural settlements and towns. So far, however, the monuments that can clearly be attributed to them—such as some of those at Rusafah in northern Syria or the impressive ruins of Hatra in Iraq—do not appear to be stylistically or functionally differentiated from contemporary buildings in the areas directly under Sassanian or Byzantine control.

Another area between Iraq and Syria was the Jazirah, the middle and upper valleys of the Tigris and Euphrates. This was primarily an area of fortresses in the midst of an impoverished though potentially fertile land, for it was the main frontier area between Iran and Rome or Byzantium. It was by following the Euphrates that Sassanian armies moved toward Antioch, and the occupation, reoccupation, destruction, and rebuilding of fortified cities like Dara, Amida, and Nisibis takes up much of the chronicles from the second to the seventh centuries.

The essential point is that with the arrival of Islam these very different areas became united, for the first time since the early Hellenistic era, in the same administrative and cultural entity. But the ways in which they became Muslim varied considerably. In Iraq the striking phenomenon was that of urbanization. Two cities, Basrah and Kufah, which were created within the first years of the Muslim conquest primarily as settlements for immigrating Arabs and as strongholds for the Muslim armies, became very rapidly major urban centers with a strong religious and intellectual life as well as with a considerable

amount of frequently troublesome political activism. They were fol-
lowed by Wasit, primarily an administrative city located between the
two, then by Baghdad, whose early shape will be discussed in the
following chapter but whose growth into a tremendous urban center is
well known. Finally in the ninth century an enormous complex of
cities extending for over fifteen miles along the Tigris was built. Al-
though Samarra did not live very long as a great city, precisely because
of its short existence as a huge metropolis it can serve as an illustration
of the urban development of Iraq in early Islamic times.

It is equally important to emphasize that this urban development
began very early. Our earliest references to Muslim monuments are all
from Iraq. Furthermore the islamization—or at least arabicization—of
Iraq appears to have been particularly rapid. It was made easy because
the pre-Islamic population was already to a large extent an Arab popu-
lation and, more important, because Iraq, even though it harbored
major monuments of Sassanian Iranian art, did not have the depth of
cultural and religious attachment to Iran that existed between Syria
and Palestine and the rest of the Mediterranean. There was a consider-
able variety in the religious allegiances of the population of Iraq, and
the Zoroastrian ecclesiastical order cannot be compared to the Chris-
tian one, even with the latter's dissensions. It does not seem that Iraq
was an altogether culturally focused area at the time of the conquest,
although perhaps this conclusion derives in part from insufficient
information about intellectual life under the Sassanians. In any event,
Iraqi cities became the major centers of early Islamic culture to which
the most militant Arab tribes came, in which the faith was refined and
Arabic grammar as a symbol of Arabism written up and codified. This
cultural development preceded the transformation of Iraq after 750
into the political, administrative, and eventually symbolic center of the
Muslim empire.

One would like to know more about the fate and contemporary
importance of non-Muslims in Iraq—various Christian, Jewish, Man-
daean or Manichaean minorities, or Iranians whose role was to grow
so much in the ninth century. But, except for occasional references in
stories or in tax rolls, little appears about them and, in contrast to
Egypt, Spain, or, as we shall see, Syria, Iraq appears to have become
almost immediately a predominantly Muslim province. It is thus par-
ticularly unfortunate that our knowledge of seventh-century art, and
even of most of eighth-century art, is based almost entirely on texts.
Most of it concerns architecture, and material culture is accessible only

through a very small number of accidentally preserved objects from which it is most difficult to draw any sort of conclusion. The archaeology of Iraq, so well studied for earlier times, is only beginning for the period surrounding the appearance of Islam, and we are aware of only a few sites with proper stratification to suggest any kind of differentiation between early Islamic and pre-Islamic times. On the other hand, with Samarra we have a major source of information for the ninth century, even though the study and exploration of the huge site is a Herculean task which has hardly begun. I will return shortly to an evaluation of its importance for our general problem of the formation of Islamic art. Suffice it to say here that Iraq underwent a considerable ecological change in early Islamic times with the foundation of a large number of cities and rapid islamization, and that this change seems to have been superimposed over a highly developed agricultural setting which, for a while at least, continued to function. It is from Iraq that we have our earliest documentation about a new Islamic art, but most of it appears primarily in literary form. It is even more difficult to evaluate the nature and extent of Iraq's pre-Islamic remains at the time of the conquest, and the nature of the memory about the past that remained attached to the land. The persistency in later Islamic writing of the impact created by the spectacular ruins of Ctesiphon is easy to demonstrate but one would like to know, for instance, how numerous were the Christian monasteries that are often mentioned and, if they were as numerous as they appear to have been, whether they exemplified a high, sophisticated art or not.

Syria and Palestine form an extraordinary contrast to Iraq, although they were conquered simultaneously, in the 630s. But even though in 661 the capital of the Muslim empire moved to Damascus, the actual immigration of Arabs into the cities of Syria and Palestine was limited, and the only new city was Ramleh in Palestine, founded between 715 and 717. Formal Muslim buildings were few: a palace in Damascus which may even have been an earlier palace refurbished for the new owners, and a few mosques. The mosques were not impressive buildings and the western traveler Arculfus refers to the one in Jerusalem as a "quadrangular house of prayer which they [the Muslims] have rudely built."

An important change occurred after the accession to the caliphate of Abd al-Malik in 685 and especially under his successor al-Walid (705–15), as suddenly a group of major new monuments were built in the main cities of Damascus, Jerusalem, Aleppo. But of far greater impor-

tance is the change introduced in the countryside. Known archaeologically rather than through literary sources, it consists of an enormous number of constructions—nearly fifty can be identified securely and another one hundred are likely—built outside of the main urban centers. Although numerous variations exist among them, they are typologically related in that almost all of them include a large place for habitation, a mosque, a bath, and various service buildings. The first of these to have been discovered—Qusayr Amrah (fig. 2) or Mshatta (fig. 66)—were in areas which, at the time of their discovery, were deserts, and as a result they were all considered to have been retreats showing the nomad's presumed attachment to the desert. More recently, especially after the spectacular discoveries at Khirbat al-Mafjar (figs. 71 ff.) and at Qasr al-Hayr West (fig. 65), it was demonstrated that these foundations were just as common in permanently cultivated areas and that all of them—with only one possible exception, Qasr Kharaneh in Transjordan—were parts of large agricultural establishments. The exploitations themselves have generally been considered pre-Islamic in origin and illustrative of the agricultural expansion of Syria and Palestine in Roman times. In the light of some recent research—especially the excavations at Qasr al-Hayr East—the automatic assumption of a pre-Islamic origin can no longer be made in all cases, although the several likely instances of Muslim-created agricultural enterprises certainly imitated patterns developed earlier.

The answer to the problem of why the early Muslims introduced into agricultural settlements amenities of urban living like baths and at times richly decorated palaces, lies, it seems to me, in the very nature of the Muslim conquest of Syria and Palestine. It was accomplished primarily through formal treaties which forbade a Muslim confiscation of land and thus prevented a major Muslim settling of cities, while the extensive urbanization of pre-Islamic Syria made it difficult to create new cities. Treaties made it equally difficult to take over ownership of the land outside of the cities, with one exception: all abandoned properties or all state lands were automatically considered as booty and thus acquired by the Muslim state. It has been shown quite conclusively that the agricultural development of the Syrian and Palestinian countryside was successful only because it was sponsored by landowners who lived in cities or by official agencies of the central or provincial government, and since these wealthy and powerful groups emigrated at the earliest possible time their possessions became part of the booty at the disposal of the caliphs. Our suggestion is that the

caliphs distributed these lands to members of their families and to important allies and thus transformed the countryside (or part of it) into latifundia owned by the new Muslim aristocracy. The latter, rich and ambitious, gave their estates whatever amenities they wished them to have. Some, such as the owners of Khirbat al-Mafjar or of Qusayr Amrah, were lavish in the expensive decoration they provided; others were more modest, or, like the owners of Mshatta, never completed their ambitious projects.

Almost all of these estates were abandoned after 750, partly because of the vindictive destruction by the new Abbasid caliphs of the properties owned by the Umayyads or their allies. But, had these properties been economically useful, the Abbasids might have distributed them to their own followers or taken them over themselves, as they did for instance in Ramleh or in Qasr al-Hayr East. It appears rather that the operating agricultural system inherited by the early Muslims was so fully geared to the markets of the Mediterranean which had been cut off by the conquest that it lost its purpose fairly rapidly. While the Umayyad princes, thanks to their wealth, had been able to maintain it artificially, its ultimate economic aim was no longer feasible and there was no reason for the Abbasids to continue supporting it. This particular conclusion is supported among other things, by the evidence of the excavations at Qasr al-Hayr East, where the Umayyad foundation was completed and continued by the Abbasids because the estate's economic functions were geared to the newly developing Jazirah rather than to the older Mediterranean system.

Our conclusion about the ecological development of Syria in early Islamic times is thus twofold. First, Muslim involvement was limited in cities but strong in the countryside, where it occurred as a sort of aristocratic takeover of a rich agricultural organization, somewhat comparable to the development of the Italian countryside by the Roman imperial aristocracy of the first centuries of our era, or of northern Italy in Baroque times, or of the French countryside around Paris by the city bourgeoisie of the nineteenth century. Although the aristocratic character of the Muslim settlements will be quite important in explaining the art which grew there, it is equally important to point out that at first glance most of the elements which made up these country establishments are not original. Many of them have been and still are considered to be Roman. Neither economically nor materially do they appear to represent significant changes in functions or in taste. The second conclusion is that these Muslim foundations in Syria

arc quite precisely dated between 685 and 750. The mosques of al-Walid and the châteaux of the Syrian steppe form a critical mass within a restricted space and a limited time which should lead to the definition of a period style. We shall see that such a style is more difficult to define than would have been expected from the data.

The third region of the Fertile Crescent, the Jazirah, was the area which in pre-Islamic times had been mostly an area of fortresses and of military expeditions. Except for its northernmost part—around Diyarbakr, the ancient Amida—which remained a frontier between Islam and the Byzantine empire and its eastern satellites, the whole of the Jazirah became a central province of the Muslim world, the main link between Iraq and Syria. Besides its obvious strategic and commercial significance, one of its major features in early Islamic times was its transformation into an agricultural and urban area. This began in the first decades of the eighth century when the caliph al-Walid, his brother Maslamah, and later the caliph Hisham began to drain the swamps along the Euphrates, to build canals, and to introduce agriculture. Several cities were built there, the most important of which became the large urban complex of Raqqah. This development continued throughout the Abbasid period, and the ninth century in particular was a time of considerable prosperity. The population of the Jazirah was a mixed one. It included Muslim Arabs from Arabia, but a considerable part was probably Christian and in all likelihood heterodox Christian for it is through Christian Syriac sources that we acquire most of our information about the economic and social history of the Jazirah. Although the place of origin of these Christian groups is still uncertain, it is likely northern Syria. Much less information exists about the middle Tigris valley but there also it would appear that late Umayyad and early Abbasid times—essentially the eighth century—were the main periods of growth of the city of Mossul and its surroundings. Considerable developments occurred as well in the valleys of the Balikh and of the Khabur as well as in a string of cities from Edessa to Mossul which were founded at the foot of the Anatolian mountains, although the heyday of the latter would be primarily in the twelfth century after the conquest of Anatolia by the Muslims.

Unfortunately the archaeology of the Jazirah is still very badly known, for mostly practical reasons, since the medieval province was quite inaccessible in Ottoman times and is now shared by three modern countries. Only in Syria, primarily around Raqqah, has some archaeological work been done, but its continuation has been made

difficult by the enormous economic development of the region. Many other sites still await the pickax of the archaeologist.

We can sum up, then, ecological aspects of the Fertile Crescent as follows. The Jazirah was completely transformed with a new population and new functions but is least known archaeologically. Iraq was heavily arabicized, urbanized, and developed from the very beginning of Islam but our archaeological and artistic information is more complete for the ninth century than for the first two Muslim centuries. Syria and Palestine changed least of all at the beginning and their monuments are known within a limited period (685–750) and express primarily a special aristocratic taste because of the unique conditions of settlement.

Such are the coordinates affecting our understanding of the arts which can be derived from a consideration of the first and most elaborate aspect of the archaeological characteristics of the Fertile Crescent, its economic and social transformation. We can be briefer on the other two aspects that are pertinent to an understanding of the arts, even though their importance is equally considerable.

One of them is in fact crucial: the Fertile Crescent became in 661 the political and cultural center of the Muslim world and remained its major center for many centuries thereafter. From 661 until 750 the political center was in Syria, first in Damascus, then briefly in Rusafah. After that Iraq, which had already gained cultural prominence, also took over the administrative and political rule of an empire stretching from the Atlantic to the Indus. Until the tenth century, when a series of secondary centers began to grow in Iran and in the West, the preeminence of the Fertile Crescent went unchallenged. As a result there occurred first of all a tremendous influx of men, objects, and ideas from the whole known world. The Fertile Crescent became the crucible in which the patterns of life and the taste of the new culture were fashioned. For centuries thereafter a myth remained of Baghdad and of the heyday of the Abbasid empire in the latter part of the eighth and in the ninth centuries. A significant myth for our purposes, it shows that the early Abbasid achievement, even if symbolized in legend around the figure of Harun al-Rashid, was not the spontaneous and unique creation of this one time but the culmination of a series of developments that took place from 635 onward throughout the Fertile Crescent. In other words, the dynastic break that occurred in 750 between the Umayyad and the Abbasid dynasties does not have the considerable importance attributed it in the past; it is rather the reflec-

tion of a number of achievements that had been building up since the middle of the seventh century. Furthermore, precisely because of the importance of the later myth, it is hardly possible to understand much of what happened in later Islamic art without being conscious of the nature of the artistic creativity of the first centuries. For, at least in the Fertile Crescent and especially in Iraq, the myth that was later popularized in *The Thousand and One Nights* merely crystallized the notion that in the early ninth century the Muslim world had come into its own. It is the century for which one can a priori assume a classical balance.

The third and last aspect of the Fertile Crescent in early Islamic times derives from the first two and is somewhat paradoxical. Precisely because it was a rich area, still largely populated by non-Muslims, and literally covered with the brilliant ruins of older cultures, an original Islamic art had to develop there first. Had Islam continued to be ruled from the secluded oases of central Arabia or from a poor and inaccessible region like the central Maghrib, it might have preserved a certain religious purity, but it would never have become the lasting cultural force it did become. It is to the extraordinary credit of the Muslim rulers of the first two centuries of Islam— caliphs like Mu'awiyah, Abd al-Malik, al-Walid, Hisham, al-Ma'mun, Harun al-Rashid, or the remarkable crop of governors they sent to various provinces—that they rose to the cultural and political challenge of their encounter with a series of alien cultures and managed to create something unique in its own right, yet meaningful enough to non-Muslims to be often accepted by them as well. We shall return more than once to this last point, for this double meaning of early Islamic art—an internal, Muslim one and an external one in relationship to other cultures—will be one of the leitmotivs of our study. Suffice it to say here that the art was first formed in the Fertile Crescent, largely because of the peculiar ecological, psychological, and cultural conditions of the Muslim settlement there.

Finally we must turn to the world of Iran as the last major area of early Islamic history. Matters here are both simpler and more complicated. On the one hand, our information is scanty on all but the barest chronology. Except for minor and so far little-exploited excavations, at Jundishapur for instance, and quite recently at Siraf and at Bishapur, no archaeological information exists on the passage from a pre-Islamic to an Islamic culture. The early Islamic monuments in Iran itself are very few when one considers that what we have is scattered all over

an area as vast as one-fifth of the United States. Considerable confusion reigns over what the immediately pre-Islamic culture of Iran may have been, for reasons that will be mentioned presently. On the other hand, the case of Iran is particularly complicated, because the later importance of Iran in Muslim culture, and especially in Islamic art, is so great as almost to demand some sort of hypothesis about what happened during the first centuries of Muslim rule.

In order to suggest such a hypothesis it must be borne in mind that the Iranian world was not a single geographical or cultural entity. At least five areas can be defined, each having a different pre-Islamic history and a different kind of islamization. They are: southwestern and western Iran, the main stronghold of the Sassanian empire; northwestern Iran or Azerbayjan, at the frontier between Iran, the Caucasian kingdoms and the northern steppes; northern Iran, an area of wild and inaccessible mountains that became first a sanctuary against invaders and then for a couple of centuries an almost inexhaustible supplier of soldiers for Islam; Khorasan and Transoxiana, the two great northeastern provinces on the road to China and to the northern world of Turkic tribes, constantly invaded yet essential for trade; and Sistan and Afghanistan, the little-known provinces of deserts and mountains, closer to India, strongly affected by Buddhism, and populated with strangely obscure tribes and legends.

It is difficult to summarize what is known of the archaeology of Iran and central Asia between the fifth and tenth centuries. We are now quite well informed on Central Asia, for instance, but Sistan is an almost total blank. A mere list of documents pertinent to early Islam would be lengthy, but drawing general conclusions from them is difficult. I prefer to limit myself to four general points, the first two of which can perhaps not be proved in their entirety but seem to me to conform with the available documents.

First, the islamization of Iran was the work of a comparatively small number of Arabs. Most of them were military men who settled in or near older cities and it is primarily in the northeastern provinces that their impact was immediate. Balkh, Nishapur, Herat, Merv, and Bukhara—all ancient cities with a rich and impressive Zoroastrian, Manichaean, and Buddhist heritage—became major strongholds of the new faith. The fact that these cities were on or near the frontier as guardians of the Muslim world and as spearheads for the conversion of the heathen greatly affected the character of the faith found there. They are comparable to the North African centers and it is not acciden-

tal that here as well we hear of ribats, although no certain instance of the monuments themselves have been preserved. The eventual predominance of Central Asia in the growth of the special religious form of the mausoleum to holy men should probably be explained by the frontier spirit of the *ghazi*, warriors for the faith. Thus it would appear that the islamization of eastern and northeastern Iran was more rapid, more profound, and more original than that of the western Iranian world. It is in the northeast that the new Persian language developed first, that the first Islamic dynasties of Iran appeared, and that the most important artistic novelties are to be found. It is not possible to provide a clear date for these developments which spread over several centuries, but by the end of the ninth century the rise of the Samanids can serve as a convenient point in time at which a fully formed culture of Islamic Iran can be assumed, at least for the northeastern provinces, and its first masterpieces, such as the Bukhara mausoleums (fig. 128), are of the tenth century. In the western Iranian world this culture does not become clear and ubiquitous until the eleventh century, although certain ceramic sequences and texts suggest major monuments a century earlier.

Second, in Iran even more than in Iraq Islam encountered a wide variety of cultural and religious groups without the comparative coherence of the Christian world around the Mediterranean. Jewish and Christian (mostly heterodox) groups were present of course. A series of different varieties of Zoroastrianism persisted well into the eleventh century. In addition, Manichaeism and Buddhism were quite strong in the northeast, and both, but especially the latter, remained powerful for a far longer time than is usually thought. Each of these faiths had developed its own formal and iconographic vocabulary, and those of the last two were particularly rich. Iran was equally complex in its ethnic structure. Next to the majority Iranian stock divided into several groups, there were large Semitic groups, offshoots of various entities from the Fertile Crescent, major Kurdish tribes in the western mountains, and Turkic groups on the frontier. The result of this religious and ethnic variety was twofold. On the one hand, it brought the Muslim world into contact with a far wider set of ways of life, beliefs, and artistic traditions. On the other hand, it meant the Muslim world lacked a single predominant artistic koiné such as the Roman one in the Fertile Crescent and around the Mediterranean, even though certain themes were indeed shared by the whole formerly Hellenistic world. Only for western Iran, in the areas under the direct and contin-

uous influence of the Sassanian empire, is it possible to talk of a fairly clear artistic style, that is, of a commonly shared body of forms and subjects, and its impact was certainly carried all the way to India and Central Asia. But in most other areas, especially the northeast, the variety of forms is impossible to define in unified stylistic terms. Perhaps for these reasons an Islamic style grew more slowly in Iran than elsewhere in the Muslim world; there had not been a universally accepted Iranian visual language before the Islamic conquest.

Third, the archaeological documentation Iran provides for early Islamic times is quite different from that of the areas already discussed. Architecture has been less well preserved and, even in Central Asia where monuments have best remained or at least have been better studied, some uncertainty exists as to the dates of many of the monuments. Soviet archaeologists in fact have tended to classify most architectural monuments other than obviously religious ones under a general chronological category from the sixth to the tenth centuries without paying much attention to the Islamic conquest. On the other hand, Iran is remarkably rich in objects. While considerable problems of authenticity and dating remain around the celebrated silver objects which are generally called "Sassanian" (fig. 99), no such problem exists with ceramics (figs. 107–14). There we have quite clearly an Islamic development in northeastern Iran as unique as it is spectacular. An explanation will have to be provided not only for the themes and techniques of the objects themselves but for the fact of this remarkable growth of a technique for which parallels are found only in Iraq.

Finally, the Arabs who brought Islam to Iran had very little knowledge of the Iranian world, nothing comparable to the situation in the Fertile Crescent or in the Mediterranean area. At the same time, Iran in its entirety became Muslim and there did not remain for its numerous ethnic, religious, and artistic traditions some external center such as Constantinople remained for the Christians of the eastern Mediterranean or, later, Compostello for Christian Spain. In part the past was obliterated, as, for instance, the Arabic alphabet came to replace Pahlevi. But the most common phenomenon was a sort of islamization of the collective memory of the Iranian past. At times it was an arrogant islamization expressing strong resentment of the Arab takeover, as in the assertion found in many literary sources of the superiority of Iranian kingship over nomadic tribesmen. At other times it was a far subtler integration of the Iranian past into a Muslim memory. Only in Iran was the formed Muslim culture able to create a heroic and impe-

rial past for itself without encountering the ghost of a lively and flour-
ishing Christian antagonist. The naturalization of Iran into Islam was
not immediate, and it took a protean multiplicity of regional, social,
and thematic aspects, whose elucidation still demands investigation.
The phenomenon itself does, however, have a number of a priori
consequences that are pertinent to our investigations. First, the forma-
tion of a regionally identifiable Islamic art of Iran took longer than
elsewhere and appeared in very diverse modes. Further, Iranian forms
of pre-Islamic times may not have kept whatever concrete associations
they had before the arrival of Islam because there remained no guard-
ians of such associations comparable to the Christian church or to the
Byzantine empire. Thus forms of Iranian origin may be imagined as
having lost some of their meaning, as having become in a way "free"
forms to which new significations could be given. With this point,
however, a theoretical question is raised to which it will be easier to
return once we have investigated some of the monuments.

 Such appear to me to be the major characteristics of the archaeologi-
cal and ecological setting of the newly united Islamic provinces. While
it is obvious that there is an extraordinary disparity in the kind of
knowledge we possess about them, and while it seems hardly fair to
compare what is known of Morocco or northwestern Iran with the
Syrian evidence, still we must try to summarize our survey in some
sort of fashion to be able to evaluate its documents and answer the
questions raised in the first chapter.
 Four conclusions can be proposed; the first concerns chronology.
The earliest definable monuments of Islam are in Iraq, dating from as
early as the middle of the seventh century. A larger group of monu-
ments from Syria, Palestine, the Jazirah, Iraq, and to a lesser degree
Egypt, North Africa, and Spain illustrate a second moment lasting
from 685 to the end of the eighth century. This second period came to
an end with the reign of Harun al-Rashid (786–809). In the ninth
century a fully formed and fully documented Islamic art appeared in
Egypt, North Africa, Spain, and northeastern Iran, and only in the
tenth century do we have a sufficiently large series of documents from
western Iran. This chronological conclusion obviously suffers from the
possible accidental selectivity of remains, yet it appears to correspond
well enough to what is known from literary sources that, at least
hypothetically, it may be accepted. Its central point is that the relative
time for the formation of an Islamic art varied considerably from prov-

ince to province; and thus is raised the crucial question of to what extent the example of provinces with an earlier development affected those areas that acquired their monuments later. Yet, if we are to propose a time for the likely creation of a first Muslim classical moment, the ninth and early tenth centuries seem to be a priori the times suggested by archaeological history.

The second conclusion, that of the preeminence of the Fertile Crescent in the early stages of the creation of the new art, leads to two further problems. One is the degree to which the predominantly Mediterranean- and Hellenistic-inspired artistic traditions of the Fertile Crescent affected the art of Islam. Should the latter not then be considered as medieval rather than Oriental art? The other problem derives from the fact that the Fertile Crescent was the seat of power during the first centuries of Islam: did there develop an Islamic "imperial" mode, similar to what can be detected in, for instance, Byzantine art? This question has a number of corollaries of considerable importance to any general history of the arts; the one I would particularly like to single out at this stage is that of creative centers. Our brief survey indicated, for example, that Damascus and Baghdad were imperial and political centers, Kufah and Basrah were major cultural and intellectual centers, and Fustat, Kairouan, Cordoba, Bukhara, and Nishapur were regional centers. Most of these cities did not have a continuous importance of equal strength. The problem then becomes to know whether a datable and localized piece of evidence with some novel feature should be related to the major center of its time, regardless of where it was found. This is the way in which we have suggested that the evidence from Egypt be interpreted, but is it always so? And how can one decide? Furthermore, one questions whether political or intellectual and cultural centers predominated in the creation of new forms and new taste, and whether new regional centers tended to be more innovative than older established ones. The very nature of the islamization of the Muslim empire indicates potentially varied sources of inspiration for the arts: caliphs, princely aristocracy, recently immigrated Arabs, converted Muslims from different conquered areas, city dwellers, frontier men, and so forth. Is it conceivable that they all shared the same taste and the same aesthetic needs?

A partial answer is provided by our third conclusion, that the available documentation is extraordinarily varied. Although architectural monuments predominate throughout the Islamic world, objects (often the rather prosaic products of ceramicists) appear as our main evi-

dence in Spain, Egypt, or northeastern Iran. In part, our task is to find
some sort of common denominator between a mosque and a ceramic
plate. But perhaps there did occur in early Islamic times a very wide
differentiation of taste which expressed itself in different techniques
and which can, at least initially and hypothetically, be connected with
the varieties of early Islamic settlements. These settlements were aris-
tocratic and restricted in the Syro-Palestinian countryside, massive
and urban in Fustat or in Iraq, military and religiously militant in
Central Asia and in North Africa, small and attuned to local needs in
Spain. Each pattern created different psychological and emotional re-
actions and different requirements. Is it therefore justifiable to refer to
all of them as Islamic, or does such a definition weaken the term to the
point of meaninglessness?

Finally, a more concretely art historical conclusion emerges from our
sketch of the archaeological history of early Islam. The Muslim take-
over occurred without physical destruction and without massacres,
and one can point out only a small number of instances of major
population movements within the conquered area. As a result the sum
total of the art and the material culture of the pre-Islamic world re-
mained as such with the functions, purposes, and associations it had
before. But there is more to it than simply forms and meanings at-
tached to forms. Islam also inherited an immensely complex set of
collective memories, legends, and myths, some as localized as a village
cult, others as wide as the heroic legends of the Iranian hero Rustam or
of Solomon, the prophet-king. This all means that the point of depar-
ture of Islamic art does not lie merely in a physical or aesthetic reaction
to another art—as happened, for instance, after the French or Spanish
invasion of Italy in the fifteenth century—but in the actual utilization
by the Muslim world of the material, aesthetic, and emotional order of
the conquered territories. In theory, of course, one could simply imag-
ine that the earlier system of forms merely continued with a normal
life of its own, obeying whatever impulses it had in itself—unless, of
course, there was something new and different demanded by Islam
itself. It is to these possible Muslim needs that we shall devote our
next three chapters.

In a wider sense, however, the questions raised here lead to another
problem, one beyond a cultural setting specific to Islamic civilization.
The problem is the kind of category which is or ought to be used in
defining the uniqueness of a given artistic tradition. Is it merely a
question of forms? Is it a question of attitudes? And, then, what in a

given attitude affects the development of the forms? How effective can new attitudes be when they encounter deeply rooted cultures with highly sophisticated systems of forms and memories? Here the Muslim case is quite different from that of the French invasions of Italy which created a French Renaissance art in France and not in Italy. Should the Muslim case be considered as comparable to that of the barbarian invasions in late antiquity and the early Middle Ages or to later Mongol invasions in Iran and China, when the intruder adapted himself to the higher culture of the invaded country? Such are some of the questions raised by the setting in which early Islamic art appeared. The ways in which they can be answered depend not only on the documents but also on the more fundamental question whether each artistic development is a unique phenomenon or the illustration of one or more deeper but more permanent structures of man's relationship to his own creations.

3. The Symbolic Appropriation of the Land

Some time in the 630s, when Muslim forces were rapidly taking over the cities and territories of the Fertile Crescent, a curious event is said to have taken place in the small town of Qinnasrin in northern Syria. An Arab force under the celebrated general Abu Ubaydah had signed a truce of one year with the Christians of the city in order to allow those Christians who so desired to leave Syria for the Byzantine-held territories of Anatolia. A line of demarcation was established between the Christian and Muslim territories, the line being symbolized by a column on which the Christians painted a portrait of Heraclius, the ruling Byzantine emperor. There is a sequel to this event, to which I shall return in another context in Chapter 4. For the moment I would like to stop at the point that the rule of a land or an area by a culture, or even the simple presence in a land of an alien or new element, is often expressed through some visually perceptible form. At a most ludicrously simple level the signatures of tourists and visitors which deface most ancient monuments belong to this type of document. At other times these signs are more impressive commemorative statements, as in the series of inscriptions on the cliffs near the Dog River in Lebanon which celebrate the passage of conquering armies from Assyrian times to the French mandate. The Roman empire developed a term for one category of such monuments; they were called *tropaia* and could be impressive architectural constructions, as in the instance of the two which are archaeologically known in the south of France and Romania. Even contemporary nations are not averse to erecting on foreign soil monumental testimonies to their presence and victories.

Such monuments are of considerable interest because, when they can be properly identified and explained, they illustrate those aspects of the new or conquering culture which appeared most significant in its own eyes, thus making it possible to define at least one aspect of that consciousness about one's self which was set forth earlier as a major component in the formation of a new art. It so happens that three monuments exist from early Islamic times which can serve as examples of a visual symbolization of the appearance of Islam in the ancient world of the Near East.

In the desert bath of Qusayr Amrah (fig. 2), to which we shall return

43

below, Alois Musil saw in the last decade of the nineteenth century a painting since then covered with smoke but recently nearly restored to its initial state (fig. 3). Positioned on the side wall of the small throne room attached to the bath proper, this painting is surrounded by representations of princely life, mostly the pleasurable pastimes characteristic of Near Eastern aristocratic life, as well as the memories of the life of a specific individual. In the central apse the prince for whom the bath had been built was shown enthroned officially while the other images, to which we will return, are entirely original, according to a Byzantine iconographic formula.

This particular panel shows six standing personages in long robes, three in the first row and three in the back. The figures in front all extend one hand toward the right, in the general direction of the enthroned prince in the back of the room. Not much can be said about their clothes except that they were richly decorated. The peculiar arrangement of the central personage's headgear (fig. 3a) consists of a crescent pose on a raised platform and recalls more or less pre-Islamic Iranian crowns. All other heads were too damaged to be described or lacked any otherwise identifiable symbol. The identification of most of these personages is made by a series of inscriptions in Greek and Arabic above each of the heads. Four are certain: CAESAR (meaning the Byzantine emperor), RODERIC (the last Visigothic ruler of Spain before the Muslim conquest), KISRA (meaning the Sassanian emperor of Iran before the Muslim conquest), and the NEGUS (king of Ethiopia). It has generally been agreed that, since the Byzantine and Sassanian emperors are in front while the Visigothic and Ethiopian kings are only partly visible in the back, the remaining two personages, one in front and one behind, were meant to represent one major and one minor ruler. The former was in all probability the Chinese emperor, while the latter could be the *khaqan* or ruling prince of the Turks—either, as in the case of Roderic, a very specific Central Asian prince of the early eighth century or maybe merely the abstract personification of the ruler of a precise land (Central Asia) or folk (Turkish tribesmen). The knowledge of Central Asian history that we have gained in the past sixty years offers new clues as to the identities of Qusayr Amrah's personages, but further discussion of this particular topic is both unimportant and fruitless here.

The main point is clear: we have a representation of six non-Muslim royal figures arranged in a formal and hieratic composition. Three of the certainly identifiable personages were either personally defeated

by Islam or symbolize defeated political entities. There is thus a concretely Muslim meaning to this group which has been thought for a long time to consist of the vanquished enemies of Islam shown as a sort of trophy on the wall of a princely building. This interpretation, however, is not entirely satisfactory because the Negus and the third major emperor in the foreground can in no way be connected with Muslim victories, and especially because the gestures and poses are not at all the signs of defeat that are comparatively well known in the iconographic languages of Rome, Byzantium, and Iran. Admittedly it is difficult to be certain what an extended palm as it appears on a late copy may have meant, but in the earlier art of the Mediterranean or of the Near East this gesture is more commonly to be interpreted as pointing at something or as a sign of deference.

A solution suggests itself if we consider, first, a verse attributed to an early Islamic prince, the short-lived caliph Yazid III who ruled around 744. He wrote, "I am the son of Kisra and my father is Marwan [the ancestor of the second branch of the Umayyad dynasty]; Caesar is my grandfather and my grandfather is the *khaqan*" (Tabari, *Annales*, ed. Michael de Goeje, Leiden, 1885–89, vol. 2, p. 1874, among several places). Yazid, who was indeed the son of a princess of Sassanian origin, creates for himself an imaginary ancestry that includes the ruler of the major empires of his time. This claim should not be considered as a presumptuous boast or a meaningless poetic declamation. For the whole history of late antique and medieval thought is permeated with the notion of a Family of Kings, a spiritual (*pneumatikós* is the term used for it in some Greek texts) or even physical (the kings of the world are all brothers, according to many Iranian sources) relationship between the rulers of the earth, with a known hierarchy among princes, a continuous exchange of gifts, and, at least in the later Iranian versions of the system, an elaborate symbolism of international banquets and feasts. Thus the Sassanian emperor Khosrow Anushirvan had "erected a platform measuring one hundred cubits to the side and there at a great banquet the emperor of China, the *khaqan* of the Turks, the *rajah* of India, and the Caesar of Rum all kissed his hand." Representations of these accounts probably existed, although no actual example has remained. The written descriptions of monuments we do possess are not always clear, and it is possible that they interpreted more or less well preserved ruins through the prism of a literary tradition whose existence has been abundantly proved.

In this fashion, as a translation into visual form of a literary myth,

the frozen shapes of Qusayr Amrah's fresco should probably be inter-
preted. Its subject, "The Family of Kings," about ancestors of a Mus-
lim prince, is unique in Islamic art. The significance of the fresco does
not lie in its artistic merit, which was probably mediocre, nor is it
overly important for our purposes to ascertain whether Byzantium or
Iran or possibly Central Asia was more important in the formation of
this scene. What matters is that it indicates one of the aims of repre-
sentations in early Islamic times, that of illustrating the new culture's
awareness of and sense of belonging to the family of traditional rulers
on earth. Yet the Muslim prince is not shown in the midst of his
"family" or as their equal, for it is the older princes who accept and
honor him as their successor. There is something ironically incongru-
ous in interpreting in this way an image hidden away in the forlorn
steppe of Transjordan. But it is often enough that such highly signifi-
cant images appear in remote places, because they illustrate a certain
mood, a psychological setting for the mind of the early Muslim patron
and beholder, which will help us in understanding our second monu-
ment.

The Dome of the Rock in Jerusalem, admirably situated on the east
side of the Holy City, is undoubtedly one of the most celebrated and
most remarkable monuments of early Islam, visited every year by
thousands of pilgrims and tourists (fig. 4). Completed or begun in
691–92 yet certainly conceived of much earlier, it is not only the
earliest remaining major monument of Islam but in all probability the
first Islamic monument that was meant to be a major aesthetic achieve-
ment. Much has been written about it and most of the literary or
archaeological information is comparatively accessible in several lan-
guages. What complicates matters is that it is a building with a contin-
uous history of nearly 1300 years in a city with more numerous and
more contradictory emotional, pietistic, and political associations than
any other urban entity in the world. So many layers of meanings have
accumulated over the building and over its surrounding area, the
Haram al-Sharif or Noble Sanctuary, that it is not easy to get to our
central question: why is it that a structure consisting of two octagonal
ambulatories around a circular center (fig. 6) was built in 692 some-
what north of the center of an immense artificial esplanade of Hero-
dian origin in the city of Jerusalem?

Two explanations are generally given for its construction. The first,
which has the apparent merit of agreeing quite well with the historical

circumstances of the years 685–92, has been adopted by one group of scholars, especially those with a positivist bent. This interpretation is based on texts of Ya'qubi (who wrote around 874), a heterodox Muslim historian brought up in Baghdad who had traveled widely throughout the empire, and of Eutychius (d. 940), an orthodox priest from Alexandria. Although it is also found in other writers before the Crusades, especially traditional Muslim litterateurs, there are indications (a series of errors with respect to attributions and dates) which suggest that in reality we are dealing with one major tradition, or at best two, which have been passed on through definable historiographic channels. All these writers claim that, since a counter-caliph Ibn al-Zubayr was in possession of Mekkah, the Umayyad caliph Abd al-Malik built a sanctuary in Jerusalem in order to divert pilgrims from Arabia proper by establishing the Palestinian city as the religious center of Islam. It has also been asserted that the plan of the Dome of the Rock, with two ambulatories around the Rock itself, originated with the liturgical requirements of the *tawaf*, the formal circumambulation that is one of the high points of Muslim pilgrimage. There are various arguments against this interpretation. For instance, the statements of Ya'qubi and Eutychius are unique in the annals of early Muslim historiography, and yet as momentous an attempt as that of changing the site of the *hajj* (the canonical pilgrimage to Mekkah required of all Muslims) could not have been overlooked by such careful historians as Tabari and Baladhuri, and especially not by a local Jerusalem patriot like the geographer Muqaddasi. It can also be shown that the histories of Ya'qubi and Eutychius contain willful distortions of fact which indicate that these writers were highly partisan in their opposition to the Umayyads. Furthermore, it would have been politically suicidal for Abd al-Malik to have made himself into an Unbeliever by modifying one of the clearest tenets of new faith only a generation and a half after the Prophet's death. He would hardly have been able to win over, as he did, the majority of the Muslims of his time against internal political threats. Then, a comparatively recently discovered text by Baladhuri makes it clear that the Syrian forces operating against Mekkah still considered the latter as the Muslim center for pilgrimage; during the fighting their leader al-Hajjaj requests permission for his troops to make the *tawaf*, and there appears to have been a fairly constant stream of people going on to their holy duty in spite of the fighting. Nor would al-Hajjaj have taken such pains to restore the Ka'bah to its original shape had it been replaced in the mind of the Umayyads by

the new building in Jerusalem. A statement in Tabari to the effect that in 687–88 at least four different groups went on pilgrimage shows that the bitter factional strifes between Muslims were held in abeyance for ritual purposes. Finally, it is doubtful whether the comparatively small area of the Dome of the Rock could have been conveniently used for the long and complex ceremony of the *tawaf;* and it may be argued that, had Abd al-Malik wanted to replace Mekkah, he would have chosen a type of structure closer in plan to the Ka'bah (fig. 12) than the Dome of the Rock, since the sacramental and inalterable character of the Mekkan sanctuary is fully apparent in its several reconstructions.

The second explanation for the Dome of the Rock's construction is still generally accepted by the Muslim faithful, and is involved with the complex exegesis of 17.1 of the Koran: "Glorified be He who carried His servant [Muhammad] by night from the *masjid al-haram* [Mekkah] to the *masjid al-aqsa* [the farthest place of worship]." As early as the middle of the eighth century, the biographer of the Prophet, Ibn Ishaq, connected this Night-Journey (*isra'*) with the no less complex Ascension (*mi'raj*) of Muhammad, and claimed that the *masjid al-aqsa* was in fact in Jerusalem and that it was from Jerusalem that the Prophet ascended into heaven. Ya'qubi mentions the fact that the Rock in the Haram al-Sharif is "the rock on which it is said that the Messenger of God put his foot when he ascended into heaven." Furthermore, all the later geographers describing the area mention a great number of *qubbahs* (cupolas), *maqams* (holy emplacements), *mihrabs* (niches indicating direction, about which more is written below), and other features associated with the events of Muhammad's Ascension. It might thus be suggested that the Dome of the Rock was built as a sort of *martyrium* to a specific incident in Muhammad's life. The arguments can be further strengthened by the fact that the architecture of the Dome of the Rock is clearly in the tradition of the great Christian martyria and is closely related to the architecture of the Christian sanctuaries in or around Jerusalem, one of which commemorated the Ascension of Christ.

But this explanation, like the first, leads to more problems than it solves. Many early religious traditionalists, including such great ones as Bukhari and Tabari, do not accept the identification of the *masjid al-aqsa* with Jerusalem as the only possible one. Both Ibn Ishaq and Ya'qubi preface their accounts with expressions which indicate that these are stories not necessarily to be accepted as dogma. In fact, there

is little justification for assuming that the Koranic reference to the *masjid al aqsa* in its own time in any way meant Jerusalem. Some scholars thought that it was a mystical place in heaven, while others suggested that it applied specifically to a place near Mekkah, where there were two sanctuaries (*masjid al-adna* and *masjid al-aqsa*, the "nearer" mosque and the "farther" mosque) and thus was a concrete and immanent reference rather than an abstract and transcendental one. Furthermore, all early writers enumerate a series of holy places on the Haram area, the large platform of Herodian origin which became the Muslim sacred precinct. Many of these sanctuaries still exist in late medieval reconstructions. Next to the Dome of the Rock stood—as it does today—the *qubbah al-mi'raj*, the domed martyrium of the Ascension. Had the first and most imposing of all buildings on the Haram been built as a martyrium to the Ascension of Muhammad, there would certainly have been no need for a second martyrium. The Persian traveler Nasir-i Khusrow, one of the first to attempt a systematic explanation of all the buildings of the Haram, still considers the Rock under the Dome simply as the place where Muhammad prayed before ascending into heaven from the site of the *qubbah al-mi'raj*. It is rather odd that the less important moment in a sequence of commemorated events would have been glorified by a more impressive building, and Nasir-i Khusrow's statement can best be explained as reflecting a later and not very systematic attribution of meanings to already holy places.

Since the incomplete external textual evidence thus cannot provide us with a satisfactory explanation of the purpose for which Abd al-Malik built the Dome of the Rock, it is necessary to turn to the internal evidence of the building itself: its location, its architecture and decoration, and the 240-meter-long inscription inside the building, which is the only strictly contemporary piece of written evidence we possess. While none of these can alone explain the Dome of the Rock, an analysis of all three can lead to a much more comprehensive and precise explanation than hitherto offered of the reasons which led to the erection of the first major monument of the new Islamic civilization.

Since it can be shown that at the time of construction the Rock was not considered as the place from whence Muhammad ascended into heaven, why was it chosen as the obvious center of the structure? To answer this question we must ask ourselves what significance the

Rock had at the time of the Muslim conquest and whether there is any evidence for a Muslim interpretation of the Rock or its surroundings either then or between the conquest and the building of the Dome.

The exact function of the Rock in earliest times is still a matter of conjecture. While the Haram was without doubt the site of the Solomonic Temple, no definite Biblical reference to the Rock exists. Whether it was "the threshing-floor of Ornan the Jebusite" (1 Chron. 3.1, 2 Sam. 14.18), whether it was an ancient Canaanite holy place fitted by Solomon into the Jewish Temple, perhaps as a podium on which the altar stood, or whether it was the "middle of the court" which was hallowed by Solomon at the consecration of the Temple (1 Kings 8.63–64) cannot be ascertained. At the time of the Herodian reconstruction of the Temple it would appear from a more or less contemporary text that the Rock was only a few inches above the level of the terrace and that it was used as a cornerstone. But the text is not very clear and nowhere have I been able to find definite evidence of an important liturgical function of the Rock in the Jewish tradition.

In early medieval times, however, Mount Moriah in general and the Rock in particular were endowed in Jewish legend with a complex mythology. Mount Moriah, through its association with the Temple, became the *omphalos* of the earth where the tomb of Adam was to be found and where the first man was created. Yet another tradition, that of the sacrifice of Abraham, was attached to the Rock through a confusion between the land of Moriah (Gen. 22.2) and Mount Moriah. In other words, in Jewish tradition the Rock and the surrounding area acquired mystical significance as the site of the Holy of Holies and became associated with a series of legends involving major figures of the Biblical tradition, especially Abraham and Isaac. This importance is indicated in early medieval times by the statement of the anonymous Pilgrim of Bordeaux who mentions a *lapis pertusus*, a perforated stone, "to which the Jews come every year and which they anoint," probably a reference to the Rock itself which appears here to be thought of as a tangible remnant of the Temple and as a forerunner of the Wailing Wall.

During the Roman and Byzantine period the whole Haram area was left unoccupied, but under Christian rule the Holy City itself witnessed a new and remarkable development in the "New Jerusalem," the western part of the city. No Christian sanctuary appears to have been built on the area of the Haram, since the prophecy of the destruction of the Temple had to be fulfilled. Although there is some evidence

in patristic literature that the Jewish associations were accepted by some Christians, with the building of the Holy Sepulchre the *omphalos* of the earth was transferred to another hill of Jerusalem, Golgotha, and with it were also transferred the associations between Jerusalem and Adam and Jerusalem and Abraham. Such then appears to have been the situation at the time of the Muslim conquest: the Jewish tradition considered the Haram area as the site of the Temple and the place of Abraham's sacrifice and Adam's creation and death, while the Christian tradition had moved the latter two to a new site.

The conquest of Jerusalem by the Arabs in 637 was a major moment in the conquest of Syria. The Christians demanded the presence of the caliph Umar himself for the signing of the treaty of capitulation, and once the treaty was signed Umar, accompanied by the patriarch Sophronius, was led through the city. As this tour of the Holy City was endowed by later writers with a series of more or less legendary incidents, it is not easy to ascertain what happened. Most sources— early or late, Muslim or not—seem to agree on two points. First, Umar was intent on seeing one specific site in the Holy City. All sources agree on that, and, in later traditions his quest and the patriarch Sophronius's opposition to it were transformed into a dramatic contest. Second, the early sources refer not to the Rock as the main object of Umar's quest, but to the Haram area in general, which they saw as the site of the Jewish Temple, the *mihrab Dawud* ("sanctuary of David") of the Koran (38.20–21) or the *naos ton Ioudaion* ("temple of the Jews") of Greek sources. The latter mention only Umar's interest in the area of the Jewish Temple and add that a Muslim sanctuary was built on its emplacement. Although mentioned in the tradition transmitted by the Muslim historian Tabari, the Rock plays no part in the prayer and recitations made by the caliph when he reached the Haram area, and in this tradition Umar rejects the suggestion made to him by Ka'b, a Jewish convert, that the Rock be on the *qiblah* side of the Muslim sanctuary, that is, that the faithful at prayer turn themselves toward it, because this would be reverting to a Jewish practice.

In these texts then, the Rock, together with the whole Haram area, appears primarily as the symbol of the Jewish Temple, but the Rock itself was not taken into any particular consideration by Umar. It may be that Umar was merely looking for a large area on which to build a mosque and that Sophronius used the Haram's Jewish background to persuade the caliph to build the mosque in the empty space of the Haram. But it is perhaps more likely, in the face of the enormous

impact of Jewish traditions on early Islam and specifically on Umar at the time of the conquest of Jerusalem, that the caliph was genuinely interested in reviving the ancient Jewish holy site, inasmuch as it had been the first Muslim qiblah. At any rate, the Muslims took over the Haram area with a definite knowledge and consciousness of its significance in Jewish tradition, but with very few clear Muslim associations.

Later chroniclers very clearly point out that Umar withstood pressures to transform the site into a major center of Muslim worship. This fact shows, on the one hand, that Umar was pressured by Jewish and Christian groups to take up their religious quarrels. By wisely remaining aloof, the caliph emphasized the unique character of the new faith in the face of the two older ones. But, on the other hand, in building anew on the Temple area, even though in primitive fashion, the Muslims committed a political act: taking possession for the new faith of one of the most sacred spots on earth and altering the pattern imposed on that spot by the Christian domination, without restoring it to its Jewish splendor. In all these undertakings the Rock itself played but a minor part.

Some sixty years after the conquest of Jerusalem, however, the Rock had become the center of the whole area. What occurred between the time of Umar and the reign of Abd al-Malik? The texts, so far as I have been able to ascertain, are silent on this score and we will have to turn to other sources. If we consider only the location of the building and the traditions associated with it, two possible solutions can be envisaged, since neither the Ascension of Muhammad nor the imitation of the Ka'bah can be accepted. Possibly Abd al-Malik decided to commemorate the Jewish Temple and therefore built a sort of ciborium over what was thought to be the only tangible remnant of the structure. There is no evidence for this, nor is it likely that Abd al-Malik had such an idea in mind at a time when the Islamic state was fairly well settled. Or the Muslims might have brought back to the Rock and to Mount Moriah in general the localization of some biblical event of significance to them, for instance the sacrifice of Abraham. As such this hypothesis is not impossible. The importance of the "Friend of God" (*khalil Allah*), as Abraham is called, in the Koran and in the Muslim tradition is well known, and it is equally well known that he was considered the ancestor of the Arabs. In later times the major events of his later life were associated with Mekkah or its neighborhood; and it is interesting to note that the life of Adam was also transferred there, just as Abraham and Adam had moved together

from Mount Moriah to the Golgotha in Jerusalem. But is there any definite evidence about the localization of the sacrifice of Abraham in the early Islamic period?

Without going into complex details that have been studied elsewhere, it can be shown that the early Islamic tradition was very uncertain about the actual localization of the main events of Abraham's life. At least some Muslim authorities put many of them in or around Jerusalem, and it is plausible that, partly under the impact of the numerous Jewish converts who flocked to the new faith, there was an agreed association between the Rock and Abraham. One might suggest, then, that Abd al-Malik would have islamized the holy place and chosen the one symbol associated with it which was equally holy to Jews and Muslims, that of Abraham. To Muslim eyes this would have emphasized the superiority of Islam, since in the Koran (3.58 ff.) Abraham is neither a Christian nor a Jew, but a *hanif*, a holy man, and the first Muslim. This suggestion finds support in one interesting feature of the Christian polemic against the Muslims. John of Damascus and others after him always insisted on the fact that the new masters of the Near East were Ishmaelites, that is, outcasts; and it is with this implication that the old term *Sarakenoi* was explained as meaning "empty [because of or away from] of Sarah" (*ek tes Sarras Kenous*) and that the Arabs were often called *Agarenoi*, "illegitimate descendants of the slave-girl Agar," obviously in a pejorative sense. While of course the term Ishmaelite goes back to biblical times, with the arrival of the Muslims there seems to appear in Christian writing a new and greater emphasis on the sons of Agar. Whether this new emphasis by Greek and Syriac writers on the posterity of Abraham was the result of Arab claims to descent from Abraham (and the resulting building up of Ishmael) or whether it derived solely from a Christian attempt to show contempt for the new masters of the Near East is difficult to say. But granting Abraham's importance in early Islamic thought and in the traditions associated with the Rock, Abd al-Malik's building would have had an essentially polemic and political significance as a memorial to the Muslim ancestor of the three monotheistic faiths.

The place of Abraham in early Islamic times can also be discussed in a purely Muslim context. One of the most interesting acts of Ibn al-Zubayr, the opponent of the Umayyads in Mekkah, was his rebuilding of the Ka'bah after its destruction during the first Umayyad siege (683), not as it had been built with the youthful Muhammad's partici-

pation, but differently. According to a later well-known tradition he built it as the Prophet said it was in the time of Abraham. Al-Hajjaj, on the other hand, rebuilt the Ka'bah as it had been at the time of the Prophet. This curious attempt by Ibn al-Zubayr to use the prestige of Abraham to justify his building ties up with another tradition reported by al-Azraqi, the chronicler of Mekkah. The Mekkans were apparently attempting to disprove the contention that Jerusalem was "greater than the Ka'bah, because it [Jerusalem] was the place to which Prophets emigrate and because it is the Holy Land." Within the Muslim koiné, therefore, it may be suggested that by islamizing the Jewish holy place Abd al-Malik was also asserting a certain preeminence of Palestine and Jerusalem over Mekkah, not actually as a replacement of the Ka'bah but rather as a symbol of his opposition to the old-fashioned Mekkan aristocracy represented by Ibn al-Zubayr. The symbol was chosen from a religious lore which had not yet been definitely localized, but which was important to the new faith as well as in the beliefs of the older People of the Book. It did not, however, infringe—as any change of center for the pilgrimage would have done—on the very foundations of Islam. The opposition between Jerusalem and Mekkah, and Abd al-Malik's involvement in it, may have given rise to the tradition about the pilgrimage to Jerusalem transmitted by Ya'qubi and others. They would have transformed what had been a religious-political act entailing an unsettled point of religious lore into a religious-political act of impiety intended to strike at the very foundation of one of the "pillars of Islam." Thus did the later propaganda machine of the Abbasids attempt to show the Umayyads as enemies of the faith in a manner only too reminiscent of our own practices today.

From the consideration of the location of the Dome of the Rock, then, it would appear that although at the time of the conquest the main association was between the Jewish Temple and the Haram area, this association does not in itself explain the fact of the building. It is only through the person of Abraham that the ancient symbolism of the Rock could have been adapted to the new faith, since no strictly Muslim symbol seems to have been connected with it at so early a date. In itself this hypothesis cannot be more than a suggestion, for there is no clear-cut indication of Abraham's association with the Rock of Jerusalem at the time of Abd al-Malik. Furthermore, the question remains whether the monument should be understood within a strictly Muslim context or within the wider context of the relationship between the new state and faith and the older religions of the Near East. For

clarification we must turn now to the other two documents in our possession.

The second piece of contemporary evidence we can use for understanding the Umayyad Dome of the Rock is in the building itself, its decoration and its architecture (figs. 5–9). The Dome is a ciborium or "reliquary" above a sacred place, on a model which was fairly common among Christian martyria throughout the Christian world, and which was strikingly represented by the great churches of Jerusalem itself. In other words, the architecture confirms a symbolic quality of place of commemoration for the Dome of the Rock but does not provide any clue for its meaning at the time of Abd al-Malik. Most of the decorative themes of the mosaics consist of vegetal motives interspersed with vases, cornucopias, and what have been called "jewels" (figs. 8, 9). All these elements, except the "jewels," are common enough and their significance in late-seventh century art is primarily stylistic; but the "jewels" present peculiarities that may help to explain the meaning of the structure.

The jewel decoration does not appear uniformly throughout the building but almost exclusively on the inner face of the octagonal colonnade and of the drum. Although it has been suggested that this is so the decoration will appear more brilliant when seen against the light coming from the windows, it can be shown that the difference between this part of the mosaic decoration and the rest of it lies not in a jewellike effect but in the type of jewels used. Had the intended effect been purely formal, gems and mother-of-pearl, as used elsewhere in the building, would have served equally well here. It may rather be suggested that these actual crowns, bracelets, and other jeweled ornaments were meant to surround the central holy place toward which they face, and it is in this sense that they contrast with the purely decorative gemlike fragments throughout the building.

Although in most cases the jewels have been adapted to the vegetal basis of the decorative scheme, they are identifiable. There are crowns, either diadems with hangings and encrusted precious stones and in many cases topped with triangular, oval, or arched forms, or diadems surmounted by wings and a crescent. There is also a variety of breastplates, necklaces, pins, and earrings, almost all of which are set with precious stones as incrustations or as hangings. These ornaments can all be identified either as royal and imperial ornaments of the Byzantine and Persian princes, with the former largely predominant, or as the ornaments worn by Christ, the Virgin, and saints in the religious

art of Byzantium. They were all, in different degrees and ways, symbols of holiness, wealth, power, and sovereignty in the official art of the Byzantine and Persian empires. In other words, the decoration of the Dome of the Rock witnesses a conscious use of symbols belonging to the subdued or to the still active opponents of the Muslim state.

What can be the significance of such a theme in the decoration of an early Muslim monument? Through texts and images one can reconstruct with some accuracy the ways in which crowns and jewels were utilized in early Christian and Byzantine art and practice; scarcity of information makes it more difficult to decide if the same habits existed in Iran, but there are a few appropriate mostly textual, parallels. In all instances crowns and jewels served to emphasize the holiness or wealth of a sanctuary or personage by surrounding it with royal insignia. This same explanation might be offered for the use of the decorative theme in the Dome of the Rock. Perhaps under the impact of the Christian sanctuaries of Jerusalem, in particular the Holy Sepulchre, the Dome of the Rock was decorated with votive crowns simply to emphasize its holiness. This explanation, which has in fact been proposed for a number of other early Islamic themes as well, would suggest that the general ornamental, beautifying aspect of the crowns and jewels took precedence over their specific, concrete meaning as royal insignia.

Yet such an explanation, if limited to a mere imitation of Christian models and to a generalized significance of the motifs, leads to difficulties. It does not account for the inclusion of a Persian crown within the decorative scheme. Moreover, while agreeing with the purely formal aspect of the decoration, it agrees perhaps less well with the historical and cultural milieu of the Umayyads and of Islam. We must ask ourselves whether there is any evidence in the early Islamic period for the use of crowns and other royal objects in religious building and, if so, for what purposes. A fascinating document is provided by the list of objects sent to Mekkah and kept there in the Ka'bah. This list can be made up from different authors, especially from al-Azraqi whose early date (ninth century) is of particular significance to us.

In pre-Islamic times the Mekkan sanctuary had contained paintings and sculptures, which were destroyed on the Prophet's order. Apparently until the time of Ibn al-Zubayr the shrine also kept the two horns of the ram which had been sacrificed by Abraham and other prophets; when he destroyed the Ka'bah, Ibn al-Zubayr reached for them but they crumbled in his hands. In Islamic times a new series of objects

was brought into the holy place. Umar hung there two crescent-shaped ornaments taken from the capital city of the Persians. Yazid I gave two ruby-encrusted crescents belonging to a Damascene church, together with two cups. Abd al-Malik sent two necklaces and two glass cups, al-Walid I two cups, al-Walid II a throne and two crescent-shaped ornaments with an inscription, and al-Saffah a green dish. Al-Mansur had a glass cup of an ancient Egyptian type hung in the shrine. Harun al-Rashid put there two gilded and bejeweled cases containing the celebrated oaths of allegiance of his two sons to the complex political system he had established. Al-Ma'mun sent rubies attached to a golden chain, while al-Mutawakkil had a necklace of gold with precious stones, rubies, and topazes hung on a chain of gold. At a later date the agreement between al-Muwaffaq and al-Mu'tamid about the division of the empire was also sent to the Ka'bah. But the most important group of objects from our point of view is that which was sent by al-Ma'mun.

The text of al-Azraqi is somewhat confused on this score, and two more or less contemporary sets of events seem to have been mixed up by the chronicler. First, an unnamed king of Tibet had an idol of gold with a crown of gold and jewels set on a baldachin throne of silver covered with a cloth with tassels in the shape of spheres. When this king became a Muslim, he gave the throne and the idol to the Ka'bah. They were sent to Mekkah in 816–17 and exhibited at the time of the pilgrimage with an inscription emphasizing the fact that the throne was given to the Ka'bah as a token of the king's submission to Islam. During the revolt a year later the throne was destroyed, but the crown remained in the Ka'bah certainly until the time of al-Azraqi. Second, the Mekkan sanctuary also acquired the spoils of the Kabul-shah, a rather mysterious prince from Afghanistan, who submitted and became converted in 814–15. His crown seems to have been taken to Mekkah immediately, as is ascertained by an inscription of that date. The throne was kept for awhile in the treasury of the oriental provinces before being moved to Mekkah in 816. The inscriptions that were put up together with these two objects emphasize the victory of the "righteous" prince al-Ma'mun over his perjured brother and the victory of the "Commander of the Faithful" over the unbelievers.

These objects in the Ka'bah can be divided into three categories. Some were merely expensive gifts whose purpose was to emphasize the holiness of the place and the piety of the donors; just as in Byzantium these were preponderantly royal jewels. Another category need

not concern us here: the statements of oaths, which were put in the sanctuary not to enhance its holiness but to acquire holiness and sacredness from it. The third group of objects—from Umar's gift acquired in the palace of the Persian kings, to the throne and crown of Kabul-shah—were used to symbolize the unbeliever's submission to Islam through the display of his *Herrschaftszeichen*, or symbols of power, in the chief sanctuary of Islam, and as such had an uplifting value to the beholders.

Returning now to the mosaics of the Dome of the Rock, one can argue, first, that the crowns and jewels reflect an artistic theme of Byzantine origin which in an Islamic context also used royal symbols in a religious sanctuary to emphasize the sanctuary's holiness. But one can suggest too that the choice of Byzantine and Sassanian royal symbols was dictated by the desire to demonstrate that the "unbelievers" had been defeated and brought into the fold of the true faith. Thus, in the case of the mosaic decoration, just as in the problem of the building's location, explanations of the Dome of the Rock occur on a series of parallel levels. There is an internal, Islamic explanation; there is an explanation that relates the building to non-Muslim monuments and functions; and there is what may be called an accidental level, at which the mosaic decoration is simply meant to be beautiful just as the Herodian platform of the Haram may have been chosen simply because it was a large empty space. The third document in our possession, the inscription, will provide us with a possible solution.

The Dome of the Rock is unusually rich in inscriptions, of which three are Umayyad. The major one, 240 meters in length, is found above the arches of the inner octagonal arcade, on both sides. With the exception of one place where the later caliph al-Ma'mun substituted his name for that of Abd al-Malik, this inscription is throughout contemporary with the building. The other two inscriptions are on copper plaques on the eastern and northern gates. They, too, have been tampered with by the Abbasid prince, but it has been shown that they should be considered as Umayyad. The content of the inscriptions is almost exclusively religious, with the exceptions of the builder's name and of the date, and to a large extent it consists of Koranic quotations. The importance of this earliest Koranic inscription we have lies in the choice of passages and in the accompanying prayers and praises.

The inscription in the interior can be divided into six unequal parts, each of which begins with the *basmalah* or invocation to the Merciful

God. Each part, except for the one that has the date, contains a Koranic passage. The first part has *surah* 112: "Say: He is God, the One; God the Eternal; He has not begotten nor was He begotten; and there is none comparable to Him." The second part contains 33.54: "Verily God and His angels bless the Prophet; O ye who believe, bless him and salute him with a worthy salutation." The third passage is from 17.3, the *surah* of the Night-Journey, but the quotation is not connected with the *isra'* of the Prophet—a further argument against the belief that at the time of Abd al-Malik the Rock of Jerusalem was already identified with the place whence Muhammad ascended into heaven. Verse 3 goes as follows: "And say: praise be to God, Who has not taken unto Himself a son, and Who has no partner in Sovereignty, nor has He any protector on account of weakness." The fourth quotation, 64.1 and 57.2, is a simple statement of the absolute power of God: "All in heaven and on the earth glorify God; to Him is the Kingdom; to Him is praise; He has power over all things." The last part is the longest and contains several Koranic passages. First 64.1, 67.2, and 33.54 are repeated. They are followed by 4.169–71:

> O ye People of the Book, overstep not bounds in your religion; and of God speak only truth. The Messiah, Jesus, son of Mary, is only an apostle of God, and His Word which he conveyed into Mary, and a Spirit proceeding from Him. Believe therefore in God and his apostles, and say not 'Three.' It will be better for you. God is only one God. Far be it from His glory that He should have a son. His is whatever is in the heavens, and whatever is on the earth. And God is a sufficient Guardian. The Messiah does not disdain being a servant of God, nor do the Angels who are near Him. And all who disdain His service and are filled with pride, God will gather them all to Himself.

This quotation is followed by a most remarkable invitation to prayer: "Pray for your Prophet and your servant, Jesus, son of Mary," which is followed by 19.34–37: "And the peace of God was on me [Mary] the day I was born, and will be the day I shall die, and the day I shall be raised to life. This is Jesus, the son of Mary; this is a statement of the truth concerning which they doubt. It beseems not God to beget a son. Glory be to Him. When he decrees a thing,

He only says to it 'Be,' and it is. And verily God is my Lord and your Lord; adore Him then. This is the right way." And the inscription ends with the exhortation and threat of 3.16–17: "God witnesses that there is no God but He: and the angels, and men endued with knowledge, established in righteousness, proclaim there is no God but He, the Mighty, the Wise. The true religion with God is Islam; and they to whom the Scriptures had been given differed not until after the knowledge had come to them, and through mutual jealousy. But, as for him who shall not believe in the signs of God, God will be prompt to reckon with him."

The two inscriptions on the gates are not so explicit. That on the east gate bears a number of common Koranic statements dealing with the faith (2.256, 2.111, 24.35, 112, 3.25, 6.12, 7.155) and a long prayer for the Prophet and his people. The inscription on the north gate is more important since it contains two significant passages. First, 9.33 (or 61.9): "He it is who has sent His messenger with the guidance and the religion of truth, so that he may cause it to prevail over all religion, however much the idolaters may hate it." This is the so-called prophetic mission which has become the standard inscription on all Muslim coins. But, while it is true that it has become perfectly commonplace, its monumental usage is rarer and this is the first known occurrence of it. Second, the inscription contains an abridged form of 2.130 (or part of 3.78), which comes after an enumeration of the prophets: "We believe in God, in that which was passed down to Muhammad [not a Koranic quotation] and *in that which the prophets received from their Lord. And we make no distinction between any of them and unto Him we have surrendered*" (italics added).

We can emphasize three basic characterictics of these quotations. The fundamental principles of Islam are forcefully asserted, as they will be in many later inscriptions; all three inscriptions point out the special position of the prophet Muhammad and the importance and universality of his mission; and the Koranic quotations define the position of Jesus and other prophets in the theology of the new faith, with by far the greatest emphasis on Jesus and Mary (no Old Testament prophet is mentioned by name). The main inscription ends with an exhortation, mingled with the threat of divine punishment, pointing to Islam as the final revelation and directed to the Christians and the Jews ("O ye people of the Book"). These quotations do not, for the most part, belong to the usual cycle of Koranic inscriptions on monuments. Just as the Dome of the Rock is a monument

without immediate parallel in Islamic architecture, so is its inscription unique. Moreover, it must be realized that even those quotations which later became commonplace were used here, if not for the first time, at a time when they had not yet become standard. Through them the inscription has a double implication. On the one hand, it has a missionary character; it is an invitation, a rather impatient one, to "submit" to the new and final faith, which accepts Christ and the Hebrew prophets among its forerunners. At the same time it is an assertion of the superiority and strength of the new faith and of the state based on it.

The inscription also had a meaning from the point of view of the Muslims alone, for it can be used to clarify the often quoted statement of Muqaddasi on the reason for the building of the Dome of the Rock. One day Muqaddasi asked his uncle why al-Walid spent so much money on the building of the mosque of Damascus. The uncle answered:

> O my little son, thou has not understanding. Verily al-Walid was right, and he was prompted to a worthy work. For he beheld Syria to be a country that had long been occupied by the Christians, and he noted there the beautiful churches still belonging to them, so enchantingly fair, and so renowned for their splendor, as are the Church of the Holy Sepulchre, and the Churches of Lydda and Edessa. So he sought to build for the Muslims a mosque that should be unique and a wonder to the world. And in like manner is it not evident that Abd al-Malik, seeing the greatness of the martyrium [*qubbah*] of the Holy Sepulchre and its magnificence was moved lest it should dazzle the minds of the Muslims and hence erected above the Rock the Dome which is now seen there.

It is indeed very likely that the sophisticated Christian milieu of Jerusalem had tried to win to its faith the rather uncouth invaders. And it is a well-known fact that eastern Christianity had always liked to use the emotional impact of music and the visual arts to convert "barbarians." That such attempts may have been effective with the Arabs is shown in the very interesting, although little studied, group of accounts dealing with the more or less legendary trips of Arabs to the Byzantine court in early Islamic times, or sometimes even before Islam. In most cases the "highlight" of the "guided tours" to which

they submitted was a visit either to a church where a definite impact was made by the religious representations or to a court reception with similar results. In the pious accounts of later times the Muslim always leaves impressed but unpersuaded by the pageantry displayed. One may wonder, however, whether such was always the case and whether the later stories should be considered, at least in part, as moral stories intended to ward off defection. That the danger of defections existed is clearly implied in Muqaddasi's story. From a Muslim point of view, therefore, the Dome of the Rock was an answer to the attraction of Christianity, and its inscription provided the faithful with arguments to be used against Christian positions. It is of considerable importance to recall, finally, that at the very same time the neighboring basilica of the Nativity in Bethlehem was being redecorated by Christians. The new decoration consisted of symbols of the Church's councils, both ecumenical and regional, and including those councils which condemned the monophysite heresy and asserted the trinitarian dogma of Christianity. The coincidence is certainly not fortuitous.

A priori two major themes had to be present in the construction of the Dome of the Rock. First, the building of a sanctuary on Mount Moriah must have been understandable—and understood—in terms of the body of beliefs which had been associated with that ancient holy spot, since Islam was not meant as a totally new faith but as the continuation and final statement of the faith of the People of the Book. In other words, the Dome of the Rock must have had a significance in relation to Jewish and Christian beliefs. Second, the first major Muslim piece of architecture had to be meaningful to the follower of the new faith. As we have seen, these themes recur in the analysis of the three types of evidence provided by the building itself. Its location can be explained as an attempt to emphasize an event of the life of Abraham either in order to point to the Muslim character of a personage equally holy to Christians and Jews or in order to strengthen the sacredness of Palestine against Mekkan claims. The royal symbols in the mosaics could be understood as simply votive or an expression of the defeat of the Byzantine and Persian empires by the Muslims. Finally, the inscriptions are at the same time a statement of Muslim unitarianism and a proclamation to Christians and Jews, especially the former, of the final truth of Islam.

But in the inscriptions the latter theme is preponderant and it is in

the inscriptions, with their magical and symbolic significance, that we find the main idea involved in the erection of the Dome of the Rock. The inscription forcefully asserts the power and strength of the new faith and of the state based on it. It exemplifies the Umayyad leadership's realization of its own position with respect to the traditional heir of the Roman empire. In what was in the seventh century the Christian city par excellence Abd al-Malik wanted to affirm the superiority and the victory of Islam. This affirmation, to which was joined a missionary invitation to accept the new faith, was expressed in the inscriptions, in the Byzantine and Persian crowns and jewels hanging around the sacred Rock, and most immediately in the appropriation of the ancient site of Mount Moriah. Thereby the Christian prophecy was voided and the Jewish mount rehabilitated. But it was no longer a Jewish sanctuary; it was a sanctuary dedicated to the victorious faith. Thus the building of the Dome of the Rock implies what might be called a *prise de possession*, on the part of Abd al-Malik, of a hallowed area. The Dome of the Rock should be related not so much to the monuments whose form it took over, but to the more general practice of setting up a symbol of the conquering power or faith within the conquered land. In Umayyad Islam this affirmation of victory was totally bound with missionary zeal.

The formal terms used to express this symbolic appropriation were not new but consisted almost exclusively of the forms of Byzantine and, to a far smaller degree, Sassanian art. The one purely Islamic feature, the inscriptions, were for the most part in places where they were hardly visible. For, regardless of the Muslim associations that appear in the creation of the Dome of the Rock, the building's primary purpose was to be a monument for non-Muslims. With all the Islam-wide ramifications of its symbolism, it was an immanent building that served precise contemporary needs, the most crucial of which was to demonstrate to a Christian population (especially the orthodox church), which often still thought Muslim rule was a temporary misfortune, that Islam was here to stay. As Abd al-Malik succeeded in checking the dangers of Byzantine intervention and internal dissensions, this timely significance of the Dome of the Rock receded in importance. Purely Islamic religions and pietistic associations began to appear and to transform fairly rapidly the Dome of the Rock and the whole Haram area into the purely Muslim sanctuary it has remained ever since. This, however, is another story. The

main point of our demonstration is that, whereas in the Qusayr Amrah fresco we have what seems to be an original form illustrating the Muslim prince's participation in the family of the earth's rulers, in Jerusalem almost exclusively traditional non-Islamic forms served to show to the Jewish and especially Christian worlds that the new faith was their successor in the possession of the one revealed religion and that its empire had taken over their holiest city.

The third illustration of the ways in which early Islamic monumental activities served, at least in part, to demonstrate the symbolic as well as physical appropriation of the conquered land summarizes all these impulses and needs in a particularly striking fashion, even though nothing remains of it. It is Baghdad, the City of Peace, whose construction began in 762.

All sorts of events contributed to the city's foundation. Political, economic, strategic, administrative, and climatic reasons can be and have been adduced to explain why the caliph al-Mansur decided to begin a new capital for the Muslim empire. These reasons are perfectly acceptable singly and collectively but, as the most recent investigator of early Baghdad has pointed out, practically all of them could apply to several other early Arab settlements in Iraq. It is therefore legitimate enough to suppose that something else was involved here. Fortunately a number of early literary sources and descriptions have survived which make it possible to reconstruct al-Mansur's city in considerable detail. They indicate that Baghdad was not intended only to be an economically or politically important center or even to satisfy the personal or imperial ambitions of a ruler. It had a unique meaning, which can best be understood by considering the shape given to the city.

It was a round city with a diameter of some 2300 meters (Fig. 10). More important than the metric dimension, however, is the notion expressed by some sources that the diameter corresponded to a single unit of measurement, the *mil*. The city was surrounded by a heavy, high wall provided with large towers and preceded by a deep ditch; in this sense it appeared as a sort of fortress. There were four gates built on the same pattern: a series of long vaulted halls and occasional open areas with heavy double doors and windows for light. Over the principal door there was a second floor whose main feature was a large cupola, gilded on the outside. Over each dome there was a different "figure" (probably some bronze sculpture) which turned with the wind. Around the cupola reception halls and

resting places were provided. The second story was reached through a vaulted ramp wide and high enough for horses, for it served as the main passage to the walls patrolled by horsemen. The four gates—called by the names of Khorasan, the great northeastern province, Syria, and Basrah and Kufah, the two new cities in lower Iraq—served as the main axes of the city's organization. From them one could penetrate into a ring of constructions—probably about 170 meters in width—which was arranged around a partly empty center and where the shops and living quarters were found. The makeup of the population was originally chosen in such a manner that all the various ethnic, tribal, and economic groups of the Muslim empire were represented. In the center the open space was partly filled with a variety of administrative buildings, largely along the inner wall that separated the center from the ring of living quarters. But the center's most important feature was the *dar al-Khilafah*, the imperial complex, in the very middle. It consisted of a large mosque of a traditional hypostyle type which will be discussed later, and a palace, about which little is known except that it had a large reception hall (*iwan*) followed by an audience hall covered with a dome. Over this first domed hall there was a second one, surmounted by the celebrated Green Dome on top of which the statue of a horseman was seen. According to tradition its lance would always point in the direction of the enemies of the Muslim empire.

No trace is left of all this. The horseman and the Green Dome collapsed in the tenth century and it is only in a thirteenth-century manuscript depicting little mechanical toys for a second-rate Turkish prince of Anatolia that we have an echo of the imperial Abbasid palace (fig. 11)—as though the Eiffel Tower were known only through the souvenirs that copy it. A mihrab now in the Islamic Museum in Baghdad may have belonged to the great Abbasid mosque because of the early quality of its vegetal designs, but even this is not absolutely certain and it is a very minor monument anyway. The city itself hardly ever lived in the perfect shape conceived for it; even during the lifetime of al-Mansur suburbs were added, the carefully drawn internal divisions broke down, and the Round City became only a part of the enormous urban complex of Baghdad.

Yet the memory of its original shape and of the ideas behind it lasted for centuries in a way that has no parallel in the history of Islamic cities, even though dozens of new urban centers were founded by the new civilization. In one instance even—that of

Raqqah in the middle Euphrates valley—another town is said to
have copied it. Unfortunately there is considerable uncertainty as to
which part of the immense field of ruins visible at Raqqah is the one
supposedly imitating Baghdad, and the rapid growth of the contem-
porary city makes it unlikely that archaeologists will ever find out
how closely the earlier model was followed.

It is perhaps just as well that it be so, since for our purposes the
true significance of Baghdad lies not so much in the physical charac-
ter of its forms as in the ideas suggested by the forms. We are in the
presence of a walled circular entity with four axial entries leading to
a central space in the middle of which there is a palace. In the center
of the palace a tall two-storied green dome surmounted by a sculp-
ture is echoed by four golden domes over each of the entrances, also
provided with sculptures. This perfect composition is not really an
urban one but a palatial one, to which none of the early Islamic cities
correspond, with the partial exception of Qasr al-Hayr East as it
begins to emerge after recent excavations (fig. 102). There also a
palatial significance can be given to the city, although it does not
have the symbolic meaning of Baghdad. The fortresslike aspect is
that of almost all palaces from late antiquity onward, with Diocle-
tian's retreat at Spalato in Yugoslavia as one of the first examples.
But, like Diocletian's palace, it was not a mere fortress. The high
dome in the center was mostly symbolic, but its name was not new,
for already the palace of the Umayyad caliph Hisham in Rusafah in
northern Syria, the palace of the first Umayyad caliph Mu'awiyah in
Damascus, and the palace of al-Hajjaj, the powerful and brutal
Umayyad governor of Iraq at the turn of the seventh century, were
identified by green domes that could be seen from afar. It matters
little that the green color can best be understood as the result of
bronze oxydation and that, as was common in the Middle Ages,
bronze or copper sheets were used to protect the wood of the roofs.
Very early the notion of a Green Dome had become a symbol of
imperial authority. The smaller domes over the gates did not have so
exalted a symbolic meaning; according to one report they served as
audience halls when the caliph wanted to look at the countryside—
the mighty Euphrates from the Khorasan gate, the gardens and es-
tates from the Kufah gate, various suburbs from the other two. A
possible interpretation of these reports, for which fuller justification
will be given in a later chapter, is that these domed rooms were
primarily for pleasure, for the enjoyment of a pastoral setting from

within the city. While many textual and archaeological documents survive from Islamic or pre-Islamic times for the existence of such formal places of pleasure utilizing some impressive natural setting, the important point about Baghdad is that all parts of the city were both compositionally and functionally united, as though they were but parts of a single palace entity.

At the same time the shape of Baghdad is a city shape. In southwestern Iran a number of Sassanian sites like Shiz or Darabgird are circular; other examples are known in Central Asia for the centuries before the Muslim conquest, and even earlier in ancient Mesopotamia. Unfortunately none of these older sites has been excavated or provided with appropriate literary information to ascertain whether their internal arrangement was in any way comparable to Baghdad's. On the whole it seems unlikely, because to none of these cities can one attribute the importance of Baghdad at the time of its foundation and in its later development. Thus, pending the archaeological exploration of some of these comparable monuments, we may be justified in concluding that in the case of Baghdad a city shape was transformed through its internal composition into a symbolic and ceremonial palace, while maintaining a sort of token urban element in carefully measured, mapped out, and selectively settled quarters between the forbidding fortified walls and the abode of the caliph.

The explanation for this phenomenon lies, it seems to me, in a conscious attempt to make an entity that would symbolize the total rule of the Muslim prince. Baghdad became known as the navel of the universe and medieval geographers put Iraq in the central and most favored clime of the world. And in the center of the circular city in the middle of the universe the caliph sat under his double dome. The ring of living quarters was but a sort of symbol of the universe that surrounded its ruler. This interpretation is supported by several additional details. The importance of astrologers in the organization and construction demonstrates that its creation exemplified ties to an older and more profound order in the new eighth-century society. The doors in the gates came from elsewhere. One door was brought from Wasit, the Umayyad-created capital of Iraq, and was claimed to have been made by Solomon. Another gate had been carried all the way from Syria and was said to have been made for the pharaohs. Thus Baghdad must be seen not merely as a symbol of contemporary universal rule but also as an attempt once again to relate the Muslim world to the rich past of the Near East.

In this last sense Baghdad illustrates what we have also seen in the fresco from Qusayr Amrah and in the Dome of the Rock in Jerusalem. Yet it went beyond these monuments in two ways. First, its size and monumentality distinguished it; it was a whole city rather than a single building or a painting lost in an inaccessible desert hideout. Then, it was called Madinah al-Salam, the City of Peace. It exudes a sense of completed and definitive success, as though a sort of millennium had come during which the City of Peace would rule over the universe. It is a world confident in its own achievement that is symbolized by Baghdad. There is nothing surprising about the feeling nor about the fact that it was expressed monumentally. As we shall see later on, a similar interpretation can be given to the landscapes and buildings with which the mosque of Damascus was decorated. In the latter monument, however, the location of the mosaics restricted their impact on Muslims, as though their main purpose was to encourage the faithful, to give them appropriate self-confidence. Baghdad is there for everyone to see, and some of the earliest anecdotes about it relate to the impression made by the city on a Byzantine ambassador. Furthermore what Baghdad attempted to proclaim was not unique to Islam in its early formative centuries. It belongs to a general category of monuments which from Assyrian reliefs to Roman or Sassanian reliefs or to Hagia Sophia and the Byzantine imperial ceremonies forced on the visitor or user a realization of the tremendous power of the monument's creator.

The three monuments we have discussed all seek to demonstrate the presence in a precise physical area of the new faith and of the empire which embodied it. Other such monuments may have existed as well. But the peculiarity of the Qusayr Amrah fresco, the Dome of the Rock, and Baghdad is that they went beyond "presence" into a sort of affirmation of possession or rather of appropriation. Although in each instance this appropriation took different forms, in all cases the forms and symbols used were not new creations of Islam but forms and symbols that belonged to earlier cultures: inscriptions in Greek at Qusayr Amrah, a Sassanian crown in the same palace, the *martyrium* shape in the Dome of the Rock, Christology in its inscription, its relationship to Abraham and to the Jewish tradition, the circular plan of Baghdad, and so on. This point is important in defining an essential aspect of early Islamic culture, the conscious attempt to relate meaningfully to the conquered world, by islamizing

forms and ideas of old. The process was not limited to these three monuments nor to the first century and a half of Islamic history. Later holy places in Iraq or in Palestine grew on ancient sacred spots, and it is probable that the same phenomenon took place in Iran, North Africa, and later in Anatolia. In Jerusalem itself, where the process can be followed over several centuries—at least until the Crusades—it can easily be shown that most of the Islamic developments brought into the city, and especially to its sacred Haram al-Sharif, were often the result of a reaction—psychological or physical—to the continuous importance of Jews and especially of Christians in the Holy City. It is as though one aspect of the energies devoted by Islam for several centuries to its monumental infrastructure lay in making sure that its work was on a par with that of the older or competing cultures, especially Byzantium (although we may simply be better informed on the relations between early Muslims and Byzantium than on similar relations in Iran or Central Asia). Psychologically this makes sense since for many centuries two emotional attitudes can be detected in the Muslim world (and not only among Muslims, themselves), especially in Syria and Palestine, and it is unfortunate that the history of our time can help us understand these attitudes. One is an "occupied" mentality, physically weaker but conscious of its past and its contact with an external power and thus constantly taunting—especially in words—the "occupying" power. The other attitude is that of the "new" force with physical power in its possession but with a mixed feeling of envy and condescension toward the old or alien worlds. These attitudes often appear in many stories about the Byzantine envoy who is critical of new Islamic creations in Baghdad or Damascus but also impressed by the artistic successes of the Muslims. It is to this series of complexes that one can attribute the growth in Islamic historiography of the notion of the Rumi or Christian (Byzantine or not, depending on the context) as a paragon in the arts against whose words all monuments must be measured. But a reverse attitude existed as well, that of despising artistic creativity as characteristic of a non-Islamic, alien world. This attitude, however, is closely tied to other, more specifically Muslim concerns and will be discussed in our next chapter in fuller detail. More important is the conclusion that in all these examples the Muslim world sought to define itself both for itself and in relationship to the contemporary and early civilizations of the Near East.

Thus Qusayr Amrah's fresco, the Dome of the Rock, and Baghdad illustrate more than a visually perceptible appropriation of a land with its traditions or the symbolization of this appropriation. They may also serve as examples of a psychological attitude that affected not only the arts but almost the whole of early Islamic culture. The final aspect of these monuments concerns the history of art. Insofar as the meanings that can be attributed to them are concerned, all three are unique and their forms are very rare in later Islamic art. Yet two of them—the Dome of the Rock and Baghdad—have remained until today in the consciousness of the Muslim world, one in its original form as a sort of symbol of the power and greatness of Islam in its heyday, the other through the slow association with it of one of the most important and most profound mystical events of the Prophet's life, his Journey into heaven. There are several conclusions to draw from these developments. One is that a monumental form tends to survive only if the associations surrounding it continue to be meaningful. When such meanings disappear, wither away, or are no longer important, the form either disappears—as seems to have been the case with the Qusayr Amrah fresco—or acquires new meanings. And, if the monument is unique, as in the case of the Dome of the Rock, then a unique new association is made around it. Thus it is that certain kinds of monuments are not merely the expressive result of various historically definable needs and pressures but also become, so to speak, active themselves in creating new needs and meanings. It is of some significance to contrast such monuments with typologically definable ones like mosques or houses.

It should be added, finally, that the aspects of these three monuments which have been examined in this chapter do not exhaust them, and we shall return to them from other points of view later. What matters at this stage is that one first motivation to be detected in the formation of Islamic art was that of symbolically or practically expressing the appropriation of a given territory with its body of traditions. The monuments that exemplified this expression are among the unique monuments of the new culture, and their importance to history and to our understanding of early Islamic psychology is perhaps greater than their importance to the history of art. Yet one of them is certainly to be counted among the masterpieces of early Islamic art. What makes it a masterpiece is not pertinent to the subject of this chapter, but the fact that it was meant to be one further confirms the importance in the art of any cultural moment of

those monuments that identify it in contrast to what preceded it. One aspect of early Islamic art—perhaps of any art—is that which identifies itself as unique and different and, while the forms and the meanings of these uniquenesses vary, the structural fact remains.

4. *Islamic Attitudes toward the Arts*

Much has been written about Islamic attitudes toward the arts. Encyclopedias or general works on the history of art simply assert that, for a variety of reasons which are rarely explored, Islam was theologically opposed to the representation of living beings. While it is fairly well known by now that the Koran contains no prohibition of such representations, the undeniable denunciations of artists and of representations found in many traditions about the life of the Prophet are taken as genuine expressions of an original Muslim attitude. Scholarly and Muslim apologetic writing since the last decade of the nineteenth century has generally concentrated on this single question of the lawfulness of the representation of living beings. Among orientalists the problem began to appear in the wake of the discovery around 1890 of mural paintings at Qusayr Amrah, and scholars sought to explain what seemed to be an anomaly in the then prevalent impression of the nature of the faith and of the culture issued from it. Or else they sought to define more precisely the philosophical and theological causes and consequences of a presumed prohibition of images. Furthermore, the contemporaneity of the rise of Islam with Byzantine iconoclasm also led to a consideration of the political aspects of a presumed Muslim prohibition. More rarely, attempts have been made to provide secure dates and even specific localizations for the formation of permissive attitudes. Thus Iran was deemed to be more "liberal" than Semitic provinces, the second half of the eighth century more restrictive than the first half or than the twelfth century, and shii'ite heterodoxy more permissive than sunnite orthodoxy. Among Muslim scholars other reactions occurred, but all were centered on the same question. Some sought to justify the prohibition on various theological grounds, whereas others tended to minimize it as only one facet of a living Islam but by no means a canonically compulsory one nor even a predominant one.

Out of all these studies—the most important of which are listed in the bibliographical appendix for this chapter—a large number of important texts have been brought to light, and many far reaching concepts and ideas have been developed. Significant and important though many of these studies may be, none of them is entirely pertinent to the questions we are trying to answer: whether at the time of

the formation of Islamic civilization there occurred some element of doctrine that directly or indirectly affected the arts, and whether these elements, if they existed, were of sufficient magnitude and originality to impose a unique direction to Islamic art. Can one sketch in the abstract an attitude of early Muslims both toward the artistic creation of the cultures they encountered and toward what they themselves expected of monuments made for them?

However interesting and intellectually important it may be for its own time or for the elaboration of artistic theories, a tenth- or twelfth-century text cannot by itself be used as evidence for an earlier time; yet little of the literary documentation we possess is earlier than the ninth century and by then many classical features of the new Muslim artistic tradition had already been created. Furthermore, as one looks over the numerous texts assembled by scholars, two features occur consistently. One is that the texts are usually difficult to find; they do not form a distinct intellectual entity in the religious or philosophical literature of the medieval tradition. They appear rather as a sort of afterthought in order to elucidate a minor exegetic or legal point, as a diversion in discussions of weightier problems. Concern with a theory of the arts or even of representations was not central to Islam. This is not surprising, for, if one excepts the very precise and highly verbal iconoclastic controversy of Byzantium, the Christian Middle Ages rarely formalized its own view of the arts. Suger's account of his work at St.-Denis is particularly valuable because of its rarity, as is St. Bernard's celebrated speech against images in churches. But Thomas Aquinas did not raise problems of representation in his *Summa Theologica*, and much of what we know of Christian attitudes about the arts derives either from formal panegyrics like Procopius's description of Hagia Sophia or from incidental references. But if the Middle Ages in general tended to see its arts as an automatic corollary of any sort of cultural existence, are we in any way justified in talking about a specifically Islamic attitude to the arts? Should we not on the contrary deemphasize the import of a theological system, or concentrate exclusively on those aspects of the specific way of life it fostered which could in some fashion affect material and artistic creation? Should we not conclude that what did affect the arts was the existence of a social ethos—social being understood in a very wide sense here—rather than of religious or intellectual doctrines, not to speak of aesthetic ones?

The other characteristic of the majority of the texts concerning the

arts is that they are usually triggered by a work of art or a representa-
tion. They almost never begin with the theoretical question of the
relationship between a man-made image and a reality that inspired the
image. The most common intellectual procedure of a medieval Islamic
text can be summarized in the following manner: "Here is an image,
how did it happen to be?" It is never: "How shall one go about making
an image of this subject or representing visually this idea?" It is as
though there always existed a world of images and representations
which occasionally struck observers as somehow anomalous or
wrong, as somehow clashing with the world view of the Muslim. Such
a reaction is once again not unique to Islam. We have mentioned St.
Bernard's invectives against the figural bestiary of the Romanesque
world. Later on, militant Protestantism destroyed the sculptures of
churches as did the French Revolution because of a series of religious,
political, emotional, or social relationships between these images and
some "enemy": the devil, the Catholics, or the ancien régime. And in
our own day we have witnessed more than once the systematic de-
struction of visual images, associated for instance with various aspects
of the "cult of personality." All of these activities have acquired a more
or less fully formulated theoretical justification, but almost always
after the fact, not as an intellectual proposition. In most of these
instances it seems as though a "natural" life of representations goes on
until something in the culture, a precise historically definable event or
a sublimated instinct of some sort, suddenly erupts and destroys im-
ages, only to have them come back after the storm is over.

These preliminary remarks and the questions they raise indicate
that traditional Muslim culture did not possess a doctrine about the
arts, neither formal thought-out rejections of certain kinds of creative
activities nor positive notions about the possible instructional or beau-
tifying values of the various existing techniques of art. At best one can
assume that the doctrines and ways of life characteristic of early Islam
may have directed the culture toward channeling its artistic activities
in certain directions rather than in others. Attitudes existed, rather
than doctrines and clear needs, and our purpose in this chapter will be
to determine what all or some of these may have been. The only
obvious exception is that of the mosque which will be treated in detail
in the following chapter.

A final observation derives from these introductory remarks. It is
not entirely an accident or a misplaced scholarly fixation that has led

most writers to wonder about the kind and limits of prohibition that may have affected the representation of living things and to concentrate their efforts on this key issue of artistic creativity. By doing so, however, they escape in part a narrow historical or cultural framework and involve wider, anthropological issues about images and about their relationship to a nature and to a life they presumably copy or influence. For all these reasons our investigation toward a definition of the character of the early Islamic position on the arts limits as much as possible the evidence to such documents as are clearly early and by avoiding the opinions of later theologians and lawyers; and we shall end it with some remarks on the wider implications of the Muslim concern with images and representations.

To sketch a sort of profile of early Islamic attitudes six documents can be utilized: the art of pre-Islamic Arabia, Koranic revelation, the traditions concerning the Prophet's life and thoughts, accounts of the conquest, early monuments, and coinage.

The living architecture of Central Arabia was not an impressive one. This is especially true of the religious sanctuaries, which were rarely more than roughly mapped out and poorly constructed holy places used for the simplest of ceremonies, most often processions. The Ka'-bah (fig. 12), the holiest of them all, was but a parallelepiped without decoration or formally composed parts like doors or windows. Only the custom of draping the sanctuary with multicolored textiles has introduced the appearance of visual wealth in the Ka'bah. Again, we don't know anything about the possible symbolism of these colors in ancient Arabia. There is no indication known to me in early Muslim writing or in pre-Islamic writing of an aesthetic reaction to the Ka'bah, of an interpretation of its holiness in terms of visual beauty. Matters were different in later mystical thought as well as in the building activities that, in the eighth and ninth centuries, transformed the sacred space of Mekkah and gave an aesthetic content, but the emotional and pietistic idealization of the holiest place in Islam hardly appears in early times.

The evidence is less clear for secular architecture. It is difficult to imagine that the wealthy merchants of Mekkah did not build for themselves fairly elaborate dwellings. But there is no evidence for it, and the developments of later centuries would tend to confirm the simplicity of the setting of aristocratic life in pre-Islamic Arabia. For instance, almost none of the visible features of Umayyad palace art—which will

be discussed in a later chapter—seems to have been derived from pre-Islamic Arabia, and it is perhaps correct to conclude that architectural ostentatiousness was not a typical feature of traditional Arabian society.

Yet there existed a myth of a grandiose secular architecture. It was recorded in an early tenth-century text translated as *The Antiquities of South Arabia,* and its best-known example is the fabulous Ghumdan in Yemen. "Twenty stories high the palace stood, flirting with the stars and the clouds. If Paradise lies over the skies, Ghumdan borders on Paradise. Should it the face of the earth inhabit, Ghumdan would be nearby or close by it. If God heaven on earth doth place, Ghumdan would its confines embrace." It was decorated with alabaster, onyx, and sculptures of lions and eagles. On its top there was a dome. Several other palaces share with Ghumdan extraordinary size and abundant decoration. Princely constructions were also associated with northern Arabian dynasties, especially the Lakhmid dynasty on the desert confines of southern Iraq, whose Khawarnaq and Sadir were often mentioned in later literature as superb examples of royal luxury. I know of no reference in texts to similar buildings in Central Arabia.

It would be interesting sometime to investigate archaeologically the Iraqi monuments of the Lakhmids whose location seems known, or the impressive ruins of Yemen. But, whatever later explorations may bring to light, the important point is the existence of an architectural palace mythology in pre-Islamic Arabia. This mythology developed primarily around constructions that, justifiably or not, were associated with rulers of Arab origin in the southern and northern edges of the peninsula and not with foreigners. Curiously, almost no memory seems to have grown around the best known and archaeologically well-documented Nabatean and Palmyrene architecture, whose monumental funerary forms seem to have passed almost unnoticed. Similarly, while the major monuments of Roman and Christian Syria were certainly known to Arab tradesmen and caravans, there is little evidence that they had a major impact, at least not as artistic monuments.

For the other arts our information is also scanty, but it is perhaps easier to imagine the nature and extent of their presence. From the paucity of originally Arabic terms referring to most artistic or artisanal works, it can be surmised that very little sculpture, painting, or manufacture of other than purely utilitarian objects took place in Arabia itself. The idols that had been assembled in Mekkah were most primitive, and the painting of a Virgin and Child found in the Ka'bah was

probably the work of a non-Arab or of local folk art. What accounts of aesthetically significant paintings and sculptures do exist refer generally to works found outside of Arabia, mostly in the Christian worlds of Syria, Egypt, and occasionally Ethiopia. Most expensive objects came from elsewhere, as demonstrated in the recent excavations in al-Faw, and the celebrated textiles and pillows with figures that were owned by A'isha, the prophet's youngest wife, were probably Syrian or Egyptian. The craftsmen of Arabia itself were generally non-Arab, mostly Jews, and the practice of crafts was not honored. When the Ka'bah was rebuilt in 605 it was done by a foreign carpenter with the help of a Coptic assistant.

In the light of much recent research which has shown the mercantile aristocracy of Mekkah and other Arabian oases to have been a wealthy and economically sophisticated class, and in the light of a rather impressive artistic achievement of Arab kingdoms in Hatra, Palmyra, Petra, and Yemen, the scarcity of information we possess either about the arts of pre-Islamic Arabia or about what pre-Islamic Arabs knew of the arts is surprising. Some scholars, in particular Monneret de Villard, have sought to redress the picture by combing literary and archaeological sources about pre-Islamic Arabia. Others have given particular preeminence to the Arab kingdoms of Syria and Iraq as possible sponsors of an original pre-Islamic Arab art. But for a definition of attitudes rather than of specific facts, the key point is that, regardless of what pre-Islamic art may have been known to the Arabs, it was largely disregarded in later Muslim tradition. There are many reasons for this, not the least of which is the rather systematic attempt of later times to eradicate the *jahiliyyah* past, the time of Ignorance, or all the centuries which preceded the Revelation to Muhammad. Whatever the pagan Arabs may have had could only be of negative value; it was something to be rejected. But a curious problem then poses itself. One can indeed accept and understand that the literati of a given culture rejected whatever historical, religious, and even literary past the culture may have had. Our own times have taught us much about rewriting history and sadly enough even about the obliteration of people and events. But can the same process apply to the world of forms? Can one imagine an obliteration of a collective memory of forms when so many of them were the very things that surrounded and accompanied the life of the whole collectivity? Can we assume it when we know of the sizable opposition that existed to the Prophet's activities in the richest and most sophisticated milieu of pre-Islamic

Arabia, the very milieu from which many of the leaders of early Islam came? Thus, while it is indeed true that the later Muslim tradition played down the existence of any art in the oases of Arabia, it may be in part because this art was too strongly associated with the hated upper classes of Mekkah. Two hypotheses are thus introduced into our considerations. One is that Muslims may have rejected artistic creativity in general or in some aspects because of its associations with certain social groups. The other hypothesis, a corollary of the first, is that a work of art has, at least in some circumstances, a social significance and that this particular aspect may on occasion be the predominant one.

The second document to be examined is the only incontrovertible early Islamic document we have, the Koran. It is a difficult source to use for our purposes, for we must try to separate those passages which were used for post facto justifications of certain theological and intellectual positions from those which appear to have been affected by actual contemporary needs. Some passages are of course significant both in their original context and in later use. I shall try to separate one type from the other in the following discussion.

The first pertinent passage is 34.12–13 and deals with Solomon: "And of the jinn, some worked before him by the leave of his Lord; and such of them as swerved away from Our commandment, We would let them taste the chastisement of the Blaze; fashioning for him whatsoever he would, places of worship, statues, porringers like water-troughs, and anchored cookingpots." The exegesis is a particularly complicated one. Outside of its general significance in identifying Solomon as the prophet-king for whom extraordinary works of art are created—a theme of considerable importance in later Islamic art—we can make three observations about this passage. One is obviously that statues are mentioned among the things made for Solomon. The term used here, *timthal,* is a confusing one; it may possibly not have had the precise connotation of three-dimensional sculpture suggested by our own term "statue," but there is little doubt that some sort of likeness to living things was meant. The second point is that statues or whatever they are seem to be associated here with very prosaic, everyday objects like cauldrons and cooking pots. It is possible that some very specific Jewish legend explains this particular passage, but we also have here a first indication of a theme to be developed at some length later on: the provision of aesthetic quality to common daily items. The

third and most significant point appears more fully if one recalls that the context of the passage is that of God providing "signs" to the apotropaic succession of prophets; it is interspersed with exhortations to the unbelievers, past, present, and future. The reference to statues or figures then does not identify them as man-made artistic creations but as divinely inspired symbols of the uniqueness of Solomon's position.

The same context can be given to a second Koranic passage, 3.43, which has been particularly often utilized by both opponents and proponents of images in Islam. It is found in the words pronounced by God to Mary: "God creates what He will. When He decrees a thing He does but say to it 'Be,' and it is. And He will teach Him [Jesus] the Book, the Wisdom, the Torah, the Gospel, to be a Messenger to the Children of Israel saying, 'I have come to you with a *sign* from your Lord. I will create for you out of clay as the likeness of a bird; then I will breathe into it, and it will be a bird, by the leave of God. I will also heal the blind and the leper, and bring to life the dead, by the leave of God.' " Even more than in the first passage, the emphasis here is on the facts that God alone creates the value to be given to a representation and that such representations belong to the "signs" God sends to man. Furthermore, as so many traditionalists have pointed out, the representation of a bird is significant only if life is provided for it; yet only God provides life. Some doubt may be expressed as to whether this particular meaning was already there at the time of the utterance of the Koranic passage. It had probably a much more metaphoric meaning, inasmuch as the term used for "likeness," *hiy'ah*, is a very abstract one meaning "shape" and rarely if ever used to refer to representations.

Finally, two closely related passages are pertinent to our purposes. The first one is 5.92: "O Believers, wine and arrowshuffling, idols and divining arrows are an abomination, some of Satan's work; so avoid it; haply so you will prosper." Then in 6.74 Abraham chides his father Azar for taking idols as divinities: "I see thee and thy people in manifest error." The words for idols in these two passages are respectively *al-ansab* and *al-asnam*, both of which imply representations, statues or paintings, used for worship. Here again the Koranic meaning is clearly that of opposing the adoration of physical idols, and not of rejecting art or representations as such. Yet these are the very passages which were later used to oppose images. Our problem is to explain why and

when a search for Koranic justifications for such opposition took place, even if it meant an extension of the original meaning of the chosen passages.

Before doing so, however, there are still several remarks to be made about the Koran as a document for the arts. It must be obvious that, even if our list of passages is not complete, there are very few of them and their application to an understanding of the arts is incidental, minimal, and often after the fact. There is nothing similar to the concise strength of Exodus 20.4: "Thou shalt not make unto thee any graven images or any likenesses of anything that is in heaven or that is in the earth beneath or that is in the water under the earth." Since the Koran deals otherwise quite concretely with many aspects of life, it may be proper to conclude simply that at the time of the Prophet the problem of artistic creativity and representations simply did not come up as a significant question requiring some sort of pronouncement or legislation. His only clearly documented action involving the arts consisted of the destruction of the idols in the Ka'bah, and the very fact that Muhammad is supposed to have left an image of a Virgin and Child suggests that representations as such did not constitute a threat to his vision of his faith.

Not only was the Koranic message of little significance to the contemporary or later artistic creativity of Islam, but the book itself was never used as a source for illustrations. This is not surprising, for, as has been pointed out, the Koran was something like a mixture of the books of Psalms, Proverbs, Leviticus, and the Epistles of St. Paul. Although there is a considerable Christian illustration of psalters, it grew mostly out of the liturgical use of psalms, and their images are among the most problematic of the Old Testament. The Epistles, the Proverbs, and Leviticus are hardly illustrated at all. In other words, and regardless of its theological and legal meanings, the Koran does not lend itself to translation into visual form. It does not have major narrative sequences, and its liturgical and other uses lacked the aesthetic complexities of the Christian use of the Gospels or of the Old Testament. The possible exceptions to this conclusion, to which we will return in the following chapter, are rare and, again, controversial. The Koran was and still is recited in mosques at prayer time but its aesthetic appeal lies in the sound of its divinely inspired words.

The life of the Prophet did acquire a legendary aspect fairly soon after his death and was occasionally illustrated from the thirteenth century onward. There is some doubt, however, that it became imme-

diately a significant aspect of the faith—except in legal matters—and it certainly did not have a formal, sacred character. In a general way the lack of a liturgy in Islam prevented the development of the sort of sacramental, ceremonial, or holy setting which in other religious systems grew irrespective of the specific requirements of the church. And in a way one may wonder whether a holy book by itself does require illustrations. It is rather when a milieu—either a whole culture or one of its parts—demands some sort of visually perceptible version that holy books are used for images and the ingenuity of artists can rise above most textual difficulties, as the history of biblical illustrations well demonstrates. It is perhaps therefore more appropriate to conclude that although the Koran does not lend itself easily to illustrations or to visual interpretations, the reason that such interpretations did not take place lies less in the Koran than in other circumstances of the Muslim ethos with which we shall deal later on.

Finally, it has often been noted that the central theological message of the Koran is that of the total uniqueness, the total power, of God. He alone is a "fashioner," a *musawwir* (59.24), the very term used for painter. As the only Creator, he cannot admit of competitors, hence the opposition to idols which by association and by extension could become an opposition to representations. But this last step was not consciously taken at the time of the faith's formation.*

Thus the model we are trying to construct of the early Muslim's attitude to the arts has acquired a second component. Next to a rather peculiar and largely mythical memory of ancient arts, and next to a partly critical awareness of contemporary arts mostly as useful objects, we have in the central book of the faith a coherent system which, if we understand correctly what it meant in its own time, was totally unaware of a visually perceptible aesthetic need. It asserted God as the single Creator and did not lend itself to obvious translation into visual form. Only incidentally can certain passages be construed otherwise.

The next two sets of documents we possess differ from the first ones both in kind and in the ways in which they can clarify our problem. They consist of the hadith, or body of Traditions describing the life of the Prophet which acquired a quasi-canonical character, and of a vari-

* It should be added here that in our own times—and to a smaller degree as early as in the twelfth century—artists or philosophers searched for and found in the Koran many passages which can be construed as justifications not only for representations but also for a glorification of the beauty of man and of man's intricate visual inventions. These passages have been particularly eloquently discussed by the Egyptian scholar and poet Bishr Farès but they are not pertinent to our present subject.

ety of early stories involving Arabs and the arts of conquered people. While some of them deal with the Prophet, his time, and his pronouncements, they were put together later and therefore they reflect in large part judgments, attitudes, and problems of a later time; and almost all of them originate from the conquered territories rather than from the homeland of Islam. Their value as indicators of widespread feelings, thoughts, and doctrines is difficult to determine. They are individual stories, accounts, or opinions, usually not part of any coherent system of interpretation, and they have usually been discovered by scholars more or less haphazardly in the course of readings. They do not form nor do they lend themselves to a modern scientific reconstruction like a summary of what the Arabs knew of the arts. The conclusions to be deduced from these documents are thus always slightly uncertain. Yet not only are they most frequently cited in literature, but they are also most important in that they reflect the views of the Muslim world *after* Islam had embarked on its conquest.

On the Traditions—as well as on legal literature analyzed so far only by one scholar, Rudi Paret—we can be brief, for they tend to repeat the same point with only minor variations. A most typical and thorough text consists in the following succession of sayings attributed to the Prophet:

> "The angels will not enter a house in which there is a picture or a dog." "Those who will be most severely punished on the Day of Judgment are the murderer of a Prophet, one who has been put to death by a Prophet, one who leads men astray without knowledge, and a maker of images or pictures." "A head will thrust itself out of the fire and will ask, Where are those who invented lies against God, or have been the enemies of God, or have made light of God? Then men will ask, Who are these three classes of persons? It will answer, The Sorcerer is he who has invented lies against God; the maker of images or pictures is the enemy of God; and he who acts in order to be seen of men, is he that has made light of God."

It is interesting that the main thrust of blame is directed toward the painter rather than the work of art. For it is the painter making representations who appears as a sort of competitor of God by creating something that has actual or potential life. And in any number of Traditions the painter is threatened with being compelled to breathe

actual life into his creations. We cannot be certain when these types of statements were first invented or gathered in official legal texts, but the argument put forward by Creswell that they do not occur before the second half of the eighth century seems convincing.

Whatever reasons led to the growth of this position, it clearly clashed with a considerable body of authentic information about the presence of beautiful objects with figures—mostly textiles and metalwork—in the Prophet's immediate surroundings. Explanations had to be provided, and thus grew a whole additional body of Traditions that sought to show there were variations in the ways in which images could be used. Permissible in hallways, floors, or baths, they were forbidden elsewhere; in some legal texts headless figures were allowed. We are not to concern ourselves in this work with the casuistic or intellectually valid intricacies introduced in legal and religious thought, nor can we discuss at this stage whether this type of concern affected in any way the forms of Islamic art. What matters is only that at some time around the middle of the eighth century Islamic religious tradition in part or as a whole developed a hitherto unknown opposition to representations. One of the difficulties with this conclusion is that scholarly interest in ferreting out texts about images may have overlooked other possible aspects of the hadith and the arts. For instance are there in it references to the work of artisans and to objects and buildings? Are there judgments and opinions that may be understood in aesthetic terms? In the search for this kind of information lies an important, if perhaps tedious, scientific task.

It is much more difficult to draw some sort of coherent picture from our fourth type of evidence, historical accounts of early Islamic times that are likely to define something of an attitude toward the arts. Several separate and at times contradictory facets were present, and much additional work is needed before they appear completely or even clearly. In fact, if artistic problems are on one's mind, the reading of almost any early text yields results, but the problem lies in ordering these results into some sort of coherent system. For instance, while the great chronicles provide minimal but fairly secure information in terms of historical veracity, much more important and interesting documents occur in works of *adab* or belles-lettres or in poetry, but their specific validity, their "archaeological index," is not of the same magnitude. A poetical image with a reference to an object or to a monument may indicate something about contemporary taste but may also be a valueless literary cliché. Here again the collection and comparison of appro-

priate texts should be a major objective of scholarship and should replace the unfortunate tendency of many writers (including this one) to fish out a single text that appears to satisfy some otherwise developed theory or interpretation.

At the risk of continuing a debatable procedure, I shall limit myself to a consideration of only one aspect of the kind of information provided by these early texts: the reaction of early Muslims to an art we otherwise know, the art of the conquered people. I shall leave aside, for lack of sufficiently coherent documentation and because the problem will be considered in part in the next two chapters, such textual information as we do possess about the art made and used by the Muslims themselves. Because the Muslim reaction to the arts is better documented with respect to Christian art, my examples will be primarily concerned with this admittedly partial evidence. In dealing later on with the evidence of the arts themselves, I shall try to make up for this imbalance, but it must be noted that a thorough culling of the sources describing the conquests of Iran and Central Asia should yield important parallel information.

The Muslim reaction to the art of the conquered Christian world was one of awe and admiration. The brilliance of church decoration was duly noted, and we have already quoted a text describing the powerful impact of the churches of Jerusalem and of Edessa as works of art. In part this brilliance was seen as the result of superior technique. It was probably during the first Muslim century that the notion grew up of a Rumi, Christian if not always specifically Byzantine, superiority in the arts. Awe and admiration can lead to imitation and, especially when accompanied by wealth, to systematic efforts at luring technicians to one's side. It has been shown that the mosaicists who decorated the mosque of Damascus and perhaps even those who worked in Madinah were brought from Byzantium. This successful recruitment, which was probably only the result of the greater Muslim wealth, became legend. Thus in some later accounts the Byzantine emperor is portrayed as compelled by his Muslim suzerain to send mosaicists. The event also became a model, and in the tenth century the Umayyad caliph in Spain was still hiring mosaicists from Constantinople. It is probable if not certain that, in addition to the great mosques whose construction is comparatively well documented, the vast majority of early Islamic monuments, at least in Syria and Palestine, were built, made, and decorated by workers and artists either Christian or trained in the tradition of pre-Islamic Christianity. Their

presence lasted probably much longer than the presence of financial
and administrative officials. Although we are less precisely informed
on what happened in Iraq and Iran, it is likely that the same continuity
took place in workmanship.

But initial awe and admiration can also lead to rejection and con-
tempt. The preceding chapter related that, as a treaty had been signed
between Christians and Muslims providing for a year's time before a
certain town was to change hands, a statue of the emperor Heraclius
was set up at the frontier between Christian and Muslim territories.
There is a sequel to the story. One day a Muslim rider, while practicing
horsemanship, accidentally damaged the statue's eye. The Christians
protested and the local Muslim governor agreed that the damage
should be repaired. The Christians requested that the statue of the
Muslim equivalent—the caliph Umar and not the local Muslim com-
mander as he himself had suggested—be similarly defaced. So it was
decided, the eye damaged, and then everyone agreed that justice had
been done. The point of the story—probably an apocryphal one and,
interestingly enough, of Christian origin—is that the Muslim com-
mander, who agreed that a wrong had been committed on a sort of
symbolic level, agreed to have the eye of his caliph put out because he
did not believe as deeply as his Christian counterpart in the deep
significance of an image. To him it was merely a gesture and the
account, biased though it may be in favor of the Christian position,
portrays his attempt at substituting a representation of himself for that
of Heraclius as an expression of amused contempt for use of images he
did not understand.

Other examples exist of contempt for what was imagined to be a
pagan worship of images and an opiumlike use of ceremonies by the
Christian church or by the Byzantine emperor. At times contempt
could become destructive, as in a number of stories (admittedly found
mostly in Christian sources) relating either wholesale desecration of
images in churches or persecutions of Christians. The best known
event of this kind was the edict of Yazid in 721, according to which all
religious images were to be destroyed. Although the edict is known
almost exclusively through Christian sources, it has been accepted as a
reality, probably justifiably so, inasmuch as the figural elements of a
number of earlier mosaics in the Christian churches of Palestine were
replaced by vegetal ones or entirely removed. The question is whether
the edict was an ideologically iconoclastic one and thus whether it
expresses as early as 721 a militant opposition to religious or other

images. A consideration not only of the many texts about this but also of the precise historical setting of the time suggests that the edict was not so much a manifestation of Islamic iconoclasm as an attempt to persecute Christians, especially the orthodox Christians attached to Constantinople. The more important point is that to a Muslim of the early eighth century images were one of the most characteristic and in part hateful aspects of Christianity.

It was probably during the very same time that a minor incident in the later life of the Prophet—his sending of an emissary to Byzantine-held territories—was transformed into a highly organized and highly official mission for the conversion of foreign kings and rulers. The main target was the Byzantine emperor who spurned the invitation to conversion, though accounts vary as to the reasons or genuineness of his refusal. It is interesting to note that in at least one account, the emperor who was ready to accept Islam was dissuaded by the clergy and patricians of his entourage. Although these stories are only re- motely concerned with images and art, they do establish one aspect of the psychological setting of the relationship between a budding Islam and an established Christianity, a setting that includes an invitation from the new faith contemptuously spurned by the older empire. It is an attitude of self-conscious superiority mixed with a formal rejection by the world one is trying to woo. It would not even be useful for us were it not for the fact that the seventh and early eighth centuries are the very ones during which images and their meaning became one of the cultural hallmarks of the eastern Christian world. But there is more. It was a world that used its images and its dexterity with images in order to define its religious and political positions, and to persuade and to convert. One of the highlights of a visit to Constantinople was a religious service at Hagia Sophia; the Muslim sources relate how Mus- lim prisoners withstood the impact of the church's glitter and refused to be converted, whereas Christian sources describe how Muslims accepted Christianity under the same circumstances. In any event images became not merely a characteristic of the Christian world in the eyes of Islam, but one of the most important and dangerous weapons the Christians possessed.

For all these reasons one can describe the Muslim attitude toward the arts of the Christian world as a confused one, in which awe and admiration, contempt and jealousy, were uneasily mixed together. Particular emphasis has been given to this side of the picture provided

by early stories because it will be an important one in the general interpretation to be proposed; but there are many other aspects of the Muslim reaction to the arts that can be detected even from an unsystematic survey of the written evidence. One is the sudden discovery and accumulation of immense treasures of expensive objects by the Arab armies and especially by their leaders. From the frontiers of inner Asia to Spain, Muslim conquerors gathered textiles, gold and silver, ivories, and treasures of all kinds. Some of these were melted but others accumulated in the Near Eastern centers of the empire. Muslim armies also saw many new holy places and palaces; they were received at times with high honors or bribed by local rulers. As a result, not only did luxury objects appear to people who had not seen them before, but there also occurred among the Muslims a new awareness of a life of luxury at a level hitherto unknown to the Arabs. Obviously this life was not shared by all; in fact it created an apparent cleavage in the community between those who enjoyed it and those who saw in it a threat to the purity of the faith. Thus, one can postulate the formation of what may be called a resentment of the beautiful and expensive, which may tie up with a populist reaction to the arts and to images already suggested in Arabia itself.

All the documents examined so far derive from literary sources and from assumptions about the historical and psychological setting of the first Muslim century. Before trying to put it all together it is necessary to turn to the arts themselves and to one particularly telling document, coinage. At this stage it is not so much the stylistic, iconographic, or aesthetic characteristics of early Islamic art that are of significance, but rather whether, seen altogether, they provide some further dimension to the question of a Muslim attitude toward the arts.

If one surveys the many works of early Islamic art, the overwhelming impression is that of the absence of representations of living things. This conclusion may seem surprising in the light of the great discoveries at Qusayr Amrah, Khirbat al-Mafjar, Qasr al-Hayr West, and Samarra, which have raised questions about the nature of Islamic art and about which we will have much to say later on. Yet, however much we tend to give particular importance to zoomorphic or anthropomorphic themes, because it is from such themes that our own conception of the arts has tended to derive, these monuments are exceptional rather than the norm. Furthermore, all are private monuments for restricted usage and enjoyment; they are not official or

formal art. They are essential for an understanding of the culture as a whole, but they form only one aspect of the ways in which it expressed itself in a visually perceptible manner.

Let us examine several examples. The primary impression of the Mshatta facade is that of a highly thought-out composition of vegetal and geometric themes, yet animals are present in fairly large numbers (figs. 121, 122). The large early Islamic ceramic series from northeastern Iran (figs. 107ff.) contains mostly nonrepresentational themes, but occasionally a bird or an animal does occur and a small but celebrated group even has human beings. Similarly, while it is far-fetched to see human and animal elements in the Samarra stuccoes (fig. 125), there were animal friezes in the decoration of the Abbasid capital's houses and palaces, and the carved woods from Egypt contain a certain number of animal themes. It would thus be more correct to say that there occurred a balance in early Islamic art that did not give a primary or even major place to representations of men and animals. The impression of a lack of such representations is in part conditioned by the fact that comparable monuments of late antiquity, Byzantium, India, or Iran had a different balance of themes in which representational elements are predominant. The question is whether this different balance is willful and meaningful, or accidental. An answer is suggested by the mosaics of the Great Mosque in Damascus (figs. 13, 14).

Over the past two decades several scholars have proposed that the large partially preserved architectural compositions in the mosaics that decorate this early masterpiece of Islamic art symbolize a paradisiac vision of a peaceful Muslim world. Certain scholars even suggested that these compositions acted not as symbols of a vision but as illustrations of Koranic texts describing the paradise of the faithful through trees and architectural ensembles. Admittedly appealing, this interpretation is difficult to prove. The important fact, however, is that beyond their ornamental value, the mosaics would have an iconographic meaning just as the decoration of comparable monuments elsewhere, churches for instance, has an iconographic sense. A further curious feature about these mosaics has often been noted. Their main subject matter of buildings is one which in the classical and Byzantine tradition whence it derived usually formed a background—at times meaningful, at other times ornamental—to some other topic. In Damascus the latter is absent; instead, a series of large naturalistic trees is rhythmically set in the forefront. Since it appears unlikely that these trees were the main subject matter of the mosaics, they become the

formal equivalents of personages who form the main subject matter in the models used by the Damascus mosaicists, as for instance in the fifth-century mosaics of the church of St. George in Saloniki. A fascinating example of the transfer of formal relationships between the parts of an image occurred here. The desire for a concrete meaning—paradisiac architecture—in an understandable iconographic language—the vocabulary of the classical tradition—led to the mutation of a background motif into the main subject and the transformation of the foreground motif—in the tradition the main subject—into a secondary theme.

Whatever the appropriate explanation, in one of the most official buildings of early Islam, a decoration was created that was meant to have symbolic or illustrative meaning. We have seen that a symbolic meaning can be given to some of the themes of the Dome of the Rock mosaics as well. In neither Jerusalem nor in Damascus are there any representations of men or animals. But on the Mshatta façade with its vegetal themes interspersed occasionally with animal ones, no animal motif occurs on the right side of the entrance. The side without animals corresponds to the qiblah wall of the mosque facing Mekkah.

The avoidance of figural representations in early Islamic art was thus systematic and deliberate whenever a religious building was concerned, and it led to unusual choices and modifications in the vocabulary of imagery borrowed and utilized by Muslim patrons. This avoidance did not, however, mean a similar avoidance of symbolic meaning attached to those forms that were in fact used. Rather, symbolic significance was given to new forms or to adopted forms in older artistic languages for which such a symbolism had not been known. The conclusion that emerges, then, is twofold: there was indeed a consciousness in the ways that early Islamic art reached its avoidance of representations, and this consciousness was less the result of some a priori doctrine than of a response to the formal vocabulary available to the Muslims.

These conclusions can be followed up in the last document to be discussed, coinage. The story of early Islamic coinage has been told many times. Nothing is known about it before the conquest of the Fertile Crescent. The local coins, Byzantine ones in formerly Byzantine territories (fig. 17), Sassanian ones in the East (fig. 16), were continued with an Arabic inscription indicating a variety of possible things—a date, the name of a caliph or governor, the profession of faith, a mint. A number of modifications were then introduced, which on the whole

appear more clearly in imitations of Byzantine than of Sassanian coins. Some of these consist simply of removing from the prototype some obvious Christian symbol like the cross and replacing it with a knob on a stand set over three steps (fig. 17). Other modifications are more curious. Thus, a type of coin appears known as the Standing Caliph type (fig. 18). On the reverse of this coin the typical Byzantine group portrait is replaced by a standing personage with a *kufiyah* or Arab headgear instead of a crown, a large robe instead of the *loros,* and a very peculiar and hitherto unexplained cord on the right side (fig. 18). The personage is holding a sword. All these features can be interpreted as attempts at an Islamic imperial iconography using identifying visual signs from Arab life and mores.

This search for an identifying original imagery is further illustrated by an extraordinary coin known through only three examples. It shows on one side a royal representation derived from Sassanian prototypes but with clear modifications in clothes, especially in the headgear. The other side shows a niche around a standing lance (fig. 15). George Miles has suggested that it is the image of a mihrab, the niche in a mosque symbolizing the Prophet's place (which will be discussed in detail in the next chapter), and of the *'anazah,* the lance that was one of the formal symbols of Prophetic and caliphal power. There is little doubt about the correctness of the interpretation given to the lance. It is perhaps less certain that the niche represents an actual mihrab, for, as we shall see, the latter did not appear in architecture until ten years later. It could have been simply a motif of honor without concrete Muslim significance.

The third example of the iconographic search is an oddity. A group of Sassanian-derived silver coins has on the reverse a standing figure with outstretched arms, like a Mediterranean *orans* (fig. 19). There is no explanation for this type, which could be considered either as an iconographic confusion or as another attempt at expressing visually some aspect of the new culture. Several other peculiar types exist, especially in the eastern part of the empire, but they still await proper investigation.

These experimental issues came to an end in 696–97 for gold and in 698–99 for silver. Abd al-Malik's reforms, so often recounted in medieval chronicles, abandoned Byzantine and Sassanian themes and replaced them with a purely aniconic, Islamic type (fig. 20) which proclaimed that "There is no God but God, One, Without Associate." The Koranic quotation (9.33) announces that "Muhammad is the

Apostle of God whom He sent with guidance and the religion of truth (that he may make it victorious over every other religion)." In addition to these standard formulas early coinage contains a number of variants, but all of them emphasize the unique and uncreated quality of God. Except for a number of provincial issues and for occasional peculiar types, Abd al-Malik's purely epigraphic coinage remained the standard Islamic coinage for centuries.

The utilization of coinage, especially gold and silver, by the art historian is both an advantage and a danger. One important advantage of numismatic evidence is that it reflects a highly conscious and official use of visual forms and symbols. Therefore the datable succession of iconographic formulas—minor adaptations of earlier formulas, attempts at an original iconography utilizing representational and other symbols, replacement of such formulas with purely epigraphic ones— can be accepted as a succession of conscious choices by the highest level of the culture and of the empire. At a chronologically clear moment, which corresponds to the time of the Dome of the Rock, the very official art of coinage replaced representational formulas with writing and this change was irreversible. It obviously was the result of a need or of an attitude that can at least be dated, if not yet explained. Furthermore, one can usually assume that numismatic themes received wide currency and, unless otherwise indicated, implicate the culture as a whole. The same index of value cannot so easily be given to a palace or even to a religious building.

But the very fact that gold and silver coins are highly official documents suggests their limitation as such. They reflect only the preoccupations of the center of a culture; they are not necessarily indicative of the total creativity, even at the level of formal symbols, of a given moment. Thus, for instance, the very same Abd al-Malik had a seal made that shows affronted lions and birds and a traditional Byzantine *alpha* together with the profession of faith (fig. 21). The object is a unique one; it may be earlier than the reformed coins, and its possibly more private nature limits its potential significance. Yet it illustrates the crucial points of the multiplicity of themes and their levels of utilization which coexisted at any one time. This multiplicity is probably true of any one moment in the history of forms, but in our instance of early Islamic times, as in most other times, it appears to possess a quality that made it unique. It is that the official art of the empire tended to avoid representations of living things, while apparently the culture as a whole seemed indifferent to the problem.

Let us now sum up the historical evidence we have brought out about the Muslim attitude toward the arts and try to suggest an explanation for it. Seen historically, that is in some sort of chronological development, the following scheme can be proposed, without taking into consideration for the moment the limitations attached to the different kinds of information we have. The Arabian cradle of Islam was only dimly aware of the possibilities of manmade visually perceptible symbols; it was not creative itself but "consumed" objects of varying quality from elsewhere and knew that other cultures, including neighboring ones, did erect fancy buildings, paint pictures, fashion sculptures, and at times even gave a certain sacredness to these creations. But these meanings given to forms were either primitive or limited, and more general aesthetic impulses other than those of owning a "pretty" thing were absent. They remained absent from the Koran and from the Prophet's message, with its emphasis on a unique God forcefully distinct from the Christian divine view and on a certain way of life for the Community of the Faithful. During the first century after the conquest the Muslims were brought into immediate contact with the fantastic artistic wealth of the Mediterranean and Iran. They were strongly affected by a world in which images, buildings, and objects were active expressions of social standing, religion, political allegiance, and intellectual or theological positions. As many recent studies have shown, the Christian world was at that time immensely proud of both its sophistication in the use of the visual and its technical mastery of the beautiful. Matters are less clear for Iran, but, in view of the wealth of religious imagery and luxury objects identified in Central Asia, the same or at least a similar development may be suggested east of Byzantium. That the Muslims were impressed by the artistic complexity of the conquered world goes without saying. To use the term introduced by Gustav von Grunebaum, they were clearly "tempted" and we can document the accumulation of wealth together with new habits of luxurious living and the search for visual symbols of their own including representations of personages and things. But then the search stopped, or rather in the official art of mosques and coins a substitution occurred from older themes with a constant use of living things into writing or into conscious modifications of the models used. These substitutions still had iconographic content, but they lacked one element which tended to be *de rigueur* in earlier or contemporary traditions, that is, representations of living things. Even though notable exceptions exist, this avoidance of or reluctance to-

ward representations spread beyond the realm of official art into private art. By the end of the eighth century Muslim thinkers were asking themselves why they made this shift, and they answered by going back to incidental passages of the Koran and by reinterpreting the life of the Prophet.

Why, historically speaking, did this change from indifference to opposition take place? It has generally been assumed—quite correctly, it seems to me—that the doctrine (or at least the elements thereof) of opposition to representations followed rather than preceded the actual partial abandonment of such representations. It is therefore not through the impact of a specifically Muslim thought that we may provide an explanation. Some have argued for a sort of basic Semitic opposition to images which would have come to the fore with the formation of the Arab empire. Beside being rather unfortunately ethnically focused, this explanation is weakened by the existence of an art sponsored by Semitic entities since Akkadian times. Others have argued for the immediate impact of Judaism, and it is true that converted Jews played a very important part in the formation of many aspects of early Islamic thought. Furthermore, a number of events with iconoclastic overtones, such as the edict of Yazid, were said to have been inspired by Jews. It is indeed very likely that Judaic thought and arguments played an important part in the formation of a doctrine against images, but it seems improbable to me that they would have triggered it, mainly because the doctrine or even most statements about the arts always occur first as a reflection to the presence of a work of art, not as an intellectual position. Then, in the one instance— coins—where images were formally abandoned, and where the process can be followed quite accurately, there is no evidence for a Jewish influence nor is one likely.

It is simpler to argue that the formation of a Muslim attitude toward the arts was the result neither of a doctrine nor of a precise intellectual or religious influence. It was rather the result of the impact on the Arabs of the prevalent arts. Or, to put it another way, Islam burst onto the stage at the moment when, more than at any time before or after, images became more closely related to their prototypes rather than to their beholder, when religious and political factions fought with each other through images, when Christology of the most complex kind penetrated into the public symbols of coins. The new Islam could choose to compete in this particular world and it did try, in some coins, to develop a symbolic system of its own. The difficulty was,

however, not only that the Christian world in particular had acquired a tremendous sophistication in the use of forms, but also that in order to be meaningful an identifying symbolic system of visual forms has to be known and accepted by all those for whom it is destined. If it used, even with modifications, the terms of the older and more developed culture, Islam would lose its unique quality. On the other hand, the visual weakness of its Arabian past did not provide Arab Islam with visual forms that could be understood by others or with the technical sophistication needed to manipulate existing forms. The reform of Abd al-Malik crystallized and formalized an attitude that had developed in the Muslim community, according to which the prevailing specific use of representations tended to idolatry and no understandable visual system other than that of writing and of inanimate objects could avoid being confused with the alien world of Christians and eventually with Buddhists or pagans. It was therefore essentially the ideological and political circumstances of the late seventh-century Christian world that led Islam to this particular point of view. For it is in a complex relationship to the Byzantine empire that early Islam tried to define itself. This point appears clearly in many of the accounts that describe Abd al-Malik's coinage or the bringing of workers from Constantinople to make the mosaics in Damascus. Most of them describe the two events as respectively a challenge to the Byzantine emperor and his subjection to the caliph. Actual historical truth here is less important than the mood which is suggested.

To conclude then we might say that, under the impact of the Christian world of the time, Islam sought official visual symbols of itself but could not develop representational ones because of the particular nature of images in the contemporary world. Precise historical circumstances, not ideology or some sort of mystical ethnic character, led to the Muslim attitude. Two corollaries and a question derive from this conclusion. One corollary is that we can define a Muslim attitude toward the arts only in the one limited area of the representation of living things. There was no definable attitude toward other aspects of the arts. With respect to these one can simply assume the maintenance and taking over by Islam of prevalent attitudes in the conquered world, a point which will be discussed at greater length later on. The other corollary is that an attitude which defines the culture appears when the identity of the culture is affected, that is when it fears that the prevalent attitude is dangerous for the culture's unity and cohesion. We shall see in our last chapter how this can explain a number of

other features of early Islamic art. As to the question, it is this. If the
Islamic reluctance to images was the result of specific historical cir-
cumstances, why did it remain after the removal of the circumstances,
during the Iconoclastic crisis in the Christian world and after the
Islamic empire had become fully established?

For an answer, we must turn to the other, philosophical or anthro-
pological, aspect of our problem. The attitude of early Islam is more
than simply the result of concrete historical circumstances; it is a typo-
logically definable attitude that sees and understands any representa-
tion as somehow identical with that which it represents. This attitude
has been a constant in the history of the arts, at times in the forefront,
as in much of ancient Egyptian art, at other times muted under the
impact of some other aesthetic or social impulse, as in classical Greek
art. But it was always present and reappears at various moments, in
the Middle Ages or even today. The peculiarity of the Muslim attitude
is that it immediately interpreted this potential magical power of im-
ages as a deception, as an evil. This iconophobia has several further
aspects. In itself it was not a rejection of symbols as such, for, as we
have seen, there is a symbolic content to the Damascus mosaics or to
the use of writing on coins. But the later history of the Damascus
mosaics is instructive in that they, like the slightly earlier Dome of the
Rock mosaics, lost their symbolic meaning very rapidly, at least tradi-
tionally. Only through incidental remarks is one able to reconstruct
their original meanings, and even then some doubts and uncertainty
surround these interpretations. As we shall see later, matters are dif-
ferent when we turn to writing, which remained as the main vehicle
for symbolic signification in early Islamic art. The point at this stage is
merely that the rejection of a certain kind of imagery because of its
deceptive threat seems to have carried with it considerable uncertainty
about the value of visual symbols altogether.

A curious theoretical problem is posed here. One may indeed con-
clude that some uncertainty exists as to whether the forms of any
image can acquire a concrete symbolic meaning unless they use defin-
able imitations of nature. If abstract and nonfigurative signs can in-
deed acquire symbolic meanings, how can we learn to read them? By
what method of investigating visual forms can we discover if they had
a sense in their time? But there is more here than a suggestion of
modern, epistemological despair. One may in fact wonder whether a
purely abstract system of visual symbols can ever be learned even
within the culture itself, for, following here Jacques Berque, we may

suggest that a nonfigurative art, even if the nonfigurative aspect is not total, contains ipso facto an arbitrary element that somehow escapes the normal rules of communicating a visual message. The historian may be puzzled by the notion of an arbsurdity in artistic creation, absurdity at least in the sense that, to paraphrase Berque, it refers to richer and much deeper levels than those of quasi-verbal communication. Yet is it not so, that precision of meaning or of signification is automatically missing as a result of a rejection of the representation of otherwise known features? To answer these questions, theoretical and experimental investigations of a completely different order from the ones we are pursuing here are needed, mostly psychological ones about the manner in which man perceives and understands forms. It may be just as well to leave them as questions, noting simply that our problem of the formation of an artistic tradition leads to yet another series of theoretical puzzles than the ones we have raised at the beginning.

Another point, also with interesting theoretical implications, can be derived from our investigations. We may recall that it is at a popular and folk level that visual symbols are most consistently magical in significance, even if these meanings are used and organized at higher levels. On the other hand, most of the images seen by Islam as models had been sponsored by princes or by the clergy, even when their interpretation was a popular one. This sponsorship gave to the images a connotation of luxury; they were nonessential substitutes for life. Now, as several writers have shown, one of the peculiarities of early Islamic attitudes was what Marshall Hodgson called "moralism," that is, a way of interpreting any experience or need through a small and strict code of behavior and understanding. This code was largely a social one in the Muslim world and theoretically involved the whole social group, the whole *ummah*, or Muslim community of the faithful, and there was no clergy or liturgy to give it a complex mystical form in early times. In their public life at least, the princes tended (with notable exceptions duly and critically noted by chroniclers), during the formative decades of early Islam to appear as nothing but leaders of equals. The code thus lacked both canonically organized intermediaries and the need for such intermediaries, for it was the result of a small and cohesive social entity. Inasmuch as most artistic creation at that time was seen as a substitute for reality and thus an intermediary between man and that reality, it appeared as evil in a much wider sense than the technically precise one of confrontation between God,

the *musawwir* par excellence, and the maker of images, the *musawwir* in stone or in paint. It was evil because it interfered between man and the morally good life, because it was a gratuitous temptation.

To some extent this social code was an abstraction, a body of beliefs and attitudes that did not always find legal and practical expression, inasmuch as there was no ecclesiastical unifying force among the Muslims and the organized system of jurisprudence was only in its infancy, even around 800. Yet by then many very different non-Islamic or very recently converted groups had become part of the Muslim community itself. The original social code was subjected to a variety of tensions, two of which are of particular importance.

At one extreme were a number of folk cultures that continued to see images as magic and that were deeply rooted in every part of the Muslim world. These cultures maintained, however remotely and insecurely, an attachment to the pre-Islamic past of the Near East. At the other extreme there came to be an aristocratic culture — the caliphs, their families, high officials—that saw images as luxury and that consciously borrowed forms from earlier Near Eastern traditions, mostly royal ones. Between these two extremes the dominant Muslim code appeared at its best in the early cities of Iraq or in Egypt rather than in the largely alien cities of Syria or western Iran. This Islamic middle rejected both extremes, the popular world as pagan and the artistocratic one as alien and hypocritical. This rejection may have been supported by the social side of the poverty of aesthetic thought in early Arabian Islam discussed earlier in the chapter. But it is most important to note that it was this literate middle which provided us with most of the texts by which early Islamic culture is defined and which institutionalized into legal terms the moralistic attitude of the early ummah. We shall see later that a precise material culture can be attributed to it as well.

In the meantime one can put forward the concluding hypothesis that there grew in early Islamic times a new social entity whose ethos rejected the complex uses of representations in conquered areas and thereby revived the iconophobia latent in any culture. It became the dominant tastemaker in a system that included much more than itself. But it also went a step further, for, in legalizing its rejection, it also gave it a moral quality. The following passage from the tenth-century moralist and historian Ibn Miskawayh may serve as a concrete illustration of this point. In listing and discussing various vices, he mentions "the seeking of that which is precious and which is a source of dispute

for all. . . . When a king for instance owns in his treasury an object of rare quality or a precious stone, he thereby exposes himself to being afflicted by its loss. For such objects are unfailingly destined to be damaged when we consider the nature of the generated world and the corruption which wills that all things be altered and transformed and that all that is treasured or acquired become corrupted. . . . Unable to replace [a lost object of quality] with an exact equivalent, the king becomes a prisoner of necessity." These excerpts go beyond a rejection of representations. They suggest that all aesthetic creativity that is tied to the material world is a vanity and an evil. In this manner Islamic attitudes, conditioned by precise historical circumstances, reach a rejection of art altogether, as almost every puritanical reaction has done.

It is beyond my task to do more than suggest that the full originality of the early Islamic attitude to the arts can best be understood if its reluctance to images and its various attempts at visual symbolism through other means are related to the theoretical problem of the relationships between art and civilization with many intellectual and social connotations. The questions raised in this fashion, however, no longer pertain to Islamic art alone but invoke wider problems of the formal and social natures of visual perception under a variety of circumstances. In the meantime, whatever the attitudes may have been, they did not prevent the creation of monuments, whose survey takes up the next two chapters. The deeper question that remains is whether, in the light of the evidence and hypotheses presented in this chapter, it is entirely appropriate to think of these monuments as works of art.

5. Islamic Religious Art: The Mosque

It is customary to separate secular and religious impulses in the forma-
tion and development of an art. It is also often said that the separation
is not entirely meaningful in Islam, which did not make a distinction
between the realms of God and of Caesar. A word of explanation must
therefore be provided to justify our use of the term "religious" in the
title of this chapter. What we are trying to identify are those elements
or sources of inspiration in early Islamic art that could not have existed
without the growth of the new faith and of the way of life issued from
it or compelled by it. Our initial quest is therefore wider than that of
simply looking for those peculiarly Islamic ritual or pietistic needs that
could be or actually were translated into works of art. Yet for practical
purposes, if we recall the nature of the establishment of Islam over the
vast conquered area, most of material life can be assumed to have
continued without significant modification. It is only little by little that
changes can be detected, and few of them affected the arts until the
eighth century, as we saw for instance in the case of an attitude toward
representation. Thus, even though it is probably wrong to think in
terms of religious needs and requirements in early Islamic times, we
shall concern ourselves with those impetuses that became later appro-
priately defined as religious. At this stage we should think rather of
such needs as were by definition limited to the Muslim community.

Foremost among these is the building and institution known as the
mosque. The word itself derives from the Arabic *masjid* (plural *masajid*)
meaning "a place where one prostrates one's self [in front of God]."
The early history of the term is a peculiar one. It is fairly common in
the Koran, but not once does it seem to refer to a specifically Muslim
new kind of building. One celebrated passage is 9.17–18: "He shall
only tend God's sanctuaries [*masajid Allah*] who believeth in God and
the Last Day and observeth proper worship and payeth the poor-due
and feareth none but God." The text gives an impression that some
special function exists of taking care of holy buildings, but recent
exegesis has shown that the context of this particular revelation is the
masjid al-Haram in Mekkah and that the Prophet was simply indicating
that non-Muslims were not to participate in its upkeep. Another verse,
in 9.107, reads: "Those who took a masjid by opposition and disbelief
and in order to cause dissent among the believers. . . . they will swear:

99

we purposed nought but good; but God will bear witness that they are liars." While it is conceivable that the incident recalled an attempt by some splinter group to imitate a Muslim holy place, it is far more likely that the word masjid itself means simply a "sanctuary" without specific connotation as to religious allegiance. The statement in 62.17, "Verily sanctuaries [masajid] are but for God," is too general to lead to any conclusion.

The only rather concrete passage is 22.39–40: "Sanction is given [for fighting]. . . . to those who have been expelled from their homes unjustly because they said: Our Lord is God. For had God not repelled some people by means of others, churches, synagogues, prayer places [*salawat*, a rare word of unclear meaning], and masajid would have been destroyed?" Two of the words used indicate known religious buildings, and it can be thought that the other two also referred to institutions specific to a given faith and that the last one was a Muslim holy place. But this would be rather circuitous reasoning, and it seems to me more appropriate to conclude that in the Koran itself there is no indication for the existence of a new kind of Muslim religious building. The word masjid usually meant any building or place where God was worshipped; alternately it was used in a compound expression with *al-haram* to refer to the unique sanctuary in Mekkah. Except for the latter, which became quite early the spiritual and physical center of the Community, it would appear then that the divine revelation did not introduce a holy Muslim building. In spite of the obvious development of a mosque architecture, it is interesting to note that even in the fifteenth century the great Ibn Khaldun recognized only three masjids, in Mekkah, Madinah, and Jerusalem, following in this the Koranic conception of a sanctuary.

But the Koran did lay down one rule for all Muslims that is of crucial significance to the architectural history of the mosque: the obligation to perform prayers. The act of prayer is a private act, and a celebrated tradition asserts that wherever one prays there is a masjid. But the act of prayer is also a collective act of the whole Community. The actual forms taken by prayer and its transformation into a collective act were less Koranic creations than the result of the Muslim community's life between 622 and 632. This life is best known through the Traditions and through chronicles, with the usual methodological problems of interpretation attached to these sources. The following characteristics of Muslim prayer are of particular importance for architecture. First of all, a ritual of prayer was created. Once a week, on

Fridays at noon, it involved the whole Community and the Prophet or his representative (eventually his successors, the caliphs and their representatives) became *imams*, or leaders of collective worship. A *Khutbah* was pronounced, which was both a sermon and an act of allegiance of the Community to its leader. This was the time not merely for a pietistic performance but also for the announcement of news and decisions pertaining to the whole group and even for certain collective decisions. The time for Friday prayer served thus as the time when, as social scientists might put it, the collectivity and its leaders communicated with each other. The leaders were considered as the guardians of the place of prayer and Ibn Khaldun, for instance, discusses what we call mosques in his chapter on the *imamate*, or the political leadership of Islam. For the formal ceremony of prayer, the imam stands in front of the other faithful near the qiblah wall, the wall indicating the direction of prayer. He pronounces the *khutbah* from a pulpit known as a minbar. The minbar became the symbol of legal authority in a place of worship, and for several centuries Muslim writers identified those mosques for whose upkeep the central authority was responsible as having a minbar. Both the Friday prayer and the daily compulsory prayers are preceded by a formal call to worship. The Prophet considered using either the Jewish horn or the Christian *semantron* but settled eventually for the human voice from the roof of the place of gathering. A specific individual, the muezzin, became appointed for this task. Finally, the act of prayer must be preceded by ablutions.

Much discussion has arisen around every one of these aspects of Muslim prayer, and there is little doubt that the canonically standardized prayer of today is the result of a complex but rather rapid development in which singular, accidental events and revealed religious practices interacted. All the events and most of the practices share one feature: they served to strengthen the formal ties of the Muslim community and to separate it from other, Jewish, Christian, and pagan, communities. These two characteristics, an all-embracing, egalitarian one in relationship to its own members, and a restrictive one in relationship to others, are essential general requirements of what became the mosque. Moreover, the internal Muslim purpose was not only, perhaps not even primarily, religious but included all the activities that made the community function.

The Traditions and the early stories are also quite unclear as to whether these requirements found expression in a building. The tex-

tual information is rather confusing on the subject and demands an eventual systematic investigation. For the time being, the following scheme may be proposed. Most of the towns and villages around Madinah, and Madinah itself, seem to have had a place known as a masjid that was used by the Prophet when he visited these settlements. Some became celebrated because an important event took place there, such as the change of the direction of prayer from Jerusalem to Mekkah that occurred at the small village of Qoba. Some seem even to have had a partially commemorative function; thus a masjid seems to have been built at the place where a certain Abu Basir had been buried, or conceivably the man was buried near a masjid. What is troubling about all these masjids is that no information exists about their shape or, in many cases, about the exact time of their construction. Some were in all probability older holy places of pagan Arabia taken over by the new faith; others may have been simple enclosures or houses without identifiable or identified form.

Two exceptions can be made, both of which are specifically tied to the Prophet alone. The first is his private house in Madinah (fig. 22). However much the story of that house has been transformed by later hagiography, it seems clear that it was meant to be simply a private dwelling with a large area for the numerous public functions of the spiritual and political leader of the new community. Its major feature was a large courtyard (probably about fifty meters at the side) with two shaded areas. One, toward the south, consisted of two rows of palm trunks with a thatched roof; although it served to indicate the direction of prayer in all probability its original function—like that of a smaller row of palm trunks on the north side—was that of a *zullah*, or a "shaded place." On the east side were the rooms of the Prophet's wives which opened directly into the court; in one of them the Prophet was buried. This courtyard became, for practical purposes, the place in which almost all the official activities of early Islam took place. In the collective memory of the culture, therefore, it became not merely a sanctuary but the second holiest masjid of Islam. Yet there is little evidence that it was built as a sanctuary or even really considered as such during the Prophet's own time; it is the history of what happened in it that transformed it into one.

One may wonder why the Prophet did not develop a uniquely Muslim sanctuary beyond the mystical *Haram* in Mekkah. It is possible that, just as in the case of his attitude toward representations, the problem and the need did not arise. Moreover, religious buildings

were too closely associated with priesthood, a clergy that Muhammad and early Islam strove to avoid. Whatever the Prophet may or may not have tried to do, the events associated with his house made the latter into a holy place. More important, in contrast to what is known of sanctuaries or houses elsewhere in Arabia, we are provided with a form, or at least an embryonic formal arrangement, in that a large open space has two covered areas at two opposite ends. The impulses for the forms were purely practical and we have no information about an aesthetic reaction to the building.* But recent work based on a small number of poetic fragments has raised doubts about the traditional explanation that the house of the Prophet was transformed into a masjid and, as suggested, that a separate building was in fact built.

The house of the Prophet or an independent masjid was not the only legacy from early Islamic times to the later history of Muslim religious building. We also know that on certain formal occasions, especially feast days, the Prophet used to lead his community outside the city itself to a *musalla*, where he performed the necessary prayers and ceremonies. "Musalla" simply means "a place for prayer," and it appears to have been a large open space totally devoid of constructions, although one can suppose that it had some kind of boundaries. Musallas still exist today, and a fair number are known from more ancient times all over the Muslim world. In the absence of a comprehensive study of these buildings, we can only conclude that, at the very beginning of Islam, the most uniquely religious ceremonies took place outside of the city and that no architectural or symbolic form appears to be associated with musallas.

The following, then, appears to be the information available before

* A curious story may serve to illustrate an aspect of medieval Muslim historiography about the mosque of Madinah and the difficulties of dealing with it. According to the tenth-century geographer Ibn Rustah, one Uthman ibn Maz'un spat in the qiblah, the covered part of the court. It made him so sad that his wife inquired about the reason for his unhappiness. He answered, "I spat in the qiblah while praying. But I did then go back there to wash it, then I made a paste made of saffron and covered it with it." The geographer's comment is: "It is thus this particular Uthman who was the first one to cover the qiblah with perfume." While acquiring interesting information about one kind of beautification in the mosque, we cannot determine whether it goes back to the Prophet's time or whether the story was invented in order to make a later practice not so much canonical as ancient. The very nature of story, its incidental and accidental character personalized through some otherwise little known individual, illustrates the point that, in the Muslim view of Islam and of its growth, there was no preconceived, theoretical notion of a holy place but an accretion of unique and at times trival events that became accepted. It is as though the culture were psychologically reluctant to interpret abstractly the physical reality of its Muslim life.

the Muslim conquest. A very generalized notion existed of a masjid as a place where God is worshipped; the masjid was only identified as specifically Muslim when the term was in grammatical construct with another, as in the masjid al-*haram* of Mekkah; a ceremony of private and collective prayer was established which, among other things, separated Muslims from non-Muslims by requiring the proclamation of the Profession of Faith; private prayer was associated not with locale but with direction, the qiblah; and collective prayer was associated with a formal call, with an imam speaking from a minbar, with ablutions, with a proclamation of allegiance, with an obligation to attend on the part of the whole community both as a symbolic gesture and because pertinent affairs were discussed and decided upon. Finally, even though it was initially only his private house, the Prophet's dwelling in Madinah became the place in which occurred most of the events that determined the liturgical and political decisions of Islam; a sort of sacralization of this house into the first masjid took place in the collective memory of the followers of the faith; the form of the house can be reconstructed, but no formal definition of the musalla can be given. All these features are practical and concrete, none of them suggesting either a theoretical notion of a holy place or an aesthetic impulse for any part of the ceremonies of early Islam.

Our problem is to determine how this rather amorphous, or at best incomplete, set of requirements with so few physically identifiable features was transformed into a kind of building that occurs in all lands with a Muslim population. As the bibliographical appendix to this chapter introduces most of the pertinent monuments and the most important studies dealing with them, I shall begin with two acknowledged masterpieces of early Islamic architecture, the mosques of Damascus and Cordoba. By their very existence and their often demonstrated impact, they imply the existence of a *type* for the early Islamic mosque, and therefore such features as are shared by them may be considered characteristic of mosques. It has also seemed that, by focusing on two major works of art, it will be easier to define the aesthetic and formal qualities of the most Islamic or early Muslim monuments. Occasionally a number of exceptions are brought up, because, as will be discussed more fully in conclusion, some of them became quite important in later centuries.

The great mosque of Damascus (fig. 23) was built between 706 and 714–15 by the Umayyad caliph al-Walid. Its history and specifications are clear enough. It is a rectangle, 157 by 100 meters, with square

towers (serving as minarets) in the corners, only one of which has been preserved; its shape, dimensions, and most of its outer characteristics are not Muslim but were created by the *temenos* or sacred precinct of a Roman temple. The building has three main entrances, of which the eastern and western ones are part of the antique composition; the northern one was also antique but was partly remodeled, while the southern one, on the qiblah side, was blocked. Inside, the available space contains an open area, generally identified as a courtyard (*sahn*), 122 by 50 meters (fig. 25). On three sides it is surrounded by a portico of piers alternating with two columns. On the fourth or southern side, three long and equal naves, each of 24 columns set parallel to the south wall, are intersected in the middle by an axial nave perpendicular to the qiblah wall (fig. 24). The axial nave is higher than the lateral ones and serves as the compositional center of the southern court façade. In its center today is a dome whose existence is documented only from the twelfth century; there is some uncertainty about the existence of a cupola in the first mosque and, if there was one, it may not have been in the center but in front of the *qiblah* wall.

The axial nave leads to a large niche in the back of the building. It is a mihrab, one of three that existed already in the Middle Ages. The walls are antique in their location and in most of their construction. The main supports are piers and columns; most of the latter are reused from older buildings, and their shape and composition in the courtyard are only slightly modified from the techniques used in the Christian architecture of pre-Islamic Syria. The arches have all been restored, but they are derived from the same architectural tradition; the ones in the covered part of the building have been almost entirely redone. The mosque was lavishly decorated: on the lower part of the walls were marble panels, and the upper part, the soffits and spandrels of the arches, and most of the court façade were covered with the mosaics mentioned in the previous chapter (figs. 13, 14). A curious octagonal building on top of columns is found in the northwestern corner of the courtyard. According to the Tradition, it was the treasury of the first mosque, the place where the Community's funds were kept, actually or symbolically protected by all the faithful. While the mosque's dimensions and almost all its elements of construction have been taken from earlier buildings, no completed part of Roman or Christian architecture has remained and, in spite of numerous repairs over the years, what is visible is, in all features but ceilings, the Umayyad building.

The mosque of Cordoba has had a far more complicated history. As it stands today, and disregarding numerous Christian additions, it is a large rectangle, 175 by 128 meters, whose last Muslim construction is dated in 987–88 (fig. 26). On the outside its buttressed walls are pierced by nineteen doors—seven on the west side, two on the north, nine on the east, and one, now blocked, on the south. In their present state all these gates have been restored, but the basic scheme of their decoration, a horseshoe arch set in a square, harks back to a manner that already appears in the St. Stephen gate of 855–56 on the western side (fig. 29). Near one of the northern gates stands a square minaret. The interior includes a courtyard, 120 by 58 meters, which was probably surrounded on three sides by porticoes, at least after 958, and which is planted with orange trees. Although the trees are obviously modern, there is evidence that a gardenlike effect was achieved through trees or water channels already in Muslim times. The southern side of the court opens on a large hall consisting of nineteen naves (figs. 28, 31). These naves are remarkable, first of all, for the variety of their widths. From west to east there are one of 5.35 meters, four of 6.86, one of 7.85, four of 6.26, two of 5.35, and seven of 6.86. The fifth nave ends in a small octagonal room (figs. 30, 32) preceded by three domed units that are heavily decorated with carved marble and mosaics composed of geometric and vegetal ornamentation, and some inscriptions. This area is separated from the rest of the mosque by a barrier. The room is identified by an inscription as the mihrab, and the barrier outlines a *maqsurah,* a special enclosure reserved for a prince. Nine bays northward from the maqsurah another cupola is found, while the rest of the mosque was covered with a flat wooden roof. The interior supports of the naves consist of 514 columns, all topped by a unique system of two-tiered arches, and thirty-four piers arranged in two rows of seventeen each, one of simple piers, the other of articulated ones. Ten segments of walls run north–south about two-thirds of the way across the covered hall. The variety of the building's constituent elements and the asymmetry of their arrangement, make its internal arrangement unusual, although one would hardly guess it by looking at it from the outside (fig. 28).

Both mosques are a far cry from the house of the Prophet in Madinah, and our purpose is to explain what happened and why. Both buildings are parallelograms of considerable size, and almost all city mosques known from the first three centuries of Islam are of the same shape; two mosques in Samarra (figs. 33, 36) are even larger than the

Cordoba one, the largest one being 240 by 156 meters and surrounded by an empty area which makes it almost a square, 350 by 362 meters. It is easy to explain why mosques developed on such a scale when we recall that the masjid was supposed to contain the whole Muslim population of a given city. In the largest cities, like Baghdad and Cairo, several such large mosques are found. While each city had at least one huge mosque, these were not always conveniently located for every collective prayer. Thus, from the very beginning in the early Muslim cities of Kufah and Basrah in Iraq and later elsewhere as well, we hear of smaller, quarter or tribal, mosques, about whose shape almost nothing is known. A terminological distinction was eventually made between a masjid and a *masjid al-jami'*, the mosque of the collectivity, sometimes called a cathedral-mosque or Friday mosque. Only the latter was directly supervised and paid for by the central Muslim authority, even when local governors had achieved considerable political independence. For regardless of political vagaries and misunderstandings, the *masjid al-jami'* was the place where allegiance was sworn to the successor of the Prophet and not merely to a local governor.

The internal arrangement of our two mosques is somewhat more difficult to define. Both have an open and a covered part. All other early Islamic large mosques—except the Aqsa mosque in Jerusalem (fig. 37), which has certain peculiarities due to its location in a unique setting—share this feature, but not in the same fashion. In most instances there were no doors, at best perhaps curtains, between the supports separating open and covered areas. But in some mosques a composed façade facing the open area developed, while in others there was no distinction between the supports facing the court and the internal supports. The majority of Iraqi, Egyptian, and western Islamic mosques were of the latter type. It is perhaps incorrect to talk there of a courtyard surrounded by a portico on three sides and adjoining a covered hall on the fourth. For initially at least the Muslim builders did not create a composition consisting of two parts, a hall and a porticoed court, but a single, unique space part of which was covered. In fact, early texts rarely refer to the open part of a mosque as a *sahn* or court; in Kufah (fig. 35) the covered part was called a *zullah* or shaded area, just as in the Prophet's house in Madinah. In time mosque compositions increased in complexity and a sense of court façade appeared, often, as in the example of Kairouan (fig. 41), after a reconstruction. The major exception seems to be the mosque of Damascus, whose sturdily harmonious arrangement, possibly inspired by Byzantine pal-

ace façades, does indeed give the impression of a self-contained rectangular porticoed court. The example of Damascus was followed in a number of mosques that were directly influenced by it, for example in Aleppo. It was an exception that became crystallized because of the importance of the Syrian capital.

A clear contrast between the mosques of Cordoba and Damascus occurs in the covered part of the building. The Syrian building is composed in a balanced and organized fashion whereas the Spanish one is peculiarly asymmetrical. The Cordoba mosque, as it appeared at the end of the tenth century, was the result of a historical process which had begun in 784. As the diagram illustrates, a first mosque was built with eleven naves of twelve bays each (fig. 27). This mosque was lengthened twice, in 833–48 and 965–66, creating in this fashion the symmetrical western two-thirds of the present building. In 987–88 a whole additional third was added to the east. All the additions tended to follow the original arrangements of arches and columns of the 784 building, thus maintaining for the whole mosque a striking stylistic unity. Enlargements of this sort were fairly common in mosque architecture and can be described in some detail in the mosques of Amr and al-Azhar in Egypt, in Kufah, Basrah, and Baghdad, in Madinah, and in Nayin in Iran. The most remarkable instance is that of the Aqsa mosque in Jerusalem (fig. 37), for which textual and literary sources document additions and eventually also a contraction. In all instances the justification for the modifications is the same: a change in the size of the city's population.

Two conclusions emerge: first, that the main mosque of a city remained physically attuned to the culture's requirement of a single space for the whole community; and second, that there was no conception of the building as a physical, complete entity. The compositional imbalance of Cordoba did not seem to be a problem. It may thus be suggested that as a type the mosque of early Islamic times tended to be defined in terms of certain social needs and not as a more or less perfect or successful reflection of an ideal composition. This point may find further confirmation in the fact that the mosque did not develop an organized façade or even elaborate gates until much later. The number and location of gates were regulated by the city around the mosque, not by an architectural or aesthetic conception of the nature of the building. An exception such as that of Damascus only confirms the rule, for its gateways belonged to the earlier Roman building and it was the overwhelming presence of the classical scheme that prevented in Damascus internal changes of the magnitude of Cordoba's.

To be able to expand or contract, the mosque had to have a flexible and additive system of construction. The early Muslim hypostyle system can be defined as one in which the main internal support consisted of a single element that could be multiplied at will in any needed direction. Two supports were available. In the first Iraqi mosques, in Syria, and in all Muslim regions west of Syria, it was the ancient unit of the column with its base, shaft, and capital. In many instances, for example in Damascus or Jerusalem, these columns were taken from Roman or Christian buildings or ruins. In the very large buildings like some of the Cairene mosques, Kairouan, or Cordoba, new columns were added to the reused ones. In most cases the former imitated the latter in all but the smallest details, and one of the traditional exercises of early Muslim archaeology has been the separation of one from the other. For our purposes here the differences are not pertinent. The other support was the pier, usually of brick. It occurs in Iran, as in Nayin or Damghan where it imitates a column, but its most characteristic form occurs in the great Samarra mosques, in Raqqah, and in the Ibn Tulun mosque in Egypt built under the influence of Iraq (fig. 42). Its shape is most commonly that of a rectangle with engaged colonnettes. In certain cases, as in the Abu Dulaf mosque in Samarra, the piers do not have engaged elements and are so long that they appear almost like segments of walls (fig. 36). Although it is easy enough to explain how and why the brick pier developed in Iraq and Iran with their more limited columnar tradition, it is interesting to note that these piers do not appear in the earliest known buildings and that Sassanian architecture there did not utilize them as fully and as efficiently as early Islam. The brick pier, whose history became so brilliant in later Islamic architecture, seems to have developed primarily because of its usefulness in the mosque and to have acquired there its later versatility. But the original model for the single support seems to have been the column. Texts are fairly clear on this score, even in Iraq, where the first mosque in Kufah utilized columns borrowed from older Christian churches.

To define the hypostyle system as it appeared in early mosques simply as a flexible and easily adaptable way of covering large spaces through the multiplicity of single, repetitive supports would not, however, do it complete justice or exhaust all of its characteristics. In its simplest fashion it existed in the earliest Iraqi mosques, in most of the later ones in Iraq, and in most Egyptian buildings. But in Cordoba, Damascus, or the Aqsa mosque in Jerusalem, something else is involved other than a building consisting of single more or less equal

supports over its whole area. In all three examples the unit around which the covered part of the building was arranged was the nave, that is, a succession of supports rather than a single one. In Cordoba and Jerusalem it is clearly by the addition and subtraction of naves, not single supports, that the building grew. In all these buildings the arrangement of naves provided the direction of the form. Thus the multiple directions of the purer hypostyle of early Iraqi mosques are replaced by clearer and more limiting directional vectors, while the great masterpieces, such as the mosque of Cordoba, have been known to preserve the characteristics of both systems. Then in a number of rather peculiar smaller buildings like a mosque at Balkh (fig. 39) and one near Cairo, the unit of composition seems to have been the square bay, as it would be in later Islamic architecture, especially in Iran and Turkey. We can thus modify our statement about the hypostyle by suggesting that, while the principle of the single, flexible support is consistently present in almost all early mosques, it is not always operative only as a single support but may work at times as a unit of several such supports or even of the space between such supports. I shall propose an explanation for this phenomenon later in this chapter and return to it in more general terms in conclusion, but in the meantime a linguistic parallel may be proposed. It can be imagined that the architectural morpheme of the mosque—that is, the smallest meaningful unit of the building—is at times a single phoneme—a single unit of construction—and at other times either a set of such single phonemes or even a sort of phonemic absence, like the visual or auditory interval between words or sentences.

How did the hypostyle come about in early Islam? There is no point in reviving one older theory that saw in the mosque the reappearance of an alleged traditional Near Eastern hypostyle known in ancient Egyptian or Achaemenid architecture. This old system was gone by the fourth century B.C. and there are no archaeological or cultural reasons to justify a sudden renaissance. A second source could have been the Roman forum, which utilized a number of comparable forms for the similar purpose of gathering large crowds. Although we cannot be certain that imperial fora were still in use in Christian times, the immense number of Roman ruins from the Euphrates westward could easily have served as models. The main difficulty here is that Iraq, the main area where the hypostyle mosque first developed, is one area where the Roman model is least likely.

A third explanation, which seems at first glance far more plausible

and has been often propounded in recent years, is that the house of
the Prophet with its accidental groups of palm trunks covered with
straw at the southern and northern ends of a large open space (fig. 22)
can be considered as the model for later mosques; it would have been
the first hypostyle building in the tradition enlarged and formalized in
Iraq and then adapted to whatever techniques of construction were
available elsewhere in the conquered areas. Two major arguments
favor this particular interpretation. First, since the first mosques were
built in the newly created Arab cities of Iraq and since these mosques
more than any of the later ones were used for the numerous functions
of the Madinah one in the Prophet's time, the latter was the only
definite model available in Iraq. Second, at that time, in the thirties
and forties of the seventh century, the Muslim contact with other
architectural traditions was still very limited; yet our first clearly com-
posed hypostyle mosque is the 670 reconstruction of the Kufah
mosque (fig. 35). This explanation supposes that by the time of the
caliph 'Umar (634–64) the Muslims not only had developed the no-
tion of a masjid as the peculiarly unique building restricted in its use to
the members of the Muslim community but had translated the house
of the Prophet into an abstract architectural reality, into an idealized
type that could be translated into a variety of forms. Although by no
means impossible, this theoretical process is an internal one and diffi-
cult to demonstrate; it seems unlikely in these first decades. I would
therefore prefer to propose a fourth interpretation for the formation of
the hypostyle, one that actually incorporates in part the notion of a
Medinese impact.

In Iraq, with its purely Muslim new cities, the essential problem was
to keep some sort of order and sense of community in the large,
recently settled Arabian population. A focal point was required, and
this is why the caliph Umar ordered the construction of a *masjid al-
jama'ah*, a mosque for the Muslim community. The local architectural
tradition had no way of providing the building's central need, a large
space, except through expensive and cumbersome means like the
large Sassanian vaults that were anything but flexible. What happened
there, then, was the spontaneous local invention of an easily erected
large space with shade provided by a flat or gabled roof on reused
columns. In the very first mosques there were no outer walls, only a
ditch; many openings were used to communicate with the outside in
all directions, and there was no clear or formal place for the imam.
These constructions were simple sheds, not buildings with a formal

prototype or a holy meaning. For instance, one of the early mosques was paved only after people complained of the dust raised by the shuffling of feet during prayers. Some sort of organized form was given to these buildings only through a series of reconstructions and consolidations that took place between 640 and 670. Most of these are well documented, and they always had a practical, local purpose. By 670 the house of the Prophet in Madinah had already been enlarged twice and had begun to acquire a holy character as administrative and other functions were either moved to other buildings or removed from Madinah altogether. Thus the sanctification of the house of the Prophet and the transformation of the early Iraqi mosques from disorganized sheds into organized formal compositions using the elements introduced haphazardly at the beginning were approximately contemporary occurrences. They preceded the major constructions of mosques elsewhere in the Muslim world. There, in a few instances, Christian or other religious buildings had been transformed into masjids, or, as the Western pilgrim Arculfus said of Jerusalem, a "rudely built" house of prayer was built over ruins. By the time of the great imperial constructions of the eighth century, a formal hypostyle type had been established in the new cities of Iraq—and, it should be added, in Fustat, with a number of peculiar developments of its own— and the house of the Prophet had acquired its holiness as the first masjid. Thus two somewhat accidental, historically definable events based on purely Muslim needs would have led to the creation of the type which, from that moment until the fourteenth century (and in some places even later) became the most characteristic architectural form of Islam. It would then have to be considered also as a Muslim formal invention that is not genetically or historically related to earlier comparable forms.

Within this large hypostyle space, whose limits were determined by the community and whose module was a single support, a nave, or a bay, several features appear that deserve particular mention. In a general sense they may be called symbols or signs; they are architecturally definable entities that acquired a sufficient differentiation from the rest of the hypostyle building to indicate that a special connotative or denotative meaning can be attached to them. Most of them are also typologically definable in the sense that they tend to occur in most if not all mosques, and that each is comparable to any other one regardless of its spatial or temporal location. Five of these features appear in the beginning of Islam, but it must be recalled that the minbar or

formal pulpit for the imam already existed in the Prophet's own time.

The first is the minaret. Its official purpose is that of calling the faithful to prayer, and its shape is that of a high tower either immediately attached to the mosque as in Damascus, Kairouan (fig. 44) and Cordoba, or standing nearby as in Samarra (fig. 43), Fustat, and most early Iranian examples. In all early Islamic mosques except at Damascus there was only one minaret by the building. Its shape varies. Early minarets from Syria westward in Islam are square (fig. 44), for their physical shape derives directly from the characteristic square towers of Christian churches, themselves issued from Roman and Hellenistic constructions. A few instances of square minarets are also known in Iraq and Iran, for instance in Damghan, or in the recently excavated ninth-century mosque at Siraf, indicating that the Syrian-created type extended beyond the area of its origins. In Iraq, most particularly in Samarra, there was formed a second, spiral type of minaret (fig. 43), for which one additional example occurs in the mosque of Ibn Tulun in Cairo. The origin of the spiral minaret is not to be sought in the ancient ziggurats of Mesopotamia, but in a certain kind of spiral tower known in Sassanian Iran for hitherto undetermined purposes. There are no instances known so far in early Islamic times of the cylindrical minarets that developed in Iran from the eleventh century on. Composite minarets are certainly a much later development. It is thus fairly simple to conclude that a certain function appeared fairly early in Islamic mosques and that the forms used for it were taken from older architectural vocabularies and therefore varied from area to area. But during the first centuries of Islam the formal predominance of the Syrian square minaret is clear.

The main problem of the minaret is when and why this particular function acquired the form of a tower. For the function of calling to prayer is almost as old as the establishment of Muhammad in Madinah and used to be carried out from the roof of his house. It did not then demand an architectural shape. More curious is that none of the early mosques in the purely Muslim cities of Iraq were provided with a structure for the call to prayer. Matters are less clear in Fustat, but the latest discussion of the pertinent texts suggests that there was no structure there either. It seems that the first monuments to have been used for the call to prayer were the corner towers of the Roman *temenos* in Damascus when the area was transformed into a mosque. It was thus in an older city that a pre-existing architectural form, incidentally incorporated in a new mosque some seventy years after the appear-

ance of Islam, was first utilized for a characteristic Muslim liturgical need that had existed from the very beginning. The most likely explanation for what appears to be a historical oddity lies in the fact that Damascus was at the time primarily a Christian city. Inasmuch as we know that, at the beginning at least, the Muslim population was not concentrated in a single quarter but spread wherever there were houses abandoned by their Christian owners, the minaret could not have easily fulfilled its technical purpose of calling the faithful to prayer, especially over the noise of a city. Rather than reject its liturgical function, however, I would prefer to interpret the minaret as a symbolic expression of the presence of Islam directed primarily at the non-Muslims in the city. One may also wonder whether the peculiar proliferation of handsomely composed minarets in the later architecture of such towns as Isfahan, Istanbul, or Cairo does not indicate the persistent importance of the minaret as a symbol of social, imperial, or personal prestige or as a purely aesthetic device rather than as the expression of a simple ritual function. The latter, of course, was always present after the beginning of the eighth century, but in practice it was often carried out, as in the beginning, from the rooftops of mosques. Archaic ways of calling to prayer remained in many parts of the Muslim world; in Iran they found a unique architectural feature, the small ciborium known as a *goldasteh* that often occurs together with handsome minarets. There is therefore a history of the architectural forms given to the call of prayer as well as of the ceremonies attached to it. This history is still to be worked out. There is also a history of the tower in urban Islamic architecture. The two histories might not be the same.

Next to the minaret, the most important new feature in the mosque was the mihrab (figs. 45, 46). In common usage it is a niche, usually concave and generally heavily decorated, found on the wall of the mosque directed toward Mekkah. In most early mosques there was only one mihrab, and one cannot be sure, for instance, that the three medieval ones from Damascus are as early as the 705–10 mosque. Over the first centuries of Islam the mihrab grew enormously in importance. In Cordoba it is actually a whole room that appears as an opening from the interior of the mosque toward something else. In Kairouan or Samarra it acquired considerable size and, as early as in the Umayyad reconstruction of the mosque of Madinah, a cupola appeared in front of it. The cupola, although common, is not consistent, whereas the mihrab became a necessary "sign" in the mosque and

obviously an important one. The most common explanation for the mihrab is that it indicates the direction toward which one must turn to pray. This explanation is not acceptable for three reasons. One is again the historical argument that there was no mihrab in any of the early mosques; the second—which will be discussed in some detail later on—is that the whole mosque was in fact oriented toward the qiblah; and the third is that the mihrab is invisible from most of a mosque: its size is obviously not commensurate to its presumed function.

The word mihrab itself has a complex pre-Islamic and folk history, but there is general agreement that it indicated an honorific place in a palace, at times even the whole palace. As a result it has been suggested by several scholars that the mihrab was a royal feature introduced to indicate in the mosque the position of the ruling prince or his representative. While sufficient textual evidence remains to show that the mihrab was at times used by princes, especially under the Umayyads, a major argument against this explanation is that the mihrab became an automatic feature of *all* mosques, not only of the main, official ones. There is a suggestion therefore that it had a liturgical or symbolic sense in the faith itself. The nature of this sense may be deduced from the time of the first appearance of a concave mihrab in the Umayyad mosque in Madinah (fig. 34). It served there to honor the place where, in his original house, the Prophet used to stand when leading prayers or preaching. It might then be proposed that the mihrab grew to commemorate the presence of the Prophet as the first imam, inasmuch as an early coin discussed in the previous chapter indicates there was more than one such attempt. This commemorative value can explain not only the decoration it so often acquired, but also its shape in a place like Cordoba (fig. 46) where it appears as a sort of door with the possible mystical connotation of the way in which divine grace comes to the faithful. Because of a Koranic passage (24.35–36) it often has a lamp in the middle and its shape or shapes were later often copied on tombstones or on prayer rugs. The mihrab is the first and perhaps only symbolic form that can be explained almost entirely through religious, indeed even pietistic, reasons.

The form itself varied from place to place within the general range of the niche. Its origins are fairly clear. One can propose a Jewish prototype, since old synagogues were provided with a holy niche in the back and axis of the building. But a more general explanation seems to me preferable, for the concave niche or the simple arch on two columns were one of the most ubiquitous settings for an honored

image throughout the classical world. Early Islam itself used the theme on some of its coins (fig. 15). A common motif of classical art with honorific connotations was taken over by Islam for these very purposes but acquired a uniqueness of its own because of the unique person and event it was made to celebrate. In a way for which parallels exist in Christian art as well, a curious transformation of a general visual term into a highly specific one occurred.

The third and fourth new features that appeared in Damascus and Cordoba are of lesser importance and did not become part of the mosque type. One is the maqsurah (fig. 32), the enclosed space reserved for the prince, near the mihrab. Whether it developed because a number of early caliphs feared assassination or whether it was another form of honor bestowed on the prince as imam, it occurred only in very large mosques in capital cities. It has been preserved in Kairouan as a magnificent wooden partition and in Cordoba as a built-up unit occupying three bays in front of the mihrab. The importance of the maqsurah is greater for the study of ornamental forms than for an understanding of the mosque.

The other less common feature is the domed unit in the court. Preserved in Damascus, it is generally interpreted as the *bayt al-mal*, or treasure house, of the early Muslim community. Such treasuries are known to have existed in the earliest Iraqi mosques, and a well-known story relates that the one in Kufah was robbed by a thief who dug under the wall of the mosque. The presence of a treasury in Damascus is more unusual, since by then the community no longer used and protected its own wealth as it had done during the first decades of its life. But one could imagine that the rather awkward Damascus building—possibly inspired by antique *tholoi*—was a symbolic reminder of early Islamic times. We do not know of treasuries in later mosques either archaeologically or textually, and yet in the descriptions of a number of mosques, such as Ibn Tulun's in Cairo, we read of the existence of a domed building in the open area. These buildings have disappeared or have been replaced by fountains in the case of the Ibn Tulun building, and their original purpose or meaning is quite unclear. Were they purely ornamental, perhaps treasuries which had lost their meaning? Or did they have a meaning which escapes us?

Other puzzles exist as well. For instance, there is no early information about the place for ablutions in the mosque. It seems fairly certain that ritual cleansing did not take place within the precinct of the mosque until considerably later, and it is only then that a monumental

form was given to a patently early liturgical requirement. In the ninth-century mosque at Siraf, excavations have shown that ablutions took place outside and along the building. In Samarra and in the Ibn Tulun mosque the buildings were surrounded on some or all sides by large, walled open areas known as *ziyadahs* or additions, whose function is not known but which could be related to ablutions.

Whatever explanation may eventually be given to these problematic features of some early mosques, the minaret and the mihrab joined the earlier minbar as consistent signs with a variety of functional, symbolic, or aesthetic meanings. In all three instances, however, the functional predominates as one tries to understand the form's genesis. The problem becomes more complicated when one turns to the last important formal feature of a mosque's arrangement.

In the mosque of Damascus the three naves that are parallel to the back or qiblah wall are cut in the center by a single nave, perpendicular to the wall (fig. 25). This has been called an axial nave, and in a variety of ways it occurs in a fairly large number of early mosques. Thus in the Aqsa mosque (fig. 37), in Madinah (fig. 34), and in Cordoba (fig. 26) one nave is wider than the rest, while the Damascus pattern is repeated in Aleppo and in Qasr al-Hayr East. In the mosque of Abu Dulaf in Samarra (fig. 36) and in the mosque of Kairouan (fig. 40), in addition to the axial nave, the nave nearest the qiblah wall is separated from the rest by being wider, and a cupola occurs at the point where it and the axial nave intersect. In the Tunisian sanctuary a number of later reconstructions accentuated these two naves by means of domes at the beginning of the axial nave, at the intersection, and at the two corners. This arrangement became formalized in some of the tenth- and early-eleventh-century mosques of Cairo (fig. 47). Formally the development has been called T-shaped and, out of the traditional hypostyle, there emerged a sub-branch called the T-plan hypostyle.

One explanation has seen the source of this development in the art of the palace. It has been noted that the axial nave, the mihrab, the minbar, and, when it occurred, the maqsurah form a single unit on the axis of the mosque. Taken separately each of these features has a formal and a ceremonial parallel in the architecture of the palace, as will be seen in our next chapter. Taken together they recall a throne room with an aisle for attendants and a place for the throne in a niche preceded by a dome. Existing texts do indicate that, on some occasions, royal guards lined up on the axial nave while the prince performed his function as imam. Yet this explanation does not account for

the formal development as a whole. Most of the adduced texts refer to unique, special occasions, such as the inauguration of the mosque of Madinah. And, more important, the internal organization of an axial nave occurred far more frequently than royal ceremonies would justify and at the same time is not found in a number of clearly royal mosques.

An alternate explanation combines formal and religious considerations. However convenient the hypostyle may have been, it was a diffuse system that lacked architectural focus and direction. Yet the sense of a direction is essential to the mosque, since one of the canonical obligations of prayer was that of facing the qiblah. In the earliest buildings, the political and social meeting-hall aspect of the mosque predominated—for which the hypostyle is eminently suitable—and the direction was indicated by the position or size of the covered areas. As the political function of the mosque dwindled, the purely religious one increased, as appears in the rapid growth of the mihrab in size and decoration. The qiblah wall acquired an almost mystical character, and one can explain the axial nave and the T-plan as attempts to emphasize this increasingly cultic and pietistic use of the mosque. But something else may have been involved as well. The axial nave appears first in the great constructions of Walid I, and its best preserved example is in Damascus. Although known in Iraq, the T-plan and most later axial developments occurred in the Muslim lands bordering on the Mediterranean. It could be suggested then that, as the hypostyle idea created in Iraq utilized the vocabulary and composition of classical architecture and its heirs, the simplicity of the idea could not easily be transferred to existing forms. Builders and users could no longer— if they ever did since the Parthenon—consider the single support as the only unit of composition. More complicated arrangements were demanded and adapted to the religious functions of the mosque. This structural development is strikingly similar to that of Christian architecture as it evolved the basilical hall out of classical Roman forms.

Thus at a certain moment and especially in the Mediterranean the composition of the hypostyle mosque acquired a number of formal rather than purely utilitarian aspects. One of these was the search for an axis, for a sort of backbone or skeleton around which the form itself could develop. It is in Fatimid architecture, first in Tunisia and then in Egypt, that one can observe the standardization of the several varieties of the hypostyle tradition, and it is largely in the later architecture of North Africa that the T-plan was destined to develop most fully and

was maintained the longest. It is then not accidental that exterior façades appeared in mosques also in the Mediterranean architecture of the Fatimids during the tenth century (fig. 47), thereby identifying the century and the area as the time and place of the "classical" culmination of early Islamic mosque architecture; in other words, this era exhibits an equilibrium between known functions, accepted signs and symbols, and an intentional search for formal consistency.

To sum up on the architecture of the mosque, the most original Muslim creation is that of the hypostyle mosque, best suited to the purposes of the new faith and society. In a general way the manner in which the type was created can be reconstructed. As there was no preconceived notion of the building's physical nature, the need for a certain kind of space was first met; then this space, partly open and partly covered, was enclosed by walls; finally a series of symbolic "signs" were put in it. Some were religious and ubiquitous, like the mihrab. Others were administrative, like the minbar, or princely, like the maqsurah. Some were primarily formal, like the T-plan or the axial nave. Some even altered their meaning over the centuries, like the minaret. Within the standard type, these features are variables, just as the nature of the multiplied unit—single support, bay, or nave—can be a variable. Each of these variables depended on its own set of circumstances: the importance of the mosque's locality for the minbar or the maqsurah; and the region in which the mosque is found for certain features of the plan and for its technique. There is nothing strange or unusual about an architectural form developing as a type with a set of variables, yet there are peculiarities about the formation of the mosque. One is that the type was formed in spite of the absence of a clergy, a liturgy, and a preconception of the building's physical nature. The Muslim social entity in fact devised its own form. In the early eighth century the systematic building activities of the Umayyads, particularly al-Walid I, helped to standardize certain features, especially the symbolic signs like the minaret or the mihrab. But by then the form of the type had already been created. Its sources were primarily functional, with the need for flexible space predominating; but one other need was important in the transformation of a space into a building—that of having a building which was distinguishable from other religious buildings or from buildings identifiable with other cultural entities, especially Christianity. Here, however, occurs the second peculiarity of the history of the early mosque. The constituent units of buildings like the mosques of Damascus or of Cordoba appear

to be the same as those of churches or of other pre-Islamic or non-Islamic buildings. What has changed is, first, the sequence of these units—towers, naves, columns, niches—so that three naves parallel to each other, as in Damascus (fig. 23), are no longer a church because they are of the same dimensions and run perpendicular to the orientation of the building. Another change is that the beholder understands these units in a Muslim context. The shape of the tower or niche was not modified to the point where they could no longer be a church tower or an honorific niche in a Roman ensemble. But the context in which they were put by early Islam automatically associated a tall tower or a niche with a building of the new faith and in this way discarded other meanings and associations from these forms. These two changes illustrate principles of architectural transformation valid at other times as well. For instance, one could argue that there is attached to most forms a "vectorial" quality or a certain direction, and that a change in direction, or in position within other forms, can alter the form's significance without altering the form itself. Then also, the attitude of the beholder affects the meaning of certain forms and thus compels the ways in which they develop.

One last conclusion to emphasize is that, as the decades went by and as caliphal power became imperial and remote, the mosque became less an instrument of policy (except symbolically) and more a place for religious practices and for such activities, teaching for instance, as were part of the "ethical" life of the Muslims. There occurred a sort of "interiorization" of the mosque, as though it were a world independent of its surroundings, reserved and restricted to the members of the community. An interesting aspect of this closed entity is the limited number of its own symbols. Only the mihrab appears as a religious symbol of some significance, but, however heavily decorated it may have been, never in the history of early Islam does it appear as the focal point of a mosque's plan, in the way that the altar, the iconostasis, or even certain icons and relics became the focal points of a church's structure. Islam avoided visually perceptible symbols in its early religious architecture, just as it felt reluctant toward images. This may have been once again to avoid entrapment in Christian practices. Or perhaps wider causes may be suggested. It may be proposed that nonhypostatic religious systems—that is, those that emphasize a total monism and reject the possibility of a sharing of divine grace—like Judaism or extreme Christian Protestant sects, reject or avoid even an architectural symbolism of their faith. Only much later,

with the growth of a more pantheistic Sufism, of shi'ism, and of cults of saints did Islam, especially in Iran, create a variety of architectural forms to which a religious symbolism and a mystical interpretation can be given.

While the hypostyle mosque with its variants and its implications became the dominant form of early Islamic religious architecture, others occurred as well, and other religious or quasi-religious functions found monumental expression. Inasmuch as some of these forms and functions acquired prominence in later centuries or illustrate interesting if minor aspects of the formation of Islamic art, there is some point in mentioning briefly a few of them.

Next to the large city mosque there existed from the very beginning smaller quarter mosques or typologically abnormal ones. An Umayyad mosque near Qasr al-Hallabat in Transjordan, can be interpreted simply as a miniscule hypostyle. A group that appears to have existed from Spain to Central Asia was divided into bays, usually nine of them (fig. 39). In each instance some local reason probably explained the size or type. Some regions stand out as having developed aberrant types, particularly in Iran. At Niriz a mosque seems to have been based on a single *eyvan*, a large vaulted unit opening on an open space (fig. 49). In Central Asia the Hazareh mosque consisted of a central dome surrounded by an ambulatory (fig. 50). A number of mosques may have been simply pre-Islamic Persian fire-temples consisting of a single square room taken over as mosques, or may have reproduced other Sassanian religious buildings. In Syria a number of churches were converted into mosques and, even though the architectural impact of such conversions seems to have been limited, a regional variant existed there as well.

More important is the appearance of new, particularly Islamic functions that acquired a monumental form. As early as the ninth century there were in Iran specifically Islamic schools or *madrasahs*, although none is known archaeologically. Commemorative buildings, especially mausoleums to holy men, are less uniquely Islamic; but in Egypt, Iraq, and northeastern Iran (figs. 128ff.), the cults of descendants of Ali and of spiritual leaders grew in the tenth century and at times was provided with the monumental form of a centrally planned domed building, whose development cannot be considered architecturally significant before the tenth century. The case of the ribat was brought up earlier. An institution known on almost all the frontiers of Islam, especially in Central Asia, Cilicia, and North Africa, it was dedicated

to the monastic and missionary fighters for the faith. A number of early ribats have been preserved in Tunisia, the most celebrated one being at Sussa (fig. 51). It is a fortified square building with a central courtyard surrounded by a portico and halls arranged on two floors around the court. One of the halls was a mosque and was provided with a minaret. The form of the building relates it to the secular art we shall discuss in our next chapter, but its function is uniquely Islamic. It is a feature of the Muslim frontier, of the peculiarly fascinating world at the edges of the empire where a Muslim elite sought to convert others and mixed with an astounding variety of ethnic and cultural groups. Although we know very little about the formation and history of a Muslim frontier spirit, it shaped much of the mind and the forms of later Islamic culture, and it is perhaps not an accident that original functions first developed there quite early.

Having sought to define and explain the typology and the composition of early Islamic mosques, we must turn to their construction and decoration to discover whether they exhibit characteristics that would identify a Muslim novelty and originality in building techniques or in ornamentation. Since these aspects of early Islamic art have been studied more often, we shall limit ourselves to a rapid survey of their most important features and to a few comments on their significance.

Walls were almost without exception large and massive, rarely pierced or decorated from the outside. They were primarily the means of separating a space reserved for Muslims from the external world, and there was hardly a symbol or sign on the outside that would indicate the nature of the building. Gates or doors began to appear in the western Islamic world in the latter part of the ninth century, but they are rare. In the mosques of Samarra and in the mosque of Ibn Tulun in Cairo, outer walls acquired a crenellation and an organized system of windows and openings that served to alleviate the monotony of a blank wall. Elsewhere a brick decoration of circular units set within squares appeared between the heavy buttresses typical of brick wall constructions since Sumerian times. Altogether it is not much, and not even in Iran can we discern the fascination with an architectonic treatment of the wall which will be so typical of later religious architecture in Islam.

Free supports were the main means of elevation in the mosque. Columns were either removed or copied from older buildings. Except for an occasional gathering of columns in groups of two or three (as in Kairouan or in the Amr mosque in Fustat), the column with its constit-

uent parts was used in traditional, pre-Islamic ways. Even capitals were generally reused from older buildings. The pier, that is, a supporting unit that does not possess the inner structure and divisions of the column and that tends to merge with the superstructure, was also not an Islamic novelty. Its use in Damascus or in Jerusalem is traditionally Mediterranean. But in Iraq or Egypt the Islamic brick pier, with its occasional articulation consisting of corner colonnettes, is a departure from older types of brick piers and prefigures the tremendous development of that element of construction in later Islamic architecture (fig. 42). Even the peculiarly medieval Islamic confusion or at least ambiguity between wall and pier begins to appear in the huge (4.03 meters across) piers of the Abu Dulaf mosque. Articulation of the pier occurs only in the very simple form of T-shaped, L-shaped, or cross-shaped piers. Here again, in spite of a definite crystallization of types hitherto less clearly identifiable, it is difficult to attribute to the mosque a major novelty in this particular technique of construction. Nor can a multitude of small details associated with columns, or capitals, moldings, brackets, bases, be identified as peculiarly Islamic. Yet when one contemplates a mosque like that of Qasr al-Hayr East (fig. 52) with its piers, columns, capitals, and decorative friezes all taken from a variety of older monuments, a further point emerges. Not only is there no consistent sense of an "order" in freestanding supports, it is almost as though such an order was purposefully avoided, as though the specific architectural notion of an order was aesthetically meaningless. Even a great composition like that of the Damascus mosque shows a similar disregard for the traditional Roman relationships between structural and ornamental parts in the mosque's supports.

The vast majority of supports are surmounted by arches; most of these are semicircular, but, as has been often pointed out, the pointed arch that culminates in the mosque of Ibn Tulun appears in a number of early Islamic monuments. The full architectonic properties of the pointed arch were not fully realized except in the comparatively minor aspect of lightening the spandrels on the arch's sides. Thus most early Islamic arches simply continued earlier practices without significant change. The same appears to be true of vaults, rarely found in mosques at that time except in a few Iranian buildings, and of ceilings and roofs, which were flat or gabled, usually in wood.

The exception occurs in Cordoba, whose two-tiered arches exhibit a variety of shapes, from simply horseshoe to a number of polylobed

modifications of the horseshoe shape (fig. 31). The pointed arch does
not serve here to span variable spaces, as it does in Gothic architec-
ture, but in order to lighten the thrusts carried by any one of its
components and thus to make it more easily ornamented. As it be-
came lighter it was less effective as a support, and thus a system of
crisscrossing polylobed arches was introduced, in which the arch ap-
pears to be broken into segments. The very same kind of virtuosity
occurs in the four tenth-century cupolas of Cordoba (fig. 30). The only
earlier example of a major stone dome is found in Kairouan (fig. 54).
What makes the Kairouan example remarkable is not its structural
novelty but the robustness and clarity of its movement from square to
octagonal zone, sixteen-sided zone to ribbed cupola, and the sobriety
of its ornament. In Cordoba, on the other hand, a particularly rich
ornament does not overshadow the structural novelty of large ribs
cutting across the inner surface of the spherical shape and thus subdi-
viding it into a number of smaller sections while maintaining the
cupola's unity. As with the arches, a certain ambiguity exists between
structural and ornamental value, but the originality of these domes is
obvious.

Although it is possible that there was a foreign, Armenian impact
on the arches and vaults of Cordoba, they can equally well be ex-
plained as a result of local needs. Spanish Muslim architects had to be
concerned with arches, whereas their Syrian counterparts did not feel
the same demand. The Spanish lacked the mass of large columns
found in Syria, and the small supports of Visigothic Spain were hardly
suitable for the huge space of the mosque. Thus means to heighten the
building had to be discovered; this search led to the double-tiered
system, and the rest may be understood simply as further elaborations
on an initial concern for height. The cupolas can also be explained as
reflecting the newly acquired playfulness with arches and the feeling
that these traditional units could be broken up into small entities. No
iconographic meaning as such can be given to the forms of the arches
and domes, but one can be suggested for the existence of more elabo-
rate forms in a certain part of the mosque. They are all found around
the mihrab (figs. 32, 45) and on the axial nave, serving thus to empha-
size the holiest part of the mosque or its royal part. Thus a major
structural uniqueness in the arches and ceilings of Cordoba can be
interpreted, because of their elaborate and ornamental character, as
the result of an internal need of the mosque. Their origins can perhaps
be sought in the art of the court, a point to which we shall return in the

next chapter. Yet, however one explains these Cordoban peculiarities, two points about them seem essential: they are unique and thus lose somewhat their indicative value to demonstrate major structural changes in the forms of early Islamic mosques; and, even though the original entity, indeed Vitruvian integrity, of the arch or cupola is broken—and thus one is forewarned of the great Muslim achievements in vaults several centuries later—the Cordoban elements are not revolutionary changes of structure but merely advanced modifications possible from the nature of the form itself.

The techniques of decoration utilized in early Islamic mosques are remarkable first of all for their variety. Mosaics occur in the Umayyad buildings of Syria (figs. 13, 14) and in Cordoba (fig. 30). In both instances the workers seem to have been brought from Constantinople. Carved and painted woodwork as well as stucco were used to give emphasis to major architectural lines, as in the Aqsa mosque (fig. 53) or in the mosque of Ibn Tulun (fig. 42). At times whole wooden panels were set on walls, as in the Aqsa mosque. In Nayin in western Iran and in Balkh in northeastern Iran, carved stucco covered columns as well as parts of walls. Wood was also commonly used to make and decorate mihrabs, minbars, and maqsurahs (fig. 45). Sculpted stone was somewhat rarer but occurred in the cupola of Kairouan and in Cordoba, where superb marble panels have been preserved (fig. 55). Glass, at times probably of different colors, was used in windows, which often had a stone or stucco grillwork of considerable complexity, as we know from Damascus and Cordoba. In Kairouan there has been preserved a unique decoration of ceramic tiles—in this instance imported from Iraq—that were inlaid in the masonry (fig. 45). Possibly rugs and textiles were utilized as well. Curtains were found in a number of places, as we know from texts, but there is no indication as to whether these were merely utilitarian means of separating various parts of the mosque or whether they had a definable aesthetic intent in the manner of contemporary textiles in Byzantine churches.

The significance of this variety of techniques lies primarily in the absence of the technical automatism of mosaics and painting found in Byzantium or of sculpture and glass in the Gothic. In other words, there was in early Islamic times no formal association between the mosque and certain techniques of decoration. Yet it should be noted that a precise technique of decoration tends to predominate in any one monument: mosaics in Damascus, stucco in Ibn Tulun's mosque, stone and ceramics in Kairouan. Except perhaps in Cordoba, there does not

seem to have existed a building (as there would in later Islamic art), in which a museum of available techniques would have been created. One small point about the techniques is rather puzzling. What we know of Iraqi mosques indicates that they were far less decorated than mosques elsewhere, which is all the more strange since a number of mosques in Egypt, North Africa, or Iran are supposed to have been influenced by an Iraqi decoration we know otherwise from secular buildings. In all probability the new cities of Iraq did not feel as strongly as their Mediterranean counterparts the pressure of imitating the elaborately decorated churches and temples of the conquered territories.

The main problem with this decoration is to ascertain its meaning. Is it simply ornament, that is, designs of whatever nature whose primary purpose is to enhance and beautify whatever part of the building it covers? Or does the decoration or any part of it possess some sort of symbolic significance that would make it an image, related to the mosque but independent from its ideological or aesthetic goals? The difficulty in answering these questions derives first from the fact that almost all the designs found in mosques can be interpreted simply as ornament. The long inscriptions in the Dome of the Rock, in the mosque of Ibn Tulun, or in Cordoba frame and emphasize certain architectural parts, and their intelligibility as texts may not be pertinent to their utilization in the decoration. The architectural compositions of the mosque of Damascus, when imagined as a sort of sheath covering the whole building, can also be understood as just a sheath of glitter and not with the iconographic meanings we have discussed in our last chapter. In other words, it is not only possible but even correct to see the decoration of mosques as primarily ornamental, as a faithful handmaiden of architecture. It has its importance in a history of pure ornament and to this we shall return in our last chapter. From the point of view of the mosque a possible iconographic significance of this decoration lies in two areas.

First, an analysis of its frequency in a given building indicates the respective importance of various parts of the mosque, as we have shown for Kairouan or Cordoba. The use of decoration in these instances would be mainly to accentuate the parts which, for symbolic or practical reasons, were singled out. One might divide almost all mosques with an extensively preserved decoration into a group that sought to identify some parts of the building as more important than others, and into a group (the mosque of Ibn Tulun, for instance) whose

decoration on the contrary sought to strengthen the total unity of the monument. One wonders whether in the mosque of Damascus the largely lost mosaics were meant to emphasize the axial nave or to decrease its impact by covering it with the same themes as were found in the secondary porticoes of the court. In the absence of sufficient evidence this particular query is fruitless, but the hypothesis can be proposed that two separate and contradictory functions of a mosque's decoration, those of unifying or singling out parts, were found alongside of each other. It is not yet possible to decide whether regional or chronological considerations, or considerations of patronage, were responsible for the choice made in any one instance.

The second aspect of this decoration is that on occasion it is possible to suggest for some of its themes a concrete iconographic meaning. The jewels and crowns in the Dome of the Rock, the architectural landscape in Damascus, perhaps even some of the details of the mosaics in Cordoba or in the Aqsa mosque can be understood in their times as images of victory, glory, and paradise. The idea of a vegetal and architectural decoration as an expression of paradise is a particularly tempting one, for there are other indications that a mosque's courtyard or open area was meant to be a sort of paradise. It contained trees and running water in Cordoba and Seville, and the rather mysterious domed buildings which existed in Nishapur and in the mosque of Ibn Tulun could be interpreted as the architectural translation of the small pavilions of a paradisiac landscape. But, even if these interpretations are acceptable, the main point is that they were soon forgotten or relegated to the background of the culture's collective memory. With the concrete historical meanings gone, the forms appeared so abnormal that they were hardly ever repeated. If meanings existed originally, then the impetus for their rejection and eventually oblivion did not come from the patrons or the artists of the time but from the beholders, the community that used the mosque. Whether it was already their taste that compelled Abd al-Malik or al-Walid to limit the formal range of the decoration or whether, as was suggested in the previous chapter, the princes themselves made the choices, the meanings originally associated with these forms were rejected by the Muslim beholders, even assuming that the majority had understood them initially. By rejecting them the community affected the shape of future designs and refused, in all but a few architectural features, a visually perceptible formal symbolism of their faith.

On the whole this conclusion seems valid, for the early centuries of

Islam and several more centuries passed before a formal religious symbolism reappeared in Iran or in Turkey. Yet one must be aware of actual or possible exceptions, such as popular faith. For what is reflected in most large monuments or in literary sources is the view of princely patrons and of a literate urban Islam. Underneath were the rapidly growing converts from older and often image-ridden religions, and also the partly settled but still half-pagan desert Arabs. The accounts of various heretical revolts, especially in Iraq, often mention the presence of idols or visual symbols in what are presumed to be Muslim heterodoxies; the popular cults of holy places that developed in later centuries often occurred on the spot of pre-Islamic cults; and funerary practices did use a variety of visual symbols, although much of them are unknown or unstudied. On the basis of what happened later we can assume the existence of a folk Islam that may not have abandoned as rigorously as official Islam the magic or semi-magic of religious symbols.

The other exception is a very official one: writing. One of the fairly common motifs of mosque decoration was the writing of a variety of Arabic texts, mostly Koranic but including as well vital statistics about the building. In an early mosque in Kairouan, the mosque of the Three Gates (fig. 56), a large inscription covers most of the façade and appears as the main subject of decoration. This inscription had an iconographic meaning, as did those for the Dome of the Rock, for coins, and for any number of other examples. Arabic writing on monuments was thus more than decoration; it was a subject matter restricted to the Muslim or Muslim-ruled community and thereby expressing concrete meanings belonging to the members of the faith. It can appropriately be considered as an invention inspired by Islam, and its manipulation on monuments was comparable to the ways in which images were used in Christianity. Next to standard texts repeated over and over again (especially Koranic quotations), one can find fairly often an innovation or a modification that usually reflects some peculiarity of the monument or some unique meaning given to it.

These uses of writing for iconographic or ornamental purposes were not current in monuments at the very beginning. Most early Iraqi and Syrian buildings are devoid of inscriptions, and it is perhaps not before the ninth century that they become almost automatic. Since so many of the formal elements used by Islam at the beginning were those of previous cultures, the Muslims were constantly affected by their properties. And, just as they only removed or rejected older

themes when it was essential to the maintenance of their own integrity, so also they avoided grafting onto them anything new unless it was necessary or until they felt sufficiently secure to be able to do so.

The use of writing was not limited to monuments. As Islam settled in the conquered lands, it became an immensely literary culture, in which the written word was the main vehicle of thought and communication. But, because of the sacredness of the Word, next to the normal growth of a variety of scripts there occurred an art of calligraphy which soon became a most uniquely Muslim art. It is one of the few artistic techniques about which we are fairly well informed through literary sources. Since the many remaining fragments of Korans have never been properly studied from paleographic and formal points of view, only a few general remarks can be made. First, most of these Koranic pages (fig. 57) are very difficult to read, for they lack diacritical marks and other aids developed over the centuries to clarify the Arabic script. This difficulty is explained if we recall that the beholder knew the Koran and found a minimal "sign" sufficient. An art of calligraphy, whatever its abstract values visible to all, very much presupposes a full knowledge of the text, but is this not true of any religious art—that it can be fully understood only if its sense is already known? Then, calligraphy in early Islam cannot be seen as writing alone, for it was but the most important impulse for the formation of a whole art of the book with a host of ancillary techniques. Little though it is known before the twelfth century, this art of the book became, far more than the mosque, the Muslim's most sacred personal experience.

Since the last chapter will return to some of the implications suggested by the preceding discussion, the conclusion here is limited to summary answers to the following three questions. What is it, if anything, that Islam created that appears to be unique because of its being Muslim? And what does it tell us about Islam in general and about early Islam in particular? In other words, are there historical lessons to be drawn from our remarks?

To the first of our questions, the answer is fairly simple. The hypostyle mosque became a *type* that presupposed an idea of a mosque, a collective memory of certain forms best suited to the universal needs of the community. This type was created in the new Muslim cities, primarily in Iraq, rather than in older conquered cities, and its spiritual prototype may have been the house of the Prophet in Madinah. Over the first century of Islam a number of features were added to the type.

Few had a strictly religious content and few became compulsory, for there was only one clear need in the mosque, that for a huge space. Most additional developments pertained to an aesthetic or princely and ceremonial ordering of the space. The architectural or decorative terms used in the making of the mosque were never new inventions, and even when certain formal or constructional modifications did occur, they were largely contained within existing pre-Islamic forms. Yet it is almost impossible to confuse a Muslim mosque with a pre-Islamic building, for what changed were not the phonetic or morphemic elements of the building but its syntactical structure. There was no uniformity in the nature of the syntactical change. At times, as in the case of the nave in Damascus or Jerusalem, it was simply that a new direction was given to otherwise known entities. At other times, as in the instances of the mihrab or of the minaret, an older term with a fairly general significance was given a new and concrete one. Or a term that had for centuries a fairly precise aesthetic significance in the ordering and composition of an elevation lost that significance and became, as in the case of capitals, merely the constructional element between a column shaft and an arch, a simple redundancy. There were no major constructional changes in the artistic vocabulary of the Mediterranean or the Near East, merely a series of new combinations of existing forms. Only the slow appearance of calligraphy as a major vehicle for aesthetic energies and symbolic meanings is a true novelty of the early Islamic period.

If one turns to the historical lessons that may be drawn from the formation of an art inspired by Islam, three points emerge. First, there were considerable regional variations. These go far beyond such facts as that Iranian mosques used vaulting before Syrian ones or that the lack of large columns in pre-Islamic Spain can explain certain peculiarities of the development of arches. Rather, the qualitative density of an Islam-inspired art varied from area to area. The main and most successful forms were created in Iraq, Syria, and around the Mediterranean; Iran, especially the western part, was least affected, and its monumental growth did not begin before the eleventh century. Throughout, the preeminence of the Fertile Crescent is apparent.

Second, two impetuses underlay the formation of this aspect of Islamic art. One was a reaction to earlier artistic traditions, especially those of Byzantine Christianity; the other was the continuous impact of the Muslim ummah, that is, the continuous presence of a large social body that molded and modeled the forms of its art. It appeared

in the community mosque, but also in the peculiarities of the frontier's ribats and in the cult of holy men.

Third point, early Islam seems on the whole to have avoided visual symbols that identified it clearly and precisely. Whether this was a negative result of the power of symbols in Christian art or whether some internal Islamic reason brought it about, the new culture did not endow its novel forms with liturgical or symbolic meanings; or rather it did not compel such meanings on the whole body social. It did not exclude them. Individual mystics and later certain groups did use and understand visual religious symbols, but an ambiguity of meaning remained a permanent characteristic of Islamic forms. One may wonder whether this conclusion cannot be widened to Islamic culture in general, at least at its high orthodox level. Was it not a culture which, in the abstract fullness of its unique divine vision and in the concreteness of its social concerns, never quite succeeded—or consciously refused—to bridge through physical symbols the gap between one God and a good life?

6. *Secular Art: Palace and City*

The previous three chapters have considered those early Islamic monuments or attitudes whose functions and forms were directly inspired by the new faith or by the state and civilization derived from it. These monuments and attitudes had a culturally restricted significance and—even though they were not always strictly speaking religious—pietistic and ritual needs, habits, and symbols tended to predominate in their evolution, if not in their creation. Coinage acquired Koranic quotations, the Dome of the Rock became a holy sanctuary, and the mosque grew in liturgical and religious meaning.

But early Islamic art was not limited to such monuments, nor can it be established a priori that the attitudes defined in the fourth chapter affected all aspects of material culture and aesthetic creativity. On the contrary, since the conquest and establishment of Islam were in most cases not accompanied by major destruction, it can be assumed that the vast majority of the needs and activities of life continued "as usual." The variety of these activities makes it rather difficult to group them all in the same category, but the term "secular" may be used, because clearly religious features (Muslim, Jewish, Christian, Zoroastrian) are automatically excluded. "Secular" should not, however, be understood negatively as whatever is left over. In a positive way, it is an art whose apparent inspiration and purpose are defined in social and individual terms rather than in spiritual or cultural ones. Secular art can be just as restricted as religious art, for a palace is reserved for a prince and only the rich can afford certain objects. The epistemological difference between the two is that there is much more common ground in the functions and inspirations (but not necessarily forms) of secular arts from different cultures than of religious arts. In this aspect of secular art lies its importance for our purposes, for its forms and functions can be imagined as the expression of an aristocratic social level continuing older ways. Therefore, the modifications made in earlier forms by the new culture, if they can be properly identified, are essential in defining cultural and aesthetic changes peculiar to Islam. It is also possible that the changes are only accidentally preserved in Islamic culture, having disappeared in Byzantium and in the West, and thus that the value of the secular arts of Islam extends far beyond the Muslim world itself.

Secular inspiration or meanings have already been mentioned for a

number of features in previously discussed monuments and, before
proceeding to a systematic study of the theme, we may recall some of
these. In coinage the Muslim world failed to adopt an iconography of
power that would define its nature in the terms of previous cultures,
and it substituted a written statement of its doctrine. As an artistic
element, coinage thereby lost some of its significance, for the medium
itself makes it rather difficult to decide whether changes in epigraphi-
cal style corresponded to wider changes in the culture itself. Only very
rarely has it been possible, so far, to use coins for the elaboration and
solution of Islamic art historical problems as has been done in classical
or Byzantine studies. But this may also be the result of insufficient
investigations, as has been demonstrated by a few recent studies that
have dated and explained through numismatic evidence stylistic pecu-
liarities of other techniques such as ceramics.

Then, in the Cordoba mosque the maqsurah complex with its elabo-
rate decoration, and perhaps even other parts of the masjid, axial
nave, or mihrab, could be interpreted as intrusions of a palace art into
a sanctuary. Next to clearly religious mausoleums there were secular
ones, the most remarkable being that built in the first half of the tenth
century for a Samanid prince at Bukhara with its elaborate, jewellike
decoration and formal gateways which do not agree with the main
trends of religious architecture (figs. 128, 129). There is a strong possi-
bility of an impact from court art, and even some sanctuaries may have
been inspired by such royal mausoleums. Finally, in many instances
the decoration of mosques was primarily ornamental, hence much of
that decoration would qualify as secular, for, if its formal and signifi-
cating ties are not with the building in which it is found, it lacks the
culturally restricted meaning attributed to religious inspiration.

Much else is known about the secular art of early Islamic times. The
main difficulty lies in presenting it in a coherent manner. At the risk of
oversimplifying a little and of prejudging some of the conclusions of
this chapter, the mass of material is divided according to two subhead-
ings: the art of the court and the art of the city.

A. The Art of the Court

The most celebrated and important documents about an Islamic
court art are palaces, which can be divided into two groups. The first
is generally associated with the Umayyad dynasty because its best
known and best preserved examples were built by Umayyad princes in

connection with the agricultural enterprises mentioned earlier. It is known primarily through archaeological sources. The second group is more clearly related to the Abbasid dynasty, although the type is known also in Egypt, Spain, Tunisia, and eastern Iran. Most of its examples are found in cities, large or small. Archaeologically it is a far less well-known group and, imperfectly though they have been excavated, the palaces of Samarra in Iraq and of Madinah al-Zahra in Spain are its best illustrations. On the other hand, much information about these buildings can be derived from literary descriptions and from imperial ceremonies. Because of these differences in the nature of the information we possess, it seems preferable to discuss the two groups separately and then to attempt to tie them together with some considerations on the nature of early Muslim palace architecture.

About twenty early Islamic, primarily agricultural sites in the Fertile Crescent show some evidence of a palace, or at least some sort of more elaborate establishment than simple inhabitations. Of these the most important are Khirbat Minyah, Qusayr Amrah, Khirbat al-Mafjar, Jabal Says, Qasr al-Hayr West, Qasr al-Hayr East, Mshatta, and Ukhaydir, the latter being the only example found in Iraq rather than in the western half of the Fertile Crescent. One early Islamic palace, in Kufah, is an urban one and will be discussed later. Few of these buildings can be *proved* to have been constructed by and for the caliphs themselves, and although the inscriptions found on some of them provide the name of a ruling prince they do not usually indicate that the palace was built for him. It is in fact much more likely that we are dealing with an aristocratic architecture rather than with a strictly imperial one. Typologically these early Muslim foundations are related to the Roman tradition of the villa, especially the villa rustica, that country establishment of Roman aristocracy which could reach imperial proportions in Tivoli and Piazza Armerina but which more often than not was merely a sort of elaborate farmhouse with physical amenities brought in from the city. Late antiquity and the early Middle Ages continued this Roman tradition, as is known from examples in Tunisia, Anatolia, and Syria, where the celebrated Qasr ibn Wardan is to be so interpreted. Comparatively little is known about the shapes and internal arrangements of these early medieval villas, and the accidental preservation of so many Islamic examples illustrates the character of the type for a much wider area and longer time than the Fertile Crescent in the early eighth century. It may be recalled that these

examples can be related to Renaissance and Baroque Roman castelli, to northern Italian villas, and to eighteenth- and nineteenth-century English or French country residences or châteaux. In all these instances one can identify a number of shared purposes regardless of the immense differences in styles: intermittent rather than permanent full use for living, quality of amenities, few public functions, pleasure rather than power. The latter point is of considerable importance in defining the index of value for historical and even formal purposes of this kind of establishment. Because it was not meant to be used primarily for official state occasions, it reflects private needs and private whims, thus lending itself with greater difficulty to stylistic generalization. Conversely, such features of this art as may be shown to have been repeated systematically can quite securely be taken as characteristic of their time.

Such establishments do not seem to have remained characteristic of the Islamic culture. To my knowledge there is no archaeological or textual information about them from Egypt, the Jazirah, Spain, and Western Iran. In Transoxiana, especially in the area of Soghd and to a smaller degree in Khorezm, there existed a continuous tradition starting at least as early as the fifth century A.D. of fortified establishments in the country and, in spite of still very incomplete archaeological evidence, it seems that this type of building continued until the tenth or eleventh century. At first glance many of these buildings could be considered as nothing more than forts, but their rather elaborate internal composition—at times with a central cupola and formally differentiated halls around the domed room—suggests some sort of more official purpose. Furthermore, some of these buildings exhibit a rather novel experimentation with brick vaults which does not seem to fit with purely military architecture. Unfortunately, none of them has been excavated; they do not seem to have been provided with an abundant decoration and it has not been possible so far to adapt known functions to such parts of the buildings as can be differentiated architecturally. Furthermore, proper criteria have not been developed for the dating of many of these monuments. While textual evidence such as Narshakhi's *History of Bukhara* does suggest that the landed gentry of Transoxiana—perhaps also of Khorasan—owned and built country estates, the texts do not imply anything similar in size or wealth of decoration to the Umayyad constructions of the Fertile Crescent; thus, without excluding its possibility, the existence of an aristo-

cratic palace architecture in the agricultural countryside of the northeastern Iranian world in early Islamic times is not entirely demonstrated.

The other region is North Africa, especially Tunisia and Algeria. The pertinent archaeological information there is comparatively late for our purposes, for hardly anything exists before the tenth century and the establishment of the Fatimids in Tunisia. At the same time, partly excavated sites such as Mahdiyah, Mansuriyah, Ashir, and the Qal'ah of the Beni Hammad offer a sufficient number of analogies with earlier establishments in the Fertile Crescent. All North African examples are much larger than their predecessors, and most of them can almost be considered as cities. Yet, cities though they may have been, they were too small to be urban centers. They were official settlements for princes away from the large urban centers and, at least in Tunisia, there is good reason to believe that they had an agricultural function. Even if the latter is not their primary explanation, even if their size and monuments were affected by a series of other developments than those of the early establishments and especially even if they had more of an official and less of a private character, they appear far more clearly than their Central Asian counterparts to be in some sort of succession to the eighth-century foundations in the Fertile Crescent.

Altogether such examples of succession are few, and the Umayyad group of monuments in Syria, Palestine, Transjordan, and Iraq form a unified set. In the past they were understood as peculiarly early Islamic reflections of a taste for a life in the desert, or at least at the edges of the desert. The Arabic term *badiyah*, which refers to the semiarid zone with many of the buildings, was used for this taste. This explanation has to be abandoned, not only because the presence of the desert near many of these settlements is secondary to their existence, but also because the word *badiyah* never had the highly romantic meaning given to it by a romantic generation of investigators. To use the merely economic explanation proposed in the second chapter, that lands were inherited by Muslim owners on which they built palaces and other monuments, is also insufficient. For there was no need to build elaborate constructions in the lands one exploited, and many a latifundium did not possess such constructions. Another explanation for these establishments can almost be called one of sanitation, for poets often expressed their distaste for plague-infested cities and their yearning for a free and unpolluted air, but such statements are mostly literary clichés and are certainly contradicted by the immense urban effort of

early Islam. Thus, even though a certain degree of simple physical "escapism" may have been involved in some instances, like those of the strange exiled poet-prince al-Walid ibn Yazid, some other explanation must be provided.

It is perhaps not an accident that the largest number of such establishments is found in Syria and Palestine, the region with the smallest immediate islamization of earlier urban centers. Far longer than other provinces it remained predominantly non-Muslim, even though the empire's capital was there. It is then quite understandable that Muslim princes might have felt more at ease in the less populated countryside in expressing their newly acquired wealth and way of life. It is also possible that more examples than we know had remained of rich Roman villas, but this point is rather debatable. Finally, it is likely that, since at this time the power of what had been called the "Arab kingdom" was very much dependent on nomadic, half-nomadic, or newly sedentary tribes, the countryside seemed to be a better meeting ground between the princes and the great tribal chieftains with their huge retinues than the cities, notoriously wary of and inhospitable to nomads. When the sources of power came to be located in the cities and in a professional mercenary army—as happened from the latter part of the eighth century onward—such country establishments lost their raison d'être.

The ultimate explanation for the phenomenon probably lies in some sort of combination of all these possible causes. The significant point—and the main reason for these details in trying to explain the existence of Umayyad villas or castles—is that, however fascinating they may be individually, these monuments have only a limited historical importance in the formation of an Islamic art. They were not in the mainstream of the culture's development. Probably for this reason no memory of these palaces has remained in medieval chronicles, except in the very faint way that Umayyad princes spent a lot of money for buildings. But, if their historical importance is limited, they provide considerable information in two other areas. One is that of pre-Islamic art, for we have here a large body of monuments whose forms had to have been taken or adapted from something earlier; the other is cultural, for, even without textual sources, the comparatively large number of preserved examples suggests something about the setting and taste early Muslim aristocrats sought to create for their way of life and thus perhaps something of importance can be said about the style of life.

In turning to the monuments themselves, we shall first try to identify those features that seem to be common to all of them, in other words to define the type from which any one of them was a variant. Except in points of detail the variants as such will not be discussed. A typological definition can be made from considerations of internal functions, construction, and decoration.

Three functions appear in almost all early Islamic palaces. The first one is a mosque, which occurs in one of two ways. In Khirbat al-Mafjar (fig. 60), Jabal Says, or Qasr al-Hayr West, as well as in a number of smaller sites in Transjordan, it is a separate building, usually a miniaturized hypostyle. At Mafjar such a building is roughly part of the general planning of the establishment's units, but it is still a separate entity with one door leading outside and a smaller one connecting the mosque with the main place of habitation. In other palaces, Khirbat Minyah (fig. 58), Ukhaydir (fig. 63), or Mshatta (fig. 62), the mosque is included in the composition of a single building and forms one of its component units, at times, as at Ukhaydir, a fairly elaborate one. Only at Mafjar do we encounter both types of mosques. When it is an integral part of the building it may also be a modified hypostyle, or simply a hall. All these mosques have a mihrab but none of the other additions to a religious building, a possible exception being the large square tower base excavated by the qiblah wall of the smaller Mafjar mosque. It could have been a minaret, although there is something odd about the presence of a minaret in what was a private internal mosque and its absence near the public one.

There is nothing particularly surprising about the existence of mosques in country estates. We meet here with a Muslim adaptation of the characteristic feature of a palace chapel or sanctuary. Just as in European aristocratic architecture of a later time, the chapel is near the entrance, so that the retinue that does not necessarily live with the prince can participate in the religious service. It is likely that Islam picked up the idea of such "chapels" from pre-Islamic architecture, but I do not know of a single example of such institutions in early Christian medieval villas. More important, the automatic presence of small mosques in country palaces is a further indication of the growing pietism of the mosque's meaning. These estates certainly did not require an architectural form for the expression of the collective will of the Muslim group, since most of the cultivators were still Christian. The presence of the mosque may have identified the local owner as

belonging to a different entity than the majority of the population and, as will be shown more systematically in the conclusion, both aspects were certainly involved.

The second function appearing in all these estates may be called a residential one. The term must be understood rather widely, for it also includes official functions, but for practical purposes it makes sense to put the two together. The main residential and official unit was a square building, generally some seventy meters to a side (fig. 61). On the outside it appeared to be a fortress with heavy, almost always round, corner towers, a varying number of half-towers on each side, and a single entrance. But the fortified look was only that; it hardly corresponded to any military function. The towers were full of rubble and, when not, served as latrines. The façades were frequently decorated. At Mafjar the presence of a forecourt in front of the residential unit led to the transformation of the façade into a two-storied portico framing a high gateway. At Qasr al-Hayr West (fig. 65) the whole wall was covered with stucco sculptures, and at Mshatta (figs. 120ff.) the celebrated series of triangles with stone carvings gives anything but an impression of defense.

The interior arrangements of the residential building were of two kinds. By far the most common one consisted of a central courtyard surrounded by a portico and of rooms arranged along the walls. In almost all instances there were two floors. The precise pre-Islamic history of this type is still very obscure, but its formal prototype seems most likely to be found in the late antique and early Byzantine forts erected all over Syria and Transjordan. More problematic is the fact that none of the pertinent examples were really palaces, except the so-called palace of the *Dux Ripae* at Dura-Europos which is earlier than the mid-third century A.D. But perhaps this is merely a matter of insufficient exploration of the Syrian countryside.

The second type of internal arrangement is known through only two monuments, but they are major ones indeed: Mshatta and Ukhaydir (figs. 62, 63). Here the fortified enclosure was subdivided into smaller, apparently self-sufficient, units. In Mshatta the central part remains as a primarily formal unit, while the two side thirds were provided with smaller units of inhabitation, if one is to judge from the position of bonds in the inner face of the wall. Unfortunately Mshatta was never finished, and the several rather fancy reconstructions which have been proposed are based on very uncertain evidence.

Ukhaydir, on the other hand, is quite well preserved. There we find a whole palace as a separate entity within a wider enclosure. The palace was subdivided into individual units arranged around courtyards, with a central unit given particular prominence. Although the entrance has several floors, the rest of the building, like Mshatta, had one story only. There is no clear parallel for the internal composition of Mshatta and Ukhaydir in Mediterranean architecture, but prototypes do exist in Sassanian Iran, as in palaces like Firuzabad and Qasr-i Shirin. It is thus possible and perhaps simplest to consider this second type of arrangement as Iranian in origin, the first example seen so far of a major impact from the non-Mediterranean part of Islam. At the same time it is important to note that Mshatta and Ukhaydir are the latest in date of the series of monuments we are examining, and one may wonder whether the greater complexity of the plan indicates simply the influence of a different tradition that predominated at the beginning, or rather a growth in the complexity of functional needs that would have led to a search for or discovery of new models. The problem, in other words, is whether in this particular instance a formal distinction should be explained in terms of regional formal influences or in terms of willed needs within the culture itself.

Within each palace certain architectural units stand out clearly enough to be identifiable functionally: gate, reception hall, living places. The entrances were all fairly elaborate compositions, which can be divided into three groups. A first one, found for instance at Khirbat Minyah, consists of a projecting hall, covered by a large cupola, that leads into a long hall (fig. 58). A second and more common one had one or two long halls with side benches; at Khirbat al-Mafjar this was a particularly heavily decorated area of the palace (fig. 60). The third group, which may be called complex or composite, occurs in the later palaces of Ukhaydir and of Mshatta. There a whole entrance complex was created consisting of long halls, domed rooms, and a variety of attendant halls; in both the mosque was attached to the complex. What is important about these entrances is, first, that only one function can be clearly suggested for the gate. It was a place of waiting, and numerous texts tell of individuals waiting by a palace gate for some princely favor. There is no evidence for princely ceremonies at the gate, which thus served primarily as a physical protection for the personage inhabiting the palace. An evolution seems to be visible from the early Khirbat Minyah with a simple entrance to the elaborate

complex of Ukhaydir. It is, however, uncertain whether it is entirely proper to deduce a growing separation between a prince and his clients that would be valid for the culture as a whole, or whether the two buildings simply reflect the varying needs and taste of two different owners. An additional curious aspect of the early Islamic gate is illustrated by a recent discovery at Qasr al-Hayr East (fig. 69). Three gates are known in the huge, 17-kilometers-long wall of the site's outer enclosure, one of which is of the domical type found at Khirbat Minyah and posesses a very similar decoration of niches and sculpted stones. None of these gates led to buildings, and the most impressive one was found nearly a mile from any trace of life. This suggests that, whatever its formal origins and whatever the specific explanation for the Qasr al-Hayr example, the gate existed as a separate unit, as an independent term in the vocabulary of early Islamic shapes.

The problem of the official reception hall or throne room is more complicated. It can be assumed that every establishment had some sort of formal room; in most early texts these are called *majlis*, formal "sitting rooms," although later other terms, *diwan* or *iwan*, occur as well. Whatever its name, there was a need for a prince or wealthy owner to receive guests and visitors a practice for which ample evidence exists both in pre-Islamic imperial ceremonies and in traditional Arab mores. Arabic historical literature and particularly the special genre of anecdotes surrounding the lives of poets—most of whom were attached to individual princes—has actually preserved a number of instances of the very type of ceremony that can be associated with country estates. These were not great receptions of foreign ambassadors, but visits of tribal chieftains, plaintiffs, and especially poets, all of whom expected by right or wit to obtain some money or some favor. The prince usually sat at one end of the *majlis* on a large bench-like throne to which he may have invited some honored guest. There was no organized ceremony of arrival and departure, and the prince's clothing was generally informal, although some Umayyad princes already liked initially to have a curtain drawn between themselves and their audience. A fairly large crowd was usually present and the proceedings were somewhat casual, with a chamberlain or *hajib* as a sort of master of ceremonies. Often a meal and occasionally a drink were shared by some of the participants. The problem is to find in excavated palaces a setting for this sort of affair.

Whenever, as at Qasr al-Hayr West and Khirbat al-Mafjar, there was

a second floor, the reception hall was on it, right over the entrance, with a window on the outside for light (figs. 60, 65, 68). When only one floor was present, the audience room or rooms were either on one side of the porticoed courtyard as at Khirbat Minyah (fig. 58) or formed elaborate complexes as at Mshatta or Ukhaydir (figs. 70, 63). The forms given to these rooms were remarkably traditional. For the most part they were basilical halls with three naves leading to an apse, an elaborate triple apse at Mshatta, where presumably the throne was found. In Ukhaydir the basilical hall is replaced by an iwan on a court, followed by a square domed room which in turn opened into a series of porticoed courts. The features in Ukhaydir have characteristically Iranian prototypes, and it can be suggested that the position of Mshatta's basilical hall opening directly onto the court reflects an eastern influence as well. In most instances side rooms are found near the apse, probably for the changes of clothes that preceded certain receptions or for whatever implements, money, gifts, food, might be required for the ceremony.

Not one of these formal elements is original with Islam, and so far it has not been possible to detect an architectural change that could be attributed to specifically Muslim ceremonial purposes. The only exception is the rather awkward one of Khirbat Minyah, where the presumed reception hall consisted of a basilical hall without apse but where a heavily decorated hall with a pair of smaller rooms on either side appears right next to the basilical hall. It was probably a misunderstanding of a borrowed form, whose sole significance would be that the Muslim architectural planner understood the combination basilical hall-apse as a form that could be broken into smaller units. In general, architectural forms were taken from traditions issued from the Roman empire because they had been associated with a formal architecture of princes, even though nowhere do we find evidence for an elaborateness of ceremonies comparable to what is known in Byzantium or in Sassanian Iran. It is possible that this lack of correspondence between official forms and official ceremonies was already a feature of the art of country estates from Rome onward, but the main point is that of the new culture's complete takeover of an older formal vocabulary for reception halls.

A methodological problem occurs when we turn to living units, for we have no absolutely certain knowledge of the purposes to which parts of the palaces other than reception halls and entrances were put.

The evidence is clearest at Qasr al-Hayr West and at Ukhaydir (figs. 61, 63). In both instances a repeated grouping of rooms forms separate, apartment-like units. In the Syrian example one long hall is flanked by three rooms on each side, and one of the towers along the wall contains several latrines. In Ukhaydir a courtyard is provided with a group of rooms on two sides; each group consists of one regular or modified iwan flanked by rooms with narrower entrances. These self-contained units, definable as comprising one central room or hall and a number of secondary ones, have been called *bayts*, the Arabic term for houses, and have been considered as the characteristic living entities of the early Islamic country estate. Barring new evidence this interpretation seems acceptable, and only two additional comments may be made.

The first one concerns the sort of life that can be imagined in these buildings. Literary evidence so far has not provided any significant information, and it is quite difficult to translate architectural forms into life without the help of texts. Should we see these units as demonstrating that the inhabitants of the palaces were divided into equal family units? Were these guest rooms or apartments? No archaeological differentiation exists between rooms and it is thus impossible to decide on more precise functions, to differentiate between places for cooking, eating, sleeping, or even some kind of work. Although archaeological information is far from complete or satisfactory, the rather odd conclusion emerges that a magnificent formal architecture was created without any visible differentiation in the setting of daily life. Was this really so and should we see most of these rooms as barely organized shelters to which a still partly nomadic population brought rugs, pots, and bundles? The consequences for cultural history would be important. Or else have many of these buildings been improperly excavated or published?

The second point is that the bayt arrangement of whatever kind is not characteristic of all palaces. At Khirbat al-Mafjar (fig. 60) single long halls are found, divided into halves and occasionally communicating with each other. A combination of the single hall and of the bayt occurs at Jabal Says. It is possible that these variations are the result of individual circumstances at each establishment, but the main point would remain that the bayt arrangement was not the only kind, merely the prevalent one.

It is equally difficult to explain the formal origins of these living

arrangements. Imperial Roman villas had a far clearer functional dif-
ferentiation of forms, but it is not clear how much of this was carried
down to the simpler houses and villas of the provinces. Military build-
ings did not differentiate between halls, but then the functions of the
latter were probably more consistently the same than in villas. None of
these earlier arrangements in the Mediterranean are obvious proto-
types for the early Islamic bayts, but Sassanian palace architecture was
already provided with similar compositions which are as unexplained.

A number of rooms have architecturally identifiable features that
distinguish them from the rest. Such are the large room on the north
side or the main western one over an underground cool room with a
pool, both at Khirbat al-Mafjar, but none of the interpretations pro-
posed for these rooms is particularly convincing. Thus we are faced
with the further peculiarity that architectural differentiation in living
areas is not clear enough to be understood.

The general impression given by the main living entity of the early
Muslim palace is curiously paradoxical: a fortified aspect without mili-
tary possibilities (fig. 67), interior differentiation limited to audience
halls and entrances, an apparently very limited amount of living com-
fort, almost total lack of formal or informal internal architectural de-
tails such as doors and windows. There are several ways of explaining
this series of paradoxes. One is primarily cultural with important art
historical ramifications. These palaces were instances of the adapta-
tion of a new way of life to an existing vocabulary of forms. The entire
typology of at least the early palaces was pre-Islamic, and the awk-
wardness of certain compositions or our inability to give a precise
meaning to each part would be the results of a series of forms that
were not fully adapted to the functions for which they were used. An
explanation of the forms becomes then a problem of pre-Islamic,
mostly Mediterranean, art and culture. An argument in favor of this
interpretation is the rapid abandonment of this type of early Islamic
building, which obviously did not correspond to the mainstream of
Islamic needs. Information about life in these palaces has to come from
literary sources, and as it can be reconstructed from episodes found in
chronicles or from the lives of poets, it was a rather disorganized life in
all but a few major ceremonies. Almost any setting could harbor the
peripatetic life of the Umayyad prince.

A second explanation is primarily art historical with significant cul-
tural consequences. The circumstances of the conquest led to the de-
velopment of estates owned by a nouveau riche aristocracy of Arabian
descent. As some of these princes decided to live permanently or

sporadically in their estates, they sought in existing architectural practices such forms as best expressed their own needs and purposes. Thus the military exterior was adopted because it was the most common symbol of power; audience halls were taken as such from earlier units because the reception was a major Arabian ceremony; living places were simple shelters because the society's mores did not require elaborate bedrooms or dining rooms; kitchens were absent because food was prepared outside and brought in, in the manner of Bedouins today. Compositional awkwardnesses reflect a lack of interest in architectural planning as well as a lack of prototypes. The peculiarly unsystematic planning of an early building like Khirbat Minyah and the far more thoughtful organization of Mshatta or Ukhaydir illustrate the growth of a concern for planning, the slow achievement of an early Muslim type of building. Altogether the many examples of palaces can serve as examples of an architecture in the making, of a series of adaptations of older forms chosen for new purposes, at times, as in the Syrian bayt, even with original inventions. The type that was eventually created did not survive because, as has been mentioned, its ecological purpose disappeared. With this explanation the importance of these palaces for pre-Islamic architecture disappears, since it is only fragments from older traditions which they adopted and recomposed. On the other hand, their significance for early Islamic culture and in a way for a general theory of the arts is considerable, for one can observe how a new culture picked and organized units from a variety of spatial and functional origins in order to express its own needs.

It is not yet possible to choose between these two explanations. Monographic analyses of individual architectural motifs are still necessary, as well as further textual investigations of the life of the Umayyads. Some useful ideas may also be provided by ethnographic studies of comparable changes in the quality of life characteristic of contemporary Arabia. Finally, one may have to consider a more thorough elaboration of the theoretical problem involved, that of the manner in which a human entity—the new aristocratic landed gentry with more or less definable habits of life—finds its own physical setting out of the architectural vocabulary created for a very different social and cultural entity.

Next to mosques and living or formal units, the most common feature of early Muslim estates was the bath. Baths are known at Qasr al-Hayr West, Jabal Says, and Khirbat al-Mafjar. A small bath was seen near Khirbat Minyah, and a large one has just been discovered at Qasr

al-Hayr East (fig. 74). Several baths are independent of any major living unit. Such is the celebrated Qusayr Amrah (fig. 59), located in a secluded part of the Transjordanian steppe. In reality it can be connected with a number of constructions farther away which indicate that the area itself was used as an estate, but it is rather remarkable that only the bath acquired a monumental form and, at least here, a celebrated painted decoration. No baths were known until recently at Mshatta or Ukhaydir. Had the former been completed it would certainly have had one; as to the latter, a bath was discovered near its mosque during excavations carried out in 1965.

All these baths belong typologically to the same series. Their heating systems, hot rooms, and service areas directly continued a Roman tradition of baths, especially of a smaller type commonly found in Syria (fig. 74). The only modification was that the *tepidarium* or warm room tended to disappear. Yet in most of these baths the actual bathing area occupied only a small part of the building. Most of the space consisted of a single large hall, whose shape varied considerably from site to site. At Qasr al-Hayr West it was a simple rectangular room. At Qasr al-Hayr East a rectangular porticoed court was provided at one end with two marble-lined pools filled by two fountains (fig. 73). Between the pools a formal gate led to a long hall with a painted decoration, before the bathing area proper. At Qusayr Amrah a small basilical hall ended in a squared apse framed by two small rooms. At Jabal Says a modified version of the same type occurred. The most impressive area was at Khirbat al-Mafjar (fig. 72). There a huge hall of twenty-five square units was covered with a central cupola and then two series of vaults around the dome; the hall was provided with a large pool at one end, with a formal domed entrance, and with a small private room and apse in its southwestern corner (fig. 75). All parts of the hall were heavily decorated with mosaics, paintings, and carved stuccoes.

If we except the purely technical problems of heating rooms, spreading heat through the building, and distributing water, two questions are posed by the existence of these baths. Why were they so frequently found as major monuments in Umayyad foundations, and what is the significance and function of the hall attached to the bathing area proper?

There is no great difficulty in answering the first question. The bath was a characteristic function of classical urban culture and would remain a typical feature of medieval Islamic culture, but not of the

Christian world. In both cultures it was not only a matter of personal cleanliness—tied in Islam with the practice of ritual ablutions—but also of social organization and habits. The bath served as a meeting place for relaxation and communication; it would be interesting some day to collect available literary data about the uses of the bath in the Middle Ages and about its importance in the transmission of oral literature and in the formation of social movements. Already in Roman times the urban bath was transferred to the country villa, to which it introduced the amenities of urban living, a process that finds an interesting parallel in the suburban and exurban developments of our own time. This function of providing country establishments with luxurious life can also be assumed for the Umayyads. The only problem is whether the early Muslim phenomenon should be considered as a more or less conscious revival of the classical practice, or whether because of the Muslim examples we can assume that the Christian world of the preceding centuries had continued the Roman practice. Unfortunately we are far less informed about Byzantine country estates than about later and earlier ones, but it is interesting to note that in the admittedly limited area of northern Syria which has been studied exhaustively the bath hardly plays a role at all. Whether continuation or revival of earlier ways, the urban origin of the Umayyad bath would find confirmation in the fact that all investigators of both techniques and internal arrangements have seen in the country examples the transition between classical Roman and medieval Islamic city types.

If then the fact of the bath's existence does not pose a particular problem and if its technical features are sufficiently clear in a historical perspective, what was the function of the large hall attached to the bath but not directly used for bathing? Such a large hall could be considered as an *apodyterium* or dressing room, but it is not very likely that this was its only function. It often had complicated shapes and much decoration, and at Qasr al-Hayr East another room, right by the entrance, can be identified as being the dressing room. Then it has been noted by many investigators that a series of Syrian baths, at Dura-Europos, Brad, and Serjilla, whose technical characteristics are quite close to the Umayyad ones, were provided with particularly large halls, proportionately much larger than the *apodyterium* of the classical bath. It had been suggested that these served as meeting places, but these are all city baths and one may wonder what sort of social purpose our country baths could have. It is also unlikely that

they were vestigial forms taken over without a clear function attached to them, because of the obvious care given to their organization and decoration.

The remarkable feature of these halls is that they were so different from each other: a basilical hall that could look almost like a church at Qusayr Amrah, a large court with a portico and two marble-lined pools and fountains at Qasr al-Hayr East, a large hall with a complex vaulted structure, a big but shallow pool, and a uniquely rich decoration at Khirbat al-Mafjar. This variety suggests that the halls' function or functions were not provided for in the architectural vocabulary from which Islamic builders borrowed their terms. Textual information about Umayyad ceremonies and ways of life may provide an answer. A number of accounts indicate that next to the formal *majlis* for receptions there was also a *majlis al-lahwah*, a place for entertainment and pleasure. The main activities were drinking, singing, listening to poetry recitals, watching dancers, and listening to musicians; meals were occasionally involved as well. At times there was a slightly orgiastic quality to these ceremonies. At other times they were merely eccentric, as when the future al-Walid II had a curtain drawn across a pool filled with wine and jumped in after each song performed by a singer on the other side of the curtain; if the singer was good, he or she was invited to join the prince in the swimming pool. But it would be wrong to interpret some of these practices only as a simple form of licentious behavior on the part of an aristocracy that had recently acquired an immense wealth. In reality they had a formal, semi-official character. Abd al-Malik, a very straightforward ruler, appeared occasionally on a throne holding a cup of wine and surrounded by two girls. The sober and miserly Hisham occasionally got drunk right after going to Friday prayers. At one performance for al-Walid II, actors arrived dressed as stars and planets and seem to have performed a sort of cosmic dance. Many other stories and accounts could be gathered to indicate that Umayyad princes adopted as their own an ancient Near Eastern tradition of transforming pastime and pleasure into a formal activity illustrating the power and the greatness of the prince.

By the time of the Muslim conquest this tradition was primarily associated with the Sassanian dynasty of Iran, and whatever impact it may have had in Rome had been played down, if not entirely given up, in official Byzantine ceremonies. One can only speculate as to why the Muslims did not adopt the complex processions, appearances, and acclamations of the Christian empire, whereas they picked up quite

rapidly the Iranian ceremonial system of a static prince appearing in majesty or of pastimes as identifying royalty. It can be argued with some justification that in the formation of a Muslim empire, in the development of what medieval writers called *mulk*, "princehood" or "kingship," ancient oriental traditions unfettered by the possible disapproval of the church took precedence, inasmuch as the whole Persian empire had been conquered. It is possible also that a number of the ceremonial themes—feasting, drinking, music or poetry, and also hunting—corresponded to habits of pleasure and pastime in traditional Arab society and thus that their adoption was easy. Some evidence for this interpretation can be found in a certain lack of seriousness, a playfulness that permeates some of the accounts of the ceremonial *lahwah* of Umayyad princes. Finally, in line with an argument that has been one of our leitmotivs, it may be that early Muslim princes quite consciously rejected those ceremonial practices that had been too closely identified with the Byzantine emperor.

Whatever cause or combination of causes may eventually explain the appearance of this particular type of ceremony in early Islam, its existence is certain, and I would like to suggest that the main function of the group of elaborate halls associated with baths was that of a *majlis al-lahwah*, a pleasure hall comparable to the ballrooms of the aristocratic architecture of another age. Its association with the bath need not be surprising for it belonged to that type of luxury from elsewhere which characterizes the bath in the country as well. This association was possibly only occasional, since some baths do not have such rooms and some palaces may have had them elsewhere in their arrangement, perhaps on the roof.

Many aspects of the decoration of these palaces confirm the proposed interpretation, but it is first necessary to consider the shape given to these halls. In a way each building poses its own problem. At Qusayr Amrah (fig. 59) the use of a shrunken tripartite basilical hall with apse and side rooms possibly indicates that the hall was also used for formal receptions, but it primarily suggests that the basilical form was a sort of *passe partout* form without clear function attached to it. At Qasr al-Hayr East the pools are clear, but the three-naved room has been damaged too much to offer many conclusions. The most puzzling instance is that of Khirbat al-Mafjar (figs. 60, 72), for until now no appropriate prototype has been found for the form and elevation of the bath's main hall. Could it have been an invention of the architects working for the Umayyads? If so, we would have here a fascinating

occurrence of a new form specifically created for a new function. The point could be pushed a step further. While the general shape of the building indicates a centrally planned construction, with the cupola in the middle as the unit around which the rest of the building rotates, several other features suggest other axes as well. The elaborate gateway and the unique mosaic unit in the central exedra on the west side of the hall indicate a longitudinal axis similar to that of a basilical reception hall. The pool on the south side, the close proximity to latrines, to the bathing part of the establishment, and to the small heavily decorated room in the northwestern corner (fig. 75), all suggest a sort of hallway, an elaborate vestibule used for a variety of purposes, many of which were simply movement and communication. Finally, the small northwestern room and the southwestern door which through a passageway leads directly to the living unit indicate the private quality of the bath hall.

One can argue, then, that the form of the building was developed for its flexibility and that, as with the hypostyle mosque, individual elements of known Mediterranean background—exedrae, heavy piers, central cupola—were recomposed to accommodate a variety of purposes. Eventually each one of the variety of functions the bath fulfilled acquired its own characteristic form and the Mafjar shape appears to be unique because it was created before each function had acquired its own form. At this stage, however, we may be moving too far ahead of our information, for private palace or royal bath architecture is very badly known in later or earlier times. Perhaps it is simpler to suggest that the Mafjar hall is merely the only example left of an architectural form that was fairly common in pre-Islamic secular architecture, in palaces or baths.

The pool in the forecourt of Mafjar (fig. 76) poses a similar problem. Its superstructure consisting of an octagonal arcade around a square covered by a dome and a balustrade has no immediately known parallels but almost certainly reflects a classical tradition of *ciborium*-like pavilions in gardens. Once again early Islamic evidence illustrates a lost secular architecture from earlier times. But one cannot totally rule out an Umayyad invention.

Just as in the case of religious architecture, the vast majority of the structural and technical features of these palaces show little novelty and seem to continue, with few modifications, earlier traditions of Syria and Palestine or, in the instances of Ukhaydir, of Iraq. Furthermore, the fact that almost all of them are found in ruins (figs. 67, 70)

renders many conclusions about construction, especially in super-structures, somewhat uncertain. A few remarks may suffice. Iranian or at least Iraqi techniques of brick construction were introduced into the western half of the Fertile Crescent, and Mshatta (fig. 70) is the best known example of this phenomenon which is visible in less obvious details elsewhere. Historically it illustrates the new balance between regions achieved by the Muslim world, but its real importance is in the fact that the secular architecture of Umayyad princes exhibits this balance much better than the architecture of the early mosque. Next, vaulting played a far more important part in secular than in religious architecture; thus from the very beginning there appears the preponderance of secular functions in the development of vaulting that remained characteristic of much of medieval Islamic art. Finally, Umayyad estates brought to light much information about secondary architectural features such as balustrades, windows, doorways, and the like. At Khirbat al-Mafjar and at Qasr al-Hayr East and West, fragments of stained glass windows as well as numerous examples of tracery work were found (fig. 77). Much of the latter was done in stucco, and most of it is not found in pre-Islamic Mediterranean architecture. Whether all of it should be considered as an early Islamic invention, as an importation from the east (perhaps from as far as Central Asia where some similar remains have been found), or whether once again Umayyad evidence should be used to reconstruct an earlier architecture, are all so far unanswered questions. A side aspect of these archaeological finds is the commonness of stucco as the means by which a building's effect was given; walls, columns, capitals, and balustrades were covered in a way that was not in the mainstream of the Mediterranean architectural tradition. We shall return to further implications of this point in our next chapter.

The decoration of these country establishments has been, since the first discovery of Qusayr Amrah, their most extraordinary and best known feature. Three techniques are represented: mosaics, painting, and sculpture. The most remarkable examples of mosaics, known almost exclusively as floor mosaics, are at Khirbat Minyah (fig. 78) and Khirbat al-Mafjar. There is nothing original about the technique as such, which belongs to the standard system of building decoration all over the Mediterranean. Painting (figs. 87, 88) is equally common, not only in former classical lands but also in Iraq, Iran, and Central Asia. There is no way of determining at this time whether any changes occurred in the technique itself, which is represented in almost all

Umayyad monuments, with Qusayr Amrah and Qasr al-Hayr West
having the best-preserved examples. Sculpture (figs. 79–86) is more
problematic. Occurring in all sites, most of it is stucco sculpture
wherein lies its first peculiarity, for, while stucco sculpture was not
unknown in pre-Islamic Syria and Palestine, it was not as common as it
became in the eighth century. Before Islam, stucco sculpture was char-
acteristic of the art of Iraq, Iran, and Central Asia, and thus a signifi-
cant shift took place in the decorative techniques of an area. It is less
clear, however, whether stucco was used because of an impact of the
East or simply because it was a cheap technique that could rapidly
transform the visible aspect of a building. Another peculiarity of this
sculpture is that it includes both relief sculpture (figs. 118–23) and a
sculpture in the round or at least in very high relief (figs. 79–86). The
latter is often a sculpture of various human and animal forms and
therein lies its most outstanding peculiarity. For a monumental sculp-
ture had just about disappeared from the whole Mediterranean and
Near East in the centuries preceding the birth of Islam, even though all
areas had a major monumental sculpture before the ninth century. It is
as though the Islamic world of Syria deliberately revived an antique
technique that had been given up for several centuries. It can indeed
be argued that this revival was conscious, for, as already mentioned,
the Muslim world did not feel bound to continue automatically the
techniques of the immediately preceding generations, and it could
easily see that an art of monumental sculpture had been one of the
main decorative techniques of more ancient times. Its best examples
were uncovered at Khirbat al-Mafjar, Qasr al-Hayr West, and Mshatta.
Sculpture in the round did not survive the Umayyad period as a major
artistic technique, and it is only through an occasional text that its
existence in the ninth and tenth centuries is known.

One last point about the techniques deserves mention: practically all
our information comes from Syria and Palestine. Ukhaydir has very
little decoration and utilizes either simply molded stucco or a tech-
nique destined to be of tremendous importance in later Islamic times,
the articulation of brick, the medium of construction, for decorative
effects. But even the latter is used sparingly and, however dangerous
it may be to use a single preserved example, it would appear that, as
we shall see later, Iraq did not develop decorative techniques in its
country estates to the same extent as Syria.

Turning to the subject matter of the decoration, the immense variety
of available themes is at first glance quite overwhelming. Some of the

monuments look like enormous bric-a-bracs of motifs and themes whose actual signifying precision is difficult to determine. One wonders whether at times the artists and patrons of Qusayr Amrah, Khirbat al-Mafjar, and Qasr al-Hayr West did not simply accumulate masses of subjects and transfer them onto the walls of their buildings without worrying too much about the concrete meaning of any one of them. This original impression is all the more striking when the decoration is compared as a whole not only to the iconographic precision of Christian or Buddhist religious decoration but also to the organized systems of Roman, Byzantine, and Sassanian art. The question is whether this impression of wealth and disorganization is valid and whether the decoration of these palaces does indeed have an iconographic ambiguity, an ambivalence of meaning, or whether we are simply not yet able to understand the structure of the visual language utilized by early Muslim princes because the private meaning of the language was greater than the public one.

The difficulties are compounded by the astounding variety of the stylistic origins of this architectural decoration. At Qusayr Amrah the astronomical ceiling in the domed room and a number of personifications in the main hall are directly taken from classical Roman art, the representation of the prince in the apse copies a Byzantine model, while the half-naked women standing in front of a curtain behind which other faces appear are Iranian in background, if not even Indian (fig. 87). At Qasr al-Hayr West, a sculpture imitating a Palmyrene relief (fig. 79) occurs together with sculptures of princes copying both Byzantine (fig. 80) and Sassanian models; of two large floor paintings one is purely "classical" (fig. 88), while the other is adapted from Sassanian models; some unpublished fragments recall demonic faces from Central Asian Buddhist art. At Khirbat al-Mafjar, the very Mediterranean classical mosaic floors contain one celebrated panel of Oriental origin; the statue of a prince is Sassanian (fig. 81), while the almost life-size statues of male and female personages with their peculiar hairdo and their bouquets of flowers (figs. 82, 83) have their closest parallels in Central Asian sculpture. It would be easy to multiply examples illustrating a sort of stylistic Esperanto that makes a systematic analysis of subjects particularly difficult. Either the patrons had a precise program—and then one may wonder at their fantastic visual versatility in understanding a message sent in so many different stylistic codes—or else the messages were secondary to the accumulated effect of a mass of themes from different origins.

In spite of these queries and uncertainties, it is possible to distinguish a number of iconographic threads in the decoration of Umayyad palaces. First, much of it is exclusively ornamental, with no other value than that of enhancing the architecture on which it is put; it is this kind that will emerge as almost the sole decoration at Mshatta (figs. 120–23) and, because of its importance in Islamic art in general, its study is deferred to the last chapter. All geometric and vegetal designs belong to the category of ornament. Problems occur when animal and especially human themes occur in their midst. For instance, a well-known panel at Khirbat al-Mafjar shows interlaced roundels filled with diversified human busts (figs. 85, 86); there is some uncertainty as to whether these may not have had a concrete iconographic meaning. Hypothetically, as long as such meanings have not been found, it is preferable to consider this type of motif as ornamental.

A second theme, most easily recognizable in all buildings, is the princely cycle (figs. 3, 80–89). It consists of a number of representations of princes, always in either imperial Byzantine or Sassanian garb, thus indicating a clear consciousness on the part of the early Muslims of which artistic traditions were truly imperial. But, especially in the case of Sassanian imitations in Khirbat al-Mafjar and in Qasr al-Hayr, the costumes of princes vary and do not correspond either to the last Sassanian practice or to Arab usage. It was thus through images generally identified as Sassanian or Byzantine that the theme reached Umayyad art. Besides representations of the prince, we meet with illustrations of the pastimes discussed in dealing with the architecture of the buildings: hunting, dancing, musicmaking, nude or half-clad women, games, acrobatics, gift-bearing, are themes found in all three major buildings. In almost all instances the origins of these themes are Iranian, and so we have here the first examples of the princely cycle which became the main subject matter of so much of later Islamic art.

The princely cycle of Umayyad art had not yet acquired the abstract and standardized quality it would have later but maintained a concrete character, as though some very precise local events were involved. This appears, for instance, in a painting at Qusayr Amrah (fig. 89) showing a tall nude woman standing by a pool surrounded by a portico, not unlike the pool at Khirbat al-Mafjar. The image may be understood as a generalized one of a handsome woman normally found in the entourage of the prince, but the personage standing to the side and the precision of the architectural setting seem to indicate a

precise reference to some event, perhaps one of those semi-orgiastic pageants described in texts. Both at Qusayr Amrah and at Qasr al-Hayr West the hunting scenes possess concrete details that may have had a specific, local connotation. In several sculpted ensembles at Khirbat al-Mafjar variations in the detailed treatment of otherwise repeated subjects can be explained in the same way. Altogether, most Umayyad princely themes lack the stereotyped quality of the cycle in later Islamic art and, while the theme itself became a cliché, its Umayyad forms were not often repeated.

Besides the princely cycle with its idiosyncrasies, it is almost impossible to establish clear iconographic groups. There were certainly erotic, perhaps even pornographic, images at Qusayr Amrah. Astronomical themes are clear at Qusayr Amrah and possible in some of the stucco ensembles found at Khirbat al-Mafjar where, however, they are not demonstrated. For the rest we are still in the dark, and it does not seem to me that any clear explanation exists for the almost life-size horsemen at Qasr al-Hayr West, for the panels showing various activities at Qusayr Amrah, or for most of the bestiary of Khirbat al-Mafjar, even if here and there some suggestions can be made. The difficulty can easily be illustrated by the small mosaic panel at Mafjar (fig. 71), whose location on the main axis and formal distinction obviously identifies it as meaningful. Yet no acceptable explanation has been provided for this strange fruit and knife.

Lest all of this appear discouraging, one last point may be made about the representational decoration of these Umayyad country establishments. They are quite unique and without immediate followers, at least within our present knowledge. This suggests that, while they are of great importance for an understanding of the eighth century and its taste, they may not be that important per se for an understanding of the formation of Islamic art. As illustrations of a certain princely, private style of life, their contribution to an evolution of art and of taste was minimal. Their significance lies first on a more general typological level as the art of a nouveau riche taste, akin perhaps to that of Hollywood movie stars a generation ago or to that of the Mongols later on in the Middle Ages. At the same time each of the major monuments of this art—especially Qusayr Amrah, Khirbat al-Mafjar, and Qasr al-Hayr West—expresses the unique, personal desires of a prince. It is through a deeper perception of the private character of early Islamic princes that the monuments' elucidation may come about. Their historical importance, if any, is that they demonstrate in a way hitherto

not seen the great accumulation in one region of themes and motifs from all over the Muslim world. But it is not this particular artistic moment that created a style or a synthesis out of the wealth of its themes, for it was too tied to a unique set of circumstances.

While the Umayyad country estates are the most spectacular and original monuments of early Islamic secular art, they were not the only ones, and royal foundations existed in cities as well. About the Umayyad capitals in Syria, Damascus, and Rusafah, we know next to nothing. Except for the fact that they were provided with a room called the Green Dome, and in spite of the partial excavations carried out at Rusafah, it is not possible to reconstruct their internal arrangements or even to imagine the functions that were carried out in them. It is even uncertain whether the Damascus building was an original Umayyad creation or a reused older Byzantine one. Some of the features and associations found in Syrian city palaces were carried over to Iraq, at least to the major palace erected by Hajjaj in Wasit. The latter has unfortunately never been excavated, but something of its possible shape can be imagined from the excavated but incompletely published palace at Kufah (fig. 64). It was known as a *dar al-imarah* or house of government. The implication is primarily that of an administrative building, perhaps even more than of a residence and, while the available archaeological evidence is not sufficiently clear, it is perhaps possible to suggest that some of the units around the courtyards were used for offices or diwans as well as for residential purposes. The main official unit with its iwan-like basilical hall and its domed room appears to be a combination of Sassanian and Mediterranean features similar to what is otherwise known in Mshatta. It is also possible that the existence of organized smaller living units or offices in city establishments like that at Kufah had an influence on the similar units of late country palaces like Mshatta and Ukhaydir.

Thus the limited existing evidence for the earliest city palaces does not bring to light any significant architectural difference from the residential units of country estates, the only important new characteristic being that they are almost always located next to the main city mosque. Such is the case of the culmination of this first series of buildings, the impressive palace of the caliphs in the Baghdad of Mansur, which has been discussed earlier. It may be simply recalled that almost nothing is known about its internal arrangements, except that administrative functions seem to have been taken out of the pal-

ace itself and that its main formal unit was some sort of combination of iwans and domes.

An important side aspect of these city palaces is that, once they have been excavated, they yield a far more limited amount of architectural decoration than the country estates. Aside from confirming the uniqueness of the latter's ornamental exuberance, this fact also indicates that the princes apparently avoided artistic ostentatiousness in their earliest establishments in the midst of cities, where they were accessible to the majority of the population.

The Baghdad of the second half of the eighth century (fig. 10) can be considered as the beginning of a second series of city palaces. It will be recalled that the whole layout and symbolic associations of the City of Peace were those of a palace, of an imperial building. Its imperial connotation derives, at least in part, from the sheer magnitude of the construction. As Baghdad grew by a constant addition of suburbs, ruling caliphs, princes, and at times viziers and other wealthy men started building palaces and residences. These are known only by their names—palaces of the Crown, of Paradise, of the Elephant, of Kingship. Although incidental accounts indicate very little of their shape or of the events that took place in them, they give an impression that is quite alien to what is known of earlier cities. It is that, in the midst of a teeming, proletarian city, there were large numbers of imperial and aristocratic establishments with a variety of functions and dimensions. They were not all built at the same time nor did they always remain in use after the lifetime of their builder. But both popular memory and chronicles have preserved an association between these buildings and social events, such as the marriage of Ma'mun's daughter, which had struck the imagination of the time. Attached therefore to Baghdad was the dimension of a city of brilliant imperial life.

Some idea of what it all looked like can be suggested by the ninth-century buildings at Samarra, the enormous succession of cities built along the Tigris to serve as military and administrative centers away from the popular turmoil of Baghdad itself. The relationship between the two cities is not unlike that of Versailles and Paris in the seventeenth and eighteenth centuries. The archaeological exploration of Samarra is far from being complete and what is available is not more than a schematic view. Let us take as an example the Jawsaq al-Khaqani (fig. 90). It was an immense building, comprising some 432

acres, of which 172 were gardens, and entirely surrounded by high walls with only one main entrance and provided inside with a large number of little understood units. Its formal part was on the axis and consisted of a succession of gates separated by open spaces leading to a cruciform official unit with a central domed hall opening on iwans and courts. Between branches of the cross were baths, a mosque, and probably some living quarters. The immensity of the royal compound was like a forbidden town within the city. Such a development is not unique. The Roman imperial palaces on the Palatine, the Great Palace at Constantinople, belong to the same typological series, as do, for instance, the Kremlin or Peking. The tradition remained as a major feature of Islamic palace architecture. The Fatimid palaces of Cairo and in a way much of the city of Cairo, some of the North African palaces, Madinah al-Zahra in Spain, and eventually the Alhambra, all followed in the footsteps of the Baghdad and Samarra creations of the late eighth and ninth centuries.

While the general point of the size of these royal entities seems clear enough, the difficulty lies in imagining them as functioning units and thus in being able to identify those architectural or decorative forms that characterize them. Archaeological information is simply insufficient, even if a detail like the cruciform arrangement of formal reception rooms in Samarra finds a striking parallel in Central Asian palaces. Textual information is also inadequate, for nowhere, to my knowledge, do we read a description that can incontrovertibly be translated into architectural forms. Literary sources do, however, provide a number of moods surrounding the city palaces created during the first centuries of Islam.

One mood, merely continuing what has been seen in Umayyad country establishments, is that of pleasure. City palaces were used for drinking bouts, singing and poetry recitals, feasts, and orgies. Harems were found in them, whether or not they reached Hollywood proportions. Game preserves served for hunting. Out of this mood one form seems to emerge: the pavilion or kiosk, typically a small and secluded domed construction set in the midst of an artificial nature, usually provided with fountains and running water. There are clear paradisiac implications in these pavilions, and it is from the sense of pleasure that the spectacular medieval Islamic development of an architecture of water was derived, the first examples of which occurred at Khirbat al-Mafjar. Pavilions and water were not necessarily limited to the closed compounds of the palaces. In Fatimid Cairo they are found all over the

city, but this may have been a peculiarity of that dynasty whose validity for the rest of the Muslim world cannot be demonstrated. And it is in the Fatimid inspired architecture of Sicily that we find some of the earliest remaining examples of this type of pavilion with water. The origins of these forms and of the mood associated with them were probably quite varied, since both Roman gardens and Sassanian monuments and ceremonies provided comparative models. The former are, however, several centuries removed from the ninth century in Iraq, and what we know of the latter is far too colored by Islamic developments to be used indiscriminately. While there is nothing original about palaces as places of pleasure, the "pleasure domes" of Islam acquired a peculiar coloring of their own and an indication of this uniqueness is the rapidity with which Byzantium and the Christian West understood it as such and either imitated them or rejected them as sensuous evil.

A second mood, also occurring in country establishments but acquiring in the cities an enormous importance, was the official one, which we may best define by reproducing al-Khatib's account in the *History of Baghdad* of the arrival of Byzantine ambassadors to the Abbasid capital in A.D. 917:

> Then it was commanded that the ambassadors should be taken round the palace. Now there were no soldiers here, but only the eunuchs and the chamberlains and the black pages. The number of the eunuchs was seven thousand in all, four thousand of them white and three thousand black; the number of the chamberlains was also seven thousand, and the number of the black pages, other than the eunuchs, was four thousand; the flat roofs of all the palace being occupied by them, as also of the banqueting-halls. Further, the store-chambers had been opened, and the treasures therein had been set out as is customary for a bride's array; the jewels of the Caliph being arranged in trays, on steps, and covered with cloths of black brocade. When the ambassadors entered the Palace of the Tree and gazed upon the Tree, their astonishment was great. For there they saw birds fashioned out of silver and whistling with every motion, while perched on a tree of silver weighing 500 *dirhams*. Now the wonder of the ambassadors was greater at seeing these than at any of the other sights that they saw.
>
> . . . The number of the hangings in the Palaces of the Caliph

was thirty-eight thousand. These were curtains of gold—of brocade embroidered with gold—all magnificently figured with representations of drinking-vessels, and with elephants and horses, camels, lions, and birds. There were also long curtains, both plain and figured, of the sort made at Basinna, in Armenai, at Wasit, and Bahasna; also embroideries of Dabik to the number of thirty-eight thousand; while of the curtains that were of gold brocade, as before described, these were numbered at twelve thousand and five hundred. The number of the carpets and mats of the kinds made at Jahram and Darabgird and at Ad-Dawrak was twenty-two thousand pieces; these were laid in the corridors and courts, being spread under the feet of the nobles, and the Greek Envoys walked over such carpets all the way from the limit of the new Official Gate, right to the presence of the Caliph—but this number did not include the fine rugs in the chambers and halls of assembly, of the manufacture of Tabaristan and Dabik, spread over the other carpets, and these were not to be trodden with the feet.

The envoys of the Greek Emperor, being brought in by the Hall of the Official Gate were taken first to the palace known as the Khan al-Khayl (the Cavalry House). This was a palace that was for the most part a peristyle court with marble columns. On the right side of this house stood five hundred horses caparisoned each with a saddle of gold or silver, while on the left side stood five hundred horses with brocade saddlecloths and long head-covers; also every horse was held in hand by a groom magnificently dressed. From this palace the ambassadors passed through corridors and halls, opening one into the other, until they entered the Park of the Wild Beasts. This was a palace with various kinds of wild animals therein, who entered it from the park and came up close to the visitors, sniffing them, and eating from their hands. Next the envoys went out to the palace where stood four elephants caparisoned in peacock-silk brocade; and on the back of each were eight men of Sind, and javelin-men with fire, and the sight of these caused much terror to the Greeks. Then they came to a palace where there were one hundred lions, fifty to the right hand and fifty to the left, every lion being held in by the hand of its keeper, and about its head and neck were iron chains.

Then the envoys passed to what was called the New Kiosk which is a palace in the midst of two gardens. In the center was

an artificial pond of white lead, round which flows a stream of white lead more lustrous than polished silver. This pond was thirty cubits in the length by twenty across, and round it were set four magnificent boats with gilt seats adorned with embroidery of Dabik, and the pavilions were covered over with the gold work of Dabik. All round this tank extended a garden with lawns with palm-trees, and it is said that their number was four hundred, and the height of each is five cubits. Now the entire height of these trees, from top to bottom, was enclosed in carved teak-wood, encircled with gilt copper rings. And all these palms bore full-grown dates, which were not quite ripe. Round the sides of the garden also are citrons and also other kinds of fruit. The ambassadors went out of this palace, and next came to the Palace of the Tree, where there is a tree standing in the midst of a great circular pond filled with clear water. The tree has eighteen branches, every branch having numberous twigs, on which sit all sorts of gold and silver birds, both large and small. Most of the branches of this tree are of silver, but some are of gold, and they spread into the air carrying leaves of divers colors. The leaves of the tree move as the wind blows, while the birds pipe and sing. On the one side of the palace, to the right of the tank, are the figures of fifteen horsemen, mounted upon their mares, and both men and steeds are clothed caparisoned in brocade. In their hands the horsemen carry long-poled javelins, and those on the right are all pointed in one direction it being as though each were attacking his adversary, for on the left hand side is a like row of horsemen. Next the Greek envoys entered the Palace of Paradise. Here there were carpets and furniture in such quantity as cannot be detailed or enumerated, and round the hall were hung ten thousand gilded breastplates. From hence the ambassadors went forth crossing a corridor that was three hundred cubits in length, on either side of which were hung some ten thousand other pieces of arms, bucklers, helmets, casques, cuirasses, coats of mail, with ornamented quivers and bows. Here, too, were stationed nearly two thousand eunuchs, black and white, in double line, to right and left.

Then at length, after the ambassadors had thus been taken round twenty-three various palaces, they were brought forth to the Court of the Ninety. Here were the pages of the Privy Chamber, full-armed, sumptuously dressed, each of admirable stature.

In their hands they carried swords, small battle-axes, and maces. The ambassadors next passed down the lines formed by the black slaves; the deputy chamberlains, the soldiers, the footmen, and the sons of the chieftains, until they again came to the Presence Hall. Now there were a great number of the Slavic eunuchs in all these palaces, who during the visit were occupied in offering to all present water, cooled with snow, to drink; also sherbets and beer and some of these slaves went round with the ambassadors, to whom, as they walked or sat to take rest in some seven different places, water was thus offered, and they drank.

. . . Finally, they came again to the presence of the Caliph Muktadir, whom they found in the Palace of the Crown upon the bank of the Tigris. He was arrayed in clothes of Dabikstuff embroidered in gold, being seated on an ebony throne overlaid with Dabik-stuff embroidered in gold likewise, and on his head was the tall bonnet called galansuwah. Suspended on the right of the throne were nine necklaces, like prayer beads and to the left were seven others, all of famous jewels, the largest of which was of such a size that its sheen eclipsed the daylight. Before the Caliph stood five of his sons, three to the right and two to the left. Then the ambassadors, with their interpreter, halted before Muktakir, and stood in the posture of humility, with their arms crossed.

An enormous amount of information can be derived from this text, even though some terms in it are not very clear and political considerations made this event a unique one. In order to define the official mood of the palaces, three points are of particular significance. One is that only one hall, the *bab-al-ammah* or Official Gate, seems to have had no other function than that of formal reception. All other units were prepared for the occasion. It may be concluded that these palaces did not have functionally defined forms and that human activity determined the function of a given space; thus we encounter once again the peculiarly early Islamic characteristic of formal ambiguity.

The second point is that the description concerns itself primarily with movable things temporarily arranged for this ceremonial occasion. For a performance, treasures and storerooms were emptied out, and royal art seems to have been identified by what a prince owned rather than by the physical nature of the setting in which he lived. Among the very important consequences of this point is that the building was not a formal end in itself but a flexible support, a frame, like the stage of a theater, whose visible aspect could be modified to

suit the need of the moment. This aspect of the official mood explains a feature of the decoration of ninth-century palaces in Samarra and Madinah al-Zahra, the only two such buildings whose decoration is partly known. Most of it consisted of large stucco, or at times stone in Spain panels with a variety of geometric and floral designs (figs. 124, 125). Paintings are known from Samarra but seem to have been limited to private areas (fig. 91). This stucco work does not contain the exuberant representational themes of Umayyad art, nor the epigraphical themes of later monuments. It may be proposed that both representations and writing were concrete motifs that gave a building a precise meaning, thus tying it to certain functions. Since what was sought in the city palaces was a neutral type of decoration that would not automatically limit the building's purposes, representations that continued even in the guise of sculptures—as we know from texts, even though no fragments have been preserved—were relegated to the realm of private art. The exceptions that do occur, as in the case of the Fatimids in Egypt, can usually be explained through precise local developments. For instance, while the Fatimids also gave special prominence to beautiful objects and to textiles in their official ceremonies, the latter were usually kept in treasure rooms which served as museums that could be visited. It is possible that some ceremonies took place in these rooms.

The third point deriving from the description of the visit of the Byzantine ambassador is of lesser importance for the arts than for cultural history. In a highly official ceremony, the caliph hardly appeared at all, except at the very end. The impact on Muslim royal practices was that of the ceremonial ways from Iran and not the Mediterranean ones, with their elaborate processions, taken over by Byzantium. The Fatimids of Egypt who did have formal processions are again rather uncharacteristic of the Islamic norm. On the whole, it was an Iranian imperial system of practices which, with modifications, was taken over by Muslim princes, and it is interesting to note that neither in the above account nor in any similar one do we find any expression of anything Islamic, not even a symbol of the presence of judges or of learned men. The realm of the prince as it was made visible to others was, at this time, as unaffected by the faith as the prince's private palaces were earlier. Herein lies a key aspect of princely culture and hence of princely art. Because it was not modified or controlled by the faith and because it took its themes and practices from the enormous body of habits and motifs inherited from the classical and Near Eastern traditions, it created a system and vocabulary that could be under-

stood by all comparable princely realms. We do not know directly what the Byzantine reaction to the Abbasid display may have been, but, if one can judge from certain Byzantine ceremonies, the palaces built by a Theophilus, and the objects gathered by them in their own treasuries, it seems that the nature and purpose of the Muslim show were perfectly understood and accepted by Constantinople.

Besides the moods of pleasure and office is that of isolation and separateness. The plans of Samarra's palaces (fig. 90) or of the North African ones exhibit high fortified walls and a remarkable lack of external decoration. But the notion of a prince living in a separate world appears at its best in literature, where it is often connected with a secondary theme, that the interior of the forbidding and forbidden palace consists of a labyrinth of separate elements secretly and mysteriously related to each other. Such a world of courts, pavilions, baths, strange doors, and fantastically elaborate decorations appears in the story of the City of Brass from *The Thousand and One Nights*. It is from this kind of slightly immoral, if exciting, realm that Harun al-Rashid escapes for his forays into the living city. For, in line with our discussion of Muslim attitudes about the arts, the world of the prince— secluded, rich, and mysteriously complicated—was seen by the Muslim as an evil, and the just man, if called to it, never penetrated it without his own shroud. More is involved in this tradition than a merely moralistic dictum, for the prince and the world he had created became a myth and to a true believer myths, like works of art, were substitutes and deceptions which could tempt but which certainly were obstacles on the path of moral life.

The last category of documents on the art of the court consists in the objects whose importance was already clear in the account of the Byzantine emperor's visit. In a general way these were manufactured portable items which, in a variety of ways, served to enhance the prince's life and prestige. They were kept in treasuries. Some of them were especially made for a given court or prince, but many were of foreign origin, Chinese, Byzantine, perhaps even antique. It is difficult to assess the impact of these objects from alien traditions, but the fact that Fatimid princes in Cairo kept historical souvenirs from the early Abbasid period or saddles purported to have belonged to Alexander the Great indicates that these if not all major Muslim princes continued to define themselves in relationship to the ancient kings of the earth and to contemporary kings and rulers. This theme has been discussed; in practice it explains the continuity between pre-Islamic

and Islamic art of certain subjects and the rapid success of Islamic motifs in the non-Islamic world. Literary sources also provide information on the techniques of courtly objects. Two of them, goldwork and textiles, were almost entirely controlled by the central government; of the two the most prestigious was textiles. Imperial factories made textiles both for the internal consumption of the palace and as gifts and rewards, for, together with money and positions, it was through the award of textiles that caliphs and governors recompensed their subjects. Large numbers of names of royal textiles are known, as well as the occasional description of some unique piece, but so far not one name of a royal textile has been directly connected with any one of the mass of preserved fragments. Thus one of the key royal techniques whose spread and uses can be demonstrated is almost totally impossible to illustrate, even though so many examples have remained. We do not know, for instance, whether the thousands of so-called tiraz fragments of textiles whose decoration is limited to the name of a prince and to the date and place of manufacture (fig. 101) are remains of the actual objects made for a court or whether the inscription merely indicates some kind of governmental control. The celebrated and often very handsome Buyid textiles (fig. 100), with their elaborate decorative programs, have not yet been established as creations of princely workships. Even the unique northeastern Iranian silk in the Louvre datable around A.D. 960 has not yet been put in its proper technical and stylistic sequence (fig. 93).

If such are the difficulties in dealing with textiles, about which both texts and fragments are available, it is not surprising that so little is known about other techniques. It is not before the second half of the tenth century that a few gold objects have become identifiable, and most of them, such as a medallion and a ewer (fig. 116) in the Freer Gallery, seem to me to illustrate a renaissance of earlier themes that is more typical of later Islamic art in Iran. A handsome group of Fatimid rock crystals (fig. 92), made around A.D. 1000 in Egypt, is limited in importance because of its late date, the small number of objects, and the technical difficulties involved in working rock crystal. To this state of knowledge there are two exceptions, two series of objects that are sufficiently numerous to warrant a fuller discussion.

The first of these is in a group of ivories from the second half of the tenth century and the early part of the eleventh, all made in Spain (figs. 94–97). They are all caskets of various shapes and were probably used as containers for textiles or other precious possessions. In-

scriptions identify the most important ones among them as made for members of the ruling families of Umayyad Spain. They show considerable stylistic and qualitative variations, but an important similarity is their comparatively standard organization: over a field of vegetal ornament covering the whole object are found medallions with animals or personages. The latter illustrate not only the typical themes of a life of pleasure—hunting, enthronement, music, dancing, games—but also a series of more uncommon themes, such as bears attacking men who are catching birds, or riders picking dates from a palm tree. In other words a group of stereotyped images coexist with less understandable ones, for which one could propose some sort of private significance. A fairly wide variety of sources can be supplied for most of the images, from purely classical poses and movements to highly symmetrical textile designs or to Iranian compositions. Even though representational scenes play an important part in the decoration of the ivories and even though the arrangement by medallions gives these scenes a special prominence, there in fact occurs a rather striking balance between the presumed neutral vegetal background and the presumably more important groups with personages. Just as with the Umayyad sculptures of Khirbat al-Mafjar or Qasr al-Hayr West, this decoration reveals an uncertainty about the ultimate nature of the imagery, an uncertainty as to whether ornamental or iconographic values take precedence.

The writing that identifies the time of manufacture and the owner of the object is always clearly written, if not always literate. As a result, these ivories are almost the only certainly dated group illustrating the art of the princely object. Their themes of princely pleasure, partly stereotypical, partly unique, suggest that it was through objects of this sort, especially textiles, that themes were transmitted from one court to another. The variety of their stylistic and iconographic sources can be explained if we recall that the art of princes had continuous contacts with a wide range of older and alien traditions.

The second group of objects that can be associated with early Muslim courts consists of silver plates and ewers presumably made in Iran or in Central Asia (figs. 98, 99). The study of these objects, of which several hundreds exist, is very much complicated by considerable methodological problems and by the existence of contemporary forgeries. Without entering into the questions posed by any one of the works, it can be assumed that the techniques of making silver objects that were characteristic in Iran and Central Asia before Islam were

continued without interruption. Secular and religious themes are found on these objects, especially hunting scenes and scenes showing partly clad females in a variety of activities; most of them pertain to princely life or can be so interpreted. At drinking bouts described by an early ninth-century poet objects with designs strikingly like those of known silver plates and ewers were used. Errors in details, misunderstandings of traditional Sassanian symbols, a freezing of certain formulas of representations, at times a lowering in quality, occur in some of these implements. These features can best be explained as illustrations of an epigonic artistic tradition, that is, as the continuation by a new culture of an older artistic vocabulary not because any one motif with all of its original implications was still significant but because the manufacture of such objects was important to the new culture. The great unsolved problem is that of separating pre-Islamic from Islamic objects. It is possible that purely art historical criteria are not precise enough to solve the problem and that other means have to be devised. In the meantime it is safer and simpler merely to conclude that one pre-Islamic technique was continued as part of the art of new princes until the tenth and eleventh centuries.

The preceding pages cannot claim to have covered all the monuments, even all the existing aspects of early Islamic courtly art. Too much in it is still problematic, unstudied in detail, all too often unexcavated or unpublished. A number of general conclusions, however, do emerge. For many reasons the patronage of princes was astounding for both its quantity and its variety. A great wealth, a nouveau riche spirit, simply the enormous size of the empire, all played a part. But more importantly, as newcomers who established themselves as different from their predecessors Muslim princes did not simply take over the princely settings of old. This was especially true of buildings, and for this reason so much of the early Islamic art of the court consists of architectural monuments. Furthermore, changes in the respective importance of various regions transformed provincial cities into capitals and olive plantations into royal estates. There were new needs for princely settings in hitherto unimportant areas.

In this art of princes there was almost nothing that could not have been accepted and understood by non-Muslims. Except for those instances in which one can suspect the appearance of a private whim or a private reference (a problem inherent within secular art everywhere), the functions, needs, buildings, and motifs of Islamic courtly art directly imitated or continued pre-Islamic princely traditions and

habits. Even entire Islamic buildings or monuments could be, have been, and at times still are, considered as Byzantine or Sassanian, or even Egyptian Coptic. Mshatta, Khirbat al-Mafjar, Khirbat Minyah, Qasr al-Hayr were all thought first to be Roman or Byzantine, and even today with our more precise knowledge much doubt exists as to whether the ruins at Anjar in Lebanon are Umayyad or earlier. The situation regarding silver objects is particularly confused, and regarding late-eleventh-century ivory objects without Arabic inscriptions uncertainty exists as to whether they are of Muslim or Christian manufacture. Scholarship alone is not to be blamed for this state of affairs. For in a much wider sense the art of princes in the early Middle Ages—and perhaps at all times—was not tied to any single culture but belonged to a fraternity of princes and transcended cultural barriers, at least in the vast world from the Atlantic to India and the Pamirs which owed so much to Hellenistic civilization. Borrowings from one political entity or another, or from the past of any one of these entities, were as frequent as they were normal.

Does this mean that there was no Muslim flavor to any of the monuments we have discussed? Not at all. Rather, the kind of flavor or quality that Muslim princes introduced was not structurally different from what a Byzantine emperor would have introduced. At the level of formal and iconographic vocabularies, the circumstances of the Muslim conquest brought together motifs from a far larger set of sources than were available to a Byzantine prince or earlier to a Sassanian emperor, not to speak of a Visigothic king. In fact, this variety was an integral part of a Muslim princely art, a willful piece of showmanship. By having been assimilated into princely art, these motifs became less important for their subjects or for their styles than for their association with a life of wealth. Thus a second level of Muslim courtly art is this level of luxury, which can be explained as the result of a new social and ethnic group coming to tremendous power. A third, cultural, level of a Muslim art of princes can be defined. Its very ambivalence and lack of iconographic precision made it possible for Islamic princely themes to be copied on such diverse monuments as the tenth-century Armenian church at Akhtamar or the twelfth-century Capella Palatina in Sicily. The motifs represented luxury, not Islam, and in this sense the historical and sociological circumstances of early Islamic times transformed one aspect of Islamic art into a sort of luxurious consciousness for a much wider world than Islam itself.

The art of the mosque was far more conservative and tended much

more consistently to use local architectural and even decorative forms than did the art of princes, but its impact was limited because its functions were exclusive and culturally restricted. However close to antique and Christian art the mosques of Cordoba and Damascus may be in the forms they used, their underlying structure was totally alien to that of a Christian building, whereas an Iranian or Central Asian decorative design or animal could appear in Spain and in western or Byzantine Christianity because it was structurally a sign of luxury and not necessarily an Iranian motif. It was exotic and not Islamic. In art historical terms what was created was a princely mode, that is a series of forms more important by the associations they evoked than by their visual characteristics.

B. The Art of the City

It is part of the extraordinary wealth of early Islamic secular art that, besides an art of the court, one can identify a wholly different artistic impetus, in many ways a far more original one. As a hypothesis at least, we may call it the art of the city. Much has already been said about the Muslim city. The mosque's immensely urban character and its strong physical ties with the city were pointed out. The palace and its administrative extension appeared at times within the city's compounds. In explaining the growth of forms like the minaret, the point was made that two major types of cities occurred in the Muslim world, older cities with a predominantly non-Muslim population and new cities originally limited to Muslims. Finally, in the new Muslim cities like Kufah or Basrah grew what has been called a Muslim moralism, that is, an ethic and at times a metaphysic that made it possible for a culture without clergy to maintain its identity between the princely circle and the large numbers of alien non-Muslims. From this particular world would come the writers, judges, and merchants of the Muslim empire and, whatever internal sectarian or other struggles existed within the cities, it is perhaps legitimate to hypothesize that, during the first centuries of Islam, more characteristic elements united than separated them.

The first question to raise is whether the Muslim urban order took on an original physical form, and the answer has to be mostly in the negative. In the same sense that there was no purely Islamic palace type, there was no Islamic city form. Each area taken over by Muslims

had had its own regional urban development and had created its own formal answers to whatever physical needs the region might have had: fortifications when the area was near nomadic marauders, water storage and distribution when its rainfall was insufficient, a balance between agricultural suburbs and manufacturing or trading city cores depending on the ecological potential of the land. There was little that Islam, especially at the beginning, could do to alter the nature of the land, and it is particularly unfortunate that areas like the Jazirah or Morocco where we know that Islam modified local economies are still archaeologically so badly known. Similarly, it is not yet possible to describe adequately the physical appearance of the large urban entities of southern Iraq, even though their social, cultural, and economic histories have recently been studied. In addition to natural local conditions, each area was affected by its past. Central Asian cities maintained the balance between a citadel and a city that had characterized the earlier forms, and in Syria or Palestine Muslims almost automatically built porticoed units for every function they introduced or developed, as had been the pre-Islamic practice. It does not seem that the introduction of the mosque as such altered, at least initially, the forms used in Muslim cities, and it is not an accident that Qasr al-Hayr East (fig. 102) with its fairly well preserved mosque was considered for a long time to be a Roman fort or city.

If we can then assume a basic continuity in the technical and formal structure of the city according to pre-Islamic patterns that varied from region to region, we may also be able to identify novelties or changes in emphasis that could be considered Islamic. Some features were the results of an alteration in the ecological balance. Thus the urbanization of southern Iraq or the creation of the huge Cairene metropolis introduced new foci in these two regions; but the present state of our knowledge does not yet make it possible to identify the formal results of these changes. This is an area in which the completion and publication of the excavations being carried out at Fustat, at Balis on the Euphrates, and at Siraf should bring information of such importance that any hypothesis at this stage is premature. Only two points can be considered established. One, which seems to be true of the whole Muslim world, consists in the great development of a monumental architecture of trade. Caravansaries, bridges, market places, shopping areas, all became functions for which private and public funds were spent lavishly. Both Qasr al-Hayrs (fig. 103) were provided with large khans for travelers and goods and it is interesting to note that, al-

though their monumentality varies, their form—a square with halls around a porticoed courtyard—is closely related to the form we have identified for ribats and for living units in country estates. In Baghdad (fig. 10) the organization of the town itself took into consideration the need for shops and we have here one of the earliest existing examples of the long *suq*, or merchants' street, so typical of medieval Islam. Early examples of an important commercial architecture are lacking elsewhere, but this may simply be the result of an insufficient exploration of remaining monuments.

The other point is that the Muslim frontier areas—North Africa, Cilicia, Central Asia—seem to have been particularly creative in the formation of new cities. Many of these began as forts, at times as ribats, and we may have here the formation of a uniquely Islamic type of urban growth, in the way that a missionary military center acquires living and trading accretions. Whether such unique conditions led to equally unique forms is a question that will only be answered by excavations.

Altogether then we are still very inadequately informed about the architectural forms and monuments of the early Islamic city. The task of searching for such literary and archaeological documents as may exist is likely to have important results for the history of art. For instance, the excavations carried out at Nishapur by the Metropolitan Museum in New York have brought to light a considerable number of ninth- and tenth-century stuccoes and paintings, whose architectural setting is not always very clear but whose quality of design illustrates that a brilliance of wall coverings was not the privilege only of courtly art. Among these a unique group consists of small curved stucco fragments with painted designs (fig. 106). They appear to have been originally assembled together in order to decorate the sides or corners of a room. We have here the first example of a kind of decorative design known as the *muqarnas*, consisting of a three-dimensional composition made up of a variable number of smaller units. From the latter part of the tenth century onward this sort of composition became tied to architecture, although its origins are apparently found in an ornamental development of a private city architecture in northeastern Iran. At the opposite end of the Muslim world, a similar kind of motif that led to the western type of *muqarnas* was discovered during the excavations of the Qal'ah of the Beni Hammad (eleventh century) in Algeria. Thus there was a major impetus for artistic creativity in many, if not all, early Islamic cities. Whether this was a consistently original crea-

tivity or a derivative one imitating court art is still an unsolved question, at least for architectural decoration.

Another example of the sort of art historical information that can be provided by the investigation of city archaeology can be illustrated by the excavation of Qasr al-Hayr East (fig. 103), a minor settlement in a rather forsaken part of the world which has the distinction of having survived from the eighth to the early fourteenth century. Its monuments and material culture can be considered average for their time, the norm against which more important but less often preserved masterpieces can be evaluated. Its stucco fragments, ceramic series, and planning helps to solve problems of far wider import than its own area. Similarly, the excavations carried out in Sedrata, an oasis in southern Algeria, have brought to light documents about the history and spread of early Islamic ornament whose importance could not be guessed from the isolation of the site.

But these considerations still have to be hypothetical, since so much about the architecture of the city remains to be studied. Let us turn instead to a series of monuments about whose existence and meaning we can feel more secure. One of the most extraordinary, and long recognized, achievements of early Islamic art was the sudden appearance of a new art of ceramics. Pottery, of course, is not new, but until the formation of the Muslim world it mostly served a purely utilitarian function. It was transformed into a work of art through the appearance of one new technique, luster painting, which gives a metallike shine to an object, and through the discovery or rediscovery of many ways to keep different colors on objects. Interesting though the new techniques are, the most important point is that the prosaic and ubiquitous ceramic object suddenly became the vehicle for an elaborate decoration. Of course this development did not affect all ceramic types, many of which continued to have only modest uses and designs. It seems to have been most common on small jugs and especially on plates, thus suggesting that the new techniques were developed on those shapes with the largest flat or slightly curved surfaces. Thus was established one of the most crucial and typical features of almost all Islamic ceramics from then onward, one that distinguishes them from Chinese or Greek ceramics: the overwhelming preeminence of surface decoration over shape, of the two-dimensional composition over the sculptural effect.

The area or areas in which these novelties appeared are fairly clear. The main ones were Iraq and northeastern Iran, with lusterware char-

acteristic of Iraq only before the tenth century and in such regions, Egypt for instance, as were under direct Iraqi influence. While the uniqueness of northeastern Iranian ceramics in early Islamic times is generally recognized, this is not so of Iraq and many scholars have argued for an Egyptian invention of luster. The discovery at Fustat of a handsome luster-painted glass goblet of the second half of the eighth century (fig. 115) is one of the latest arguments for an Egyptian origin of new techniques. It seems most unlikely that this was so, for it has been very difficult to demonstrate any major Islamic novelty from Egypt before the second half of the tenth century, whereas novelties from Iraq are consistent. Furthermore, even though the first luster-ware identified in Samarra could not be earlier than 833, much recent evidence in Iraq and Syria suggests that the technique may have appeared as early as in the second half of the eighth century. These academic arguments are not, however, very important, and the essential point is that from the ninth century on a new art of ceramics occurred in at least three major provinces of the Muslim world.

No known literary information exists about the possible causes for this unique development, and we must therefore examine the decoration itself in order to make some suggestion. Although there are stylistic and technical differences between Iranian or Iraqi and Egyptian types (the latter two have much in common), we shall treat them all together for our concern is for the phenomenon itself.

In a variety of different ways, much in these ceramics (figs. 107–14) is derivative. Thus the development of luster can appropriately be considered as an attempt to copy or imitate gold, and several early Iraqi examples have designs clearly reminiscent of metal designs (fig. 107). This is also true of a group of western Iranian ceramics of a slightly later date. Then, both in Iraq and in northeastern Iran certain themes and techniques—polychrome splash (fig. 108) or cobalt blue (fig. 109)—are obviously imitations of Chinese types. The compositions of floral designs on many Iraqi ceramics are awkward, as if the artisan-painter had searched for an adaption of foreign motifs (fig. 110). The princely cycle occurs occasionally on northeastern Iranian ceramics—almost never in Iraq—but its hunting princes or feasting personages are caricaturized (fig. 111) in ways that suggest that the artists understood princely themes but had little practice in treating them. In general, representations of human beings are strikingly rare in most of these objects. Thus, in a model of the ceramicists' inspiration, we can identify an attempt at a substitution for expensive metal,

an awareness of China, a lack of profound knowledge of princely themes and at times of the ways to adapt to ceramic shapes themes from elsewhere.

The great importance of writing in the decoration is most characteristic of the eastern Iranian examples (figs. 113, 114). This writing is quite remarkable, for those inscriptions that can be read tend to consist either in a series of good wishes for an anonymous owner or in sayings and proverbs. A sample of the latter includes: "He who is content with his own opinion runs into danger," "Patience in learning is first bitter to the taste but then its end is sweeter than honey," "Generosity is one of the qualities of good men." Most of the aphorisms reflect the morality of hard work as a source of success as well as the virtues of learning and patience. Thus we can add to our model, at least for Iran, an idea of the mentality of the makers or users of the objects.

Also more Iranian than Iraqi, although lines here are less clearly drawn, is the existence of a bestiary on the new ceramics. No conclusions about it can be reached until a number of monographic studies test their validity, but it would seem that birds, mythical animals, and horned animals predominate, with the more common animals of the land appearing only occasionally in Iraq and later in Egypt. Many of the animals are derived from traditional Iranian themes for which examples can be gathered from prehistoric times onward. Often they signified good wishes and well-being in a manner similar to the inscriptions. What is important, however, is that these animal themes seem to reflect a local folk culture, a suggestion that may also apply to slightly later Egyptian series. They are only rarely the animals of princely hunting scenes or of princely textiles. Recently, certain animals were interpreted as representing astronomical or astrological symbols or themes. The hypothesis is supported by the importance of astrology in the daily life of the Middle Ages, but it has not yet been backed up by sufficiently probing studies.

The last feature of the ceramics I should like to emphasize is the great variety of their styles. Thus handsomely pure and readable inscriptions (fig. 114) are found together with highly ornamental and baroque ones or with totally illegible imitations of writing. Animals or trees (fig. 110) can be the main and single subject of decoration, clearly drawn against some background, or they can be multiplied into complex compositions and merge with the background in a way that makes main subject and background inseparable. This tendency obvi-

ously fits in with the general ambiguity of meaning we have detected
so often in very different aspects of Islamic art. All these differences
may simply indicate stylistic evolution, an internal rhythm of change
in the decorative types which could be studied, either in the abstract
or purely formally. Yet the few attempts made in these directions have
not yet been successful and, without denying the possibility, indeed
the likelihood, of an evolution, it is preferable to interpret these varia-
tions as contemporary expressions of a number of purposes and
tastes. It seems justifiable to conclude that a wide contemporary mar-
ket existed for these ceramic objects and that two of the criteria by
which they were defined were cost and taste.

These four features—derivation, moralizing inscriptions, folktype
animals, great qualitative variations possibly connected with market
needs—delineate a patronage which is not that of the court but rather
of the city. And I would like to suggest that the growth of ceramics as a
major art form is the result of the appearance of a new patronage, the
mercantile middle class of the Muslim world. It is indeed in Iraq and
eastern Iran that its major centers are found and that the most striking
urban development of early Islam took place. It is a primarily Muslim
world (although evidence exists that Christians participated in the
sponsorship of the new themes), and by rejecting the international
themes of princely art and its luxury it did express something of the
moralism of early Islam. It was, of course, affected by the art of princes
as it did at times seek to imitate those techniques if not those subjects.
Aesthetically its most superb creations are the inscribed plates of east-
ern Iran, and thus once again writing appears as a peculiarly Islamic
vehicle, although here without a strictly religious connotation. But the
greatest significance of this new class of patron lies in two further
facts. One is that the importance of ceramics remained typical of the
whole Muslim world for several centuries. It rather made sense for a
middle class of merchants and artisans to raise to a fine art the humble
work of the potter, as they would do for the glass maker, the bronze
maker, and all the workers in techniques not controlled by princes.
This development was in fact suggested by one of the Koranic pas-
sages about the arts that was discussed in a previous chapter. The
other fact is that the art created by and for the city's bourgeoisie is far
more original to Islam than the art of the princes.

One last point about the art of the city is that, while its ceramics are
best known and most original, they were probably not the only new

technique to have developed "city characteristics" of their own. Certainly there was an art of city textiles, and perhaps enough examples are preserved from Iraq and Egypt to identify various social levels in this most Islamic of crafts. More problematic are the few bronzes remaining from the first centuries of Islam (fig. 117). Are they imitations of royal gold or silver objects made for the court? Are they also middle-class reflections of a higher princely art? Too few have remained to draw any clear conclusions, but the question may just be a matter of more thorough investigation.

Two major conclusions can be drawn from this long chapter on the enormous amount of preserved documents about the secular inspiration of early Islamic art. First, even though too arbitrary a line may have been drawn between the art of the court and the art of the city, and even though there were throughout the first centuries of Islam constant contacts between them, it seems to me that these two entities, the prince and the bourgeoisie, can appropriately be considered the main foci around which early Islamic artistic creativity developed. The functions and forms of the first source of inspiration were not structurally or essentially different from similar ones elsewhere in the Mediterranean and Near East except insofar as the concrete historical circumstances of Islam led to new and different combinations of them. These combinations did not result in a new art, only a different version of an art which could be and was universally acceptable. The art of the city was different and, especially in the instance of ceramics, it created something quite original. But then the forms it took tended to vary much more from one region to the other and to appear later than the forms created by the court. All of this makes theoretical sense, for the city with its large population became automatically inward-oriented, locally tied to regional sources, even though the rhythm and scale of these differentiations are difficult to determine and probably varied from place to place. Altogether, early Islam is the first medieval illustration of the phenomenon of an art of the bourgeoisie in contrast to the art of the church or of an aristocracy.

Second, objects were important in both royal art and the art of the city. Next to palaces, they appear in texts as the most frequently mentioned item defining wealth, and a variety of controls existed over their manufacture. Through objects themes and motifs traveled from place to place and, even though least known, textiles played a particularly important part in this process of transmission. The more difficult

question is whether this significance of the industrial arts was peculiar to Islam. As far as the secular arts are concerned, it probably was, for quite rapidly—certainly by the tenth century—almost all surrounding cultures became strongly influenced by the forms and the subjects of the new tradition in their midst.

7. Early Islamic Decoration: The Idea of an Arabesque

Throughout the preceding chapters we have encountered a rather unusual problem, which can be defined by a few examples. With the Dome of the Rock and the mosque of Damascus, it was pointed out that a symbolic or iconographic meaning could be given to some of the motifs found on the mosaics covering most of their walls. But these meanings were soon lost, they did not "take" within the active living tradition of Islamic art. Furthermore, without denying an original symbolic significance, the impression can hardly be avoided that the main function of the decoration in both instances was to provide the monument with the glitter of handsome and expensive mosaics. Although the façade of Mshatta carefully avoids the representation of living beings on the side of the building that forms the back of the mosque, still it cannot easily be concluded that the decoration as a whole has an iconographic significance. The absence of animals does not point to the presence of a mosque, it merely reflects its existence. The façade of Qasr al-Hayr West (fig. 65) and the bath hall of Khirbat al-Mafjar contain a large number of motifs for which an iconographic significance has been proposed, yet they are all inextricably mixed with motifs that do not seem to lend themselves to such definition. One wonders whether the latter had an iconographic significance that is no longer understood or whether it is an error to interpret too precisely the meaning of the former. Then, on a different level, as arches in mosques, squinches, or epigraphic themes on ceramics were discussed, it was noted that almost every one of these elements occurs both in a simple and straightforward way with a totally visible function or meaning, and also in modifications, complicated at times beyond recognition into meaninglessness, at least from the point of view of the element's original definition. It is particularly notable that this development or parallelism of contradictory kinds of meanings occurs even in the instance of writing, which appeared until then as the one iconographically consistent feature of early Islamic art.

These are only a few of the examples seen so far of a phenomenon that is particularly striking when it is compared either to most of medieval Christian art or to traditional imperial art. In the latter, what-

ever unique formal or aesthetic values any one monument may have, one can usually recognize a precise subject matter, an iconographic language independent of any one work of art. Even if, as in the case of Romanesque capitals, the language is not always well understood, iconographic legibility and meaning are presumed. The historian then searches for possible meanings and, in a larger sense, seeks to explain the ways in which independent meanings are translated into forms and to evaluate the effectiveness of these translations. This procedure is valid, for it is demonstrable that the main function of the work of art was to transmit the message of its iconographic component and, in the case of a building, to make its function or cluster of functions immediately visible. How does the Islamic phenomenon differ? And what does its uniqueness imply? On the visual level the difference can be defined as a modification in the signifying value of forms; this is easiest to observe in architectural decoration, where the majority of themes do not have a meaning independent of the monument itself. Although they have an independent style in the sense that motifs of one time or one area share common characteristics whether in stucco or in metalwork, they do not seem to have an intellectual or cultural content, and their function is simply that of beautification, of endowing the monument on which they are found with visual pleasure.

I should like to call this kind of theme *ornamental*, reserving the term *decorative* for *all* the themes—regardless of iconographic meanings— that are applied to the simple shape of a building or an object. Ornament has always existed. The Ara Pacis in Rome, Hagia Sophia, or any classical capital contain any number of motifs, usually vegetal, which are essentially redundant in the sense given to the word by linguists and communications engineers. Their presence does not affect or modify the sense of the monument on which they are found, but their absence is very much detrimental to its being appreciated and perceived. One could argue that, as Islam imposed upon itself a number of limitations on the iconographically significant, it simply concentrated its energies on the ornamental. The redundant became the main subject of an artistic tradition and, as the tradition grew and developed, its every new motif, even inscriptions, was ornamentalized. The task of the historian, then, is to identify the forms involved, describe their evolution, and explain their origins and aesthetic value on any one monument. This epistemological procedure, which has been followed in a small number of studies, has one very interesting virtue, that of concentrating on the work of art, for the value of an ornament

is far more intimately tied to its placement than to its existence as a schematic design in a manual of ornaments.

The definition of an ornamental theme or an ornamental value in early Islamic art is not the only pertinent problem derived from our previous observations. On a number of occasions another value has come to light, that of ambiguity or ambivalence, whereby a given feature lends itself to two simultaneous and partly contradictory interpretations, a precisely iconographic one and an ornamental one. Such is the case in some of Khirbat al-Mafjar's sculptures (fig. 85) as well as on Spanish ivories (fig. 94). The question is whether this conclusion results from the original creator's will or from insufficiently developed criteria of interpretation. If the first, we encounter a very interesting type of artistic creativity in which the primary burden of interpreting and enjoying a monument lies in the mood or need of the beholder. It would be a remarkably contemporary aesthetic procedure, and an explanation ought to be provided for it.

The purpose of this chapter is to investigate in greater detail than has been possible so far some of the questions posed by these observations. First, a survey of a few of the more outstanding monuments can lead to conclusions about the precise character and evolution of ornament. A second objective is to find out whether there are ways of defining an ornamental style, or perhaps an ornamental mode, for, if it is true that the artistic energies of early Islam tended to ornamentalize whatever they touched, the underlying attitude is independent of a given motif and thus may more appropriately be called a mode. Yet there is something troublesome in limiting ourselves to these two objectives. By stating that the Muslim world, for whatever reasons, diverted its energies into ornament, we are actually making a highly debatable assumption that the dichotomy between the iconographically meaningful and the ornamental reflects two entirely independent artistic purposes and visual experiences. In reality, we must ask whether some meaning cannot be given to those forms of early Islamic art that appear ornamental only in contrast to the art of other traditions. Alternately, we may have to conclude that the Muslim world simply rejected visual forms as major expressions of its culture, or that it discovered some totally new ways of contemplating and then of making works of art.

The tremendous accumulation of archaeological information over the past fifty years has made the task of discussing ornament particularly difficult, for the investigator is faced with irreconcilable method-

ological choices. He can operate chronologically, starting with the Dome of the Rock, and draw up an evolutionary curve until such time and place as seems to satisfy or exhaust him. He can choose one or more motifs and treat their appearance in a variety of monuments. He can emphasize a technique or arbitrarily select a small number of monuments and base his conclusions on these alone. Any one of these choices is legitimate and necessary. All of them, however, require detailed discussions which run the risk of diluting our purpose of establishing hypotheses for further work. Therefore, after three general remarks, a small group of examples will be used to introduce a few conclusions and interpretations.

The first preliminary remark concerns the regions and time spans which are represented and which illustrate an important variable in any consideration of the problem of ornament. Starting with the Dome of the Rock in 691 and ending with Mshatta around 740 or 745, the western half of the Fertile Crescent contains the single largest number of pertinent monuments. Only there can a *style* of ornament eventually be defined. But almost nothing is known about Syrian ornament between 750 and the twelfth century. Although recent discoveries at Qasr al-Hayr East and Raqqah—when they are published and studied—may provide some answer to the later evolution of Syrian styles, for the time being Syrian Umayyad art stands alone, and it is far more difficult to assume continuity or evolution in ornament than in mosques or palaces, or to relate ornamental forms to actual uses or actual taste, for contemporary judgments about ornament are lacking. Then, a ninth-century style or group of styles can be identified in Iraq, both in architectural ornament and in ceramics, largely through the Samarra finds. This style, or parts of it, has been shown to have had a fairly wide influence, since one of its most original components, the so-called beveled style, occurs from Morocco to Central Asia. Most of the available examples are, however, incidental details except in Egypt where both archaeological and historical sources confirm a major Iraqi influence in the late ninth century. Egypt, however, has preserved major series of wood carvings which, in part, reflect local traditions as well. A third early Islamic group comes from Spain, where the mosque of Cordoba and Madinah al-Zahra have preserved large numbers of documents, mostly from the tenth century. For a variety of reasons architectural decoration in Spain has archaizing tendencies and is stylistically closer to Umayyad models in Syria or to early Byzantine art than to Iraqi Abbasid art, whereas the ivories exhibit much more

stylistic originality. From eastern Iran we possess mainly large ceramic series; architectural remains like those of Nishapur are fragmentary, although the recently published Abbasid mosque at Balkh, the un-clearly dated but extremely wealthy Afrasiyab stuccoes, and especially the Samanid mausoleum at Bukhara are major masterpieces of orna-ment. The tenth-century mosque at Nayin is the only major monu-ment from western Iran. This rapid enumeration clearly indicates, once again, that the information we possess is very much weighted toward Syria and the eighth century. But a more important point is that any history of ornamental forms has more components than chronological ones. The date of any monument may be secondary to its actual meaning. For instance, the religious and social setting of Sedrata in southern Algeria makes the conclusions to be derived from its ornament of little importance for Algeria or for the tenth century but of much significance for Syria in the eighth and for Iraq, because the heterodox settlers of Sedrata lived in a closed world that had first been inspired by early Iraqi and Syrian movements.

A second variable in our considerations are the many techniques represented: stuccoes, stone, mosaics, ceramics, woodwork, ivories, and occasionally metalwork (mostly bronze) or glass. Although there is some point in studying each technique's nature and history sepa-rately, two features justify a consideration of ornament as ornament regardless of technique. One is the demonstrably numerous attempts by early Islam to transfer effects from one technique to the other. Some of these attempts are self-conscious, as in mosaics from Khirbat Min-yah (fig. 78) and Khirbat al-Mafjar where rugs are indicated by re-maining tassels and in one instance by the apparent indication of a weaving technique. Other transfers are less obvious. But it can be argued that a continuous series of Iranian *senmurvs* or dog-headed mythical animals among the paintings of Khirbat al-Mafjar copy a Persian textile, while a group of stucco busts set in interlaced roundels (figs. 85, 86) can be interpreted as the transformation into sculpture of a textile design known in Coptic art and elsewhere. In a general way much of the decoration from the rich palaces of Syria and Palestine seems to have been derived from small objects magnified in a manner reminiscent of later Romanesque art.

Although it has been shown that the conclusions to be derived from Umayyad palaces may be invalidated by the monuments' private func-tions and unique locations, the far more abundant but less rich orna-ment from Samarra confirms the constant existence of such transfers

from one technique to the other. Its stylistically most original group—
stuccoes, about which more will be said later—is usually considered to
have been taken over from a Central Asian tradition of work in metal
and wood. It is possible that its sources were even quite precisely a
Turkic art known as early as in the Altai finds from the first centuries
before our era. This specifically Turkish impact has not been demon-
strated convincingly enough and poses too many unsolved chronolog-
ical, historical, and ethnic questions to be more than a hypothesis, but
the assumption of metalwork as an inspiration for the stuccoes is
acceptable enough. Matters are more complicated when one turns to
the industrial arts, but it has been shown that some of the technical
innovations of ceramics were influenced by metalwork and luster oc-
curs both on pottery and on glass. The possibility or likelihood of
influences from other media on northeastern ceramics is less clearly
demonstrated. But this is perhaps because they have not yet been
sufficiently studied, for in later Islamic industrial arts such transfers
became common.

The second feature of early Islamic art that justifies the study of
ornament regardless of technique is the novel and extraordinary im-
portance of stucco. Its utilization as a technique of architectural deco-
ration is not new. From Parthian times onward it was one of the most
characteristic techniques of Iranian art, as it was used to cover up the
rather unassuming rubble masonry of most of Iran and of Central
Asia. Sometimes it was painted but most often it was carved or
molded into a variety of designs. Stucco was known in the Mediterra-
nean as well, but its main uses seem to have been the secondary ones
of repairs or rapid completions of unfinished works, and there is in
particular very little stucco sculpture of any quality. One of the main
consequences of the new balance between regions introduced by Islam
was the sudden and rapid spread of stucco from Iran and Iraq all over
the Muslim world. Large new building programs required rapid
means of construction and decoration; the total conquest of the Iranian
world put at the disposal of Muslim princes both an Iranian taste and
masses of artisans trained in Iranian techniques. But the primary im-
portance of stucco lay in some of its properties. Its cheapness made it a
technique accessible to all, and it offers an interesting parallel to ce-
ramics in that it could provide certain desired effects at any social
level. Its flexibility allowed it to be used for a life-size sculpture in the
round or for a minor repair to a broken capital. It lent itself to color.
There was almost no end to the ways in which it could be used and

transformed. The point here was to introduce and try out newly imported designs and also to continue local themes and motifs. Thus throughout almost the entire history of Islamic art monuments with stucco decoration appear as museums of forms. A third property of stucco is that it was both the freest and the most dependent technique of architectural decoration. On the one hand it was independent of the architectural units on which it was put; it could be used for whatever purpose a patron or an artist may have wanted. But on the other it was therefore also very dependent, for it hardly ever occurred without architectural support. It was a handmaiden of architecture whose forms could be quite free of architecture and could cover up entirely all parts of a building, thus modifying its architectonic qualities and the visible features of its construction.

Stucco, then, was a technique of surface decoration that transformed a building cheaply and flexibly (as opposed to mosaics, for instance). But almost every one of the innovative techniques of early Islamic art were those of surface effects: luster painting, opaque glazes, fixation of colors on pottery. We may be justified in concluding that the new culture, quite consciously and on several different technical levels, sought to emphasize surface over shape and gave itself the means to be as free as possible of an object's or monument's physical properties. It was—or at least could become—an art of illusion, which could make things look different from what they were. One may wonder why the culture's energies were pushed so much in these directions, and I will return to some aspects of this problem further on.

Our third preliminary consideration pertains to the motifs used in early Islamic ornament. A cursory survey of the mass of remains reveals an unbelievable number and variety of motifs for which an iconographic meaning cannot yet be proposed. This impression is particularly strong as one looks at the Umayyad monuments of Syria or at the Spanish ones, where in addition to the new creation of ornaments many older ones were reused and imitated or repaired. The architectural ornament of ninth-century Iraq appears less varied, but then Iraqi ceramics do provide a rather extensive ornamental vocabulary, as do northeastern Iranian ceramics. Architectural ornament in Iran is remarkable for its variety, and almost every discovery brings to light a new group of designs and styles. More than any other series of monuments or themes discussed so far, ornament depends on an almost infinite number of variables, many of which are independent of the motifs themselves, for every new patron or purpose may introduce

a new taste or a new idea. Social, psychological, ethnic, religious, economic functions are all involved in the explanation of a given ornamental design.

Despite the overwhelming variety of motifs, it is possible to organize them according to broad categories. Since I shall return in greater detail to the syntax of this ornament, I should first like to limit myself to a consideration of the themes themselves, that is, of such individual units as can be separated from their context and used in a list of designs. With a major exception in Samarra that will be explained later, almost all the available fragments can be divided into three groups. The first and largest consists of vegetal elements. While palmettes, half-palmettes, grape leaves and bunches, and rosettes predominate, almost every motif of vegetal origin found in classical, early Byzantine, Sassanian, Central Asian, and possible Indian ornament can be found at least once in Islamic art as well. Moreover, if we limit ourselves to a fairly narrow typological definition of a motif, it does not seem that a single new design was invented in early Islamic times. What did change enormously was the geographical distribution of ornament. There occurred a massive invasion of vegetal themes of eastern, especially Sassanian, origin into the Mediterranean, even as far as Spain, but there did not occur a similar movement of Mediterranean themes eastward, except in isolated instances. This phenomenon is more puzzling than it seems, for, even if one grants the importance taken quite rapidly by Iranian leaders and tastes in early Islamic art, architecture for instance does not exhibit the same tendency.

The second group of motifs consists of designs that can only be defined as geometric. These can be merely frames for other kinds of design or they can be the whole design, as commonly found in mosaics or windows. Two very tentative hypotheses can be proposed for these geometric themes. One is that, just as in the case of vegetal ornament, almost all identifiable types of design are found in pre-Islamic art and that the elaborate geometry of the stuccoes of Khirbat al-Mafjar and Qasr al-Hayr West is a translation into a new medium of fairly common mosaic motifs. The other is that in almost all instances the main characteristic of the geometric design is a tension between a complete and a broken unit. In other words, whether he created a pattern based on intersecting straight lines, on circles, or on combinations of circles and straight lines, the most artful creator tended to avoid making the unit or units with which he was working totally visible and explicit. He often broke them off suddenly or combined

neighboring motifs in some new fashion. While operating primarily only with a ruler and compass, he sought as much as possible to avoid the rigidity of a purely geometric composition and at times succeeded quite spectacularly, as in some of the mosaics at Khirbat al-Mafjar or in the carved marbles of Cordoba.

The third group of motifs is a miscellaneous category which, after further study, may be defined more exactly or incorporated into either one of the first two. But there are all sorts of motifs such as hatchings or dots in ceramics, or certain border designs on the Khirbat al-Mafjar stuccoes, for which no clear category can be provided for the time being. On manuscript illuminations and on bronzes there appears the motif of an arcade which may be merely ornamental but which may also have a clear iconographic meaning, as it did on the canon tables of Christian art. The same uncertainty of meaning surrounds the animals and occasional human beings which appear on some monuments and objects.

A proper understanding of Islamic ornament cannot be reached without detailed studies of the regional, social, and temporal variations of techniques of individual motifs. For the purposes of the chapter, the discussion is limited to architectural decoration, for it provides the most examples. A brief description of a few characteristic monuments is followed by a broader interpretation.

Let us consider first two stucco fragments from Qasr al-Hayr West (fig. 118) and from Khirbat al-Mafjar (fig. 119). The former is a single rectangular panel found on one of the towers of the façade. It is part of a series of panels over a band of lively acanthus leaves. A group of diagonally arranged double lines filled with heart-shaped leaves divides the field into regular diamonds that are then filled either with centrally composed rosettes or with artificial floral units arranged around a single vertical axis. It is not known how many different units there were nor how they were arranged, for the panel has been reconstructed from a myriad of small fragments. The Khirbat al-Mafjar example consists of a similar panel divided into rows of quadrilobed units separated by circular ones; the interstices are each filled with a single half-palmette. The circular units contain centrally composed rosettes or combinations of half-palmettes; the quadrilobed ones contain vertical designs of treelike elements which end in grape bunches, grape leaves, or palmettes, the three motifs seemingly indiscriminately used.

The second example is the celebrated Mshatta façade (figs. 120–

23). As it has often been described only a few salient features need be mentioned. A large band (over 4.25 meters high) framed by elaborately decorated moldings is carved on the central part of the palace's façade. The main feature of this long band is a series of twenty-eight equal triangles. In reality it is only because the building was never finished that these elements appear as clear triangles, for what was intended was a long zigzag border that would have divided the area into fifty-six equal triangular areas, alternately on their bases and on their points. Each triangle contains one enormous rosette which is in high relief and which contains a group of concentric designs; the rest of the field contains consistently different compositions in which vine rinceaux are found together with separate circles and occasionally animals. As has often been pointed out, animals are absent on the mosque side of the building, and thus a negatively iconographic meaning could be given to them.

A tenth-century piece of carved marble on the side of the mihrab in Cordoba (fig. 55) can serve as an example from the western Islamic world. The main design is framed by a border of hardly distinguishable leaves and stems creating a sort of undulating pattern around the object. In the center a single, straight, trunklike unit serves as the axis and the generator of a complex pattern of stems, leaves, split and complete calyces, that covers the rest of the field.

Finally, in the third or beveled style at Samarra (fig. 125) the repetition of characteristically slanted cuts has obliterated the originally vegetal nature of the units of decoration. Similar techniques were used in a group of Egyptian wood carvings (figs. 126, 127), in which at regular intervals a deep notch appears. A number of other illustrated fragments, for instance the stuccoes of Nishapur, or certain varieties of ceramics, are also appropriate examples for a study of decoration (figs. 105, 108, 110), each deserving a long and descriptive study.

In all these works the visible unit of design—vegetal, geometric, or other—has been totally subordinated to a number of abstract principles. Physical form has been constricted into a vehicle for the expression of something else than itself. First, each object or wall is totally covered; no part is left without ornament. This is the celebrated *horror vacui* by which Islamic decoration has so often been defined. More precisely, the relationship found in classical Roman ornament between a background on or against which ornament stands out has been replaced either by a contrast between light and shade—most remarkably in Mshatta—or, as at Samarra, by an impossibility of distinguish-

ing between the two. Second, the ornament can best be defined as a relationship between forms rather than as a sum of forms. This relationship can most often be expressed in geometric terms, and every one of the selected examples—especially the Qasr al-Hayr sculpture —can be defined through some sort of geometric structure. It is in Samarra that this system of definition is most striking, for there is no way of describing the stucco design except as a relation between lines and shapes, neither of which can be defined separately. It is interesting to note that this procedure was actually not only an end in itself but a device for representation, as can be shown through a celebrated Egyptian wood carving where a bird is attempted by contrasting shapes and lines (fig. 126). But its degree of abstraction ultimately made it unsuitable for representations. One may wonder in fact whether it is even theoretically possible that abstract designs represent concrete subjects.

The impact of geometry is the third principle I should like to suggest. The main geometric units translated into lines are circles and rhombs and, while there are instances (especially in mosaics) of rather extraordinary compositions, they are not comparable in complexity to the motifs of later centuries. In addition, we have quite consistently in this ornament a symmetry around a variable number of axes, which serve as the centers around which a motif develops, often almost mirror-reversed. But most of the axes are not finite, physical entities. Except for the Cordoba example (fig. 55) with its concrete rodlike compositional center with a clear beginning and end, the axes tend to be a form of visual imagination, for they do not exist by themselves but because of the rest of the design. The latter, however, does not make sense and cannot be described without them. Alternately, as in the Qasr al-Hayr and Khirbat al-Mafjar fragments, symmetry is replaced or completed by what may be called an overall pattern: one (rarely) or more units are multiplied so as to fit into the available space. At times, as in the Mafjar example and in a number of ceramics, a sort of tension appears between one motif that is self-contained and static and another that is growing and dynamic. But the most important aspect about symmetry as well as about the overall pattern is that, in the ways in which each is used, neither one contains within itself a logical end to the design. Thus the fourth principle of early Islamic ornament is the possibility of infinite growth, of which Mshatta's façade is the earliest illustration. On the one hand, the design can be extended at will in any direction, as it can also be extended in Samarra; it is the will

of the decorator which defines the limits of the design. On the other hand, this type of design endows its observer with considerable freedom. He can choose the point of view from which he wishes to enjoy or appreciate a design like Mshatta's. He can lose himself in the contemplation of details, in a count of thematic units. He can pick a single motif and follow it up in one triangle or examine its variations in a dozen triangles. He can search for compositional patterns or for effects of light and shade. It is as though a richly orchestrated symphony had been frozen in space. Its themes and motifs and its dozens of instruments are permanently available for inspection and meditation, and yet the finished work of art is still there.

The fifth principle is that a theme from any origin could be and was incorporated in ornament. Although vegetal and geometric themes predominate, animal, human, and epigraphical ones exist as well. In the case of the last three, however, there is a problem of interpretation, for a few investigations dealing mostly with later times have shown that an iconographic meaning *can* be given to certain animal themes used ornamentally. One may wonder whether writing did not preserve a symbolic value even when it was not used for specific words. Thus we may have to modify our statement to say that ornament became a mode, that is, a way of treating a variety of subjects without destroying their meaning, instead of saying that any subject can become a pure ornament. In any event, a certain ambiguity remains in the use of representations of living beings and of writing.

The sixth and last principle, which sums up almost all the points made so far, is that of arbitrariness. The most consistent characteristic of most early Islamic ornament is that neither its size nor its internal forms are dictated by anything but itself. Not only is Mshatta a wonderful example of this totally arbitrary band set across a building's façade but, even more importantly, none of its features are indicative of the building behind the decoration. This is true of any ornament, but the peculiarity of the Muslim type of arbitrariness is twofold. On the one hand, it was carried down to the level of the design's composition. And on the other, it tended to separate a monument's or object's surface from its shape. In itself this separation may not be new, for the utilization of stucco in Sassanian art already suggests an aesthetic process of the same nature. It is possible that Islam simply widened, complicated, and spread to many lands and to many techniques what seems to have been limited to a single technique in palaces and private houses of pre-Islamic Iran. By spreading it in this fashion, Islam added

to it a peculiar characteristic, impermanence. For an arbitrary ornament that separates the surface from the rest of the monument may be compared to a skin that can be removed and changed as needs or tastes change. In reality, of course, the situation was more complex. For later times it is known that the maker of an object or monument and its decorator were one and the same person and, if this was so in early Islamic times as well (as it was certainly true in the case of ceramicists for instance), one has to assume on the part of the artisan himself a sort of double and partly contradictory vision of the finished monument. Then also, a correlation between certain shapes and certain designs occurred at a fairly early time. For instance, Dome of the Rock spandrels or soffits do not share the same compositions. But, whatever the variances and exceptions, the general point of an arbitrary design, largely independent of the surface on which it was put, is a valid generalization about early Islamic ornament.

One can only speculate as to the reasons for this particular aspect of Muslim ornament. Possibly Muslim taste was influenced by the visual effects of rugs and textiles; the nomadic background of the Arabs and later of the Turks may have remained present and utilized or expanded a precise Iranian technique. Yet one must beware of such arguments: even if occasionally present in a romantic fashion among poets and in the social organization of cities, a nomadic mood or nomadic pride was not in the mainstream of a medieval Muslim ethos. But perhaps the reluctance of so much of early urban Islam to use in full the aesthetic forms and ways of the conquered world led to a sort of automatic, almost subconscious appearance of earlier and culturally differentiated ways and forms.

Before returning to other possible interpretations, it is worthwhile to bring up again a curiously unique monument in which almost all the characteristics of ornament are found, but with an important twist: the tenth-century Samanid mausoleum in Bukhara (figs. 128, 129). Architecturally it is a work of secular art that used the pavilion form for funerary purposes, and for our present concerns the important point is that brick, its medium of construction, also became its decoration. Its designs and effects are all definable by the principles we have provided, and the monument thus appears as a rich surface as well as a fully developed shape. The significant aspect of this first instance of what will be known as a "brick style" is that an attempt was made to realize in architectonic terms a taste developed first as an arbitrary surface ornament. The next period of Islamic art, especially in Iran,

continued this process, and some of its greatest masterpieces can be explained in this fashion.

Total covering, relationships between forms, geometric motifs, infinite potential growth, freedom in the choice of subjects, arbitrariness —such appear to be some of the salient characteristics of early Islamic ornament. It is paradoxical for three reasons. One is that its abstraction is not, like a chemical formula, the simplified symbolization of some reality; like certain mathematical abstractions it is a reality in itself, an artificial invention that acquired its own set of rules. It is quite possible that the ultimate explanation of its character lies far less in art historical exercises than in a comprehension of contemporary mathematical thought, as has been demonstrated for later Central Asian art. The paradox is that, with the exception of the important but ultimately sterile beveled Samarra style, these essentially abstract qualities are made visible through concrete "things," and some uncertainty remains as to whether the abstract qualities were the willed cause of the ornament or else the result of some hitherto unclear development of traditional decorative forms. Whatever the ultimate explanation, this is the level at which Islamic ornament acquires the intellectual status of a work of art, for it raises fundamental questions about the relationship between the visible and its meaning.

The second paradox, which has been sufficiently elaborated, is that this ornament is both the slave and the master of the space on which it occurs. The third paradox is partly subjective: at its best this ornament is a practical exercise and an intellectual meditation. It is an exercise in the sense that it consists for the most part in isolable formulas; yet it is also a meditation for there always is in it, to use a colloquial expression, more than meets the eye. But, like the beads of the holy man, the meditation it suggests is not in itself but in the mind of the beholder.

With this remark we penetrate another area of investigation, another facet of the possible explanation of the ornament. For we may wonder indeed whether the elaboration of this Muslim ornament could not reflect some attitude of Islamic culture as a whole. A parallel would lie more in the relationship that may have existed between scholasticism and the logic of Gothic construction rather than in the far more explicit translation into visual form of the middle Byzantine microcosm of Incarnation and Salvation.

Two themes of early Islamic thought can appropriately be connected with Islamic ornament, the first of which is symbolized by the com-

mon pietistic phrase, *lilah al-baqi*, "the Remaining is to God." The implication is that the absence of order in the world, the unreality of the visible, are necessary because they prove divine permanence. No creation of man can reflect physical reality because God alone makes anything permanent and the great sin is Pygmalion's, to fall in love with one's creation. The late Louis Massignon brought to light a beautiful story about Hallaj, the great mystic of the ninth century, which illustrates this thought. A flute was heard far away, and a disciple asked Hallaj: "What is this?" Hallaj replied: "It is the voice of Satan crying over the world because he wants to make it outlive destruction; he cries over things that pass; he wants to reanimate them, while God only remains. Satan has been condemned to stick to things that pass and this is why he cries." The second theme, which originated in Hellenic thought and became one of the central explanations of reality in the Muslim world, is known as atomism. Its central tenet is that all things are made up of and distinguished by various combinations of equal units. According to the faith of Islam, there is no compulsory, natural need that physical reality remain the same, and it is a divine miracle that the same compositions reappear. Since the artist must avoid imitating God or competing with him, he becomes free to recompose the units of nature he knows in any way he sees fit, and the more arbitrary and absurd the better.

These two themes *can* be utilized to explain the arbitrariness of ornament, its artificiality, its mixture of thematic elements from a variety of different sources, and perhaps also something of its abstraction. Such an explanation is not a causal one; at best it is structural in that the mood of the faith and the mood of the ornament seem to share a number of common assumptions. Yet doubts about the validity of these parallels linger. One may wonder whether, for this moment in Islamic history, it is entirely appropriate to find in mystical thought and imagery an explanation or even a parallel for a comparatively common ornamental tendency. Scientific or pseudo-scientific theory, while more attractive to explain the actual character of the arts, is equally difficult to imagine as having the necessary impact at a variety of social and economic levels. Furthermore, the main scientific achievement of Islamic culture is later than our period and it coincides better with a later development in ornament. If one searches for contemporary cultural associations, one should probably turn to the *madhahib*, to the legal sects around which Islamic thought and society tended to coalesce from the second half of the eighth century onward.

But far less is known about the practical and spiritual physiognomy of a Shafi'ite or of a Hanefite than about a mystic, and it does not seem possible to formulate for early Islamic times any sort of correlation between a common denominator of the arts and what appears to have been the main common denominator of the contemporary society.

Such are a few considerations that can be derived from early Islamic ornament. It is a peculiarly original creation of the first centuries of Islam which occurred all over the Muslim world and in all known techniques. Its uniqueness was almost never in the radical invention of new forms, but rather in a way of treating forms which itself may have been the result of a way of seeing man's creation. It is therefore more of an idea, a "structure," or a mode than it is a style. For this reason it appears so often to be ambiguous or ambivalent. One may question whether it really was so at the time and whether the ambivalence is not merely the result of our own inability to understand the intellectual and aesthetic motivations affecting the development of this ornament. Be this as it may, it seems appropriate to apply to it the term that the Italian Renaissance invented for its much later successors that were seen by the West as an equally original phenomenon, the *arabesque*. But instead of understanding the arabesque as a form, we may consider it as an idea.

Finally, while it is appropriate to regard the arabesque as a novelty of early Islamic art, it should be noted that not all early Islamic ornament can be considered as influenced by it. Other ways of ornamenting continued for several centuries. At times, as at Qasr al-Hayr East, we simply see complete classical or other designs taken over, repaired, and imitated. The impressively sturdy stone decoration of the ninth-century cupola in Kairouan (fig. 54), the woodwork of the Aqsa mosque in Jerusalem (fig. 53), an early mihrab in Iraq, many an eastern Iranian ceramic—all monuments of considerable aesthetic merit and technical effort—do not show, except in an occasional detail, the impact of the arabesque. Far more traditional relationships between background and foreground occur there: motifs tend to be finite complete units definable as individual subjects; symmetry, geometry, light and shade play a part in the elaboration of the designs but in a far more subdued fashion. Most of these monuments can be explained regionally; in them local traditions superseded new creations and were less affected by new attitudes.

Early Islamic ornament, when seen in its totality, appears therefore as an unusual symbiosis of a series of continuing forms, for the most

part identifiable locally, with a new, pan-Islamic idea that could be applied to them. Or, instead of symbiosis, we may talk of tension between a variety of formal tendencies, some ancient and local, others newer and Islam-wide. This tension had not yet at the time created a style, either locally or for the whole Muslim world. What it had accomplished was a unique modification of the external appearance of almost all early Islamic works of art. For, regardless of differences among individual monuments and whatever cultural or historical causes may be provided, the creation of a new syntactic structure preceded that of many new terms. If valid, the hypothesis of a syntactic change as appearing before a morphemic one and as eventually compelling the latter may be of interest for other moments of art history as well.

8. *The Formation of Islamic Art*

The purpose of this book was neither to provide a coherent and complete history of early Islamic art nor to present a monographic study of individual monuments, but rather to propose answers to two questions. One is whether there is a way of defining the nature of the changes, if any, in aesthetic and material creativity brought about by the phenomenon of an Islamic world. A corollary question is whether a time—absolute or relative—can be assigned to the acceptance of these alleged changes by the culture as a whole, that is, whether a "classical" moment occurred in the art of early Islam. The second question is whether a common ground or a common structure justifies the term "Islamic" for those features by which the art of the fledgling Muslim empire can be defined. Or, to put it another way, how different is early Islamic art from the artistic traditions it inherited? And how permanently did early Islamic characteristics remain in the later artistic development of the Muslim world? Then as various problems and monuments were discussed, additional questions were raised whose elaboration or elucidation went beyond the specific concerns of each chapter. Some of them are significant primarily to Near Eastern studies; they concern various aspects of the balance between provinces in the creation and development of Islamic art, the likelihood and nature of an early Islamic style, or the iconographic or formal connections that may have existed among different kinds of monuments. Other questions involve the position of the visual arts in early Islamic culture and the kind of documentary evidence offered to the historian by archaeological or artistic remains. Finally there are questions pertaining more narrowly to the discipline of the history of art, such as whether an artistic change can be defined in abstract terms, whether the Islamic phenomenon is unique in the history of the arts, and what kind of relationship existed between a monument and its creator or beholder.

Before an attempt to answer at least some of these questions, attention must be drawn to a basic assumption of the preceding investigations because the methodological choice underlying it has affected and colored whatever conclusions and hypotheses have been reached. The assumption is that the definition of a historical process in the arts—that is, of the ways in which changes have taken place—can most easily be made through an analysis of functions. Symbols of posses-

sion and occupation, mosques, palaces, ceramics, decorative designs, each one of the sets of monuments we have examined was defined and explained by the precise functions it served in the new civilization; these functions can be stated abstractly, independent of the monuments. There are two intellectual limitations to this procedure. One is its all too easy implication that form follows function; yet, as will be seen presently, one of the peculiarities of early Islamic art is that such was not always the case. The other is that more importance is given to the practical, psychological or other motives that preceded the creation of a monument than to the monument itself. The latter, a building or a ceramic plate, appears almost as a sort of secondary by-product of more or less correctly defined impulses, needs, and processes. To the extent that the history of art consists in imposing an intellectual pattern over man's creativity, this approach is justified, and particularly so in the study of an artistic tradition's "formation," for the problem is more one of needs in search of forms than of the forms themselves. But it is not the only possible approach, and a very different book could be written which would have found its point of departure in the monuments themselves, in their character and in their physical and aesthetic significance. Such a book should in fact be written, and the conclusions that follow are less a summary of what has preceded than an attempt to use the evidence and hypotheses of the previous chapters as an introduction to another kind of investigation.

If one considers the mass of monuments that have remained from the first three centuries of Islamic history, the first conclusion is that, on the simplest levels of techniques and of "phonetic" forms, there is hardly anything new. Practically every decorative motif considered in isolation, every unit of planning, every detail of construction, and every kind of object has a direct prototype in the earlier artistic traditions of the Near East and the Mediterranean. Even when an occasional feature like the pool in the forecourt of Khirbat al-Mafjar has no known model, the existence of such an earlier model can be assumed, at least hypothetically. Modifications in the shape of arches, as in Cordoba or in the mosque of Ibn Tulun, and even experiments with vaults found in northeastern Iran do not seem at this time and from the narrow viewpoint of the forms themselves to be more than evolutionary changes and exercises. They could have taken place in any cultural setting that had spent as many funds and energies as did the early Muslim princes. In the instances of floor mosaics and sculpture, it can even be suggested that Umayyad patrons consciously sought

archaizing models from the Mediterranean past. At this level, therefore, the monuments of early Islamic art fully belong to the succession of the vast empires of Rome, early Byzantium, and Iran.

To this generalization there are exceptions: in technique a totally new art of ceramics appeared, and in decoration Arabic writing appeared as a major iconographic and ornamental device. But the most important exception was the distribution of forms and techniques. Architectural units of Iranian origin such as the iwan occurred in Syria, Sassanian decorative designs appeared in North Africa, stucco became ubiquitous as a technique of decoration. Most of these distributional changes involved the spread of Iranian motifs westward, but the absence of Syrian features in the East may in part be the result of our more limited archaeological knowledge of Iran. The most remarkable feature of these exceptions is that all of them remained characteristics of later Islamic art, including the tendency for motifs to move from the east westward. Thus our first conclusion can be modified to state that, while the vast majority of the simplest elements in the early Islamic artistic vocabulary were mere continuations of older traditions, identifiable exceptions became uniquely significant aspects of Islamic art. From this conclusion can be derived the two hypotheses that these were particularly important to the new culture and that such early Islamic features as were not continued had to have had pre-Islamic prototypes.

From this level of simple forms and techniques we can move to the far more complex level of meanings, the level at which the originality and uniqueness of Islamic art begin to appear. Of the several aspects to this originality, one is primarily compositional and distributional. Thus, while none of the simplest elements of the hypostyle mosque was original, the composition of a completed building was different from anything preceding it. In decoration the characteristic new distribution of forms acquired a special thrust: representations of living things decreased, while vegetal and geometric elements predominated. The new distribution, therefore, not only reflected the size of the new empire but possessed rules and directions.

Concrete meanings can be attributed to some of the forms. Without significant alteration of shape, towers became minarets, niches became mihrabs, and a concentration of aisles on one side of the building indicated the qiblah, whenever these features were found in a mosque. Arabic inscriptions—whether partly invisible as on the upper part of the Dome of the Rock's mosaic decoration, or immediately

accessible as on the façade of the Tim mausoleum, on the mihrab of the Cordoba mosque, or on plates from northeastern Iran —became concrete iconographic elements that defined the specific significance of a monument. Thus a number of formal features acquired a very precise Islamic signifying power, and all of them maintained their meaning over the centuries of growth.

Yet the interesting aspect of early Islamic art is the paucity of such features. As various groups of monuments were described and discussed, a constant of their interpretation was ambiguity or ambivalence of meaning, as though either the visible form had no significance beyond itself, or the significance of the form was provided through some other means. A country estate, a ribat, and a caravanserai shared the same formal arrangement; the same decorative designs and techniques were used for entirely different buildings. In these cases differences in purpose and use were not established by the monuments but by the activities taking place in them. This primacy of human life and social needs also explains why, from the mosque to stuccoes or to ornament, almost all groups of Islamic monuments were flexible, adaptable to a variety of purposes. This characteristic also remained for centuries and, for example, the magnificent façades that came to adorn so many Muslim buildings from the twelfth century on almost never indicated whether the building was a mosque or a caravanserai. Along with ambiguity and flexibility, early Islamic art is characterized by a concerted avoidance of symbols. The contrast with the medieval Christian development is quite striking.

The most important reason for this feature, discussed in the preceding chapters, was the new culture's conscious rejection of the habits and practices of the tradition it replaced, especially Mediterranean Christianity. It is not that the Muslim world rejected their artistic forms, it is rather that it refused to utilize them in the same manner. For the type of legal and moral coherence that Islam created could not take over an older or contemporary artistic vocabulary without accepting the complexities of its meanings and thereby losing something of its own individuality. At the same time, it lacked a new vocabulary of its own because of the regions and ways in which it grew. The absence of an ecclesiastical organization and the alienation that occurred between the good life of the Muslim and the beautiful life of the prince further served to restrict, at times even to dessicate, meaningful visual creativity. At the one extreme of Ibn Miskawayh's ethics, the very notion of a work of art appeared as a sort of evil, or at best an unneces-

sary distraction from morality, a temptation by the vanities of the world. This reluctance toward concrete symbolism remained characteristic of Islamic art over the centuries, but from the eleventh century on it became tempered by a series of internal upheavals and ideological changes as well as by a lessening fear of alien power and a greater internal self-assurance. In the artistic explosion that followed the early Islamic period Iranian forms played a singularly important part for many reasons, one of which was a direct result of the achievements of the first Muslim centuries. For, whereas the Christian Mediterranean world remained strong and often inimical, ancient Iran slowly disappeared into myth or remained only as a vestige. The forms of Iranian art were therefore, so to speak, "liberated" from their non-Muslim associations and could be re-employed as "free" forms. The process is not without parallel in the utilization of classical forms in western art.

The formation of Islamic art can be seen, then, as an accumulation and novel distribution of forms from all over the conquered world, as a conscious sorting out of the meanings associated with the forms, and as a creation of a limited number of new, characteristic forms. Within this process certain directions can be detected, which provide at the same time a sense of the evolution of early Islamic art and some of the effects it sought to create. One direction is the slow impact of Muslim piety. Certain aspects of the architectural development of the mosque can be attributed to growing ritualization and to a growing sense of the mosque's holiness. Although it is less clear whether Muslim piety can really explain the complexities of Islamic ornament, such a hypothesis can be advanced. Another direction consists in the double patronage of early Islamic art. Princely patronage predominated; but even if the many preserved monuments sponsored by it exhibit unique formal combinations and express original functions, they are less Islamic than a Near Eastern-centered version of a princely art with universal values. Next to princely patronage there grew an urban one, particularly original in both the techniques it developed and the themes it used. This patronage, strongly affected by the faith, does not exhibit the exuberant wealth of princely art. Its forms tend to be more clearly localized than those of courtly art, and for the time being it is only in northeastern Iran, Iraq, and Egypt that this bourgeois patronage can be identified.

A third direction of early Islamic art is more difficult to express. From such apparently diverse phenomena as the break-up of arches in Cordoba, the creation of the *muqarnas* in northeastern Iran, the utiliza-

tion of expensive and cheap objects to copy and transmit almost all forms, the ubiquity of stucco covering, and the characteristics of ornament, it could be concluded that there occurred a separation between the material medium of a monument and the forms given to it. Formal units were meant to give the illusion of something different from what they were, and technical virtuosity became prized at the expense of other creative virtues. But this development also provided early Islamic art with an extraordinary freedom to adapt itself to local patrons and local needs, inasmuch as it was not fettered by any consensus of taste or patronage. For this reason, above all others, we encounter the at times bewildering variety of early Islamic monuments.

Altogether, it is not possible to consider all these characteristics as creating a period style, for what unifies these monuments are not individual forms and their arrangements, nor even a body of functions, but a series of attitudes toward the very process of artistic creation. These attitudes are contradictory, for at times they deny the validity of visual symbols and major permanent monuments, while at other times they demand a great virtuosity in beautifying an imperial palace or a prosaic ceramic plate. But the greatest achievement of these centuries was the successful creation of a monumental setting for the new culture, that is, a consistent body of forms different from other contemporary ones while utilizing in large part the same elements. The attitudes as well as the setting were conscious attempts at self-definition, at formulating with the terms of older cultures a language of visual forms that would serve the needs of the new culture and maintain its separate identity. Because they are most easily defined through attitudes than through forms it is appropriate to use the term "Islamic" for the monuments which extend over several centuries from the Atlantic to the steppes of Central Asia. But because the elements used in the creation of this language are for the most part older Mediterranean and Middle Eastern, the art of early Islam is a medieval art, one of the variants of the rich inheritance of classical antiquity.

Even though it extended all over the vast world conquered by Islam, early medieval Islamic art was not created simultaneously in all of its provinces. Chronologically and geographically, it first appeared in the Fertile Crescent during the eighth and ninth centuries. Within the Fertile Crescent Iraq predominated; it was the province of the first purely Muslim cities, and the imperial and urban ideals of Islam first crystallized in Baghdad and Samarra. Except for a few examples from

Umayyad Spain, the vast majority of early Islamic monuments can better be explained in relationship to Iraq than to Syria. In Iraq the style of early Islamic decoration was culminated, and from Iraq the builders of the mosques of Ibn Tulun and Kairouan brought their ornament and some of their methods of construction. The imperial life of Baghdad and Samarra, not the numerous estates of the Syrian steppe or the singular remains of Spain or Transoxiana, became the main focus of the princely myth of medieval Islam.

The creation of a physical setting which became ubiquitous, a series of attitudes toward artistic creation which even if contradictory at times were shared from Cordoba to Bukhara, and a formal and mythical focus in ninth-century Iraq—all these features coincide with the definition of a "classical" moment proposed at the beginning of this book. A northeastern Iranian ceramic with inscription, the mosque of Ibn Tulun, and the architecture or decoration of the Cordoba mosque all possess the clarity of forms, the understanding of media, and a unique combination of otherwise known units of composition which illustrate a mastery of the vocabulary of early Islamic art. They are superb examples of what can be called the moment of a *sunni* orthodox supremacy in the taste of the Muslim world; they fully express both its dialectic logic or order and perhaps something of the dryness of its legalism. The monuments of the first decades of Fatimid rule in Egypt—the Hakim mosque, the rock crystals, some of the woodwork—comprise, around the year 1000, the last coherent group of the first classicism of Islamic art, and it is an interesting indication of the differences in rhythms between taste and political or religious history that these monuments were sponsored by a heterodox dynasty.

Like any living organism, however, the world of Islam was not a frozen, completed entity and, even before the year 1000 other, at first glance secondary, themes began to show up. The growth of mausoleums and the appearance of small monumental mosques from Spain to Transoxiana challenged the supremacy of the large congregational *masjid al-jami'*. At the frontiers of the Muslim world, new ethnic groups and new artistic ideas had appeared. Khorasan and Transoxiana were physically bubbling with the missionary zeal of the *ghazi*, or warriors for the faith, and with a new architecture of baked brick. In Morocco the first rumblings that created Berber dynasties appeared, and all over central and western North Africa—another frontier area—an ardently pure Islam had grown from the ribats and hetero-

dox groups of old. The daylamite or northern Iranian dynasty of the Buyids had already shifted many of its centers of power from Iraq to the less fully islamized provinces of western Iran. In northeastern Iran, in Iraq, and in Egypt representations of living beings became more common in the urban art of ceramics and even in architectural decoration. Heterodoxies and social mysticism were everywhere. The Iranian renaissance was beginning and its Turkish carriers were already established in Khorasan. Many of these dissonant novelties could be considered simply as minor peculiarities within an established classicism. Yet they foreshadowed and prepared the great changes that characterized Islamic art from the middle of the eleventh century onward. It is only from the knowledge of what happened then that these features can be identified and isolated. For in the arts, in contradistinction to life, the nature of unavoidable change can only be discovered and explained after it has happened. The full investigation of these minor but essential themes within the vast composition of early Islamic art belongs therefore to a study of the rich art of the eleventh through thirteenth centuries.

Postscriptum: Twelve Years Later

It is admittedly not very proper for an author to express satisfaction at the critical success of his work. If I allow myself to do this, it is because the critical response to it led me eventually to ask new questions requiring more rigorous analysis and subtler conclusions than appeared in the original version.

With one major exception, the reviews of the first edition of this book praised it, even if they were at times critical of some of its details and arguments; and Spanish and German translations of the book appeared quite rapidly. The paperback edition made the book accessible to students, and numerous courses in Islamic art used it as a textbook. Even with its faults, this book seems to have responded, at least in part, to two needs of the relatively small public concerned with Islamic art. It could be an introduction to the subject without being a survey. But it was also meant to be a theoretical tool adaptable both to the historian of Islamic civilization and to the historian of medieval art (or of art in general); though the art historian may be a keen practitioner of iconographic or formal analysis, he may nevertheless be uncomfortable with nonrepresentational art and with an architecture that is striking but that lacks the immediate presence of real or mythical ceremony that gives life to so many palaces and large Christian sanctuaries. Revising this book more than a decade later was not merely a question of updating its information and bibliography on the monuments of early Islamic art; I also wished to review, modify, and perhaps expand certain conclusions and especially some of the explicit or implicit hypotheses that guided the earlier work.

This sort of review with revisionist overtones may in fact contribute to a new discourse on Islamic art that was just beginning fifteen years ago. The discourse has developed within the Islamic world and seeks to define the specifics of early Islamic art in order to identify and develop formal or ideological principles for a contemporary Islamic art. Seen from outside the Islamic world, this research into the past could easily seem *retardataire*, obscurantist, and destined for failure. It corresponds, however, to a profound need to understand one's own true roots and to be inspired by them. It deserves to be mentioned and perhaps even explained in a work with a broader audience than that of medievalists alone.

203

With this discourse in mind, I have tried to center my revisions around three themes: history and chronology, theory and interpretation, and contemporary significance.

History and Chronology

Traditional art history requires that the preserved monuments of the past be grouped in stylistic sequences defined by variable combinations of space (Syria, Iraq, Egypt) and time, the latter generally identified by the most powerful patronage of the time, that of ruling dynasties (Umayyads, Abbasids). Thus, we can talk of a first Islamic art dating from the beginning of Islam until 661 and known exclusively through literature, a few coins, and some inscriptions. Then there was an Umayyad art (661–750) known by a large number of mosques (in Damascus, Jerusalem, Medina, Wasit, Kufah) and other quasi-religious buildings (Dome of the Rock in Jerusalem, for example) and by the large series of palace-villas ranging from Khirbat Minyah to Mshatta and including Kufah's urban palace. This Umayyad art was concentrated, as far as we know, in Syria, Palestine, and Transjordan; an Iraqi variant had large hypostyle mosques and a sober and limited architectural decor.

After the year 750, the whole setting of Islamic civilization was modified. The founding of Baghdad, followed eighty years later by that of Samarra, transformed central Iraq into an immense urban market, a consumer of riches from the forests of northern Russia and from China. As shown recently, the ninth-century urban ensemble of Baghdad-Samarra became a metropolis unmatched since the fall of Rome. Eventually, in the tenth century, this metropolis became incapable of maintaining economic growth due to overinvestment in consumer goods rather than in capital. The human cost of this economic growth led to social conflicts often colored by religious heterodoxies and sometimes linked to intellectual movements as varied as they were original. At the same time, the period between 750 and the end of the ninth century demonstrates Abbasid art at its best. Its principal works—the architecture of Baghdad and Samarra, textiles, new ceramics series, and perhaps certain types of metalwork—are not well known because they have not been preserved in great numbers, but in Egypt (as in the mosque of Ibn Tulun), in the Kairouan mosque of

Ifrīqīyah, and in ceramics of northeastern Iran, there are clear echoes of an Abbasid art or culture formed in Baghdad, and also more indirect evidence of its influence as the original ideas were modified by local traditions. The modes of transmission are unclear, but it is reasonable to attribute a particular importance to Mekkah, favored by the caliphal patronage of Baghdad and therefore reflecting its architecture. The annual pilgrimage must have created an occasion for the dissemination of forms and ideas. At the end of the ninth century, the political weakening of the Abbasid caliphate led to the formation of regional styles of architecture and art objects in Andalusia, North Africa, Egypt, western Iran, and northeastern Iran: the mosque at Cordoba, the Samanide Mausoleum, Andalusian ivory, Iranian silverwork, and new regional series of ceramics. Later, from North Africa and then from Egypt, the Fatimid dynasty with its pan-Islamic ambitions possibly sought to express visually its autonomy from recently elaborated regional styles and, in so doing, forecast great changes that occurred in the twelfth century.

It is possible, as Michael Rogers has suggested in *Kunst des Orients* (1973–74), to relate the first centuries of Islamic art in a purely chronological manner and to define as precisely as possible one or more Umayyad styles characteristic of the first half of the eighth century, an Abbasid style centered in ninth-century Iraq, and two or three regional variations. In this literal perspective of art history, several conclusions or hypotheses insufficiently developed or wrongly placed in the preceding chapters would have found their rightful place. Here are three examples.

The palace-villas in the Umayyad era play an important role in chapter 6. The wealth and exuberance of their decoration, the presence of all kinds of representation, and the numerous techniques of ornamentation all suggest the luxurious and romantic life-style of their inhabitants. Historically, these establishments easily relate, as I have shown, to a tradition going back to ancient Rome and perhaps to Iran as well; furthermore, various types of royal villas or palaces seem to have remained as late as the twelfth century in the Muslim West, a region under Roman influence, and possibly elsewhere as well. But, while it may be valid to group these buildings together from the point of view of architectural function, it is not necessarily so in terms of form. Later monuments did not receive the same decoration as the Umayyad palaces and, except for the case of the large exterior frieze of Mshatta, almost no iconographic themes or ornaments from Khirbat

al-Mafjar, Khirbat Minyah, Qasr al-Hayr West, or Qusayr Amrah are found in later buildings with allegedly the same functions. It might be more correct to consider the set of Umayyad palaces as the result of a unique combination of a newly landed gentry (Arabian princes) with an unusually rich visual repertory available as a setting for their private lives. The inhabitants were Muslim, but there was nothing we could call Islamic in their palaces; and, most important, these monuments did not become part of the visual inheritance for later times. We could then explain why later texts, always ready to criticize the Umayyads, do not speak of these palaces: no one knew anything about them except for the landlords and their retinues. The Umayyad castles are in fact easier to understand as examples of eccentricity for private secular art in late antiquity than as the first steps of a new civilization.

This judgment, if acceptable, poses methodological difficulties. In effect, it asks the historian to disassociate from each other creations from the same era (705–45), in the same region (Syria-Palestine), built under the orders of the same princes, and in all likelihood executed by artisans trained in the same styles. The justification for this disassociation resides in the fact that later Islamic civilization accepted the architectural forms of the Iraqi or Syrian mosques; it did not understand the themes of the decoration of the Dome of the Rock or the Great Mosque of Damascus but maintained their techniques and their purely ornamental side and rejected, perhaps without even knowing it, a secular art accidentally adapted to the life of the Umayyad princes. This method of historical interpretation, based less on total contemporary evidence than on eventual filiation, is not the normal procedure for historians of medieval art but has been implemented in the study about the past two centuries in the West and about the Hellenistic era. It undoubtedly corresponds to a more theoretical implication of Umayyad art to which I shall return.

A second historical hypothesis to review concerns Abbasid art in the ninth century. For architecture and architectural decor, the Samarran monuments and the little that we know about Baghdad justify the description, sketched in the preceding chapters, of an austere style, sometimes grandiose in the large Iraqi mosques and yet humanized in the urban setting of Egypt, as in the mosque of Ibn Tulun. Palaces and private houses offer a larger selection of ornamental motifs than do mosques, where, except for inscriptions and themes originating in the architecture, the variety of motifs did not exist. But, excluding a few paintings with a concrete iconographic message, even the Samarran

stuccos tend to simplify forms and reach an ascetic abstraction of such
rigor that the work of art can only be described in theoretical terms and
its forms reach the extreme limits of their potential. This general defi-
nition of an Abbasid style is perhaps valid for the official art of the
caliphs and their representatives, and what we know of *tiraz* textiles,
with their patterned and simple, elegant letters, does not contradict
the idea of an art that is restricted in its forms but that admirably
reflects the legal order, itself in the process of elaboration.

There is, however, another side to ninth-century Islamic art.
Through ceramics, for instance, we see a remarkable capacity for all
sorts of transfers of technology and for inventing new techniques.
Thanks to these techniques, rich and varied ornamentation appears on
Iraqi ceramics in the ninth and tenth centuries, and what we discover
there is much more than simply the sober and abstract asceticism of
the official style. There are images of animals and people as well as a
complex ornamental vocabulary, unfortunately little studied and
therefore poorly understood. Likewise, for metalwork, some objects
are simple and austere, whereas the post-Sassanian silverwork about
which we have spoken and a number of large bronze plates, recently
studied by the Russian scholar Alexander Marshak, introduce a much
larger variety in ornamentation. The explanation that I have proposed,
a contrast between a princely art and an urban one, is not entirely
satisfactory except at the elementary level of technical competance and
invention. The large quantities of available material from Iraq must be
compiled in a much more systematic way than has been done so
that the origins and meanings of the motifs attributed to the ninth
century can be discovered and compared to the better known—if
not also better studied—motifs from northeastern Iranian ceramics.
We will then be able to suggest more precise definitions for Abbasid
art.

The working hypothesis for a more rigorous and narrower defini-
tion of ninth-century art comes out of the intellectual and social life of
the period. It was a period of striking and significant contrasts and
conflicts, some of which can only be mentioned: the triumph of reli-
gious legalism and numerous opposition movements; the appearance
of an Iranian ethnocentrism, the first Turkish generals, and a cult of
pre-Islamic Arabs; the great translations from Greek and Sanskrit; the
first original scientific activity; the first mystical movements; a new
poetry and serious research on pre-Islamic poetry; the canonization of
the Koran and of the life of the Prophet; the first sketches of an Islamic

dialogue with its past. All of these made the ninth century one of abounding vitality in which the arts played an important role. Thus the chronicler Mas'udi mentions that in the age of the caliph al-Mutawakkil (847–61) a new style of clothing and of private architecture was introduced. We cannot, with our present knowledge of monuments and objects, explain this passage, but we can conclude from it that visual aesthetics were valued. This conclusion is supported by another text in which the writer, describing the reconstruction of the Haram in Mekkah at the end of the century, sees the Ka'bah at the center of an open space, that is, from an aesthetic rather than a pious point of view.

In short, the first edition of this book did not try to contrast the Umayyad period, in part a continuation of past visual systems without a particular Islamic meaning, with the ninth century Abbasid, in which forms and directions arose from the new Islamic civilization.

Thus, the third hypothesis that I wish to reexamine involves the monuments of the tenth century or later that are discussed in this book, including the mihrab of the Cordoba mosque, the Fatimid monuments, the Samanid mausoleum in Bukhara, the muqarnas, and a large part of the ceramics assumed to be from Nishapur. These works did not quite belong within a more rigorous perspective of the ninth century. Some are, without a doubt, continuations of classical Abbasid art; others do not appear in the main groups or sets of Abbasid art but represent new directions that demand a different kind of study and approach from the ones in this book.

In a chronological and historical perspective, the first three centuries of Islamic art demonstrate a particularly complex process in the formation of a new art. Two parallel and more or less conscious activities contributed to this process. One consistently adapted, conserved, or abandoned the rich Hellenistic and Iranian traditions automatically found in all new Muslim regions. The other one adopted, developed, and integrated new forms and techniques inspired or required by a social and religious environment unequaled in the past. Without more documents than we possess, the exact equilibrium between these two activities will never be known and might even have been unknowable at the time. The only certain conclusion is that the character of this equilibrium varied according to functions, patronage, users, regions, and periods up to the early ninth century, at least in the central provinces of the new Muslim world.

Theory and Interpretation

The main theoretical hypothesis of this book is relatively simple. Maintenance of the early Islamic community as a cohesive and relatively unified entity required two different yet often related activities. One was to create forms corresponding to the new community's needs; only the composition (though not the techniques of construction) of the large mosques would have been such an original creation. The other was to choose within the contemporary visual languages the forms or combination of forms that could continue to serve without compromising the unified quality of the Islamic setting in the midst of the great traditions that preceded it. The results are varied: the generalized niche of the art of antiquity became the mihrab, coins lost all images and became covered with inscriptions, animated representations disappeared from all that was private, and an aniconic doctrine developed. Eventually, a purely ornamental art dominated that part of the aesthetic works available to everyone, and in Samarra it attained a rare level of abstraction. In short, within our hypothesis, the creation of an Islamic art was not the result of an artistic or aesthetic doctrine inspired by the new religion or even by social or other consequences of the prophetic message, but consisted in transforming preceding traditions compatible with the as yet barely formulated identity of the Muslim community and at times trying to serve its needs or to proclaim its presence (as in the minaret and tiraz). Many of these transformations were elisions; by the progressive abstraction of the architectural and decorative compositions, artists and artisans knew best how to avoid the moral and religious dangers of all representational art, whether in images of an individual or of a vineleaf.

This slightly simplified schema of the book's conclusion contains two difficulties that require elaboration. One is the process by which these transformations took place. Was the process one of theoretical reflection that would have acquired the quasi-legal status of a doctrine? Or rather, did the entire community reach a collective consensus, articulated or not, in reaction to the phenomenon of the arts? The first hypothesis is unlikely because, to my knowledge, the written sources do not indicate the existence of a doctrine on the arts before the tenth century. Only a careful and in-depth study of the traditions of the life of the Prophet could elicit the existence of a debate on subjects other than the representation of living things. But even if a

debate existed at a philosophical or legal level, it is difficult to imagine the mechanisms for transmitting a hypothetical doctrine on the arts during the first two or three centuries of Islam. For a long time, the artisans were non-Muslims and, even when they were Muslims, the forms and techniques that were employed belonged to civilizations other than their own. Furthermore, the absence of a clergy limited the patronage of the large monuments to the caliphs and their political representatives and the patronage of objects to their users. The terms of contact between an aesthetic thought, however limited, and the practical decisions of the users or patrons are almost impossible to imagine, therefore the hypothesis of a collective consensus seems preferable to me. The psychological explanation of the consensus was the need to maintain the integrity of the Islamic identity, but the limits of this integrity could vary within a given social or ethnic group. Thus the caliphs and the important princes separated private art from public monuments, perhaps more so than the inhabitants of the new towns did; building in the area of northeastern Iran required different choices from those of building in Syria or North Africa. Whatever the local or social situation of a particular object or monument, and as little as the functions of the visual creation changed, all works of art from the first two centuries of Islam were the result of a more or less conscious and successful filtering of past forms so as to identify the user or work as belonging to the Islamic world. Only in the ninth century did these individual operations finally reach a critical mass sufficient to create a style and thus the first steps of an internal evolution. Each time the Muslim world confronted new regions with long artistic traditions—in twelfth- and thirteenth-century Anatolia and in late twelfth-century India—a similar filtering process seems to have occurred.

The first difficult point of our hypothesis, then, is that it implies a collective process in the choice of forms that is nearly impossible to demonstrate. The second problem is perhaps easier to handle, but it has interesting consequences for the historian of art or of society. In our hypothesis, each monument or object is a separate case that represents an immediate solution to a precise problem, until we can define a continuous series of similar responses to the same problems. Thus, as early as the end of the seventh century, the hypostyle mosque had acquired an original typology, and toward the end of the eighth century certain new and consistent ceramic techniques had appeared in Iraq. This meant that the particular circumstances of the early history of Islam precluded the notion of a period style that would have in-

cluded a majority of more or less contemporary works, but the same
circumstances made possible the idea of period functions. A history of
the formation of Islamic art could ideally then be a chronological table
of the Islamicization of diverse social and aesthetic functions. The
Islamic phenomenon could be comparable to the Roman Empire of the
third and fourth centuries and to the Westernization of the Third
World in our time. What links all these very different moments of
history is that the arts or the visual functions are governed by what
one could call the socialization of an ideology, in other words, the
transformation into social forms (including taste and visual communi-
cation) of a doctrine, religious message, as in the case of Christianity
and Islam, or technologic or institutional superiority, as in the contem-
porary West. Inversely, it is perhaps reasonable to view the failure of
all socialization as deriving from the failure of the ideology, as in a
number of both ancient and contemporary examples, including Bud-
dhism in India.

Detailed investigations are necessary for a better understanding of
the situation of the arts within the much more complex phenomenon
of the transformation of societies under the impact of new doctrines. A
last theoretical problem, however, deserves to be raised anew. It con-
cerns the idea of the arabesque and of ornament in general. In using a
relatively restrictive term for nonfigurative art as it appeared during
the first two centuries of Islam, I may have contributed to confusion
rather than to clarification in my last chapter. It is perhaps legitimate to
adopt the formulation made by Alois Riegl almost one hundred years
ago in *Stilfragen* and repeated in such general works as the *Encyclopedia
of Islam*, which limits the usage of the word *arabesque* to a precise type
of vegetal motif: leaves and stems artificially arranged in continuous
sequences or symmetrical designs in a given space. Arabesque thus
refers to only one of the ornamental motifs developed by Islamic art,
the first examples of which come at the end of the eighth century. But
the study of the formation of this motif is different from the more
general notion of an art of ornamentation that replaces the representa-
tions of preceding traditions through a geometrical and vegetal vocab-
ulary. In order to know how to interpret this phenomenon and, in
particular, whether a negative meaning should be attributed to it as an
expression of the rejection of other forms, or a positive one as the
expression of certain ideas on the reality of the visible world, we must
first understand the nature of ornamentation in general. Despite sev-
eral recent attempts, especially by Ernst Gombrich, this subject is still

poorly studied beyond its purely taxonomic aspects. Thus, while recognizing the inadequacies of this chapter on the arabesque, especially from a theoretical point of view, I am not entirely clear on the path or paths to take in order to improve its conclusion.

Past and Present

Some readers have looked to this book for guidance in defining what is permanently Muslim in Islamic art. In one sense, the contemporary situation is not without analogies to that of the early centuries of Islam. A number of practical necessities as well as a fascination with the West have transformed the environment of the Muslim world to the point where the identity or identities of a civilization attached to any specific revelation was felt to be threatened. A logic found more than once in history (Protestantism and nationalist movements of the nineteenth century, among others) requires that in these circumstances artists, architects, governments, and patrons look into a more or less clearly defined past for principles, possibly even forms, that would help maintain the integrity of the culture without requiring servile copies of ancient monuments. The objective of maintaining cultural identity when tempted by a Western art from a civilization with universal pretensions is comparable to the Muslim objective in the seventh and eighth centuries. Are the solutions of these early centuries still valid, in practice or in principle?

It is easy to answer that a history book which seeks to explain the arts and the attitudes of a clearly delineated period of long ago cannot claim to have contemporary significance. Furthermore, it is not from Western academic research that principles and ideas valuable to the contemporary Islamic world should emerge. At two different levels, however, the results and hypotheses of this book lend themselves to more profound and more elaborate research on Islam as a system of thought, of life, and of art. In order to identify better what I have called the psychological and social filters that carried out the visual transformations of the first Islamic art, we must not simply analyze the Koranic passages or the traditions dealing with the representation of living beings, the mosques, and religious practices. We must try to outline the sum of questions posed by the environment and objects of early Islam and reconstruct, through the older collections of traditions

or commentaries on the Koran, the processes of developing equilibrium between the Revelation and the law, on one hand, and the necessities of practical life in very different conditions on the other. The next level, perhaps more theoretical, is that of the values, symbolic or otherwise, of forms in the early art of Islam. If our conclusion is correct, that these values were almost totally rejected, was this rejection linked to historical contingencies of the moment? Or does this rejection become normative in Islam because it appeared in the seventh century? Answers to these questions could contribute to a debate within Islamic civilization that has continued for over fourteen centuries. The answer to today's question is the privilege of contemporaries, even though elaboration of information and ideas through the ages was a major contribution to the history of the arts in general and of the Muslim world in particular. We have not, however, arrived at this stage of the problem. We have only posed the questions or sketched ideas for responses. The responses themselves still require much more research and reflection.

Appendix: *Chronology of the Early Muslim World*

This is merely a list of the most salient dates and rulers pertinent to an understanding of the text. For more complete and easily accessible information see Clifford E. Bosworth, *The Islamic Dynasties* (Edinburgh, 1967) and James J. Saunders, *A History of Medieval Islam* (London, 1965).

A.D. 622 The Hijrah, establishment in Madinah of the first Muslim state; beginning of the Muslim era

632 Death of the Prophet Muhammad

The Conquest

633–40 Conquest of Syria and Palestine
640 Completion of conquest of Iraq
642 Alexandria abandoned by Byzantine army, Lower Egypt conquered
651 Death of the last Sassanian king, conquest of western Iran
711 Beginning of conquest of Spain
732 Battle of Poitiers
751 Tashkent reached in Central Asia, symbolizing the completion of the conquest of northeastern Iran

The Caliphate

632–61 The so-called Orthodox caliphs
661–750 Umayyad caliphs, among whom the most important ones for the arts were:
 661–80 Mu'awiyah
 685–705 Abd al-Malik
 705–15 al-Walid I
 717–20 'Umar
 724–43 Hisham
 743 al-Walid II
749–945 Period during which 'Abbasid caliphs were in fairly strong control. The most important rulers were:
 754–75 al-Mansur
 786–809 Harun al-Rashid
 813–33 al-Ma'mun
 833–42 al-Mu'tasim
 847–61 al-Mutawakkil
 870–92 al-Mu'tamid
 908–32 al-Muqtadir

Early Dynasties in the Provinces

756–1031 Umayyads in Spain
800–903 Aghlabids in Tunisia and Sicily
868–905 Tulunids in Egypt
909–1171 Fatimids in Tunisia, Egypt, Sicily, Palestine
969 Foundation of Cairo
932–1062 Buyids in Persia and Iraq
821–73 Tahirids in northeastern Iran
819–1005 Samanids in northeastern Iran

Bibliography

This bibliography is arranged in the order of the chapters and, within each chapter, in the approximate order of its arguments. With a few exceptions, general works are only mentioned once. It is not meant to be an exhaustive bibliography but rather an acknowledgment of those studies which helped in the writing of this book, of the pertinent new publications since the first edition of the book, and of publications for the reader interested in further study of the first centuries of Islamic art.

1. The Problem

FORMATION OF ISLAMIC CIVILIZATION AND GENERAL INTRODUCTIONS

Carl H. Becker, "Islam als Problem," *Der Islam* 1 (1910), reproduced in vol. 1 of *Islamstudien* (Leipzig, 1924).

Jörg Kraemer, *Das Problem der islamischer Kulturgeschichte* (Tübingen, 1959).

G. von Grunebaum, "The Sources of Islamic Civilisation," *Der Islam* 46 (1970): 1–54.

Centre d'Etudes Supérieures d'Histoire des Religions, University of Strasbourg, *L'Elaboration de l'Islam* (Paris, 1961).

Dominique and Janine Sourdel, *La Civilisation de l'Islam classique* (Paris, 1968).

Marshall Hodgson, *The Venture of Islam*, vol. 1 (Chicago, 1924).

Bernard Lewis, ed., *The World of Islam* (London, 1976).

GENERAL HISTORY OF ISLAMIC ARTS

Georges Marçais, *L'Art de l'Islam* (Paris, 1946) for the discussion on p. 1.

Katerina Otto-Dorn, *Islamische Kunst* (Baden-Baden, 1964; French ed. Paris, 1967).

K. A. C. Creswell, *Early Muslim Architecture*, 2 vols. (Oxford, 1932, 1940; rev. ed. vol. 1 in 2 vols. 1969).

Richard Ettinghausen, *La Peinture arabe* (Geneva, 1962).

Berthold Spuler and Janine Sourdel-Thomine, *Die Kunst des Islams* (Berlin, 1973).

Alexandre Papadopoulo, *L'Islam et l'art musulman* (Paris, 1976).

MOSAICS OF MA'IN

Roland de Vaux, "Une Mosaïque byzantine à Ma'in," *Revue biblique* 47 (1938): 227–58.
André Grabar, *L'Iconoclasme byzantin* (Paris, 1957), 106–07.

ST. JOHN OF DAMASCUS

Jean Meyendorff, "Byzantine Views of Islam," *Dumbarton Oaks Papers* 18 (1964): 113–32.
Armand Abel, "Le chapitre CL du Livre des Hérésies," *Studia Islamica* 19 (1963): 5–26.

IRAN

Jacques Duchesne-Guillemin, *Symbols and Values in Zoroastrianism* (New York, 1966).
Bertold Spuler, *Iran in frühislamischer Zeit* (Wiesbaden, 1952).
Ehran Yarshater, ed., *The Cambridge History of Iran*, vol. 3 (Cambridge, 1983).

HERZFELD, SAUVAGET, MONNERET DE VILLARD

Ernst Herzfeld, "Die Genesis der islamischen Kunst," *Der Islam* 1 (1910): 27–63, 115–44; and "Mshatta, Hira und Badiya," *Jahrbuch der preussischen Kunstsammlungen* 42 (1921): 104–46.
Jean Sauvaget, "Comment étudier l'histoire du monde arabe," *Revue Africaine* 90 (1946): 1–24; and *Mémorial Jean Sauvaget*, 2 vols. (Damascus, 1954).
Ugo Monneret de Villard, *Introduzione allo studio dell'archeologia islamica* (Rome, 1966).

2. The Land of Early Islam

GENERAL

Baladhuri, *Futuh al-Buldan*, ed. Michel de Goeje (Leiden, 1866); *The Origins of the Islamic State*, half translated K. Hitti (New York, 1916), and rest translated Francis C. Murgotten (New York, 1924).
George Marçais, *La Berbèrie et l'Orient* (Paris, 1946).

Hamilton A. R. Gibb, *Studies on the Civilization of Islam*, ed. S. Shaw and W. Polk (Boston, 1962).

Xavier de Planhol, *Les Fondements géographiques de l'histoire de l'Islam* (Paris, 1968).

Guy Le Strange, *Lands of the Eastern Caliphate* (Cambridge, England, 1930).

André Miquel, *La Géographie humaine du monde musulman*, 3 vols. (Paris, 1967–80).

Patricia Crone et Michael Cook, *Hagarism* (London, 1977).

Fred Donner, *The Early Islamic Conquests* (Princeton, 1981).

MUSLIM WEST

Ars Hispaniae, vols. 3 and 4 (Madrid, 1951).

Henri Terrasse, *L'Art hispano-mauresque* (Paris, 1932).

Georges Marçais, *L'Architecture musulmane d'Occident* (Paris, 1954).

Lucien Golvin, *Le Magrib central à l'époque des Zirides* (Paris, 1957); and *Recherches archéologiques à la qal'a des Banu Hammad* (Paris, 1965).

Alexandre Lézine, *Le Ribat de Sousse* (Tunis, 1956); *Architecture de l'Ifriqiya* (Paris, 1966); and "Notes d'archéologie ifriqiyenne," *Revue des etudes islamiques* 35 (1967): 53–101.

Gaspare Messana, *L'Architettura musulmana della Libia* (Venice, 1972).

Since the journal *al-Andalus* ceased publication, the most important periodical is the *Madrider Mitteilungen* of the German Archaeological Institute.

EGYPT

K. A. C. Creswell, *Early Muslim Architecture*, 2 vols. (Oxford, 1932, 1940; rev. ed. vol. 1 in 2 vols. 1969); *Muslim Architecture of Egypt*, 2 vols. (Oxford, 1952), vol. 1.

For Fustat, see articles by George Scanlon, "Fustat and the Islamic Art of Egypt," *Archaeology* 21 (1968): 188–95; in *The Islamic City*, ed. Samuel M. Stern and Albert Hourani (Oxford, 1969); and regularly in *Journal of the American Research Center in Egypt*.

Henri Stern, "The Ivories of the Ambo of the Cathedral at Aix-la-Chapelle," *Connoisseur* (1963): 166–72.

For Coptic art see the critical review of Hjalmar Torp in *Art Bulletin* 47 (1965): 361–75.

PALESTINE, SYRIA, IRAQ

Georges Tchalenko, *Villages antiques de la Syrie du Nord* (Paris, 1953).

Robert McC. Adams, *Land behind Baghdad* (Chicago, 1965).

Oleg Grabar, "Umayyad Palaces and the Abbasid Revolution," *Studia Islamica* 18 (1963): 5–18.

Jean Sauvaget, "Chateaux omeyyades de Syrie," *Revue des Etudes islamiques* 35 (1967): 1–39.

Alois Musil, *Palmyrena* (New York, 1928); *The Middle Euphrates* (New York, 1927); *Arabia Petraea* (Vienna, 1907).

Friedrich Sarre and Ernst Herzfeld, *Archaeologische Reise im Tigris und Euphratgebiet* (Berlin, 1911–20).

Michel Morony, *Iraq after the Muslim Conquest* (Princeton, 1984).

Main periodicals are *Syria; Annales archéologiques de Syrie;* and *Damaszenische Mitteilungen* for Syria; *Levant* and *Annual of the Jordanian Department of Antiquities* for Palestine and Jordan; *Sumer* and *Baghdader Mitteilungen* for Iraq.

IRAN

Bertold Spuler, *Iran in frühislamischer Zeit* (Wiesbaden, 1952).

Richard N. Frye, *The Heritage of Persia* (London, 1962); and *The Golden Age of Persia* (London, 1975).

The Cambridge History of Iran, vol. 3, ed. Ehsan Yarshater (Cambridge, 1983) and vol. 4, ed. Richard N. Frye (Cambridge, 1975).

Arthur U. Pope and Phyllis Ackerman, *A Survey of Persian Art* (London, 1939).

Main periodicals are *Iran* and *Archaölogische Mitteilungen ans Iran.*

CENTRAL ASIA

Vladimir V. Barthold, *Turkestan down to the Mongol Invasion* (London, 1978).

Alexander Belenitsky, *Central Asia* (Geneva, 1968).

Galina A. Pugachenkova and Lazar I. Rempel, *Istoria iskusstv Uzbekistana* (Moscow, 1965).

Oleg Bolshakov and Alexander Belenitskij, *Srednevekovyi gorod Srednei Azii* (Leningrad, 1973).

3. The Symbolic Appropriation of the Land

QUSAYR AMRAH

Oleg Grabar, "The Six Kings at Qusayr Amrah," *Ars Orientalis* 1 (1954): 185–87.

DOME OF THE ROCK

Oleg Grabar, "The Umayyad Dome of the Rock," *Ars Orientalis* 3 (1959): 33–62.

Marguerite van Berchem, "The Mosaics of the Dome of the Rock in Jerusalem and the Great Mosque in Damascus," in Creswell, *Early Muslim Architecture*, rev. ed. vol. 1 part 1 (Oxford, 1969), 213–372.

Werner Caskel, *Der Felsendom und die Wallfahrt nach Jerusalem* (Cologne, 1963).

Henri Stern, "Les représentations des conciles dans l'église de la Nativité," *Byzantion* 11–13 (1936–38): 151–92 and 415–59; *Cahiers archéologiques* 3 (1948): 82–105.

For an opinion differing from mine see Robert W. Hamilton, *The Church of the Nativity* (Jerusalem, 1947).

BAGHDAD

Jacob Lassner, *The Topography of Baghdad in the Early Middle Ages* (Detroit, 1970).

For an imaginative and novel interpretation of Baghdad, see Ibrahim Abid Illawi, *Les Cités musulmanes abbasides*, Ph.D. diss., Ecole des Hautes Etudes en Sciences Sociales, Paris, 1981).

4. Islamic Attitudes toward the Arts

ANICONISM

Ahmad Muhammad Musa, "Muslims and Taswir," *Muslim World* 45 (1955): 250–68.

Thomas, W. Arnold, *Painting in Islam* (Oxford, 1928).

K. A. C. Creswell, "The Lawfulness of Painting in Early Islam," *Ars Islamica*, 11–12 (1946): 159–66.

Georges Marçais, "La Question des images dans l'art musulman," *Byzantin* 7 (1932): 161–83.

Rudi Paret, "Textbelege zum islamischen Bilderverbot," in *Studien H. Schrade dargebracht* (Stuttgart, 1960), 36–48.

Bishr Farès, *Essai sur l'esprit de la décoration islamique* (Cairo, 1952); and "Philosophie et jurisprudence illustrées par les Arabes," in *Mélanges Louis Massignon* (Damascus, 1957), 77–109.

Oleg Grabar, "Islam and Iconoclasm," in *Iconoclasm*, ed. A. Bryer and J. Herrin (Birmingham, England, 1977), 45–52.

Arabia before Islam

Ugo Monneret de Villard, *Introduzione allo studio dell'archaeologia islamica* (Rome, 1966).

Henri Lammens, "Les Sanctuaries préislamites dans l'Arabie occidentale," *Beyrout, Univ. St. Joseph: Mélanges de la faculté orientale* 2 (1926): 39–173.

al-Hamdani, *The Antiquities of South Arabia*, tr. Nabih A. Faris (Princeton, 1938).

René Dussaud, *La Pénetration des Arabes en Syrie avant l'Islam* (Paris, 1955).

Glen Bowersock, *Roman Arabia* (Cambridge, Mass., 1983).

Ahmed Fakhry, *An Archaeological Journey to Yemen* (Cairo, 1952).

Peter J. Parr et al., "Preliminary Survey in N.W. Arabia," *Bulletin, Institute of Archaeology, University of London,* 8–9 (1970): 193–242.

A. R. al-Ansary, *Qaryat al-Fau* (London, 1981).

The key periodical is *al-Atlal,* published by the Department of Antiquities of Saudi Arabia.

Islam and Byzantium

Marguerite van Berchem "The Mosaics of the Dome of the Rock in Jerusalem and the Great Mosque in Damascus," in Creswell, *Early Muslim Architecture,* rev. ed. vol. 1 part 1 (Oxford, 1969), pp. 213–372, answering H. A. R. Gibb, "Arab-Byzantine Relations under the Umayyad Caliphate," *Dumbarton Oaks Papers* 11 (1958): 221–33.

Oleg Grabar, "Islamic Art and Byzantium," *Dumbarton Oaks Papers* 18 (1964): 67–88.

A. A. Vasiliev, "The Iconoclastic Edict of the Caliph Yazid II," *Dumbarton Oaks Papers* 8 (1954): 85–150.

Numismatics

John Walker, *A Catalogue of Arab-Sassanian Coins* (London, 1941); *A Catalogue of Arab-Byzantine and Post-Reform Coins* (London, 1956).

Philip Grierson, "The Monetary Reforms of Abd-al-Malik," *Journal of the Economic and Social History of the Orient* 3 (1960): 241–64.

George C. Miles, "Mihrab and Anaza," in *Archaeologica Orientalia in Memoriam Ernst Herzfeld* (Locust Valley, N.Y., 1952), 279–80; and "The Earliest Arab Gold Coinage," *American Numismatic Society, Museum Notes* 13 (1967): 205–29 (see also vols. 7 and 9).

André Grabar, *L'Iconoclasme byzantin* (Paris, 1957), pp. 67ff.

James D. Breckenridge, *The Numismatic History of Justinian II* (New York, 1959).

GENERAL

Jacques Berque, *Normes et valeurs dans l'Islam contemporain* (Paris, 1966), esp. p. 107.

Marshall Hodgson, "Islam and Image," *History of Religion* 3 (1964): 220–60.

The quotation for Ibn Miskawayh is in *Traité d'éthique*, tr. M. Arkoun (Damascus, 1969), 301–03.

Titus Burckhardt, *Art of Islam: Language and Meaning* (London, 1976).

5. Islamic Religious Art: The Mosque

Johannes Pedersen, "Masdjid," in *Encyclopédie de l'Islam.*

Carl H. Becker, "Die Kanzel im Kultus des alten Islam," in *Orientalische Studien Th. Noeldeke herausgegeben* (Giessen, 1906).

S. D. Goitein, *Studies in Islamic Studies* (Leiden, 1966).

Oleg Grabar, "The Case of the Mosque," in *Middle Eastern Cities*, ed. Ira Lapidus (Berkeley, 1969), 26–46.

Jean Sauvaget, *La Mosqueé omeyyade de Médine* (Paris, 1947).

Lucien Golvin, *Essai sur l'architecture religieuse islamique*, 4 vols. (Paris, 1970–74).

Janine Sourdel-Thomine, "Mosquée et madrasa," *Cahiers de Civilisation Médiévale* 13 (1970): 97–115.

INDIVIDUAL MOSQUES

Most of these mosques are discussed in Creswell's *Early Muslim Architecture* and in other books listed for Chapter 2. See also the following publications:

Oleg Grabar, "La Mosquée omeyyade de Damas," *Synthronon* (Paris, 1968), 107–14.

Klaus Brisch, *Die Fenstergitter der Hauptmoschee von Cordova* (Berlin, 1966).

Christian Ewert, *Spanisch-Islamische Systeme sih kreuzenden Bogen* (Berlin, 1968); and *Forschungen zur almohadishen Moschee I: Vorstufen* (Mainz, 1981).

Henri Stern, "Recherches sur la mosquée al-Agsa," *Ars Orientalis* 5 (1963): 28–48; and *Les Mosaïques de la Grande Mosquée de Cordove* (Berlin, 1976).

Barbara Finster, "Die Mosaiken der Umayyaden moschee," *Kunst des Orients* 7 (1970–71): 83–141.

David Whitehouse, *Siraf III: The Congregational Mosque* (London, 1982).

Lisa Golombek, "Abbasid Mosque at Balkh," *Oriental Art* 15 (1969): 1–12.

A. Dietrich, "Die Moscheen von Gurgan," *Der Islam* 40 (1964): 1–17.

The text on p. 117 is based on Maqrizi, *Khitat* 2 (Cairo, n.d.), 248.

Minaret

R. J. H. Gottheil, "The Origins and History of the Minaret," *Journal of the American Oriental Society* 30 (1909–10): 132–54.

Max van Berchem "Die Inschriften der Grabtürme," in E. Diez, *Churasanische Baudenkmäler*, 1 (Berlin, 1918): 87–116.

Joseph Schacht, "Ein archäischer Minaret-Typ," *Ars Islamica* 4 (1938): 46–54; and "Further Notes," *Ars Orientalis* 4 (1961): 137–41.

Jonathan M. Bloom, "Five Fatimid Minarets," *Journal of the Society of Architectural Historians*, 43 (1984): 162–67.

Mihrab

Robert B. Sarjeant, "Mihrab," *Bulletin of the School of Oriental and African Studies* 22 (1959): 439–52.

Other

Edmond Pauty, "Le dispositif en T," *Bulletin d'Etudes orientales* 2 (1932): 91–124.

Oleg Grabar, "Earliest Commemorative Structures," *Ars Orientalis* 6 (1966): 7–46.

Nabia Abbott, *Rise of the North Arabic Script* (Chicago, 1939).

Parallel studies were carried out by V. Krachtkovskaia in *Epigrafika Vostoka*; see Oleg Grabar in *Ars Orientalis* 2 (1959): 547–60.

D. S. Rice, *The Unique Ibn al-Bawwab Manuscript* (Dublin, 1955).

Erica Dodd, "The Image of the Word," *Berytus* 18 (1969): 35–61.

All future studies on early calligraphy will eventually be based on the recent discoveries in Yemen; see Kuwait National Museum, *Masahif Sana'* (Kuwait, 1985). For methodology, it is essential to consult the two volumes by François Déroche, *Les Manuscrits du Coran* (Paris, 1983–84).

6. Secular Art: Palace and City

Country Establishments

In addition to Creswell:

Werner Caskel, "Al-Uhaidir," *Der Islam* 39 (1964): 29–37. See also *Mesopotamia* 2 (1967): 195–218 and *Sumer* 22 (1966).

Martin Almagro et al., *Qusayr Amru* (Madrid, 1975).

Klaus Brisch, "Jabal Says," *Kairener Mitteilungen*, 19, 20 (1963 and 1965).

Oleg Grabar et al., *City in the Desert* (Cambridge, Mass., 1978).

Heinz Gaube, *Hirbet el-Beida* (Beirut, 1974).

Barbara Finster and Jürgen Schmidt, "Sasanidische and frühislamische Ruine im Iraq," *Baghdader Mitteilungen* 8 (1976).

Robert Hillenbrand, " 'La Dolce Vita' in early Islamic Syria: The evidence of later Umayyad palaces," *Art History*, 5 no. 1 (1982): 1–35.

Vincenzo Strika, "La Formazione dell'iconografia del califfo," *Annali Istituto Orientale, Napoli*, 14 (1964).

Richard Ettinghausen, *From Byzantium to Sassanian Iran* (Leiden, 1973).

URBAN ESTABLISHMENTS

Ernst Herzfeld, *Geschichte des Stadt Samarra* (Hamburg, 1948).

Michael Rogers, "Samarra," in *The Islamic City*, ed. Albert Hourani and Samuel M. Stern (Oxford, 1969), 119–56.

Guy Le Strange, "A Greek Embassy," *Journal of the Royal Asiatic Society* (1897).

Dominique Sourdel, "Questions de Cérémonial abbaside," *Revue des etudes islamiques* 38 (1960): 14–48.

A. Almagro, *El Palacio Omeya de Amman* (Madrid, 1983).

OBJECTS

Paul Kahle, "Die Schaetze der Fatimiden," *Zeitschrift der deutschen Morgenlandgesellschaft* 89 (1955): 329–61.

Robert J. Serjeant, "Materials for a History of Islamic Textiles," *Ars Islamica*, from vol. 9 (1940).

Gaston Wiet, *Soieries Persanes* (Cairo, 1948).

Ernst Kuhnel and Dorothy Shepherd, "Buyid Silks," in *A Survey of Persian Art*, ed. Arthur U. Pope and Phyllis Ackerman, suppl. vol. 14 (Tokyo, 1967), 3080–99.

Ernst Kuhnel, *Die Islamische Elfenbeinskulpturen* (Berlin, 1971).

John Beckwith, *Caskets from Cordova* (London, 1967).

Oleg Grabar, *Sassanian Silver* (Ann Arbor, 1967).

Prudence O. Harper, *The Royal Hunter* (New York, 1978).

Arthur Lane, *Early Islamic Pottery* (London, 1947).

Friedrich Sarre, *Die Keramik von Samarra* (Berlin, 1925).

Charles Wilkinson, *Nishapur: Pottery of the Early Islamic Period* (New York, 1975).

S. Tashhodjaev, *Hudozhestvennaia Keramika Samarkanda* (Tashkent, 1967).

Lisa Volov, "Plaited Kufic," *Ars Orientalis* 6 (1966): 107–34.

Oleg Bolshakov, *Epigrafika Vostoka* 12–18 (1958–67).

I. Ahrarov and L. Rempel, *Reznoi Shtuk Afrasiyaba* (Tashkent, 1971).

M. Lombard, *Les Textiles dans le monde musulman* (Paris, 1978).

7. Early Islamic Decoration: The Idea of an Arabesque

Ernst Kuhnel, *Die Arabeske* (Wiesbaden, 1949).

Ernst Herzfeld, *Der Wandschmuck der Bauten von Samarra* (Berlin, 1923).

Maurice Dimand, "Studies in Islamic Ornament," *Ars Islamica* 4 (1937): 293–337.

Fouad Shafi'i, *Simple Calyx Ornament in Islamic Art* (Cairo, 1956).

Lazar I. Rempel, *Arhitekturnyi ornament Uzbekistana* (Tashkent, 1961).

M. S. Bulatov, *Geometricheskaia garmonizatziia v arhitektury Srednei Azii* (Moscow, 1978).

Louis Massignon, "Les Méthodes de réalisations artistiques des peuples de l'Islam," *Syria* 2 (1921): 47–53, 149–60.

Postscriptum: Twelve Years Later

Richard Hodges and David Whitehouse, *Mohammed, Charlemagne and the Origins of Europe* (Ithaca, 1983).

Andrew M. Watson, *Agricultural Innovation in the early Islamic World* (Cambridge, England, 1983).

B. I. Marshak, "Ranneislamski bronzovye bliuda," *Trudy Ermitazha* 19 (1978): 26–52.

A. Germen, ed., *Islamic Architecture and Urbanism* (Dammam, 1983).

Ernst Gombrich, *The Sense of Order: A Study in the Psychology of Decorative Art* (Ithaca, N.Y., 1979).

Index

Illustrations

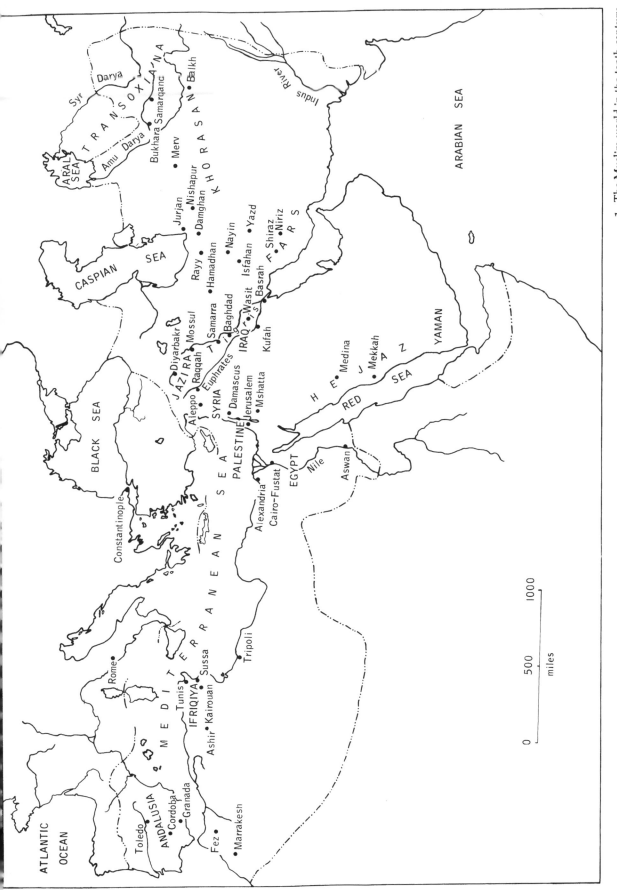

1. The Muslim world in the tenth century.

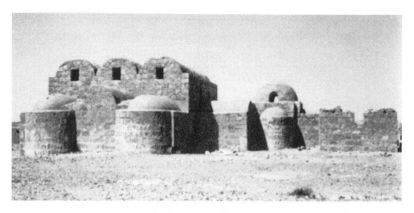

2. Qusayr Amrah. Bath, first half of the 8th century, general view.

3. Qusayr Amrah. The Six Kings, first half
of the 8th century. (After Musil)

3a. Qusayr Amrah. Sassanian King, restored.

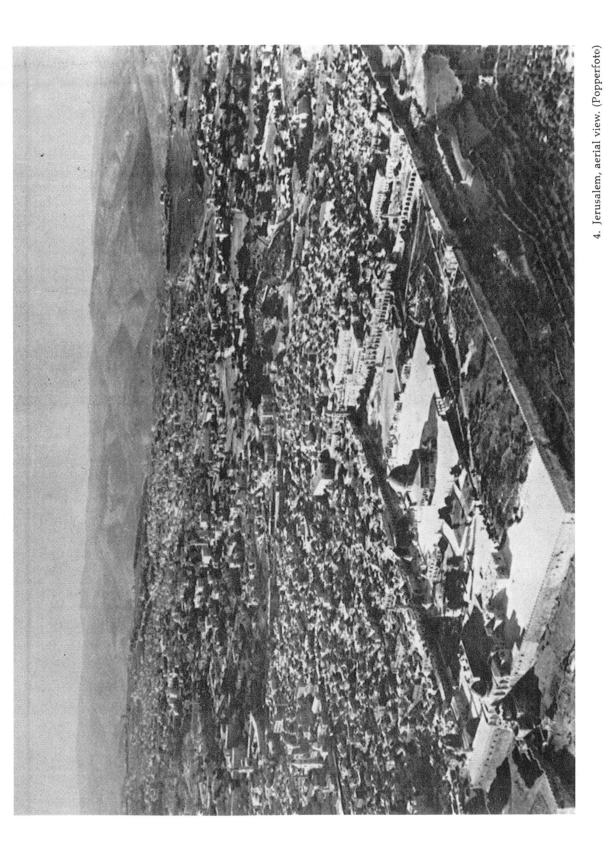

4. Jerusalem, aerial view. (Popperfoto)

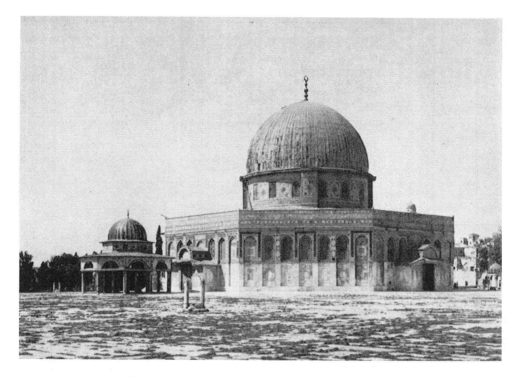

5. Jerusalem. Dome of the Rock, 692, exterior.

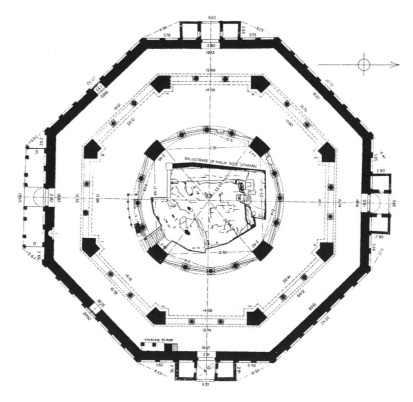

6. Dome of the Rock, plan. (After Creswell)

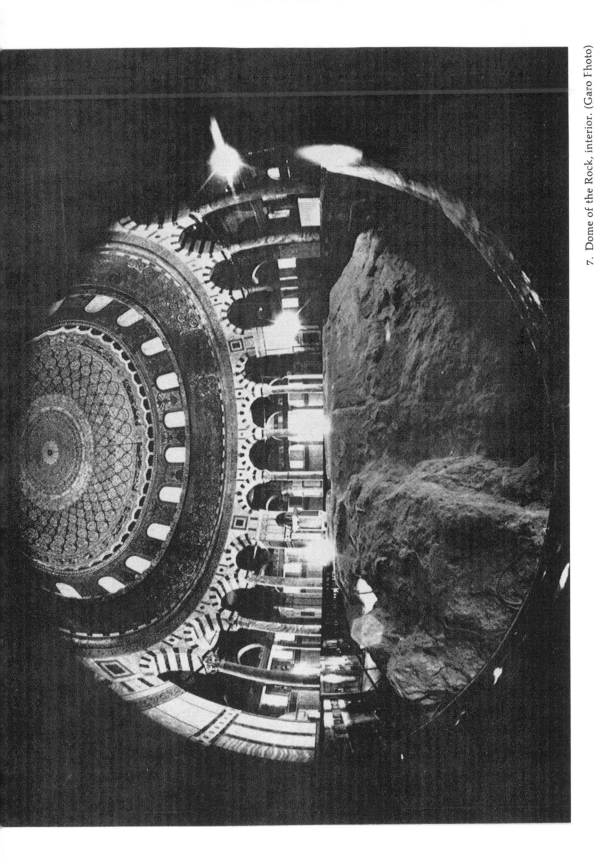

7. Dome of the Rock, interior. (Garo Fhoto)

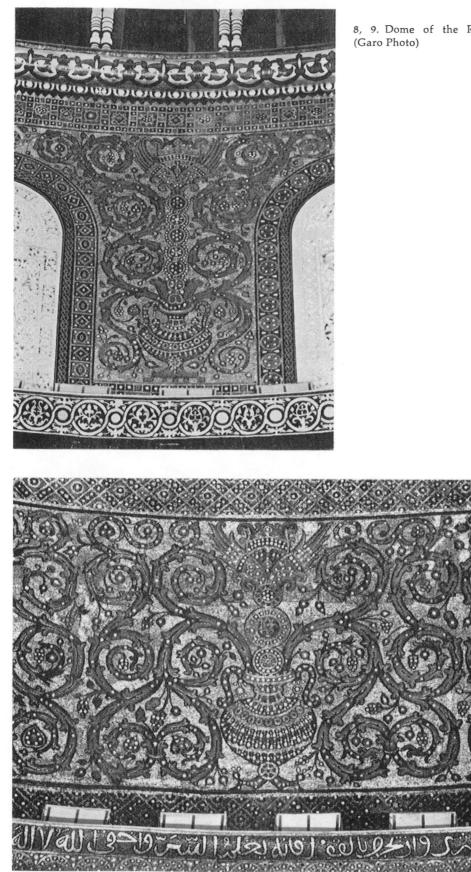

8, 9. Dome of the Rock, mosaics.
(Garo Photo)

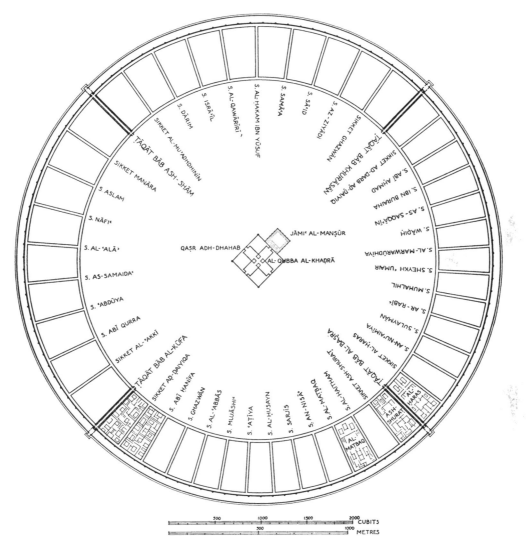

Labels on the figure (clockwise from top):

S. SAMĀ'A
S. AL-ḤAKAM IBN YŪSUF
S. AL-QAWĀRĪRĪ
S. ISRĀ'ĪL
S. DĀRIM
SIKKET AL-MU'ADHDHININ
ṬĀQĀT BĀB ASH-SHĀM
SIKKET MANĀRA
S. ASLAM
S. NĀFI'
S. AL-'ALĀ'
S. AS-SAMAIDA'
S. 'ABDŪYA
S. ABĪ QURRA
SIKKET AL-'AKKĪ
ṬĀQĀT BĀB AL-KŪFA
SIKKET AD-DANYQA
S. ABĪ ḤANĪFA
S. GHAZWĀN
S. AL-'ABBĀS
S. MU'ĀSHI'
S. 'ATĪYA
S. AL-ḤUSAYN
S. SARĪS
AN-NISĀ'
S. AL-HAYTHAM
SINKET ASH-SHURAT
ṬĀQĀT BĀB AL-BAṢRA
SINKET AL-ḤARAS
S. AN-NU'AIMIYA
S. SULAYMĀN
S. AR-RABĪ'
S. MUḤAḤIL
S. SHEYKH 'UMAR
S. AL-MARWARŪDHIYA
S. WĀḌIḤ
S. AS-SAQQĀ'ĪN
S. IBN BURAIHA
S. ABĪ AḤMAD
SIKKET AD-DARB AD-DĀYIQ
SIKKET GHAZWĀN
ṬĀQĀT BĀB KHURĀSĀN
S. ZIYAD

Centre labels:

QAṢR ADH-DHAHAB
JĀMI' AL-MANṢŪR
AL-QUBBA AL-KHAḌRĀ

Lower-right blocks:

AL-MAṬBAQ
ASH-SHURAT
AL-ḤARAS

Scale bars:

500 1000 1500 2000 CUBITS
500 1000 METRES

10. Baghdad. Reconstruction of the original city of Mansur, 762. (After Creswell)

11. Al-Jazari, *Automata*, 13th-century miniature. Formerly in the F. R. Martin collection.

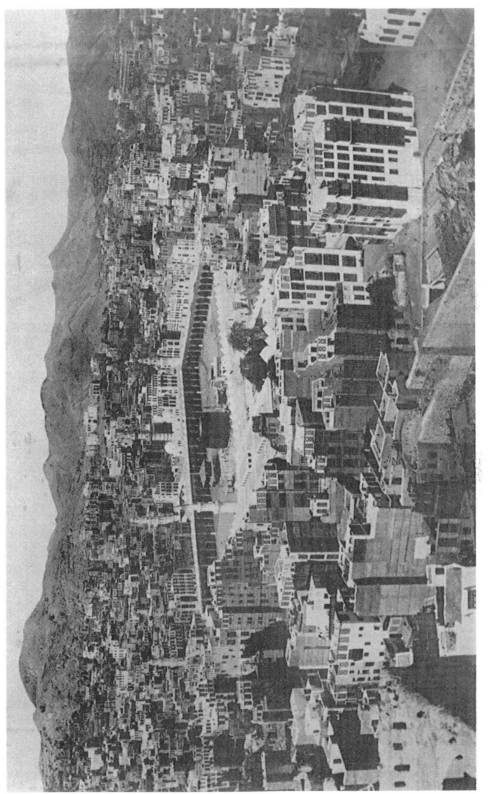

12. Mekkah. The Haram, general view. (Popperfoto)

13, 14. Damascus. Umayyad mosque, 705–15. (University Prints)

15. Early Islamic coin, "mihrab" type, reverse. (American Numismatic Society)

16. Early Islamic coin, Arab-Sassanian type, obverse and reverse. (American Numismatic Society)

17. Early Islamic coin, Arab-Byzantine type. (American Numismatic Society)

18. Early Islamic coin, Standing Caliph type, obverse and reverse. (American Numismatic Society)

19. Early Islamic coin, "Orant" type, obverse and reverse. (American Numismatic Society)

20. Early Islamic coin, new type, obverse and reverse. (American Numismatic Society)

21. Seal of Abd al-Malik. Istanbul, Archaeological Museum.

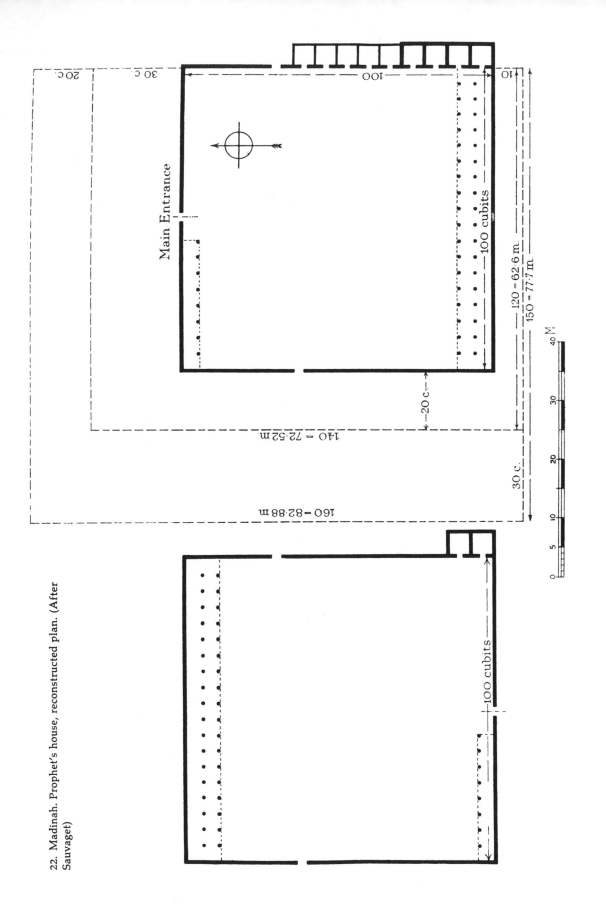

22. Madinah. Prophet's house, reconstructed plan. (After Sauvaget)

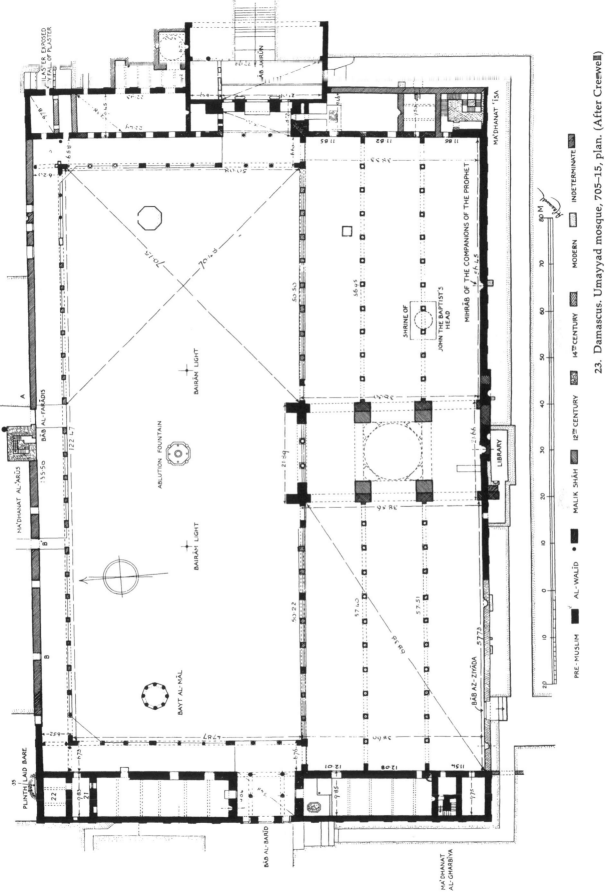

23. Damascus. Umayyad mosque, 705–15, plan. (After Creswell)

PRE-MUSLIM ▪ AL-WALĪD • MALIK SHĀH ▨ 12ᵀᴴ CENTURY ▨ 14ᵀᴴ CENTURY ▨ MODERN ▨ INDETERMINATE ▨

PLINTH LAID BARE

BĀB AL-BARĪD

MA'DHANAT AL-GHARBĪYA

BĀB AZ-ZIYĀDA

LIBRARY

MIHRĀB OF THE COMPANIONS OF THE PROPHET

SHRINE OF JOHN THE BAPTIST'S HEAD

MA'DHANAT 'ISA

BĀB JAIRŪN

PLASTER EXPOSED BY FALL OF PLASTER

MA'DHANAT AL-'ARŪS

BĀB AL-FARĀDIS

ABLUTION FOUNTAIN

BAIRĀM LIGHT

BAIRĀM LIGHT

BAYT AL-MĀL

80 M

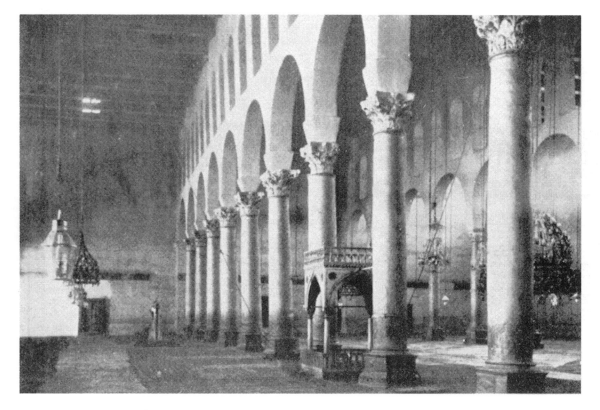

24. Damascus. Umayyad mosque, interior. (University Prints)

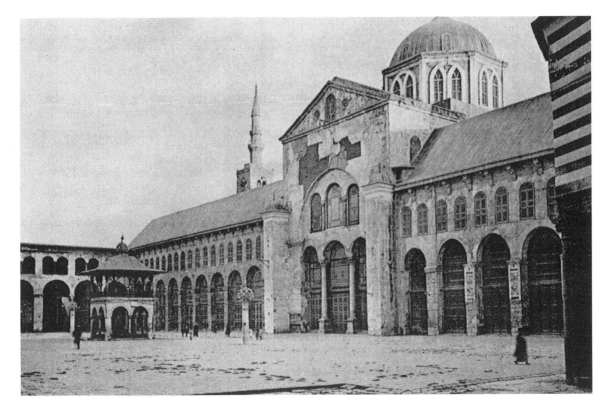

25. Damascus. Umayyad mosque, courtyard. (University Prints)

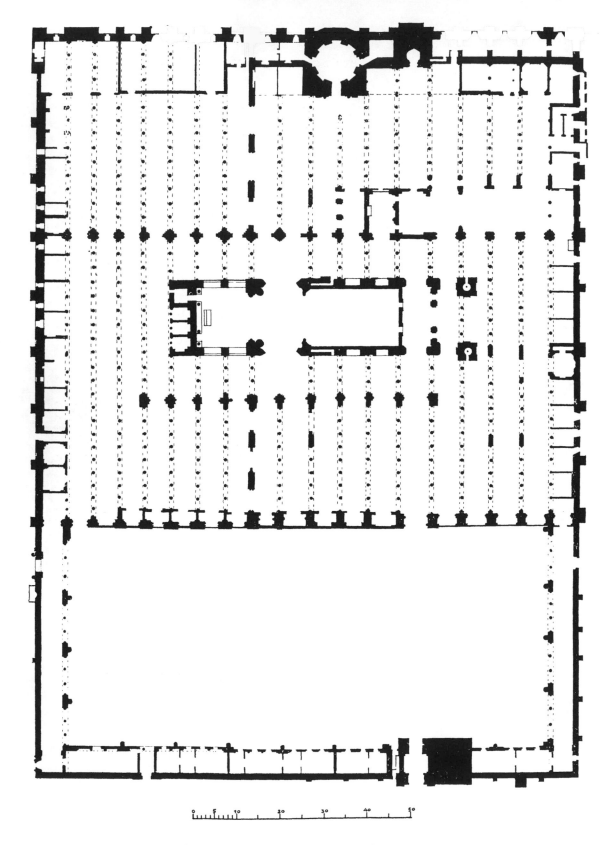

26. Cordoba. Mosque, 8th–10th centuries, plan. Scale in meters. (After *Ars Hispaniae*, vol. 3)

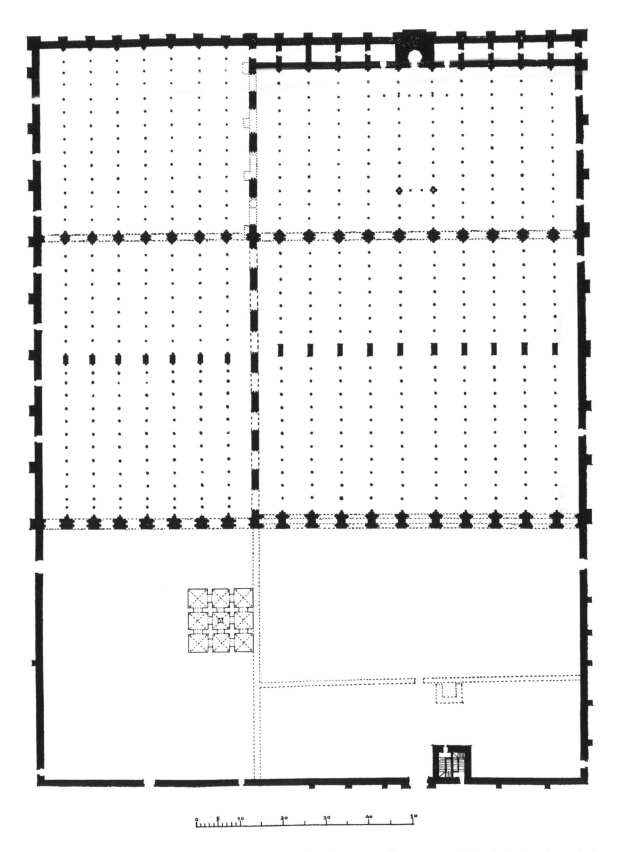

27. Cordoba. Mosque, scheme of its development. Scale in meters. (After *Ars Hispaniae*, vol. 3)

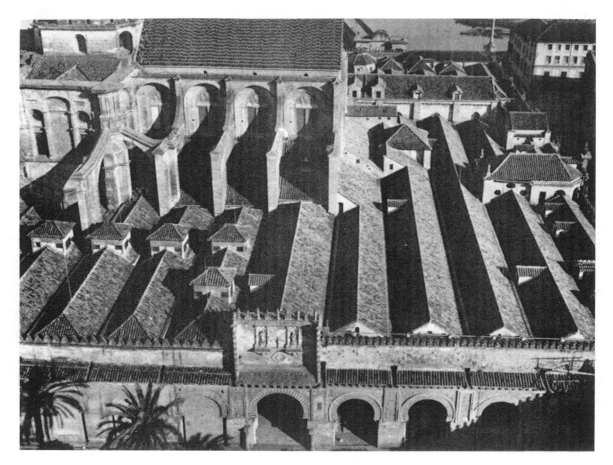

28. Cordoba. Mosque, aerial view. (MAS)

29. Cordoba. Mosque, St. Stephen's gate. (MAS)

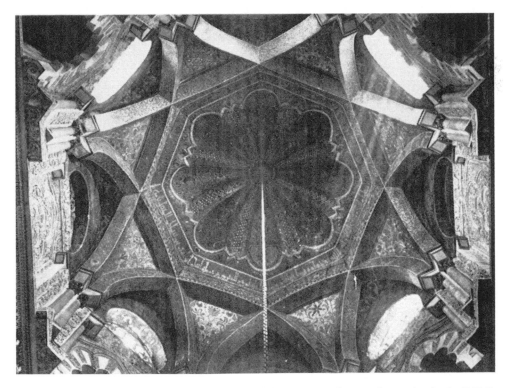

30. Cordoba. Mosque, dome in front of mihrab. (MAS)

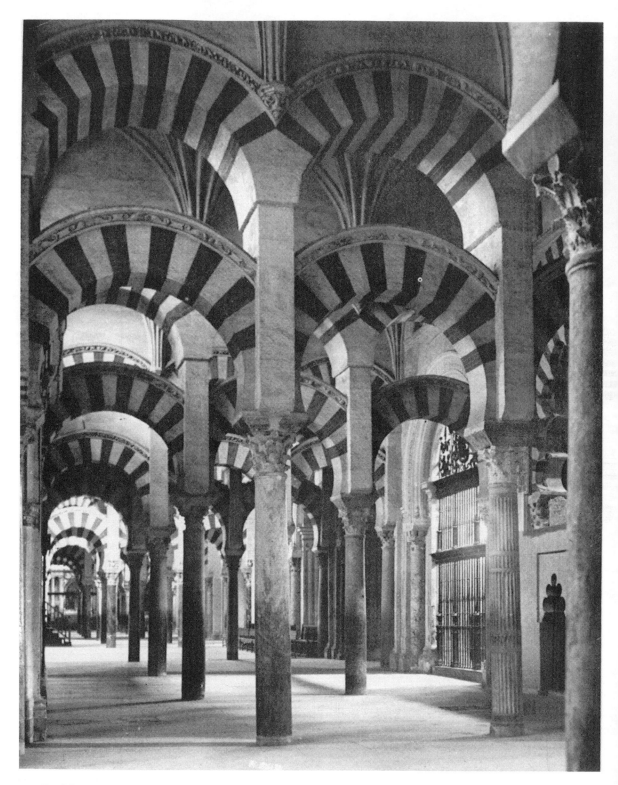

31. Cordoba. Mosque, interior. (MAS)

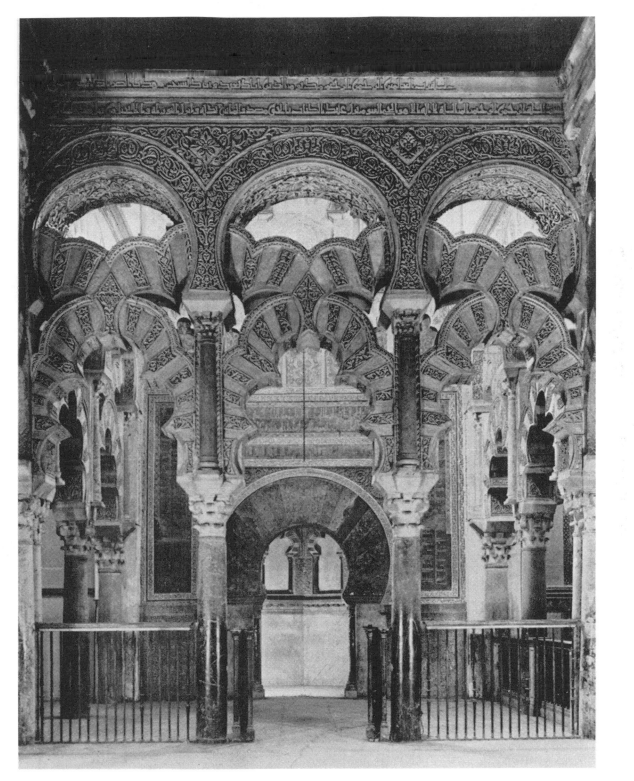

32. Cordoba. Mosque, maqsurah in front of mihrab. (MAS)

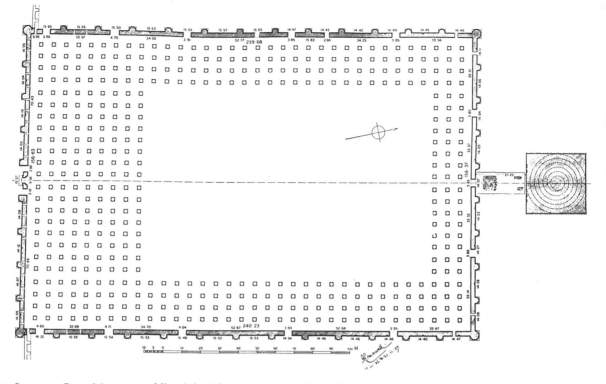

33. Samarra. Great Mosque, middle of the 9th century, plan. (After Creswell)

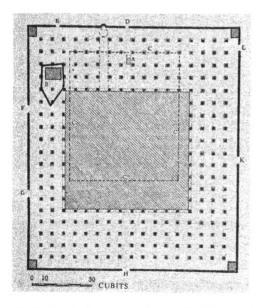

34. Madinah. Reconstruction of the Umayyad mosque, 705–15. A. Minbar; B. Tomb; C. Boundary of mosque of Muhammad; D. Imam's door; E. Door of Omar's family; F. Gabriel's door; G. Women's door; H. North door; K. Door of mercy; L. Receiving door. (After Sauvaget)

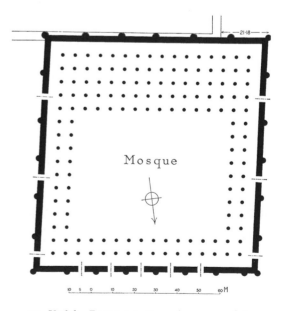

35. Kufah. Reconstruction of mosque, late 7th century. (After Creswell)

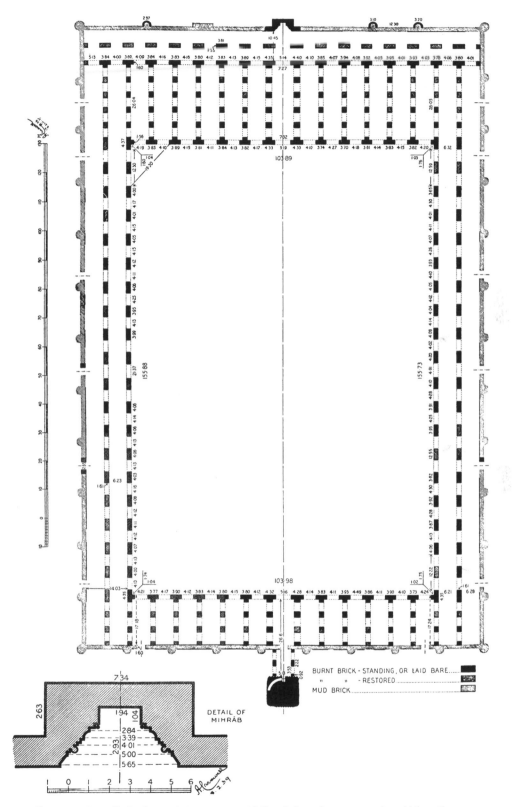

36. Samarra. So-called Abu Dulaf mosque, middle of the 9th century, plan. (After Creswell)

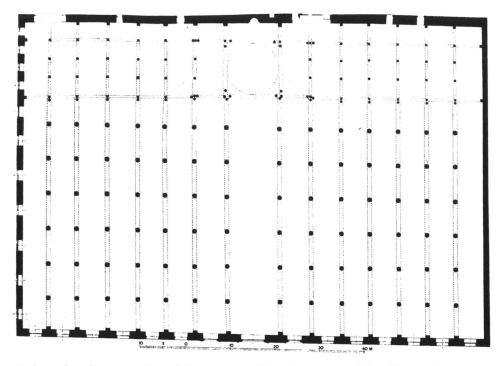

37. Jerusalem. Reconstruction of Aqsa mosque, 7th–11th centuries. (After Hamilton)

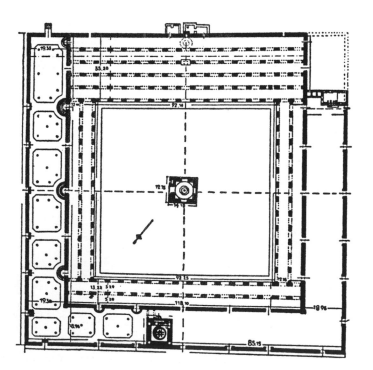

38. Cairo. Ibn Tulun mosque, 876–79, plan. (After Brandenburg)

39. Balkh. Mosque, 9th century, plan.
(After Golombek)

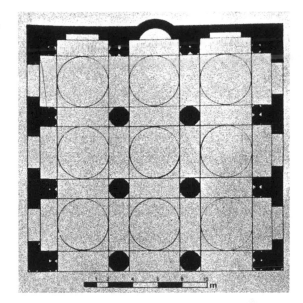

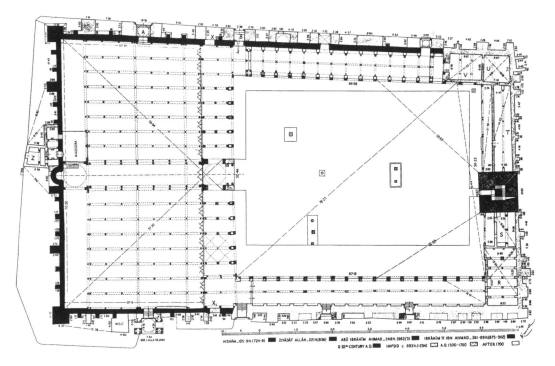

40. Kairouan. Mosque, 8th–9th centuries, plan. (After Creswell)

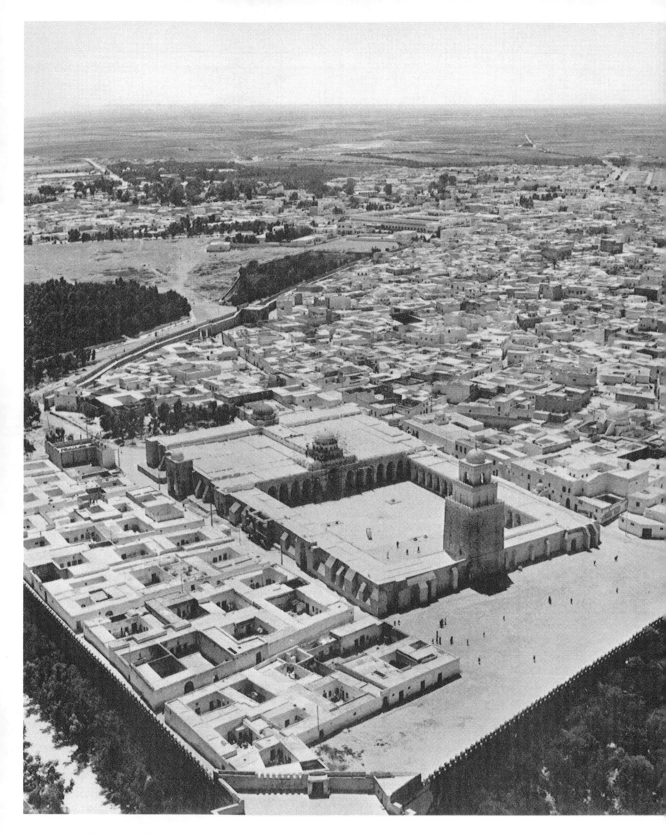

41. Kairouan. Mosque, general view. (Roger Wood Studio)

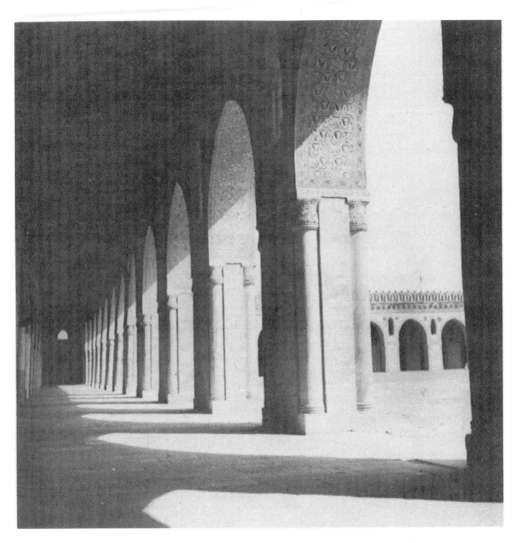

42. Cairo. Ibn Tulun mosque.

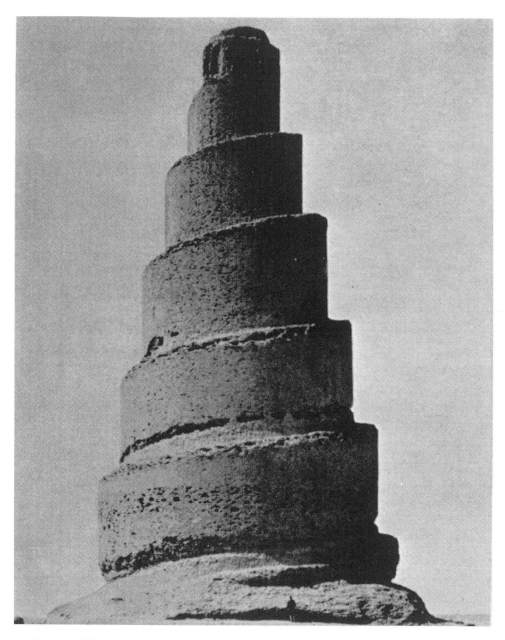

43. Samarra. Minaret of Great Mosque, middle of the 9th century. (University Prints)

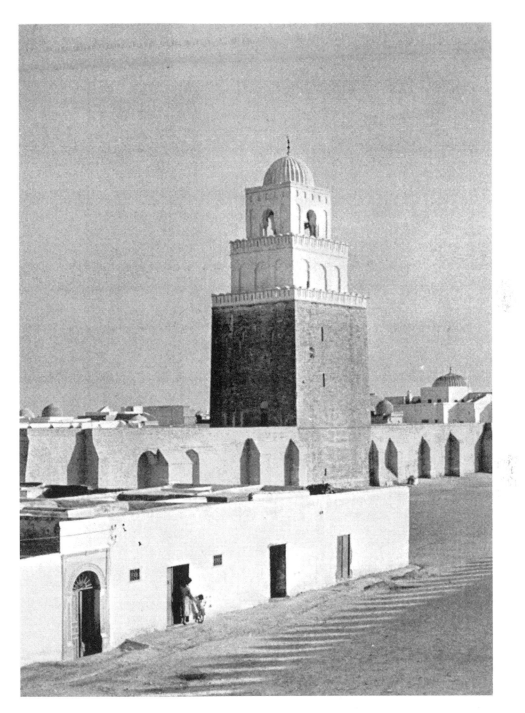

44. Kairouan. Great Mosque, 8th–9th centuries, minaret and surrounding area.

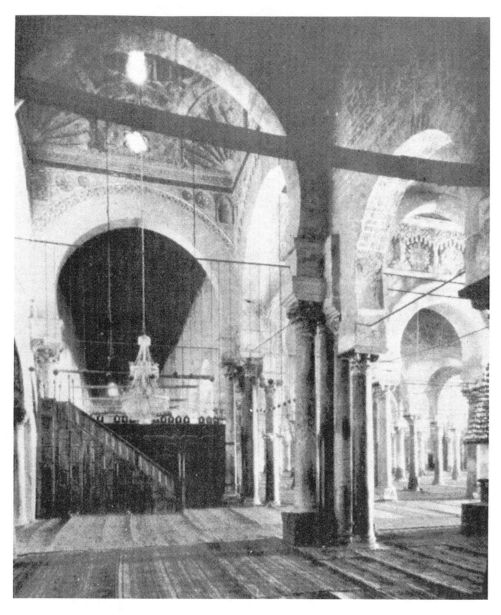

45. Kairouan. Great Mosque, mihrab area. (University Prints)

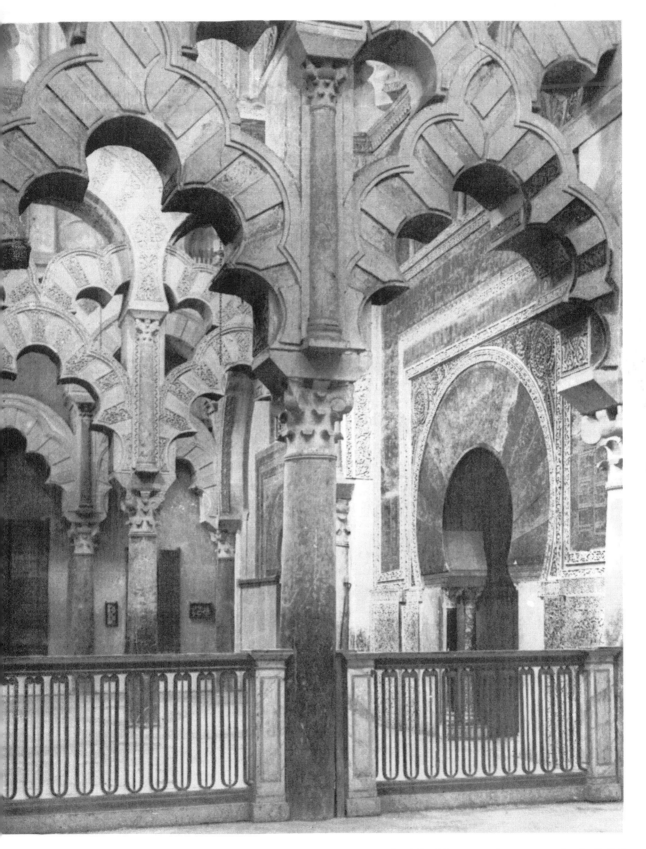

46. Cordoba. Mosque, 10th century, mihrab. (MAS)

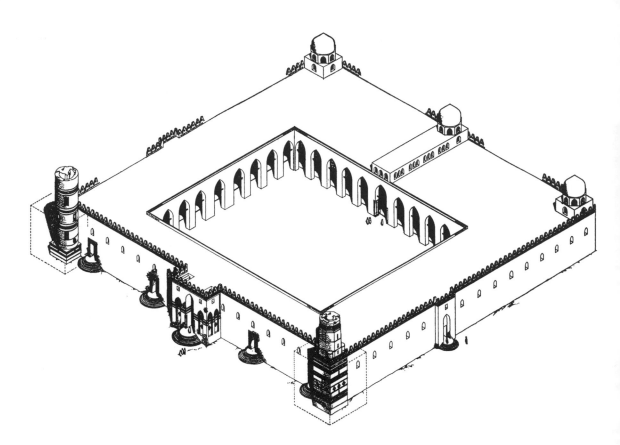

47. Cairo. Mosque of al-Hakim, 990–1013. (After Creswell)

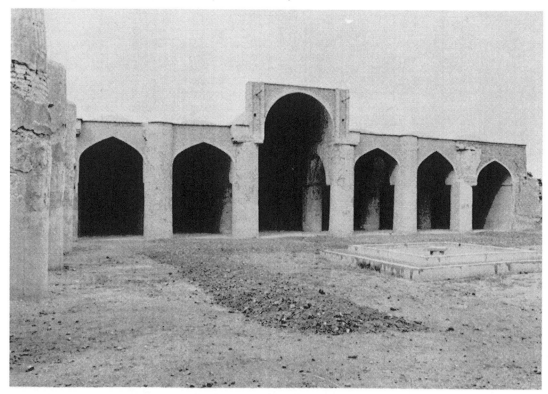

48. Damghan. Mosque, 8th or 9th century, general view.

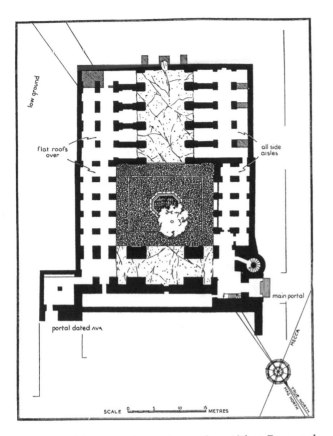

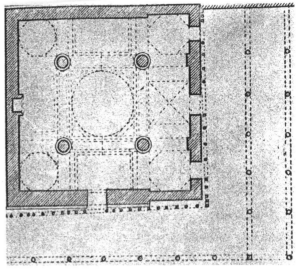

50. Hazareh. Mosque, 10th century, plan.

49. Niriz. Mosque. 10th century, plan. (After Pope and Ackerman)

51. Sussa. Ribat, second half of the 8th century, ground plan. (After Lézine)

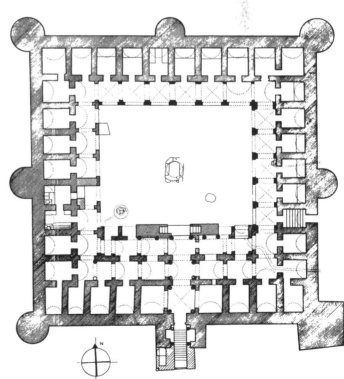

52. Qasr al-Hayr East. Mosque, early 8th century, ruins.

53. Jerusalem. Aqsa mosque, wooden panel, 8th century.

54. Kairouan. Great Mosque, 9th century, dome in front of mihrab (Roger Wood Studio)

55. Cordoba. Mosque, marble sculpture near mihrab, 10th century. (MAS)

56. Kairouan. Mosque of the Three Gates, 10th century.

57. Koran page, ninth century. Washington, D.C., Smithsonian Institution, Freer Gallery of Art.

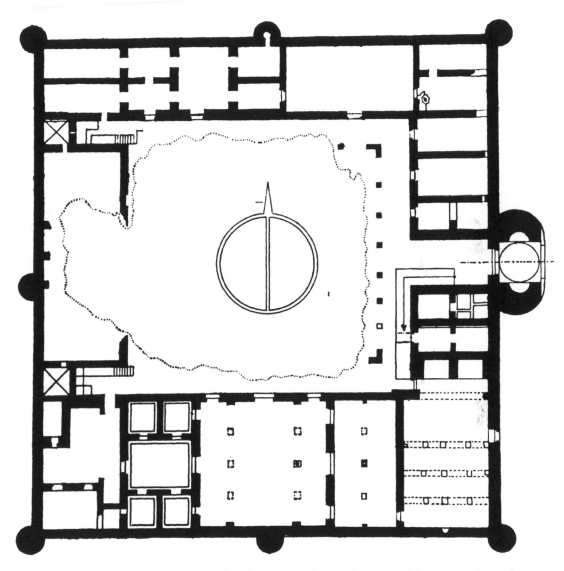

58. Khirbat Minyah. Palace, early 8th century, plan. Scale 1:500. (After Oswin Puttrich-Reignard)

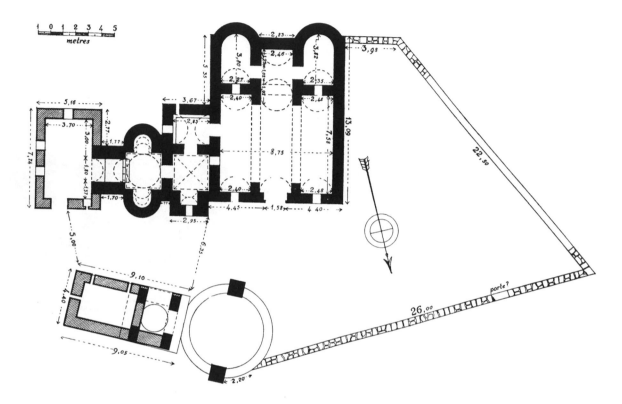

59. Qusayr Amrah. Bath, plan. (After Jaussen and Savignac)

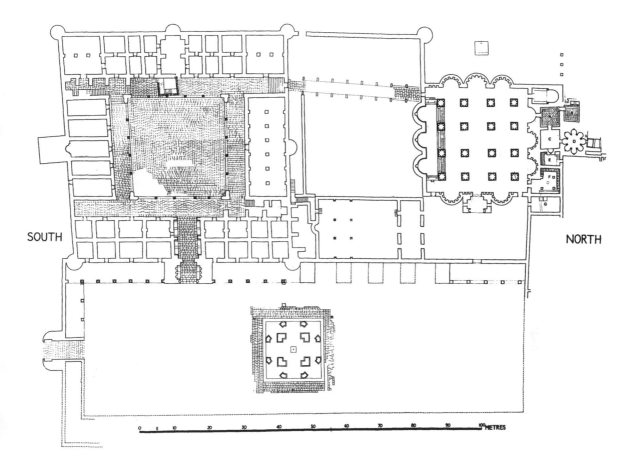

SOUTH

NORTH

60. Khirbat al-Mafjar. Palace, mosque, and bath, first half of the 8th century. (After Hamilton)

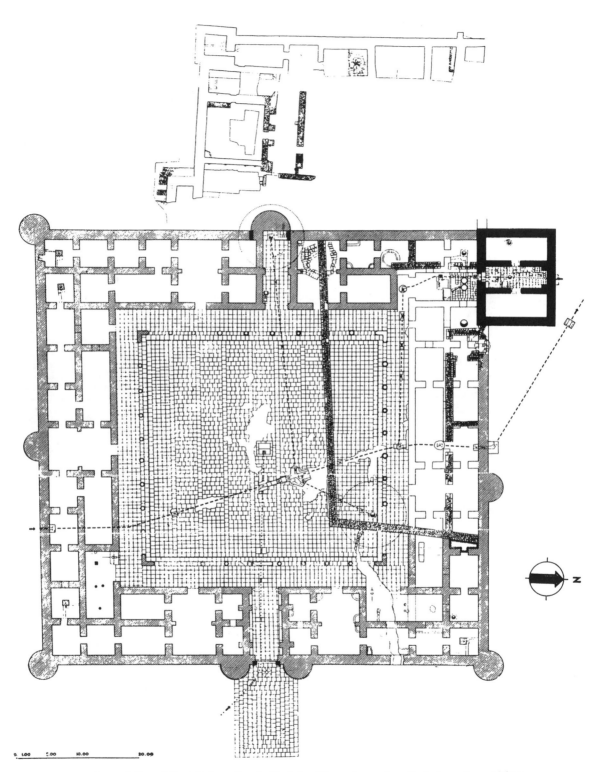

61. Qasr al-Hayr West. Palace, first half of the 8th century, plan. Scale in meters. (After Schlumberger)

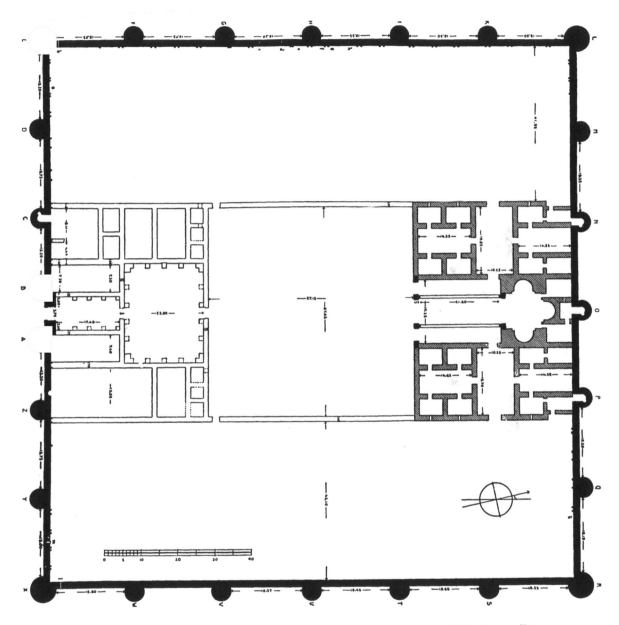

62. Mshatta. Palace, first half of the 8th century, plan. Scale in meters. (After Creswell)

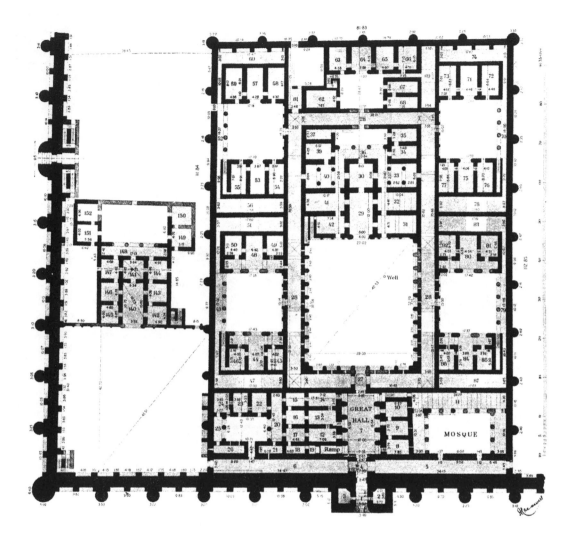

63. Ukhaydir. Palace, second half of the 8th century, plan. (After Creswell)

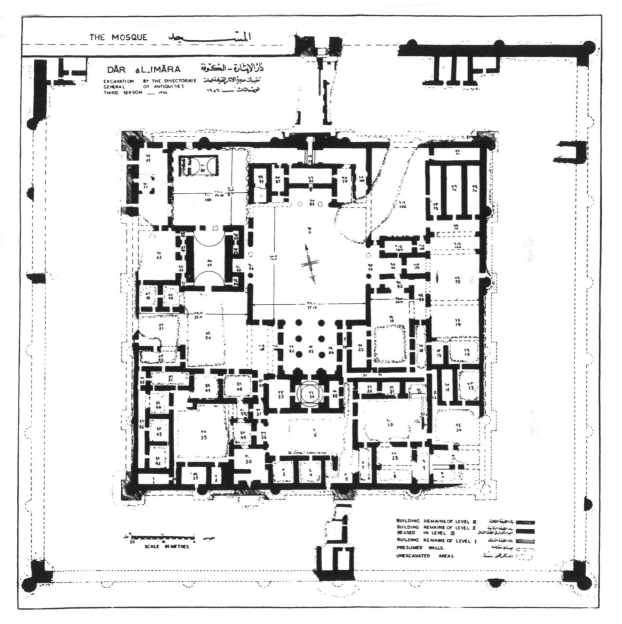

64. Kufah. City palace, late 7th and early 8th centuries, plan. (After Ali)

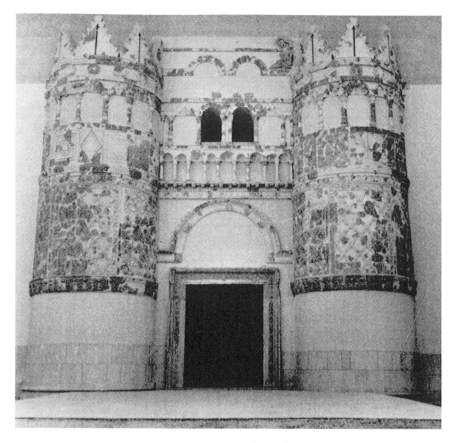

65. Qasr al-Hayr West. Palace façade, first half of the 8th century.

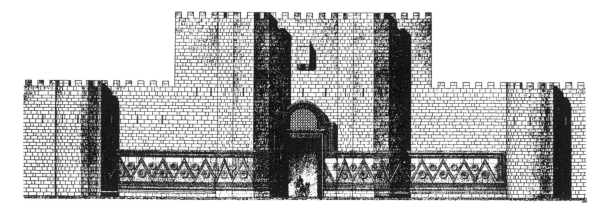

66. Mshatta. Reconstruction of façade. (After Schulz)

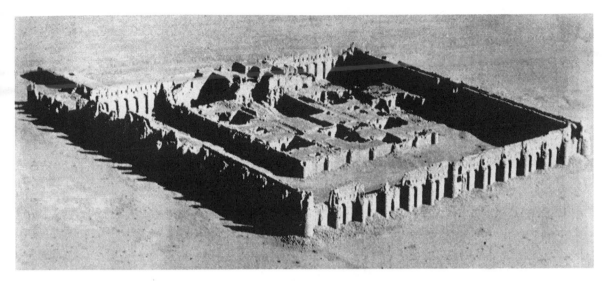

67. Ukhaydir. Palace, general view. (After Creswell)

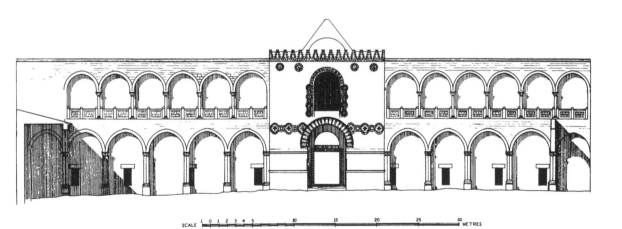

SCALE 1 0 1 2 3 4 5 10 15 20 25 30 METRES

68. Khirbat al-Mafjar. Reconstruction of palace façade. (After Hamilton)

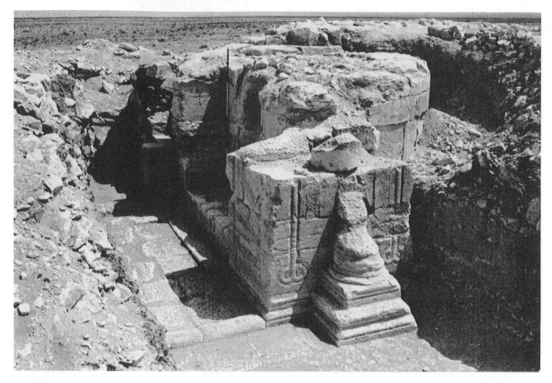

69. Qasr al-Hayr East. Single gate in outer enclosure.

70. Mshatta. Palace, view of throne room.

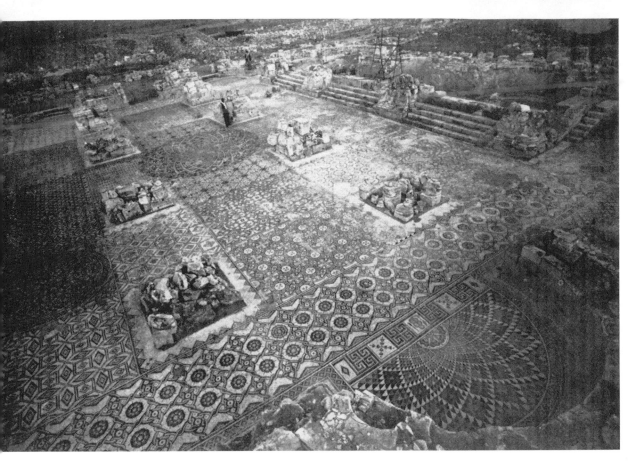

71. Khirbat al-Mafjar. Bath, mosaic floor. (Israel Department of Antiquities and Museums)

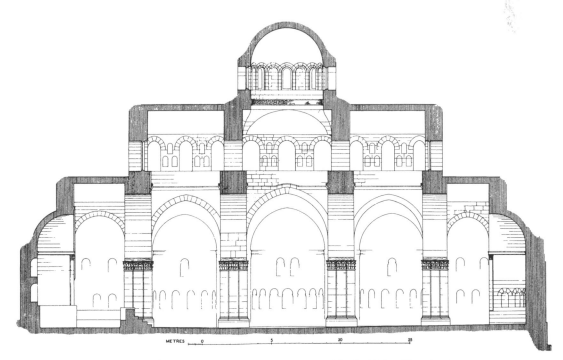

METRES 0 5 10 15

72. Khirbat al-Mafjar. Reconstruction of bath. (After Hamilton)

73. Qasr al-Hayr East. Bath, general view.

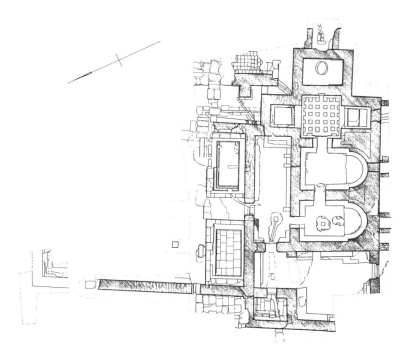

74. Qasr al-Hayr East. Bath, plan.

75. Khirbat al-Mafjar. Reconstruction of room to the north of the bath hall. (After Hamilton)

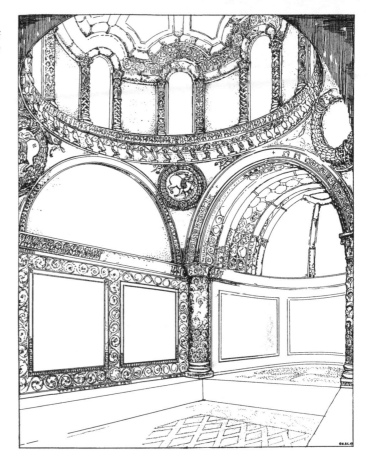

76. Khirbat al-Mafjar. Reconstruction of pool in forecourt. (After Hamilton)

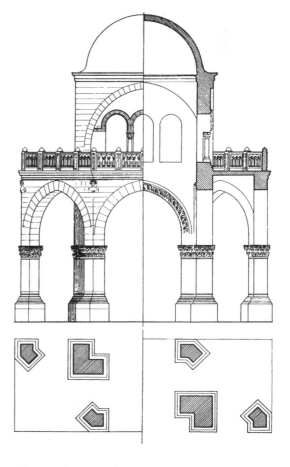

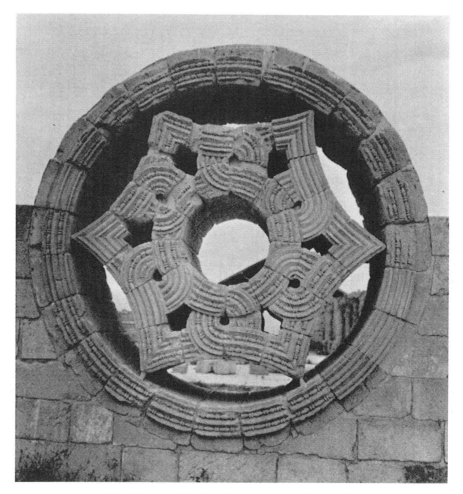

77. Khirbat al-Mafjar. Tracery window from palace.

78. Khirbat al Minyah. Mosaic floor.

79. Qasr al-Hayr West. Sculpture from the façade imitating Palmyrene art. (French Institute of Archaeology, Beirut)

80. Qasr al-Hayr West. Sculpture from the courtyard imitating a Byzantine model.

81. Khirbat al-Mafjar. Sculpture of prince imitating a Sassanian model.

82, 83. Khirbat al-Mafjar. Sculpture from bath entrance.

84. Qasr al-Hayr West. Sculpture from courtyard of palace, possibly gift bearers. (French Institute of Archaeology, Beirut)

85

85–86b. Khirbat al-Mafjar. Sculpture from palace entrance.

86a, 86b

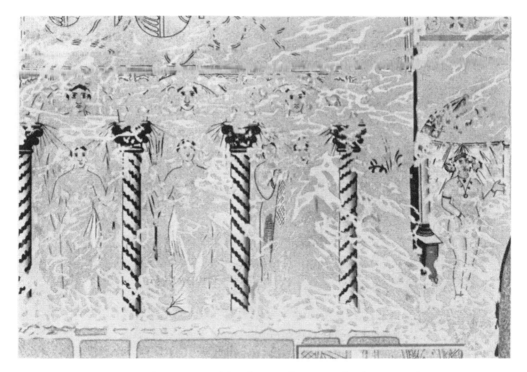

87. Qusayr Amrah. Painting of female attendants on side of prince (After Musil)

88. Qasr al-Hayr West. Floor painting imitating a classical model. (Syrian Department of Antiquities)

89. Qusayr Amrah. Painting of a tall woman standing near a swimming pool. (After Musil)

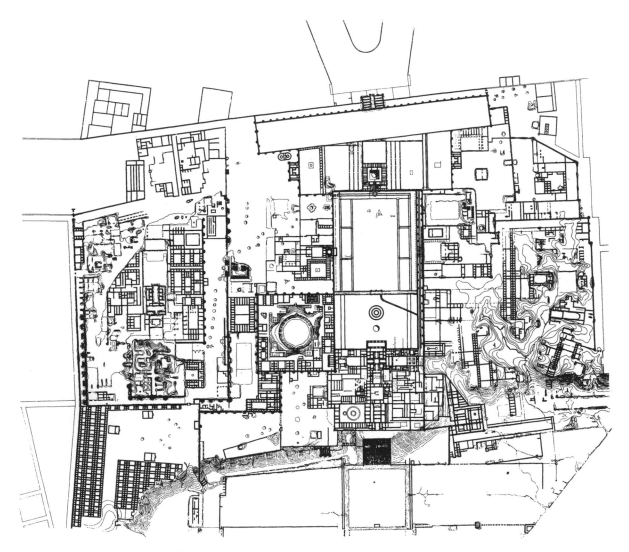

90. Samarra. Jausaq al-Khaqani palace, middle of the 9th century, plan. Scale 1 : 2000. (After Creswell)

91. Samarra. Jausaq al-Khaqani palace, painting. (University Prints)

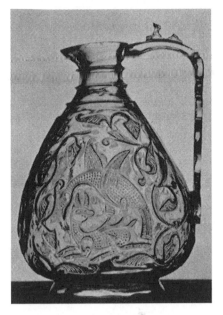

92. Fatimid rock crystal, late 10th or early 11th century. London, Victoria and Albert Museum. (Crown copyright)

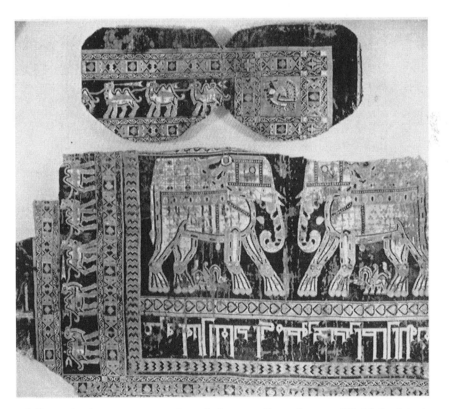

93. Silk textile, St. Josse, eastern Iran, before 961. Paris, Louvre. (Cliché des Musées Nationaux, Service de Documentation Photographique, inv. 7502)

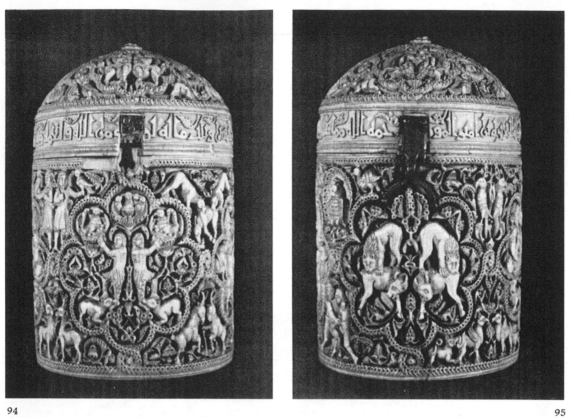

94

95

94–97. Ivory pyxis, dated in 968, details. Paris, Louvre.

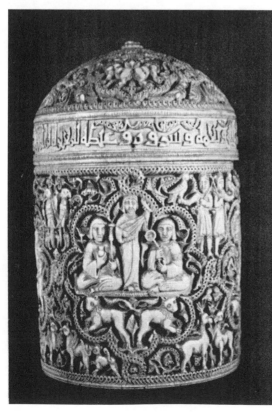

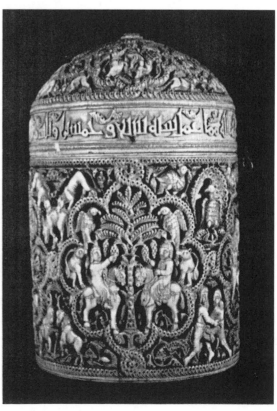

96

97

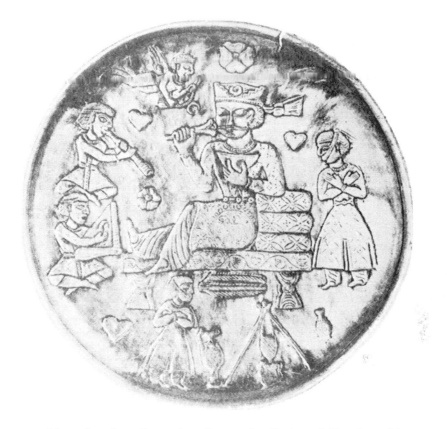

98. Silver plate from Iran, 8th–10th centuries. Leningrad, Hermitage Museum.

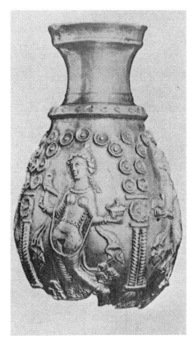

99. Silver vessel from Iran, 8th–10th centuries. Leningrad, Hermitage Museum.

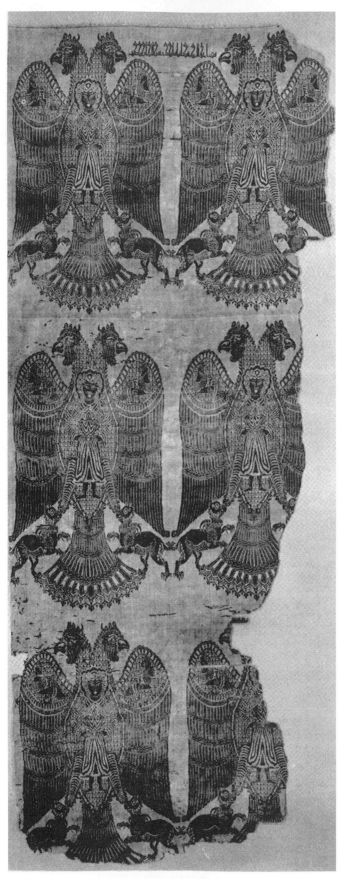

100. Buyid silk, 10th–11th centuries.
Cleveland Museum of Art.

101. Abbasid textile with inscription, 9th century. Cleveland Museum of Art.

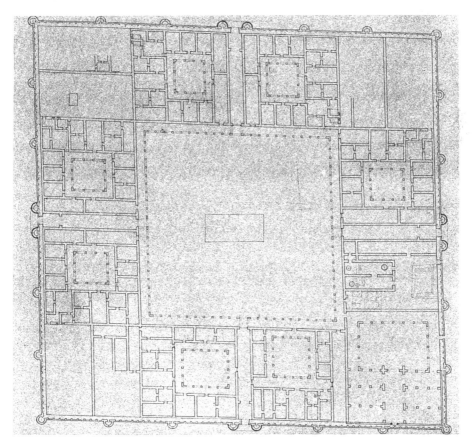

102. Qasr al-Hayr East. Plan of city.

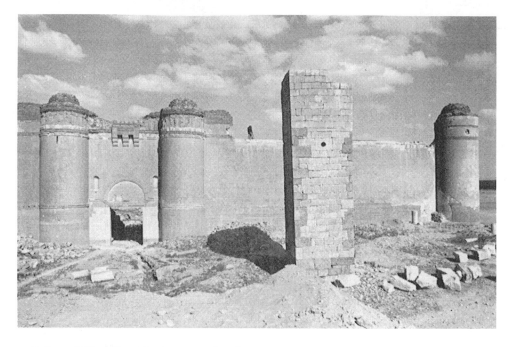

103. Qasr al-Hayr East. Caravanserai, façade.

104. Qasr al-Hayr East. Stucco fragment from small city palace.

105. Nishapur. Carved and painted stucco panel, 9th–10th centuries. New York, The Metropolitan Museum of Art.

106. Nishapur. Carved and painted stucco panel, 9th–10th centuries. New York, The Metropolitan Museum of Art.

107. Ceramic plate, luster-painted imitating metalwork, 8th–9th centuries. Washington, D.C., Smithsonian Institution, Freer Gallery of Art.

108. Ceramic bowl, polychrome splash and sgrafiato, 9th century. New York, The Metropolitan Museum of Art.

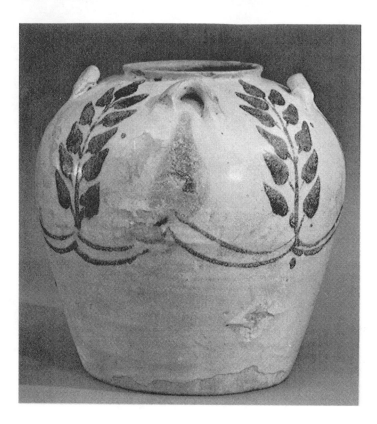

109. Ceramic bowl, cobalt blue glaze, 9th century. New York, The Metropolitan Museum of Art.

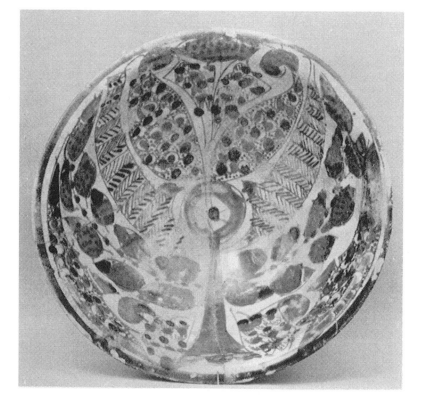

110. Ceramic plate, polychrome luster-painted, 9th century. New York, The Metropolitan Museum of Art.

111. Ceramic plate with personages, 10th century. Cleveland Museum of Art.

112. Ceramic plate with inscription, 9th–10th centuries. Washington, D.C., Smithsonian Institution, Freer Gallery of Art.

113. Ceramic plate with inscription, 9th–10th centuries. Washington, D.C., Smithsonian Institution, Freer Gallery of Art.

114. Ceramic plate with inscription, 9th–10th centuries. Paris, Louvre.

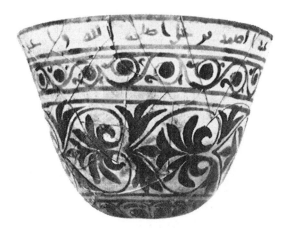

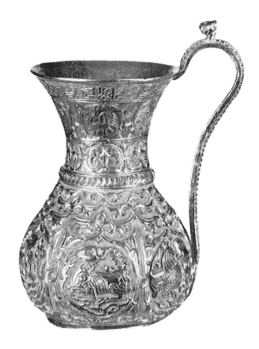

115. Luster-painted glass goblet, found in Fustat, late 8th century. (George Scanlon)

116. Gold ewer of Buyid prince, 10th century. Washington, D.C., Smithsonian Institution, Freer Gallery of Art.

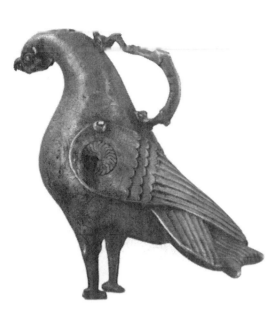

117. Bronze aquamanile, 8th–10th centuries. Berlin Museum. (Staatliche Museen Preussiche Kulturbesitz Museum für Islamische Kunst, Berlin)

118. Qasr al-Hayr West. Decorative panel on façade of palace.

119. Khirbat al-Mafjar. Decorative panel from entrance to bath.

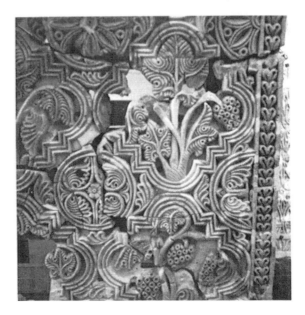

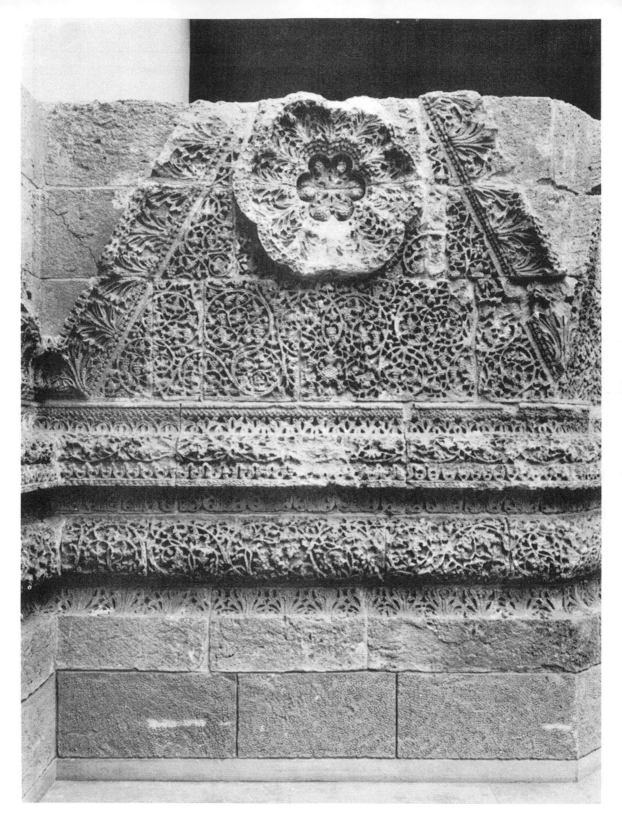

120–23. Mshatta. Stone sculpture from façade. (Staatliche Museen Preussiche Kulturbesitz Museum für Islamische Kunst, Berlin)

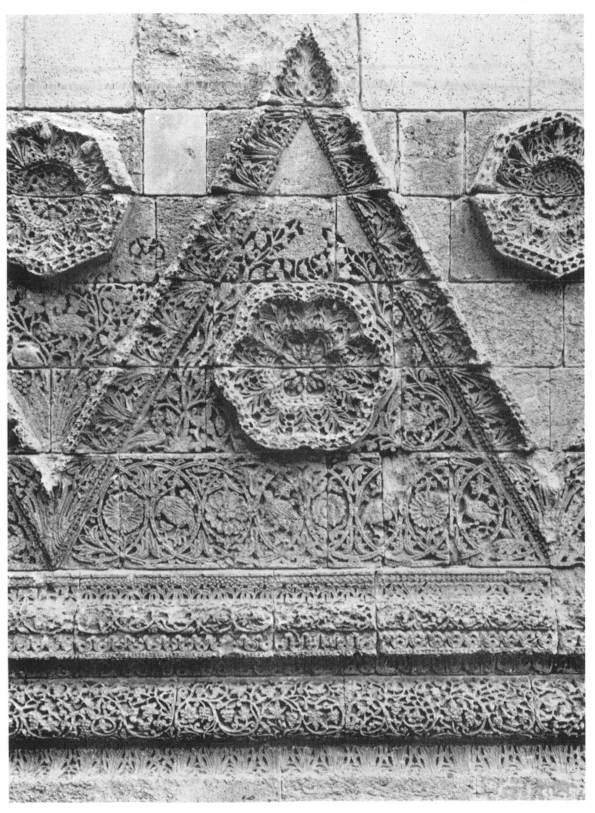

124

124, 125. Samarra. Stucco panel, middle of the 9th century. Berlin Museum. (Staatliche Museen Preussiche Kulturbesitz Museum für Islamische Kunst, Berlin)

126. Woodwork from Egypt, second half of the 9th century. Paris, Louvre. (Cliché des Musées Nationaux, Service de Documentation Photographique, inv. 6023)

127. Woodwork from Egypt, 10th century. New York, The Metropolitan Museum of Art.

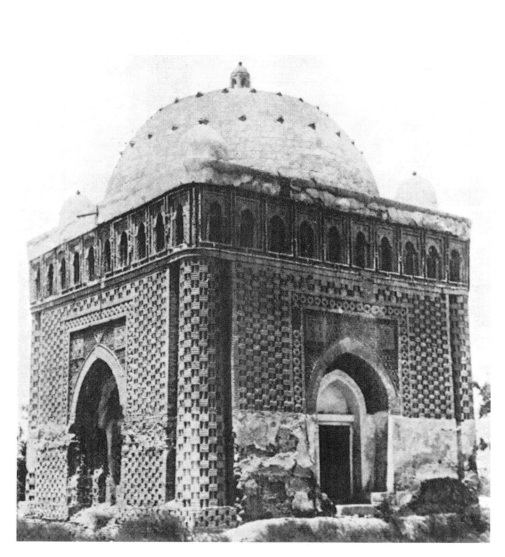

128. Bukhara. Samanid mausoleum, middle of the 10th century, general view.

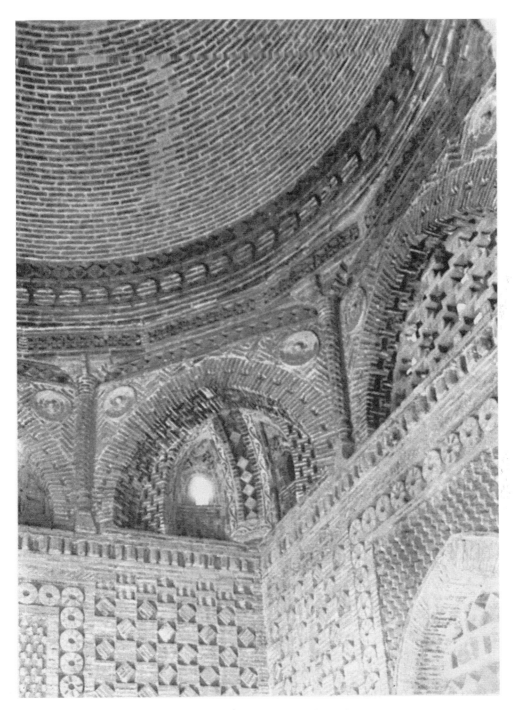

129. Bukhara. Samanid mausoleum, middle of the 10th century, interior.

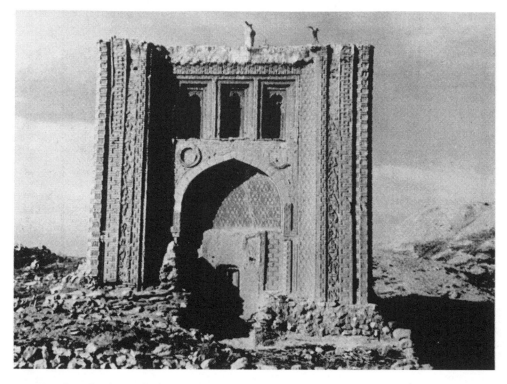

130. Tim. Façade of so-called Arab Ata mausoleum, second half of the 10th century.

131. Cairo. Fatimid mausoleums, 12th century.

Made in United States
Troutdale, OR
12/02/2023